2004

2004

2004 biennial exhibition

This book was published on the occasion of the *2004 Biennial Exhibition* at the Whitney Museum of American Art, New York, March 11–May 2004.

Lead sponsor **Altria**

Major support is provided by **Banc of America Securities**

Significant funding for the 2004 Biennial has been provided by an endowment created by Melva Bucksbaum, Emily Fisher Landau, and Leonard A. Lauder. Additional support has been given by the Director's Council, the National Committee, and the Whitney Contemporaries of the Whitney Museum of American Art.

Research for Museum publications is supported by an endowment established by The Andrew W. Mellon Foundation and other generous donors.

A portion of the proceeds from the sale of this book benefits the Whitney Museum of American Art and its programs.

ISBN 0-87427-139-8 (Abrams)
ISBN 3-88243-966-1 (Steidl)
ISSN 1043-3260

Distributed in 2004 by:
United States and Canada only

Harry N. Abrams, Inc.
100 Fifth Avenue
New York, NY 10011
www.abramsbooks.com

Abrams is a subsidiary of

LA MARTINIÈRE
GROUPE

and

STEÏDL

Steidl Publishers
Düstere Strasse 4
D-37073 Göttingen
Germany
www.steidl.de

© 2004 Whitney Museum of American Art
945 Madison Avenue at 75th Street
New York, NY 10021
www.whitney.org

Unless otherwise noted, the images on the following pages are details. The full image appears on the page within parentheses.

12–13: Robert Longo, *Untitled (Hell's Gate)* (204)
18–19: Wade Guyton, *Untitled (Gabo 28)* (184)
34–35: Banks Violette, *Untitled (model for a future disaster)* (249)
52–53: Raymond Pettibon, Installation view at Regen Projects, Los Angeles, 2000. Courtesy Regen Projects, Los Angeles
70–71: Amy Sillman, *Hamlet* (235)
76–77: Andrea Bowers, *Diabloblockade, Diablo Nuclear Power Plant, Abalone Alliance, 1981*, 2003. Graphite on paper, 8 x 10 in. (20.3 x 25.4 cm). Gaby and Wilhelm Schürmann Collection; courtesy Sara Meltzer Gallery, New York, and Chouakri Brahms, Berlin
80–81: Mel Bochner, *Nothing* (155)
84–85: Barnaby Furnas, *Hamburger Hill* (178)
90–91: Rob Fischer, *Ten Yards* (173)
98–99: Katie Grinnan, *Dreamcatcher* (183)
102–03: Fred Tomaselli, *Airborne Event* (245)
110–11: Cecily Brown, *Black Painting 2* (159)
116–17: Christian Holstad, *Fear Gives Courage Wings* (26)
122–23: Sharon Lockhart, Still from *NŌ* (203)
128–29: Alex Hay, *Gray Wood* (186)
136–37: Julie Mehretu, *Empirical Construction, Istanbul* (212)
142–43: Laylah Ali, *Untitled* (147)

whitney biennial 2004

Chrissie Iles
Shamim M. Momin
Debra Singer

Whitney Museum of American Art, New York
Distributed by Harry N. Abrams, Inc., New York,
and Steidl, Göttingen

contents

foreword

One after another, the contemporary art world's orthodoxies are set up and knocked down in a recurrent cycle of creative innovation, critical response, and market forces. The venerable Whitney Biennial resists the tendency among many art museums to favor only those whose worth is already proven. This exhibition was born of a spirit of advocacy rather than a safe affirmation of the obvious. Conservative observers assault the Biennial because of its explicitly experimental nature, while countless other critics complain of its neglect of their favorite rising stars. But the Whitney is a feisty interlocutor between artists and the public, and it is in the Museum's tradition to make room for lesser-known talents, even at the expense of artists in vogue. Each Biennial is a defining moment in the Whitney's ongoing exhibition program, which ranges from supporting artists at their first blossoming to posthumous retrospectives.

The three curators I chose to oversee this time-honored exercise in advocacy—Chrissie Iles, Shamim M. Momin, and Debra Singer—have important and distinctive perspectives on the art of our time. The hours they spent together sifting through talented artists in search of a fertile mix were sometimes tempestuous, usually spirited, and always principled. The end result is an explicitly intergenerational exhibition, one anchored in themes that are felt to be timely, including a widespread nod by younger artists to protest art of the 1960s and 1970s. In the wake of the devastation of the World Trade Center attack, the works of most of the artists chosen

manifest a sophisticated, reflective mood that is largely wanting in other forms of national self-examination.

My third and last Biennial has been as rewarding as my first two: an avowedly national survey in 2000 and an inventive identification of new trends in 2002. Unlike many other national biennial surveys spawned in the aftermath of the Museum's debut more than seventy years ago, the Whitney Biennial reaches out to a large public audience as well as the art world. That is part of what makes it both a popular event for visitors and an infuriating one for art world insiders. I take pride in thanking the exhibition's three curators, and the Whitney staff supporting them, for bravely maintaining independence of judgment, and for coming up with a rich and textured look at the art of our time. I would also like to thank the Whitney's director, Adam D. Weinberg, for very generously inviting me to contribute this foreword.

MAXWELL L. ANDERSON

preface

The idea of annual and biennial survey exhibitions had its roots in the Whitney Studio Club, the Museum's antecedent, in the early decades of the twentieth century, and they have been a hallmark of the Whitney since 1932. The byword of these exhibitions was diversity, their purpose, to provide a relatively unmediated view of the state of American art, exhibiting works by artists who were shown by neither the art establishment nor the galleries. Although the exhibitions were originally organized by medium—painting alternating with sculpture and works on paper—since 1973, when they began to occur every other year, the Biennials have pursued a different curatorial approach. The exhibitions would include all media, and would often seek out and define specific artistic tendencies. It was then-director Jack Baur's hope that "the Biennial will prove a more useful indication of current directions than the old annuals." From this point forward, to varying degrees with each exhibition, one could learn almost as much about the art and culture of the period from the curatorial approach as from the artists included. This is not to say that Biennial curators did not take pointers from the art itself, but the structure of the exhibitions was largely a reflection of their training, passions, and ideas.

This Biennial in part takes its cue from the cultural climate of post-9/11 America and reveals tendencies that the exhibitions' three curators—Chrissie Iles, Shamim M. Momin, and Debra Singer—have perceived through their assiduous and attentive consideration of art of the last two years. With ears to the ground and, more important, eyes on the work, the curators extrapolated from the art to develop the ideas behind the exhibition. While the Biennial represents the work of individual visions, it is also more than that. Given that the curators themselves come from somewhat different generations, it is not surprising that the leitmotif of this Biennial is intergenerational dialogue, a conversation that is based on distinct commonalities and threads of influence extending in both directions—from older to younger artists, and vice versa. In addition, the curators have proposed certain affinities shared by sub-groups among these artists, and although the exhibition does not have a thematic structure per se, it has an inner coherence. Upon discovering links between such diverse artists, the curators in effect cried "Eureka!" realizing that distillation is as much about discovery as it is about invention.

I would like to thank first and foremost my predecessor, Maxwell L. Anderson, who as director of the Whitney assembled the Biennial team and guided them almost to the exhibition's fruition. The curators themselves are to be congratulated for their Herculean efforts, dogged determination, and passion, passion, passion. The exhibition stayed on track under the watchful eye and through the tireless commitment of the biennial coordinator, Meg Calvert-Cason; her assistant, Jennifer Manno; Gary Carrion-Murayari, curatorial assistant; Howie Chen, gallery/curatorial coordinator; Lee Clark, gallery/curatorial assistant; Apsara DiQuinzio, curatorial assistant, contemporary art; and Henriette Huldisch, coordinator of film and video. The Biennial also benefited from the assistance of the interns Barbara Choit, Elisa D'Angelo, Holly Greenfield, Angela Go Woon Kim, Maggie Hansen, Lenore McMillan, Camila Marambio, and Joanna Montoya. Other Whitney staff to be singled out for their contributions are Jay Abu-Hamda, projectionist; Richard Bloes, projectionist; Holly Davey, audio visual coordinator; Tara Eckert, assistant registrar; Kellie Feltman, assistant registrar; Filippo Gentile, art handler, supervisor; Larry Giacoletti, assistant

registrar; Raina Lampkins-Fielder, associate director, Helena Rubinstein Chair of Education; Kelley Loftus, assistant paper preparator; Graham Miles, art handler/receiver; Christy Putnam, associate director for exhibitions and collections management; Suzanne Quigley, head registrar; Joshua Rosenblatt, head preparator; Debbie Rowe, manager of information technology; Lynne Rutkin, former deputy director for external affairs; Warfield Samuels, associate head preparator; G. R. Smith, art handler; Stephen Soba, acting director of communications; Barbi Spieler, senior registrar; and Mark Steigelman, manager, design and construction

The unique approach taken for this Biennial's catalogue was brilliantly executed by Alice Chung and Karen Hsu, Omnivore, Inc., under the supervision of Rachel Wixom, head of publications and new media. Makiko Ushiba, in-house design consultant and manager, graphic design; Kate Norment, project manager; Libby Hruska, editor; and Anita Duquette, manager, rights and reproductions, are to be commended for producing the catalogue under tight deadlines. I am also grateful for the participation of Johanna Fateman and Rachel Greene, Tim Griffin, Scott A. Sandage, Wayne Koestenbaum, Laura Mulvey, Catherine de Zegher, and Susan Buck-Morss as catalogue essayists. Howie Chen, Apsara DiQuinzio, Henriette Huldisch, Christian Rattemeyer, and Brian J. Sholis are also to be acknowledged for their contributions to the catalogue. In addition, we would like to thank Jonathan Hill, Brian Douglas, Bill Fletcher, and Corey Szopinski of Domani Studios for their work on the design and development of the website accompanying the Biennial, as well as Basem D. Aly, web coordinator, for his in-house implementation of the project.

One of the features of the Whitney's Biennial exhibitions is the Museum's collaboration with other arts and cultural institutions. The 2004 Biennial marks the second successful collaboration with the Public Art Fund, and we would especially like to thank the following individuals from that organization: Susan K. Freedman, president; Tom Eccles, director; Anne Wehr, communications director; and Miki Garcia, project coordinator. We also very much appreciate the enthusiasm and partnership of the following individuals and their organizations: Elise Bernhardt, executive director, Christina Yang, media arts curator, and Sacha Yanow, director of operations, The Kitchen; Laurie Uprichard, executive director, Danspace; Susan Feldman, artistic director, St. Ann's Warehouse; Craig Peterson and Cathy Edwards, Dance Theater Workshop; M. M. Serra, director, Filmmakers' Co-operative; Robert Slattery, Institute of International Education; Ilkka Kalliomaa, cultural attaché, Consulate General of Finland; and Alexi Rogov, Russian Cultural Center.

As part of the process of shaping this Biennial, the three curators convened an all-day roundtable in March 2003. A number of colleagues were invited to discuss salient issues in contemporary art and culture. For their participation I wish to thank George Baker, assistant professor of art history at UCLA and co-editor, *October*; Carlos Basualdo, co-curator of Documenta XI and the 2003 Venice Biennale; Catherine de Zegher, director, The Drawing Center; Lauri Firstenberg, adjunct curator, Artists Space; Rachel Greene, editor, rhizome.org; Tim Griffin, editor, *Artforum*; Branden Joseph, assistant professor of art history at the University of California, Irvine, and co-editor, *Grey Room*; Christine Kim, associate curator, The Studio Museum in Harlem; Dominic Molon, associate curator, Museum of Contemporary Art, Chicago; Sina Najafi, editor-in-chief, *Cabinet*; and Cay Sophie Rabinowitz, senior U.S. editor, *Parkett*.

A Biennial could never happen without the constant and generous involvement of so many galleries. I am delighted to acknowledge the support of: 303 Gallery; 1301PE; ACME.; American Fine Arts, Co.; Angstrom Gallery; Anthology Film Archives; Artemis Greenberg Van Doren Gallery; ArtPace; bitforms gallery; Blum & Poe; Marianne Boesky Gallery; Chouakri Brahms; Gavin Brown's enterprise; Galerie Daniel Buchholz; Cheim & Read; China Art Objects Galleries; Clementine Gallery; Cohan and Leslie; James Cohan Gallery; John Connelly Presents; CRG Gallery; Debs & Co.; Elizabeth Dee Gallery; Deitch Projects; Eslite Gallery; Feature Inc.; Feigen Contemporary; Galleria Emi Fontana; Peter Freeman, Inc.; Fredericks Freiser Gallery; Julia Friedman Gallery; Gagosian Gallery; Gasser & Grunert Inc.; Barbara Gladstone Gallery; Marian Goodman Gallery; Gorney Bravin + Lee; Guild & Greyshkul; Murray Guy; Galerie Hauser & Wirth; Inman Gallery; Sean Kelly Gallery; Galerie Yvon Lambert; Lombard-Freid Fine Arts; Luhring Augustine Gallery; maccarone inc.; Matthew Marks Gallery; Sara Meltzer Gallery; Metro Pictures; Robert Miller Gallery; Yossi Milo Gallery; Mixed Greens; neugerriemschneider; PaceWildenstein; peres projects; Postmasters Gallery; The Project; Galerie Almine Rech; Regen Projects; Daniel Reich Gallery; Sandroni Rey Gallery; Andrea Rosen Gallery; Salon 94; Brent Sikkema Gallery; Fredric Snitzer Gallery; Sonnabend Gallery; Team Gallery; Richard Telles Fine Art; Ten in One Gallery; Leslie Tonkonow Artworks + Projects; Turbulence.org; Suzanne Vielmetter Projects; White Cube; and David Zwirner.

Lending works to a museum exhibition is always a tremendous act of faith in the institution and its endeavors. The lenders to this exhibition share our passion for the support of new work. For their commitment to the Biennial we are truly thankful to Matt Aberle; American Fund for the Tate Gallery and the collection of John and Amy Phelan; Patricia A. Bell; Amy Cappellazzo and Joanne Rosen; Suzanne and Bob Cochran; Cooper Family Foundation; Robert Crabb; Douglas S. Cramer; Kenneth L. Freed; David and Nancy Frej; Mr. and Mrs. Christopher Harland; Hoffmann Collection; Susan and Michael Hort; Vicky Hughes and John A. Smith; Edward Israel; Julie Kinzelman and Christopher Tribble; Jeanne and Michael Klein and the Jack S. Blanton Museum of Art; Susan and Tony Koestler; Marvin and Alice Kosmin; Jill and Peter Kraus; Adam Levinson; Lindemann Collection; Marieluise Hessel Collection on permanent loan to the Center for Curatorial Studies, Bard College; Victor Masnyj; Susan and Harry Meltzer; The Museum of Contemporary Art, Los Angeles; Marvin Numeroff; Catherine Orentreich; William A. Palmer; Alan Powers; The Rachofsky Collection; AG Rosen; The Judith Rothschild Foundation; Rubell Family Collection LTD; Richard B. Sachs; Gaby and Wilhelm Schürmann Collection; Stanley and Nancy Singer; Karen and Andy Stillpass; Ellen and Steve Susman; Heather Urban; Dean Valentine and Amy Adelson; Weatherspoon Art Museum, The University of North Carolina at Greens-boro; Wellspring Capital Management LLC; Isabel Wilcox; Peter and Linda Zweig; and several lenders who prefer to remain anonymous.

The curators would like to thank a number of individuals for their help and support throughout the project: Jerome Agel; Bill Arning, List Visual Arts Center; Roland Augustine; Regine Basha, Arthouse, Austin; Douglas Baxter, PaceWildenstein; Jonathan Bepler; Marilyn Brakhage; Elizabeth Brown, Henry Art Gallery, University of Washington, Seattle; Gavin Brown; Daniel Buchholz; Brian Butler, 1301PE; Balasz Nyeri, Cineric Inc.; Bonnie Clearwater, Museum

of Contemporary Art, Miami; Mo Cohen; Sadie Coles, Sadie Coles HQ; Lisa Corrin, Seattle Art Museum; Ivy Crewdson, Barbara Gladstone Gallery; Clarissa Dalrymple; Michael Darling, Museum of Contemporary Art, Los Angeles; Jeffrey Deitch; Rebecca Donelson; Susan Dunne, PaceWildenstein; Corinna Durland, Gavin Brown's enterprise; Anne Ellegood, Norton Family Foundation; Cristina Enriques; Okwui Enzwezor; Gregory Evans, David Hockney Studio; Richard Flood, Walker Art Center; Douglas Fogle, Walker Art Center; Peter Freeman; Larry Gagosian; Lia Gangitano, Participant Inc.; Barbara Gladstone; Arnie Glimcher, PaceWildenstein; Mark Glimcher, PaceWildenstein; Snezana Golubovic; Marian Goodman; Jay Gorney; Amy Gotzler, Sean Kelly Gallery; Harold Gronenthal, IFC Films; Paul Ha, Contemporary Art Museum, St. Louis; K. Michael Hays; Tom Heman, Metro Pictures; Betti Sue Hertz, San Diego Museum of Art; Matthew Higgs, California College of the Arts; Antonio Homen, Sonnabend Gallery; Kerry Inman; Eungie Joo, Redcat; Toby Kamps, Museum of Contemporary Art, San Diego; Katherine Kanjo, ArtPace; Paul Kasmin; Sean Kelly; David Kiehl; Clara Kim, Redcat; Karen Kuhlman, David Hockney Studio; Kris Kuramitsu, Norton Family Foundation; Lawrence Luhring; Brian Malone; Matthew Marks; Jesse McBride, Regen Projects; Teri McLuhan; Sara Meltzer; Pamela Meredith, Henry Art Gallery, University of Washington, Seattle; Abby Messitte, Clementine Gallery; Christopher Mueller, Galerie Daniel Buchholz; Catherine Orentreich; Lisa Overdun, Regen Projects; Panasonic; Cecile Panzieri, Sean Kelly Gallery; Christiane Paul; Javier Peres; Chris Perez; Shaun Regen; Lawrence Rinder; Roger Smith Hotel; Richard Schmidt, David Hockney Studio; Claudia de Serpa; Susanna Singer; Henry Urbach, Henry Urbach Architecture; Philippe Vergne, Walker Art Center; Gilbert Vicario, The Institute of Contemporary Art, Boston; Hamza Walker, The Renaissance Society; Suzanne Weaver, Dallas Museum of Art; Helene Winer, Metro Pictures; Sylvia Wolf; and Jay Worthington.

Finally, the 2004 Biennial is sponsored by Altria. The Whitney has enjoyed a long and enduring relationship with Altria, a company that well understands the significance of the Whitney and the Biennial, but, more important, appreciates the visionary role that contemporary artists play in our society even when they are untried and pushing the boundaries. In addition, we would like to recognize the generosity of Banc of America Securities, which has provided major support for the exhibition. I am deeply grateful to Melva Bucksbaum for her support of the Biennial and the creation of the Bucksbaum Award in recognition of artistic excellence, and to Emily Fisher Landau and Leonard A. Lauder for the major roles they have played in creating an endowment for the exhibition. The Director's Council, the National Committee, and the Whitney Contemporaries are to be acknowledged for their enthusiastic support. I am also thankful for their support of the staff and their courageous advocacy of the Museum's mission as represented by the Biennial.

ADAM D. WEINBERG, Alice Pratt Brown Director

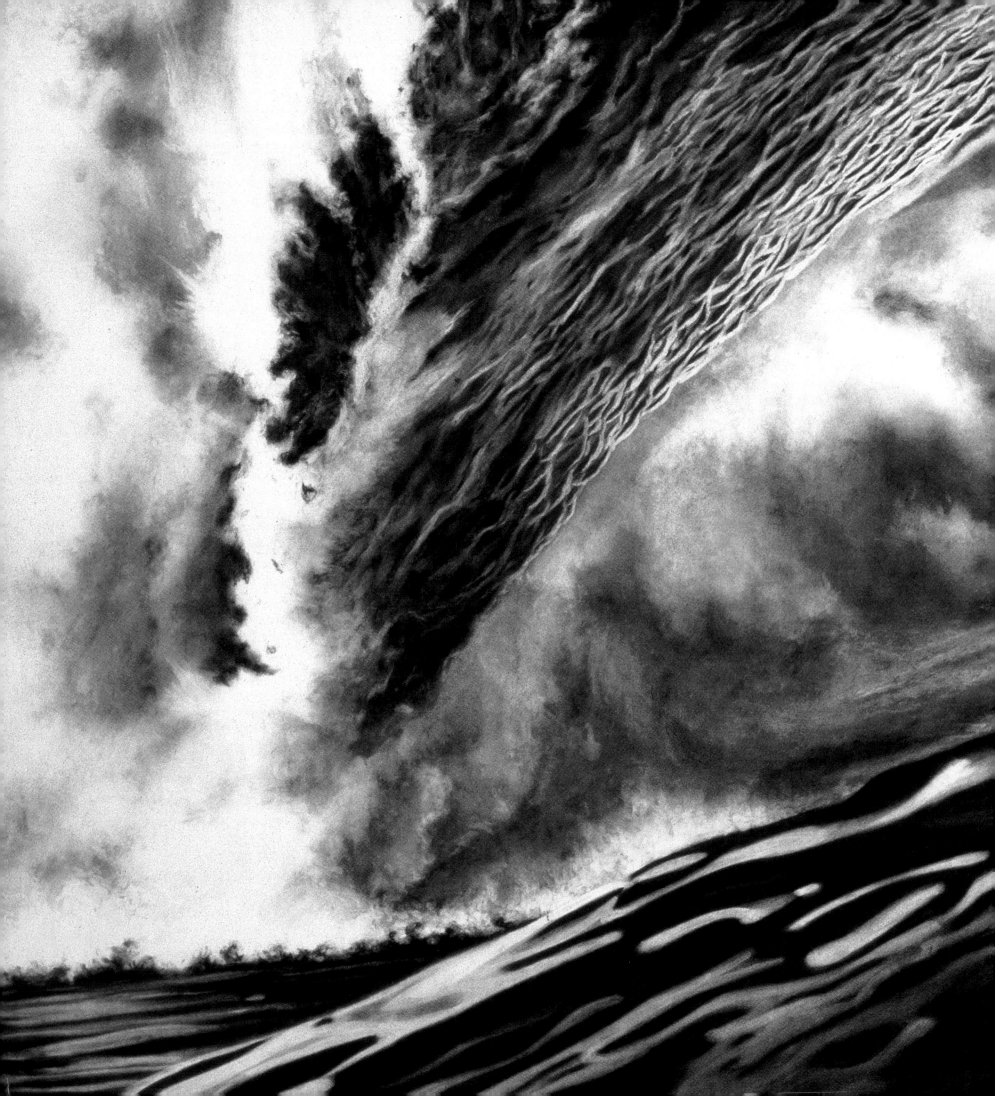

introduction

The 2004 Whitney Biennial marks a complex moment of transition in our cultural landscape. Appearing a decade after the 1993 Biennial, whose controversial curatorial thesis articulated the end of the 1980s and identified a new set of issues that came to define much of the 1990s, the 2004 Biennial suggests that another significant sea change in contemporary art may be under way. This change has arguably been catalyzed by the seismic global political and economic shifts that took place throughout the nineties, culminating in the events of September 11, 2001, and its continuing aftermath, which marked the beginning of a new millennium. During the early 2000s we have witnessed a rejection of the excessive values of the late 1990s: a conspicuous consumption that dwarfed that of the 1980s; scandals of corporate greed; the dot-com collapse; a crisis in the world financial system; and an unprecedented interdependence in the political and economic landscape. Whereas the early 1990s embraced the end of the cold war and looked toward a new, highly technologized future with optimism, the current economic, political, social, and artistic climate is dominated by anxiety, fear, and an uncertainty whether this generation is up to the daunting challenges posed by this new present.

The backdrop of recent events was an ever-present undercurrent of our discussions with artists during our research over the last year as we traveled throughout the United States. While not necessarily reflected in the content of the art we saw, the dramatic social and political upheaval of the past two years has clearly triggered a profound response among artists of all ages. Conducting our research separately, we discovered that we all noticed several of the same overlapping tendencies—diverse approaches to process, narrative, materiality, abstraction, conceptual strategies, technology, and history—stretched across three generations, creating the foundation for an exhibition that reflects this synergy. The myriad ideas contained within the exhibition are not bound by strict thematic groupings, but coexist within a kind of Venn diagram, in which clusters overlap with, or lead to, any number of other possible associations or groupings.

In the 1990s our concept of materiality was transformed, largely through the estab-lishment of the Internet as a dominant form of global communication and exchange. This shift has led to a new reading of issues related to the body and the "real," as the virtual plays an ever-expanding role in people's lives and the realities of the new tech-nology become internalized. If the body became a major subject in the 1990s as its materiality was challenged by the virtual space of technology, in the following years it has reasserted itself as a relentlessly physical presence, manifested with renewed intensity in the painted mark, the drawn line, and new ways of defining surface, image, geographical location, and social space.

An engagement with process and a desire for immediacy and intimate communication are present throughout the show, in work that is by turns fantastical, political, obsessive, formal, abstract, and narrative. A certain modesty and an interest in low-tech materials and media, whether in painting, drawing, or film, suggest a reaction against the highly produced slickness of the late 1990s and an increasingly skeptical attitude toward tech-nology and the utopian hopes for its positive global impact.

A new generation of artists is also distinguishing itself by its engagement with the politics, popular culture, and art of the late 1960s and early 1970s to explore concerns of today. These artists have been powerfully influenced by important figures from the 1960s art world, such as Robert Smithson, Sol LeWitt, and Jack Smith, as well as by the broader political and countercultural environment of the 1960s, from political demonstrations and conceptual strategies to multisensory environments and psyche-delia. While social and identity politics remain important, they appear in the work not in a forthright, didactic way, but in a more coded, internalized form. The persistence of Smithson's influence on the current generation is reflected in statements such as his observation in 1966 that "the future is but the obsolete in reverse." Looking back on a period in which international conflicts, domestic tumult, political scandals, and eco-nomic downturns formed a combustible climate as crisis-driven as our own, today's

artists relate to recent history through a kind of self-aware nostalgia; they deal with that radical moment as a way to come to terms with the conditions and circumstances of current events, and to find alternatives for the future.

Reflecting on the past as if it were "a foreign country," as L. P. Hartley put it, can be seen as the flip side of another prevalent impulse: the construction of fantastical alternative realities, in which mythmaking provides a way to understand a world that has become increasingly dangerous and alien. Many of the Biennial artists mine references ranging from science fiction to fairy tales, comic books to music culture, creating a fluid, emancipated space for the imagination. Their work is characterized by the mapping of an invented interior world, or the metaphorical exploration of the abstract, nonlinear environment of cyberspace, to investigate new belief structures that might replace those of the contemporary world that appear increasingly bankrupt. The space of the cinematic unconscious is paralleled by another kind of interior space of fantasy and memory, within which the sublime, the transcendental, and the apocalyptic course through the psyche like a hidden underground stream, expressed in obsessive drawing, painterly surfaces, conceptual filmic strategies, and dark, immersive environments.

A prominent manifestation of this approach is the reemergence of a gothic sensibility, in which darkness functions as a means of access to the perceptual sublime, both as mourning and as memorial, reflecting a desire for transcendence or the release of repressed emotional states. Umberto Eco remarked on the curious recurrence of the medieval throughout American history—often in the form of gothic fantasy—viewing it as a repeated confrontation with the modern. The roots of this sensibility in part lie in late-eighteenth-century European gothic literature and the psychoanalytic excavations of the unconscious at the end of the nineteenth century: two convulsive developments that anticipated the transformation of society into the modern age through industrial production, made evident in visual terms by the emergent mass media of photography and cinema.

This impulse is demonstrated in the work of the current generation of young artists, who have known only the extensively mediated technological, urban, and corporate environment that dominated the 1990s. In this alienated and anxiety-laden climate, chaos breeds change and the fears and desires of the world come to life, leading to a breakdown of conventional distinctions, such as those between the beautiful and the grotesque or the fantastical and the real, and resulting in new forms of meaning.

Many of these forms suggest a desire for new ideas of community—from the sense of belonging found in music culture to the social and political collective groups created by the "remote immediacy" of technology—that simultaneously allow for individual agency and a control that balances group gestures. This paradoxical desire for both connectedness and distance is also manifested in sculptures and environments in which materials such as neon lights, street signs, decorative interiors, reflective surfaces, and domestic furniture are distorted, resulting in disconcerting, warped spaces that mirror the neurotic space of the contemporary urban environment.

This interest in warped space reflects the intergenerational nature of the exhibition: it was in the 1960s that the dislocation of urban, domestic, and artistic space was strongly articulated in radical new forms of artmaking, incorporating language, performance, dance, video, drawing, process, and new forms of painting and sculpture, all produced in response to a society undergoing profound transition. In 2004 a new transition is occurring, giving rise to an unprecedented dialogue between generations sharing experiences within a time of striking uncertainty and transformation.

Chrissie Iles, Curator of Film and Video
Shamim M. Momin, Branch Director and Curator
Debra Singer, Associate Curator of Contemporary Art

ENT FOR AN AIRPORT. 1924-25.
d metal, 5' high.
y the artist.

The Way Things Never Were:

Nostalgia's Possibilities and the Unpredictable Past
Debra Singer

Concerning words and their reputations, "nostalgia" has a rather negative one. The term conjures up a slew of associations, ranging from the wistfully contemplative to the indulgently emotional, but it almost always refers to the unreliable realm of feelings rather than rational or analytical thought. Perhaps these disparaging connotations shouldn't be surprising in light of nostalgia's own history. First considered a disease, identified and named by the Swiss doctor Johannes Hofer in 1688, nostalgia was thought to be a physical illness that afflicted soldiers posted far from home.[1] (Going back to the Greek, the term literally translates as *nostos*, "a return to home," and *algia*, "pain" or "suffering," yielding the definition "homesick.") To relieve symptoms, the common prescription was opium, a course of bloodsucking leeches, and a sojourn to the Alps.[2] One early-eighteenth-century Russian general, however, was known to have tackled the problem a bit more aggressively, attempting to contain an outbreak of nostalgia in his ranks by burying soldiers alive—a severe treatment if ever there was one.[3] It was not until later in the eighteenth century that doctors, failing to make any noticeable progress, recommended that the afflicted seek counsel from poets and philosophers.[4] While subsequent generations have associated nostalgia with the psychological and sociological, its earlier misdiagnosis has had residual effects. Even in the twentieth century, nostalgia was included on the U.S. surgeon general's list of maladies through the Second World War.[5] Given both the term's elaborate evolution and today's global economy that mass-markets memories by the millisecond, nostalgia continues to have complex implications for our lives today.

Many of the artists in this Biennial and beyond take full advantage of nostalgia's possibilities, putting it to use as a means to their own critical ends. Like DJs mixing musical fragments into entirely new-sounding works, artists today plunder history, sampling elements to create their own aesthetic statements that comment on present-day concerns and consider alternatives for the future. In this exhibition, the most visible specters from the past are from the political, social, and cultural histories of the 1960s and 1970s. The artists' references range from political protests and social upheaval to the related countercultural manifestations of psychedelia, camp, glam rock, the gothic, and punk, as well as to experimental artistic practices such as Pop, Minimalism, and Postminimalism.

That the late 1960s and early 1970s have become such an important touchstone for younger artists should not seem so unexpected. It is arguably the last political decade—a period when civic activism and popular culture merged on a massive public scale. It can also be thought of as an era as tumultuous as our own; the Vietnam war, shootings at Kent State University, economic recession, and the Watergate scandal can be seen as distant analogues to the current conflict in Iraq, the mayhem at Columbine, the dot-com collapse, and the fall of Enron. By delving into the aesthetics and events of this earlier period, artists displace contemporary problems, anxieties, and hopes into visual lexicons borrowed from a psychologically more remote past, rendered less traumatic with the passing of time.

The artists' various methods for incorporating historical references can be understood within a continuum of earlier postmodern art practice based on tactics of appropriation. Many artists from the late 1970s and early 1980s made work that directly referred to other images borrowed from advertisements or films and was primarily concerned with questioning notions of artistic originality and authenticity.[6] Similar to these precursors, much new work today seeks to replace and supplant previous meanings of the appropriated imagery while tending to take on a different set of issues and references than their artistic precedents. However, today, new tactics of appropriation are often characterized by a far greater specificity of cultural or political reference than was generally present in the earlier work, and the artists tend to employ labor-intensive processes that emphasize the materiality of the art object and convey a more intimate style of direct address.

Throughout this exhibition, many of the artists unpack the constituent parts of nostalgia, which relate to notions of remembering, mourning, temporality, and underlying utopian aims. In so doing, they foreground certain facets of the term over others and, with a distanced vantage, selectively apply aspects of the past. By evoking temporal markers within a broader trajectory of political and cultural histories, they inject prior artistic styles with new formal properties and conceptual intentions, reinventing them in ways that are germane to the changed context of the present.

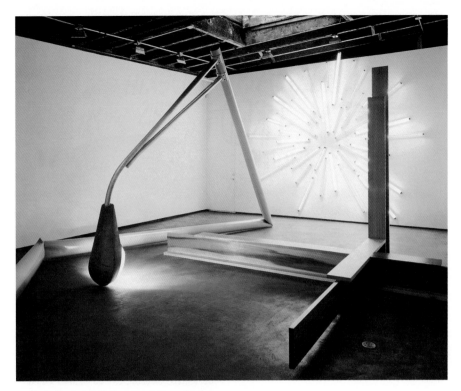

Mark Handforth. Installation view at Gavin Brown's enterprise, New York, 2002. Courtesy Gavin Brown's enterprise, New York

PURPOSEFUL MISREMEMBERING

Artists Mark Handforth, Wade Guyton, Taylor Davis, Sam Durant, and Tom Burr all engage in conscious acts of purposeful misremembering, recalling deliberately and imperfectly lived experiences, received historical notions, and learned styles. In so doing they create abstract sculptures and installations in which Minimalist and Postminimalist stylistic languages collide with references to interior design, popular music, literature, architecture, and the American suburban landscape. Among the most noticeable touchstones in their work are the art, ideas, and writings of Robert Smithson, particularly two related essays from the 1960s: "Entropy and the New Monuments," which describes Minimalist artworks as new forms of monuments, his metaphorical notion of entropy, and his interest in the "low culture" of bad horror films and the porn theaters of New York City's 42nd Street; and "A Tour of the Monuments of Passaic, New Jersey," in which Smithson ironically describes various industrial sites around Passaic as monumental artworks, linking the sites to both a distant past of ancient ruins and a distant future landscape of decay.

Wade Guyton. *Drawing for Sculpture the Size of a House*, 2001. Felt-tip pen on photograph, 4 x 6 in. (10.2 x 15.2 cm). Collection of the artist

Mark Handforth's gallery installations are made up of contorted street lamps, re-created highway signs, motor scooters, wall arrangements of fluorescent bulbs, and hand-built wooden I-beams and benches, brought together like scavenged, outsized souvenirs from America's roadsides. Mixing the eclectic visual vocabularies of found industrial elements with handmade objects relating to interior design and modern sculptural idioms, his works exude a romantically elegiac mood. The loose, easygoing relationships among the individual elements within a given installation suggest a constant state of flux—a process of being rearranged, constructed, and dismantled all at once. The works pay homage to art historical figures such as Mark di Suvero, Dan Flavin, and Marcel Duchamp, as if brought together in idiosyncratic

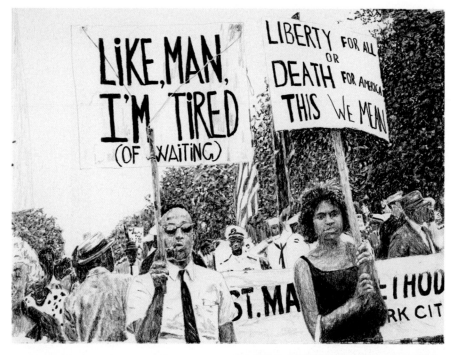

Sam Durant. *Civil Rights March, Wash., D.C., 1963*, 2002. Graphite on paper, 15 x 20 in. (38.1 x 50.8 cm). Wadsworth Atheneum, Hartford. The James L. Goodwin Fund

conversation to conjure a phantasm of beloved ruins that is equal parts sub-urban alienation and modernist transcendence.

Wade Guyton also jumbles the visual vocabularies of American suburban furniture design and domestic architecture, but with Minimalist sculptural traditions. One work, for example, turns a Breuer chair into an almost-readymade sculpture by unwinding the bends of its continuous metal frame. In another, a bulky rectangular form made from parquet dance-floor squares sits awkwardly in the middle of a doorway, consuming too much space. Similarly, he has made for various exhibitions a series of large wooden "X"s that are incongruously situated in the gallery, leaning against walls, columns, or windowsills. Such acts of blocking, or literally crossing out, space are further evident in a set of large black plywood sculptures, which Guyton refers to as "fragments." Exhibited individually in galleries because of their size, they are designed to be assembled in a way that would describe, in real scale, the contours and surface area of a typical 1970s suburban home. Mimicking visual signifiers of Minimalism in vernacular materials, his sculptures transform grand notions of architecture and public sculpture into decidedly antimonumental forms that, with coy impoliteness, slyly attack conventions of gallery space.

Taylor Davis evokes and transforms artistic precedents in decidedly differ-ent formalist terms. Her meticulously handcrafted wood sculptures suggest geometries one might associate with Minimalist art, but Davis moves away from many of its other conventions with her direct representational allusions to functional, ordinary objects such as a shipping pallet, a heating radiator, or a farm animal pen. Foregoing purist notions of materiality, Davis often incorporates mirrored elements into the inside or outside of the wood structures, which, beyond ornamentation, serve to bring the body of the viewer into the space of the sculptures and reveal the sculptures' interior, built logic. In this way, Davis creates a viewing dynamic that heightens our awareness of the processes of perception through which we determine and understand spatial circumstances.

In contrast to these more general acts of misremembering, Sam Durant and Tom Burr directly quote specific historical events and works of art. Durant's sculptures, drawings, and installations interrogate the romanticized notion of the political resistance, popular music, and avant-garde artistic practices of the late 1960s and early 1970s, not simply to question the limits of the achievements of that era's utopian ideals, but to comment critically on present-day social issues. For a recent project, Durant created detailed drawings based on photographs documenting various civil rights and political protests. These drawings were exhibited in conjunction with illuminated signs, made from standard industrial light boxes, that displayed enlargements of the hand-written texts from the protest placards in the source photographs. Chosen for their lack of temporal and topical specificity, the excised phrases in the illuminated signs are intended to apply to any number of contemporary circumstances. Together, the draw-ings and signs call attention to the unanticipated ways that historical events can be relevant to understanding current cultural conditions and offer an indirect critique of today's commercial exploitation of 1960s political iconography.

Many of Durant's earlier works take the form of models or proposals for mon-uments that, recalling Smithson's essays, are exceedingly antimonumental

and are dedicated to events unlikely to be selected for conventional commemoration. One such work was a proposed monument for California's Altamont Raceway, the location of the infamous Rolling Stones' "West Coast Woodstock" concert, which unraveled into a chaotic, violent scene that resulted in several deaths. The work is a plywood table on top of which sits an abject slump of poured polyurethane foam, suggestive of a topographical landscape and accompanied by a sound system playing a Rolling Stones song in reverse.

Several of Durant's other models directly cite Robert Smithson's works, such as his *Partially Buried Woodshed* (1970), an artwork made on the campus of Kent State University in Ohio and completed only months before members of the National Guard shot student protesters at an anti–Vietnam war rally. Smithson's piece became a kind of de facto memorial to that event, and Durant appropriates the work as a symbol for the failed utopian concepts of that era. His recurring concern with the idealism of a previous generation, however, is not about a longing for a return to those times nor about having a direct political effect, but rather about looking critically at nostalgic constructions and questioning the past in ways that acknowledge the complexities of history in order that we might learn from them.

By contrast, Tom Burr directly refers to specific artworks, films, and stories by such figures as Tony Smith, Robert Morris, Andy Warhol, Kenneth Anger, and Edgar Allan Poe to address issues concerning private and public space, and constructions of sexuality. A recent installation titled *The Screens* (2003) consists of a series of black wooden walls accented with silver metal studs, presented along with large black leather flower forms reminiscent of Warhol's silkscreened flower paintings. Burr's flower-sculptures possess uncanny, anthropomorphized qualities. Languid and erotic, they seem almost like abstract, sepulchral surrogates for swaggering, leather-clad S & M boys, leaning and drooping as if in a theatrical, drunken stupor. Similar associations are evoked in Burr's sculpture *Black Box* (1998), which echoes a work by Morris titled *Mirrored Cubes* (1965). For this work, Burr built four black plywood and mirrored corners that resembled four separated sections of an opened cube, inviting viewers to step up into it, as if it were a stage set. Outfitted in its interior with elbow-height shelves and ashtrays, Burr's work mixes the stylistic language of Minimalism with that of the black decor one might find in the back room of a biker bar. Adjacent to the sculpture are informal bulletin boards to which are pinned black-and-white photographs of scenes from Anger's film *Scorpio Rising* as well as images of sculptures by Smith. References to the past are thus invoked as temporal signposts of an era when sexuality generally, and gay sexuality in particular, were more freely experienced in public spaces.

Such concerns are more concretely memorialized in Burr's *Model in a Box* (1995), a small wooden architectural model that re-created the windowless walls, divisions, and partitions of a number of 42nd Street porn theaters, sex shops, and nightclubs that were closed during New York City mayor Rudolph Giuliani's "quality of life" campaign. Through a dialectic of mourning and desire articulated in the distanced aesthetic of Minimalism, Burr laments the loss of subcultural queer space at the same time that he criticizes our more regulated notions of public space, circumscribed in recent years by increased gentrification, conservatism, control, and surveillance.

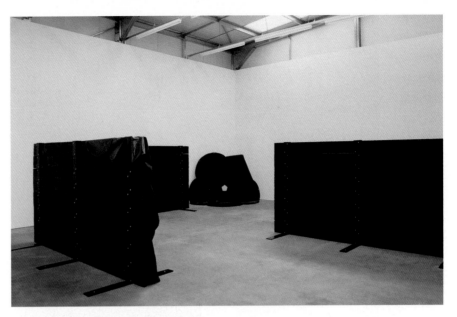

Tom Burr. Installation view of *The Screens* at the Institute of Visual Culture, Cambridge, England, 2003. Stained English oak planks, steel braces and cable, and vinyl, dimensions variable. Collection of the artist; courtesy Galerie Neu, Berlin

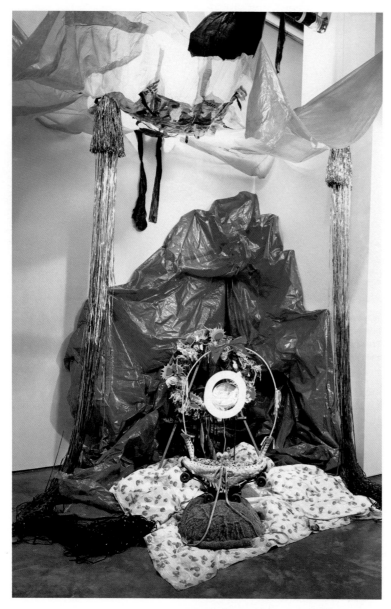

Christian Holstad. *Fear Gives Courage Wings*, 2003.
Lighted mirror, towel, iron rods, silkscreened image,
leather, plastic beads, sequins, roller skates, CD player,
speakers, felt, cotton, foam, plastic flies with glitter,
ribbon, wood, white leather handmade underwear,
altered plastic afro pick with glitter, and competition
pom-poms with mylar strips, dimensions variable.
Collection of Dean Valentine and Amy Adelson; cour-
tesy of the artist and Daniel Reich Gallery, New York

SUBLIME MOURNING

*Sometimes a dark day needs a little brightening. Bury a corpse in loud clothes
and paint the exterior of prisons plaid, I say.*
— Mike Kelley, "Urban Gothic" [7]

Susan Stewart has defined nostalgia as "the repetition that mourns the inau-
thenticity of all repetition," based as it is on both the irretrievability of time and
the futile desire to repeat that which is unrepeatable.[8] In the work of several
artists included in the exhibition, nostalgic aspects of mourning, memorializa-
tion, and death are foregrounded in unexpectedly exuberant terms. Christian
Holstad, Terence Koh, and David Altmejd, among others, pair sensibilities of
psychedelia, kitsch, and camp with aspects of nineteenth-century Romantic
ideas of the gothic relating to an interest in horror, morbidity, and eroticism as
a way to access the sublime. Together, they might fall under the rubric of an
updated "new romanticism," a term coined by artist Mike Kelley in his 1985
article "Urban Gothic."[9] It would be a particularly apt name for their nostalgic
inquiries given nineteenth-century Romantic artists' tendency to reclaim
past or forgotten artmaking styles as a style itself. These artists' hyperbolically
expressive forms seem also to connect to what Frederic Jameson described in
"The Cultural Logic of Late Capitalism" as the "hysterical sublime," an idea
fusing updated notions of the sublime with the sensibility of camp.[10] Incor-
porating camp's simultaneous embrace of opposing sensibilities and masked
rhetorical political strategy, their works are at once sincere and ironic, elegiac and
celebratory, as they convey coded social protests and critiques of convention.

Christian Holstad uses the popular aesthetics of 1960s psychedelia, kitsch,
camp, and 1970s glam rock and disco styles to create lavishly vibrant installa-
tions composed of many disparate handmade objects, drawings, and collages.
Holstad is strongly influenced by the films and performances of Jack Smith,
whose best-known work, the film *Flaming Creatures*, was "a kind of avant-garde,
transvestite, Structuralist parody of Orientalist Hollywood films of the 1940s."[11]
Holstad's work is thus doubly retrospective, adopting styles we now associate
with the 1970s, but which were themselves appropriations of feminine notions
of Hollywood glamour and power from earlier decades. His installations often
take the form of flamboyant memorials, dedicated either to real individuals or
invented characters. One installation, commemorating the "Bubble Boy," was
a clear plastic tented structure filled with colorful hand-sewn quilts and stuffed
animal–like creatures, papier-mâché balloons, erased newspaper drawings,
and psychedelic, pornographic collages.

Another work, titled *Fear Gives Courage Wings*, is a tribute, in Holstad's
words, "to a rebellious spirit everywhere." The installation is made up of a
1930s-style funeral basket made from resewn roller skates that plays a pro-
gressively slowed-down version of a disco classic and includes a light-up vanity
mirror framing a cropped photograph of an American eagle belt buckle on a
male torso, a felt funeral wreath ornamented with phallic-looking Venus's-flytraps,
men's leather underwear, and absurdly long red, white, and blue metallic
pom-poms, among other elements. The specificity and theatricality of the
installation at once mock the over-the-top patriotic displays in the United
States during the past two years and express an indirect dismay at how conser-
vative our culture has become—it is a eulogy, if you will, for the lost days of

disco, a time perceived to be more liberal, both politically and sexually. Holstad's work reflects an embrace of playful humor as a means of masked allegorical resistance against dominant conservatism, favoring instead a buoyant affirmation of gay culture, sexuality, and countercultural impulses.

David Altmejd's sculptures of crystal-studded and bejeweled werewolves have a strangely decadent beauty that both repels and attracts. His grotesque yet gorgeous displays of ornamented, severed heads and partially decomposing corpses—riddled with Romantic gothic notions of decay and resurrection and kitsch ideas of the sublime—are set on formations of geometric black platforms or within mirrored niches and often situated next to stacks of mirrored cubes. Appearing simultaneously primordial and futuristic, the theatrical presentations fluently communicate a broad array of cultural references, including Sol LeWitt's installations of cubic forms. Despite the works' otherworldly presence, their titles, such as *Clear Structures for a New Generation* or *Young Men with Revolution on their Mind*, reveal a purpose that is firmly rooted in the material world. Discreet graffitied phrases on the sculptures, such as "dissent queer, build clear," further disclose their activist purpose, like secret passwords to be discovered. The surreal clash between the garishness of the werewolf heads and bodies and the beauty of the crystals, jewels, and mirrors evokes the Romantic notion that even within decrepit ruins lies the potential for positive transformation.

Offering a different kind of sentimental intensity is the work of Terence Koh, formerly known as asianpunkboy. Desire and death circulate throughout Koh's work in installations featuring contemporary memento mori—placed on top of shelves, hanging down beneath them, or attached to walls—such as a white switchblade encrusted with rhinestones, a stack of white towels next to a small white toy horse, or an upside-down white plastic owl with oversize diamond eyes. When brought together, the objects create a blizzard of whiteness, a color that signifies death in many non-Western cultures. This symbolic obliteration of forms is echoed in many other of Koh's photographic and collage works. One such work is made up of a repeated sequence of photocopies of the same image of a handsome, young, bare-chested man, each pierced with a single bullet hole and reproduced on a lavender shade of paper, a hue often associated with homosexuality. Another work, a mirrored, rectangular coffin, edged around its bottom with white fur, is an uncanny memorial to the annihilation of the self, which mimics Minimalist sculpture through its surprisingly elegant form. Built to the artist's size, the coffin contains layer upon layer of tiny individual boxes, each holding a separate secret object of personal significance to Koh. Reminiscent of many cultures' ancient traditions of bringing along one's prized possessions into the afterlife, the boxes and their totemlike contents make up their own Lilliputian alternative universe that here serves as a surrogate for the artist's body. The coffin's mirrored surfaces, though, reflect back the viewer's own image, suggesting a sublime nostalgia for one's own inevitable death.

DELIBERATE DECELERATION

While nostalgia is often described as a longing for another point in time, it may also imply another sense of temporality, generally one where things happen more slowly, the way events may seem to unfold in our memories or dreams.[12] Cultural

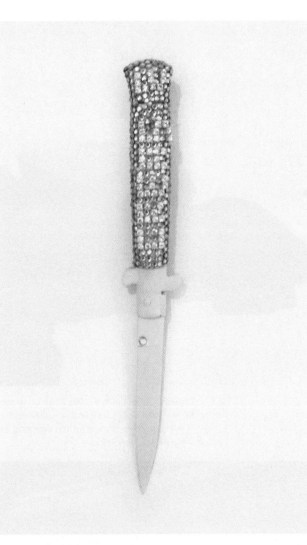

Terence Koh. *Untitled 8 (GREASE SWITCHBLADE)*, 2003. Switchblade, fake diamonds, glue, and acrylic, 9 x 1 in. (22.9 x 2.5 cm). Collection of the artist; courtesy peres projects, Los Angeles

Cameron Martin. *Untitled (100)*, 2001. Oil on canvas, 87 1/4 x 108 in. (221.6 x 274.3 cm). Collection of Adam Levinson; courtesy Artemis Greenberg Van Doren Gallery, New York

Dike Blair. *Untitled*, 2003. Gouache and graphite on paper, 18 x 24 in. (45.7 x 61 cm). Collection of the artist; courtesy Feature Inc., New York

historian and literary critic Andreas Huyssen has written about the proliferation in recent decades of manifestations of nostalgia, describing them as a "defense mechanism" against new understandings of lived time and space. He explains that the onslaught of new information technologies, mass media, rapid consumption, and increased global mobility have led to a "compressed" sense of the present, due partly to the ever-increasing rates at which things become obsolete. Such compression has changed the dynamic between memory and forgetting, Huyssen says, in that "the more we are asked to remember in the wake of the information explosion and the marketing of memory, the more we seem to be in danger of forgetting and the stronger the need to forget."[13] The challenge thus becomes how to distinguish between "disposable data" and "usable pasts,"[14] a challenge that is played out partly in displays of nostalgia.

Several artists in the exhibition use nostalgia to counter such ever-accelerating contemporary experiences of time. The work of Sharon Lockhart, Cameron Martin, Dike Blair, Jim Hodges, Spencer Finch, and Mary Kelly offers possibilities of "decompression" as they engage in acts of deliberate deceleration that often involve the trope of the landscape. Paying attention to overlooked details and events, these artists transform insignificant materials or moments into objects or scenes of beauty, and suggest alternative notions of time that allow for different ways of contemplating and comprehending the world.

Sharon Lockhart addresses issues of temporality, alongside those of ethnography and optics, through films and photographs that focus on small, understated details of mundane movements and actions that would generally pass unnoticed. Drawing on strategies pioneered by Conceptual artists, Structuralist filmmakers, and choreographers of the late 1960s and early 1970s, Lockhart's work reflects an interest in serial presentation and the straightforward repetition of ordinary images. In her recent film *NŌ*, set in the Japanese countryside, a fixed camera centers on a tilled field with a landscape of woods and hills in the background. Two farmers methodically move back and forth in and out of the frame, progressing from background to foreground, and back again, as they first make stacks of hay and then rake them across the soil to prepare for the dormant winter season. Their purposeful labor becomes a kind of slow, dancelike ritual, recalling the experimental work of the Judson Dance Theater, which proposed that everyday gestures and physical tasks could constitute dance. Similarly, the title may call to mind the tradition of Japanese No theater; however, the word was chosen for its literal translation from the Japanese word meaning "agriculture." It also refers to Nō-no ikebana, a style of flower arranging that took on symbolic significance because of its socially progressive ideals relating to the aesthetics of working in the fields. The pastoral beauty of Lockhart's film additionally calls attention to conventions of other media: its stillness and setting allude to nineteenth-century landscape painting and photography traditions that were linked to Romantic notions of the picturesque. Counteracting the quick pace and spectacular subjects of contemporary cultural production, her slow revelation of minute details suggests the possibilities opened up by a sustained, analytical use of the past to look at the places and people of the present moment.

Cameron Martin arrests time in a different way in paintings that are at once abstract and representational. Treating landscapes almost as distilled still-life genre paintings, Martin depicts pared-down images of nature—streamlined, graphic renderings of rocks, water, and tree branches—frequently appropriated from magazine advertisements stripped of their texts, products, and models.

The work is influenced in equal measure by certain historical styles of Japanese woodblock prints and by nineteenth-century landscape photography and painting traditions, as well as the work of such recent art historical figures as Andy Warhol and Richard Prince. Updated for today's commercialized world, Martin's paintings suggest that there is no longer any understanding of nature without the infiltration of the manmade. Like memory traces of a landscape we once knew, the works possess a melancholic aura of a bygone natural world, which Martin has repackaged in demure elegance. The surface beauty of his works belies their often foreboding undercurrents—an acrid color or barren terrain that hints at some forgotten atrocity. Martin's paintings subtly evoke the unsettling muteness of a strange amnesia: if things were different yesterday, we simply can't remember.

Time is evocatively suspended in a related way in Dike Blair's sculptural installations and gouaches, which represent elements of idiosyncratic "cultivated" landscapes of suburbia, such as corporate office parks, hotel lobbies, roadside restaurants, and motel interiors. Blair combines interior design styles of the last few decades with the aesthetics of modernism and Minimalism, and Romantic approaches toward natural beauty. The sculptures encompass floor-bound arrangements of industrial-looking carpet, circular light fixtures, rectangular light boxes with small inset photographs, and meandering electrical cords. The careful, ordered configuration of materials resonates with historical notions of the modernist grid as much as the formal structures of ikebana, the Japanese art of flower arranging that is meant to embody harmonious relationships among heaven, earth, and man. The works are about balance and stillness and exude a quietude one might associate with death, a connection iterated in the titles of many of the earlier works, which were taken from Japanese death haiku.

Often displayed in close proximity to the sculptures are Blair's idealized, almost photo-realist small gouaches on paper that depict scenes such as raindrops on car windows, flower buds against a perfect blue sky, or bright sun on a snow-filled swimming pool—fragments of a melancholic suburban beauty that ride the edge of sincerity and irony, good taste and kitsch. One critic described them as "outtakes" from a world whose landscapes have been altered by photography, electricity, computers, and technical gadgets and redesigned for tract homes, cars, malls, entertainment centers, and industrial parks.[15] The juxtaposition of the sculptures and the intimate paintings points to a shift in the understanding of time between the implied quickness of the readymade elements and photographs in the former and the slow, careful labor of the latter. Together the works speak to the possibility of a new kind of "technological sublime," which connects ideas about the transcendental to the seemingly opposed aesthetics of corporate culture, decoration, and design.[16]

Jim Hodges's sculptures and drawings transform simple, ordinary materials into beautiful, accessible objects that allude to both the evanescence and persistence of life. In his poetry of the everyday, slowness is literalized as Hodges tries to mark and track time through meticulously crafted work: fine brass chains are linked together to form progressions of delicate spider webs, silk flowers are stitched together into vibrant hanging fields, mirrors are hand-cut and reassembled into patterned mosaics, photographs of trees mutate into sculptural "drawings" as the outlines of leaves are partially cut out and left to dangle as tendrils. For Hodges, beauty is a way "to open the door into memory" and access the realm of free associations.[17] He began this work in the late 1980s, a time of great loss in the artistic community and beyond due to deaths from AIDS. While his

Jim Hodges. *Everything Will Happen*, 2003. Cut chromogenic color print, 72 x 48 in. (182.9 x 121.9 cm). Carlos and Rosa de la Cruz Collection; courtesy CRG Gallery, New York

works often evoke notions of loss, they are generally not memorials to specific people or events, but rather hint at the connections between personal and collective memories. Souvenirs of our mortality as well as celebratory meditations on nature's complexity, they speak to a universal sense of the ephemeral, to the unavoidable fleetingness of time as expressed through the overlooked splendor of the commonplace.

Spencer Finch explores the nature and limits of memory, consciousness, and perception in poetically humorous and humble installations, drawings, and objects that attempt to visualize what is just out of perceptual reach. Starting with recollections and records of his own memories, Finch draws distinctions between the physiological process of seeing and the psychological activity of remembering, and asks us to consider alternative ways of comprehending the world in whimsically literal ways. *Eos*, for example, was an installation of fluorescent lights wrapped in multicolored spectrum gels that attempted to re-create the quality of light during a particular sunrise on a trip to the ancient ruins of Troy in western Turkey. His reconstruction of the exact color of light suggestively links our experience in the gallery both with his individual record of remembered experience and with the idea of a collective, mythic past of Troy.

Sky, an intimately scaled, rhinestone-encrusted painting, similarly strips the landscape down to its most fundamental element of color. In this work Finch again looks toward the heavens, re-creating in modest but glittering terms the blue sky at dusk above Roswell, New Mexico—a locale famous for UFO sightings. As in *Eos*, implied temporal and spatial shifts make reference to concepts of fact and fiction from long ago and far away. The wistful pathos that suffuses the work is not a longing for a lost past, however, but for the forgotten, the infinite, and the unknowable; it is about the struggle to remember rather than what is actually recalled.

Mary Kelly's *Circa 1968* addresses issues of memory and history from a very different perspective, looking back at a representation of a particular event that was significant to her and her generation through the filter of the present. In this work, Kelly's ephemeral reconstruction of the past is inspired by a photograph of demonstrators in Paris on May 13, 1968. Taken by the photojournalist Jean-Pierre Rey and seen in many contexts, including *Life* magazine, the image depicts a young woman hoisted on a man's shoulders, waving a flag high above the crowd. Her gesture, which evokes a fervent moment in the formation of the largest mass social movement in French history, also resonates with the documentation of anti-imperialist protests throughout the world at that time.

Made of lint generated from doing thousands of pounds of laundry, *Circa 1968* plays off of different associations among the photographic, the painterly, and the cinematic image. The single image embedded in the lint marks a contradiction in time, speaking to the instant it depicts as well as to the extended duration implicit in the labor-intensive process of fabricating the image. The flickering of a projected light onto the lint image and the soft-edged, mottled qualities of its gradations of white, gray, and black recall imperfections of outmoded video or film technology from decades ago. Its just-out-of-reach legibility conveys a sense of distance and inaccessible pasts, creating an effect akin to an afterimage imprinted on one's memory.

For Kelly, an artist of the same generation as those depicted in the photograph, the work is not about idealizing a lived history or trying to recapture the truth of that event. Rather, its reflective gesture centers on Alain Badiou's notion of the "event," which he describes as something so out of the ordinary, dramatic, or

traumatic that it binds us to it.[18] For the artist, the photograph is emblematic of such a moment, but through her recuperation of it Kelly acknowledges how such images accrue different symbolic meanings over time.

UTOPIAN UNDERPINNINGS

Utopian intentions are a common underlying dynamic of nostalgia, whereby both idealized concepts of the past and actual former circumstances are regarded as keys for tomorrow's progress. Such representations surface in radically distinct ways in the work of Andrea Zittel and Emily Jacir, both of whom reconfigure individual, lived experiences to suggest broader collective possibilities for social change.

Andrea Zittel's work integrates art and life in ways that recall early-twentieth-century modernist ideals of living centered on freedom and autonomy. Her philosophy of artmaking calls for reinventing social structures and relationships in small ways, creating architecture, furniture, and clothing designs that aspire to reposition the body in the world, both spatially and socially. Her projects frequently take the form of prototypes for experimental living, such as *A–Z Food Prep Station*, whose design attempts to reinforce ideals of equality and fair division of labor; *A–Z West*, homestead units made for the demands of desert living; *A–Z Pocket Property*, individual, personal floating islands; and *A–Z Living Units*, a line of small, movable dwellings that can be adapted for different environments and tastes. Zittel generally begins with a sample model for her own use, which is designed for future reproduction and customization for others. The inspiration for the homestead units of *A–Z West*, constructed in the desert of Joshua Tree, California, dates back to the 1940s and 1950s, when the U.S. government gave homesteaders in this area five acres each if they would improve the land by building a structure on it.[19] Conceived as an antidote and an alternative to a society dominated by bureaucratic structures and consumerism, the work looks simultaneously backward and forward in order to create new modes of contemporary living. As such, Zittel's projects reflect a utopian aim that her lifestyle environments, if replicated for a mass audience, might provide broader personal freedoms for those who choose to live outside established systems. *A–Z West* demonstrates a hopeful dimension of nostalgia, whereby past idealistic propositions are reconstituted to serve as models for tomorrow's alternatives.

Emily Jacir responds to a dire present-day situation through a series of small, individual actions. Her project *Where We Come From* is a photo-text installation based on tasks she completed on behalf of Palestinians who, under current laws, are prohibited in some cases from returning home or in other cases from leaving home and moving freely throughout the area and beyond. Jacir, who is Palestinian-American, contacted Palestinian people living all over the world and asked each of them, "If I could do anything for you, anywhere in Palestine, what would it be?" The resulting photographs and texts reveal the answers, ranging from the practical to the poetic. Using her U.S. passport to move freely throughout the region, Jacir found herself delivering strawberries, paying a bill, giving a kiss to someone's mother, going on a blind date in someone else's stead, and playing soccer with a young boy. Photographs documenting Jacir's activities are juxtaposed with framed texts by the artist and the individuals on whose behalf she acted. The narratives discuss their requests and the reasons they themselves cannot perform the actions, as well as providing information about their passports, birthplaces, and citizenship. The work's intimacy and specificity runs counter

Emily Jacir. *Hana*, from the series *Where We Come From*, 2001–03. Chromogenic color print, 15 x 20 in. (38.1 x 50.8 cm). Collection of Yusef Nasri Jacir; courtesy Debs & Co., New York. Originally commissioned for Al-Ma'mal Foundation for Contemporary Art, Jerusalem

to the anonymity of media images that portray violence in the Middle East, and it poignantly communicates how political borders currently demarcating Gaza, the West Bank, and Israel fragment and stifle the lives of individuals and families in unexpected and profound ways. Nostalgia surfaces literally here as a mode of productive remembering, as individual stories convey both the subjects' situations and the implicit plea for a time of peace and a more civilized future.

As a group, all of these artists' varied incorporations of the past may be considered examples of "reflective" nostalgia, a term coined by historian Svetlana Boym in her recent book, *The Future of Nostalgia*. Boym usefully differentiates between two types of nostalgia, described as "restorative" and "reflective." If nostalgia is defined as "a bittersweet longing for things, persons, or situations of the past or for a lost time or home that no longer exists," then, according to Boym, restorative nostalgia involves attempts to reconstruct a reality along the lines of how it was once thought to have been. Reflective nostalgia, on the other hand, focuses on the longing aspect of the term rather than on restoration, and takes a more critical stance, calling circumstances into question and embracing historical contradictions, often through humor and irony. From this vantage, longing and critical thinking are not opposed to one another but intertwined activities.[20] Utilizing the productive aspects of reflective nostalgia, the artists in this Biennial shift the logic of previous artistic practice and uses of popular subcultural styles in order to examine a society engulfed by consumerist culture, tepid civic activism, and pervasive conservatism, and to explore modes of perception, issues of sexuality, shifting notions of temporality, and the regulation of the public domain. Proposing alternative perspectives through which to understand how we structure lived experience and learn from history, their approaches toward nostalgia draw on the potential for negotiations with the past to play a rewarding role in shaping ideas for the future. Above all, they demonstrate how nostalgia is almost never just about hindsight, but also foresight, looking back in order to move forward and realize new possibilities.

1 David Lowenthal, *The Past is a Foreign Country* (Cambridge and New York: Cambridge University Press, 1985), p. 10.

2 Svetlana Boym, *The Future of Nostalgia* (New York: Basic Books, 2001), p. xiv.

3 Ibid., p. 11.

4 Ibid., p. xvii.

5 Lowenthal, *The Past is a Foreign Country*, p. 11.

6 Craig Owens, "The Allegorical Impulse: Toward a Theory of Postmodernism," in *Beyond Recognition: Representation, Power, and Culture* (Berkeley and Los Angeles: University of California Press, 1992), pp. 53, 64.

7 Mike Kelley, "Urban Gothic," in *Foul Perfection: Essays and Criticism*, ed. John C. Welchman (Cambridge, Mass., and London: The MIT Press, 2003), p. 6.

8 Susan Stewart, *On Longing: Narratives of the Miniature, the Gigantic, the Souvenir, the Collection* (Durham, N.C., and London: Duke University Press, 1993), p. 23.

9 Kelley, "Urban Gothic." In the text, Kelley describes work from the mid-1980s that "layered recycled Gothic imagery over various types of industrial representation," and "typically took forms that were timeless or transcendent." In an aesthetically related vein, The Museum of Contemporary Art in Los Angeles organized the exhibition *Helter Skelter* in 1992. Concurrently, Anthony Vidler came out with his book *The Architectural Uncanny* (1992), and then Kelley himself organized an exhibition titled *The Uncanny* for Sonsbeek 1993, and Jeffrey Deitch, a traveling show titled *Post-Human*. All of these are important precursors to the resurgent interest in the gothic.

10 Frederic Jameson, "The Cultural Logic of Late Capitalism," in *Postmodernism, or, the Cultural Logic of Late Capitalism* (Durham, N.C.: Duke University Press, 1991), p. 34. Jameson, writing in 1984, was partly alluding to experiences of the sublime, triggered not through awe-inspiring moments of nature, but by the overwhelming presence of simulacra, representations of the real, that threatened the collapse of the real itself.

11 Kelley, "Urban Gothic," p. 104.

12 Boym, *The Future of Nostalgia*, p. xv.

13 Andreas Huyssen, *Present Pasts: Urban Palimpsests and the Politics of Memory* (Stanford, Calif.: Stanford University Press, 2003), p. 18.

14 Ibid.

15 Jeff Rian, "Outtakes: Dike Blair's Gouaches," in *Dike Blair: Gouaches*, exh. cat. (Los Angeles: works on paper, inc., 2001), pp. 18–19.

16 From an unpublished interview between Dike Blair and Feature Inc., October 19, 1998.

17 Ralph Rugoff, "Beauty Bites Back," *Harper's Bazaar* (October 1999): 234–35.

18 Email exchange with the artist, September 2003.

19 Andrea Zittel, *Andrea Zittel* (Milan: Tema Celeste Editions, 2002), p. 55.

20 Boym, *The Future of Nostalgia*, p. xviii.

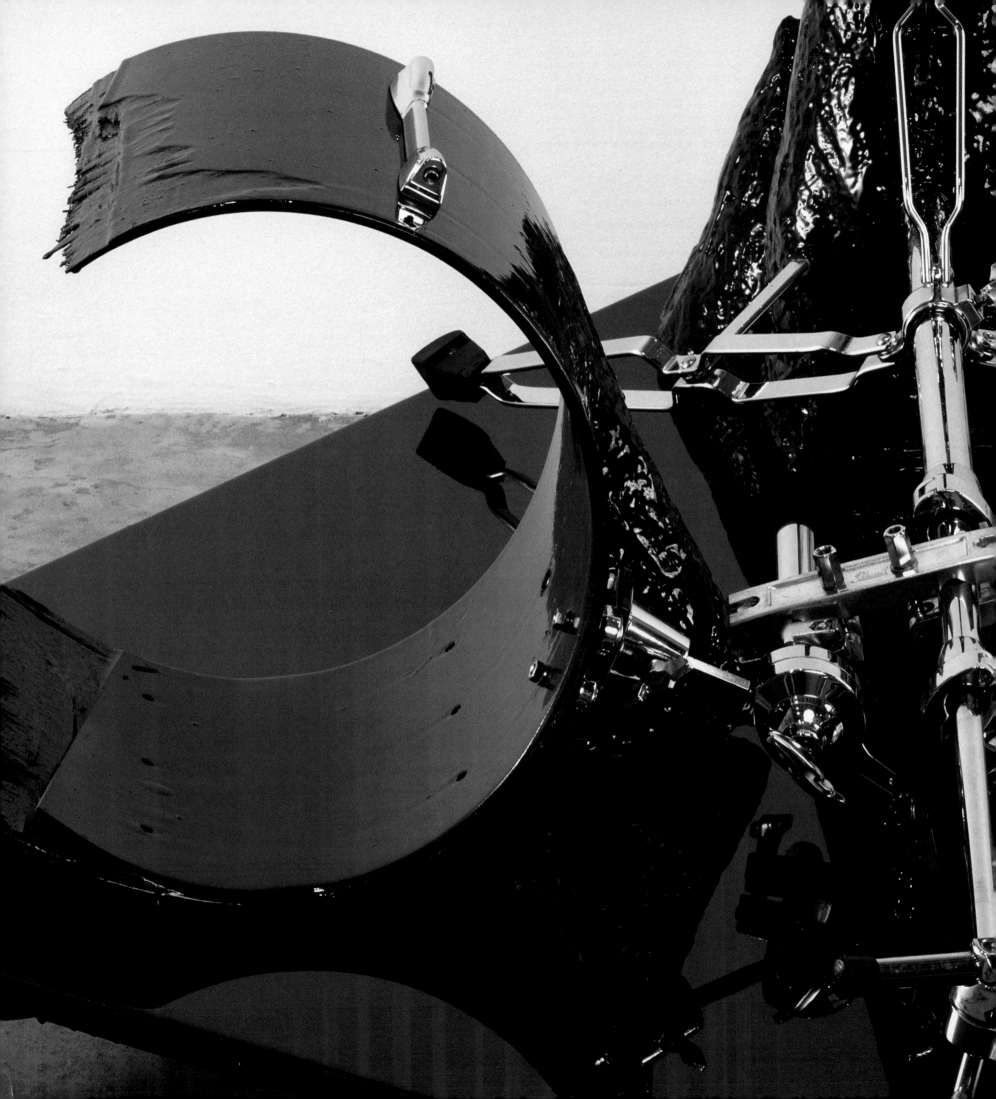

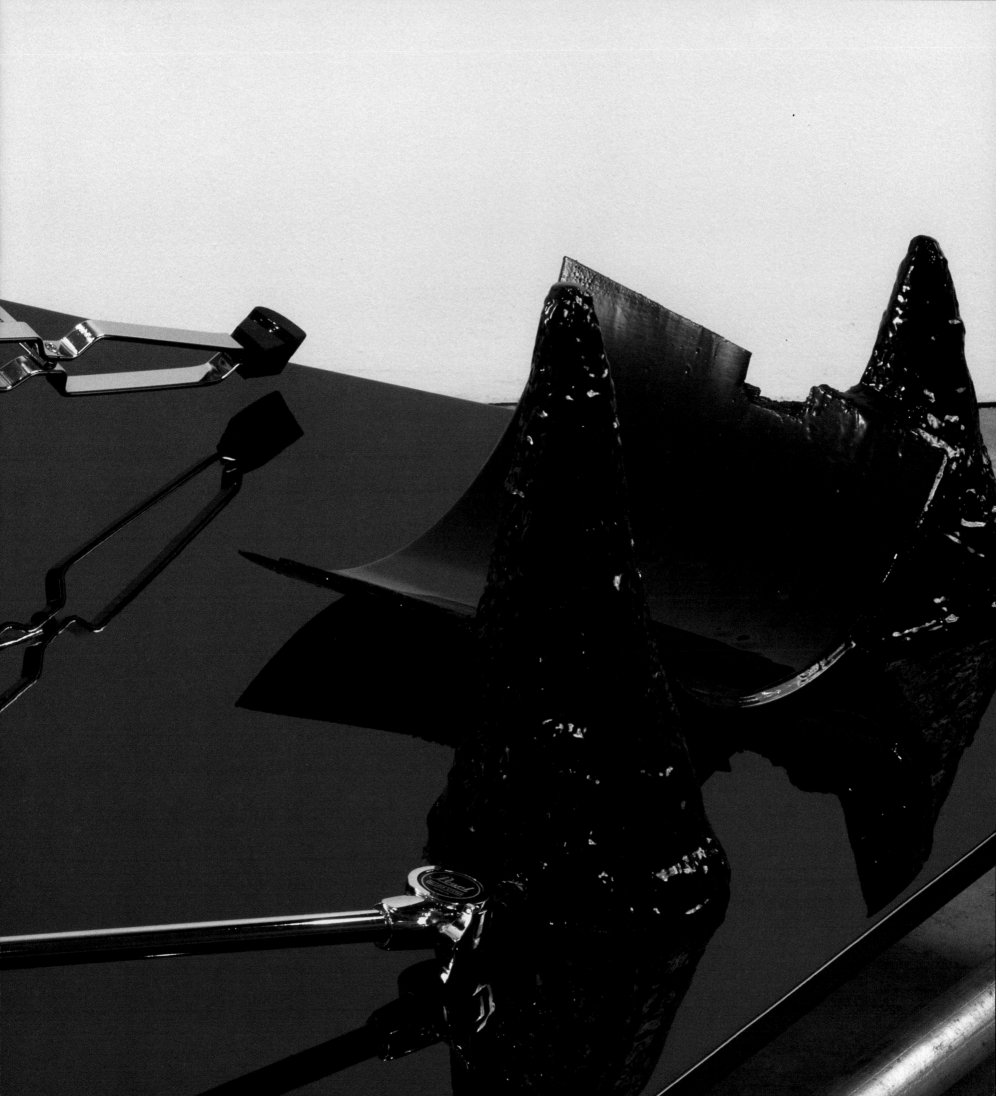

Beneath the Remains: What Magic in Myth?

Shamim M. Momin

The goal that led him was not impossible, though it was clearly super-
natural: He wanted to dream a man.... The sorcerer suddenly remembered
the god's words. He remembered that of all the creatures on earth, Fire was
the only one who knew that his son was a phantasm...he walked into the
tatters of flame, but they did not bite his flesh—they caressed him, bathed
him without heat and without combustion. With relief, with humiliation, with
terror, he realized that he, too, was but an appearance, that another man
was dreaming him.

—JORGE LUIS BORGES, "THE CIRCULAR RUINS"[1]

The one who wrestles his images from experience, from his smoky dreams,
to create, is able then to build what he has seen and hungered for.... I will
not be just a tourist in the world of images, just watching images passing by
which I cannot live in, make love to, possess as permanent sources of joy
and ecstasy.

—ANAÏS NIN[2]

The need to create myth has persisted throughout human history. Myth provides
a sanctuary for the imagination, where new ways of interpreting reality can
be proposed, where delight in complexity can be explored, and where ambiguity
permits synthesis rather than prevents analysis. As an open-ended, fluid process,
mythmaking is not merely the telling of story, nor does every artificial reality
create a discursive mythic space. Passion and intensity are common character-
istics of true myth, which when coupled with an embrace of the irrational, can
expand one's view of reality. The prevalence of contemporary artists creating
mythic worlds reflects a deep craving for these emancipating spaces. At
a moment in contemporary culture still queasy with premillennial spiritual
malaise, they seem ever more relevant. Mythmaking in contemporary art draws
on the imaginative possibilities engendered by a complex, pluralistic notion of
the world, and liberates fantasy and play as options for a new reality.

 The word myth must be invoked with care, as its definitions are fluid and
overlapping. Its Greek origin, *mythos*, has multiple meanings, including "word,"
"speech," "tale," "story," and the elegantly all-encompassing "things thought."
Today, myth is commonly defined in opposition to science and as the weak sib-
ling of religion; in the former comparison, it tends to be relegated to falsehood
or superstition, in the latter, dismissed as savage, chaotic, or pagan. Myth,
however, should not be interpreted as an imprecise explanation of facts not yet
understood, as escapism, or as history imperfectly recalled. In its essence, a
"true" myth is a revealing expression of how humans perceive, understand, and
relate to the world: the legend of the Fire God tells us far more about a people
than what they don't know about volcanoes. Historically, myths are shared with-
in a cultural group, though perhaps less so in our fractured world, where they
must balance a need for both a personal psychosocial space and an interper-
sonal area where ideas can clash, combine, and evolve.[3] They provide a vehicle
for multiple versions of speech as fundamental communication, rather than as

language or a distinct form of realization. As Roland Barthes described it, "Myth is not defined by the object of its message, but by the way in which it utters this message, there are no formal limits to myth, there are no substantial ones."[4]

In recent years, simplified versions of reality have begun to collapse under the weight of the fractal complexity that defines our "post-everything" world. For some artists in the exhibition, the ambiguity inherent in mythmaking provides generative potential that grows from an often cynical, anxious, yet still hopeful questioning of the world. Artists who draw on this potential to construct alternative worlds embrace the absurd chaos of our existence, and in so doing provide a prismatic view of a reality become increasingly dangerous and alien. Robyn O'Neil, for example, imagines a realm characterized by pervasive anxiety and melancholy beauty with her intricate, large-scale graphite drawing *Everything that stands will be at odds with its neighbor, and everything that falls will perish without grace*. While the characters in the work—unremarkable, middle-aged men—are unsettlingly normal, when taken together the scenes in this large-scale work convey a sense of looming, apocalyptic danger. The triptych format links groups of independent narratives into a composition suggestive of the surreal allegories of Hieronymus Bosch's *The Garden of Earthy Delights* (c. 1500), a kind of cosmology of the uncanny and the familiar, bound by strict rules of depiction. O'Neil's work contrasts the banal activities of the men—who run, fall, toss balls, exercise, struggle, and even die—with the hazardous terrain of the desolate landscape. Flouting order in favor of chaos, rationality in favor of the absurd, each "neighborhood" within the drawing contains a distinct leitmotif at odds with the next. The flux between calm and anxiety, normalcy and surreality, optimism and devastation evokes the world around us with its deliberate, awkward tension.

The narratives animating Laylah Ali's paintings on paper are similarly ambiguous, but suggest a more direct engagement with the social politics of identity. Ali's fresh, buoyant palette and precise, labor-intensive technique conflict with the intimate violence of her scenarios. In her earlier work, Ali conceived two new humanoid but somewhat monstrous species—Greenheads and Blueheads—that lack a specific gender, class, or ethnicity, though by playing with the palette of the characters' "skin," their clothing, or their actions the artist calls attention to the assumptions a viewer might make. The hieroglyphic flatness she employs borrows equally from collective religious myths and popular comic book aesthetics, while the scale of the works, what Ali refers to as "small aggressions," recalls the preciousness of medieval book illustration. The paintings' spare compositional elegance enhances the allegorical impact of the often violent actions contained within them—two Greenheads forcing another to watch a lynching; dismembered feet clad in sneakers raining from the skies; a masked, caped figure trailing a rope from his neck as he soars above a group of puzzled, mute onlookers—and her characters' cryptic responses to them. All of the works portray a moment just before or after an enigmatic event, rather than a definitive summation. Ali's recent paintings assume the demise of both Greenheads and Blueheads, leading to the even more warped and brutalized figures of her new species, which play out their mysterious movements in a shallow, indeterminate pictorial plane framing a silent, unexplained flight: exodus? expulsion? freedom?

Eschewing didactic moralizing in favor of ambiguity and direct emotional impact, O'Neil and Ali employ an antisensational, antimelodramatic approach, in media and composition, that allows the personalities within their works to speak eloquently through action, interaction, and even inaction. Like other mythmaking

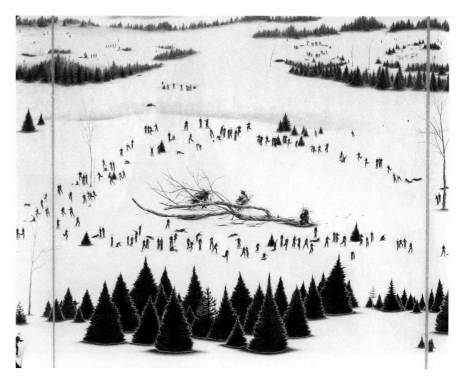

Robyn O'Neil. *Everything that stands will be at odds with its neighbor, and everything that falls will perish without grace.*, 2003 (detail). Graphite on paper, 91 3/4 x 150 3/8 in. (233 x 382 cm). Collection of Jeanne and Michael Klein and the Jack S. Blanton Museum of Art, fractional and pleged gift, 2003. Originally commissioned by ArtPace | San Antonio

Glenn Kaino. *Desktop Operation: There's No Place Like Home (10th Example of Rapid Dominance: Em City)*, 2003. Wood, paint, plastic tarp, sand, and water, 96 x 144 x 120 in. (243.8 x 365.8 x 304.8 cm). Collection of the artist; courtesy The Project, New York and Los Angeles

artists, they create impossible narratives that challenge the limitations of the world. Mythmaking in contemporary art can tell stories in fantastical spaces—sometimes a physical creation, sometimes internal to the image—in which the sense of structure and rigid but frequently obscure rules direct an ambiguous plot in a tone that is often abject, violent, or even apocalyptic. These myths excavate contemporary circumstance in enigmatic tongues, forgotten runes, and hidden signs. Some artists create mythic spaces that investigate options for transcendence through the fluid nature of belief. Others mine aspects of culture that aspire to reinvent reality through fictive transgressions ranging from a fascination with the dark side of human imagination in the reemergence of a gothic sensibility (the history of which includes, but extends beyond, its manifestation in 1970s and 1980s music and fashion) to adolescence as a metaphor for complexity. Like the multiple definitions of myth itself, these approaches are not distinct groups, but overlap and borrow from one another, providing one (partial) lens through which to view such examinations—not as examples of these ideas but as connections to them. Overall, the work can be characterized by an internalized anxiety and uncertainty about the world, existing in concert with a renewed desire for passionate engagement and re-enchantment.

You have confused the true and the real.
—GEORGE STANLEY [5]

In the last three decades, a cyclical social pessimism has produced an increasing suspicion that no established belief system—moral, political, religious, or scientific, against which myth has been typically, and unfavorably, measured—can provide a unifying cultural structure in America. The issue is less the validity of such systems—the ability of science to produce technology, the basic tenets of democracy, or the quest for morality that underlies all religions—than their translative relevance, their viability as a means of cultural organization. Actions taken in the name of these systems at times become so distanced from their origin that the connection between them exists in name only. Technology can be exploited as a means of control and surveillance, and advances produced by science employed to enforce power, from biological warfare to cloning to racial statistical approaches that "prove" why some groups will be more successful than others. Religion is used as specious ground for the tragedies of September 11 and for discrimination against basic human rights in America, while democracy and freedom become justifications for the Iraq war, corporate greed, and the expanding class struggle. This reality has been described as "a new form of life, in which all previous notions of belief and sociability have been scrambled. And the true terror of this new order has to do with its being ruled...by a system without any focusing purpose to it, or any compelling image or ritualization of that purpose." [6]

Though not positing a definitive "focusing purpose," Glenn Kaino's surreal sculptural installations unpack existing systems in search of new hybrid possibilities for belief. He dismantles American mythologies and picks and chooses from others, mixing Hollywood, Eastern religion, technology, militarism, and art history. An 8-foot-tall sand castle, *Desktop Operation: There's No Place Like Home (10th Example of Rapid Dominance: Em City)* (2003), replicates the object of the protagonists' quest in *The Wizard of Oz* within an oversize Zen "relaxation sand garden," complete with enormous rake. The slightly unsettling presence of the work is enhanced by its multiple mediations of scale—a human-size garden

transformed into a shrunken representation of a desktop toy, then reinterpreted into an imposing, superhuman state. The military movements marked into the surrounding sand like football plays suggest a fantastical game with terrible consequences. In other works, Kaino draws liberally from Duchampian humor and wordplay, Buddhist ephemerality, and sculptor Robert Smithson's ideas of entropy; massive sets of dentures function as a Rube Goldberg energy paddle wheel, or an Aeron chair (a symbol of corporate success) transforms into the Holy Grail.

At times, Kaino's constructions seem to bear out the skeptical predictions of seminal science fiction writer Philip K. Dick. In his essay "How to Build a Universe That Doesn't Fall Apart Two Days Later," Dick writes, "We live in a society in which spurious realities are manufactured by the media, by governments, by big corporations, by religious groups, political groups—and the electronic hardware exists by which to deliver these pseudo-worlds right into the heads of the reader, the viewer, the listener." [7] Media hyper-saturation, from celebrity-obsessed magazines to advertising and journalism, contributes to this sense of the unreal, dominated by a striking singularity of opinion. The simplification of human emotion and identity betrays a pervasive sociopolitical conservatism, what historian Richard Hofstadter has called the "paranoid style" of American politics: a tendency for all struggles to be represented in Manichaean battles of good and evil. It is revealed in the dual role of our obsession with sex, violence, and the grotesque: we show it to condemn it, but also to be covertly titillated by it. [8] Not so much a critique of media itself—much contemporary art stems from a deep commitment to media culture as a structuring system in the world—the mythmaking impulse of artists today can be understood as a reaction to the surfeit of spin, to the attribution of simplified motive, and to a general elision of true consequences that permeates the media presentation of both contemporary events and fictional narratives.

Despite this hyper-technologized existence, a pervasive sense of loss of "real life" persists and the desire to relocate it has recently become more visible. Reality television, for example, tweaks this desire, but never fulfills it, and often it seems the only values we are left with are production values. Suffocated by over-determined over-production, both contemporary culture and contemporary art evince a search for new forms of connections, community, and meaning. The quest to reclaim the "pseudo-worlds" described by Dick takes on a sense of urgency as space itself becomes an increasingly scarce commodity; both the decreasing availability of physical space and the desire for an uncolonized mental space—one that has not been co-opted by product placement, repressive moral or political ideology, or capitalist control—create a need for expanded and differentiated forms. As in Kaino's work, the search for space can generate mythic constructs as literal dislocations or a warping, reconfiguring of space that creates other physical worlds. Erick Swenson's uncanny collapse of nature and culture mines a sculptural realism that transforms the natural world into an arena of absurd mutations, while Katie Grinnan's photocollage sculptures distort and hybridize existing spaces (rain forests, urban backyards, corporate lobbies). Seamlessly combining high- and low-tech processes, Grinnan seeks the possibilities of individual agency within existing structures by instantiating failed utopian dreams of self-sustaining alternative systems as fluctuating, parallel universes intercalated among our quotidian ones.

The mythic spaces built by artists in this exhibition reflect the belief that freedom—of imagination, critique, pleasure, darkness, or extremity—is best explored

within distinct parameters, though these parameters, the "natural laws" of mythic space, vary from artist to artist. Many of the artists exhibit a deeply internalized commitment to individual agency, which becomes even more critical when one dispenses with absolutism and singular modes of belief. The challenge is to resist the imperatives of the simplified narratives suffusing contemporary culture, on one hand, and the excesses of pluralistic possibility on the other. How, then, can community be maintained in the context of that expanded individuality? Literalizing the need for uncolonized space, Andrea Zittel's experimental living complex in the California desert, *A–Z West*, represents a kind of R and D lab for a better world, though one aware of its possible futility.[10] Zittel's continually evolving "systems for living" coalesce ten years of her projects into a complete ideological practice. Translating the precedent of 1970s Land art to a personal, domestic arena, and drawing on influences from Le Corbusier to Walter Gropius's "machines for living," Zittel explores the arbitrariness of standardization in contemporary life, seeking to balance the tension between individuality and community.

In pity for man's darkening thought
He walked the room and issued thence
In Galilean turbulence
The Babylonian starlight brought
A fabulous, formless darkness in.

—WILLIAM BUTLER YEATS, "TWO SONG FROM A PLAY"[9]

Both parallel to and in dialogue with a similar impulse in artmaking, the shift toward mythic forms emerging in popular culture can be read as a response to this problematized desire for community and connection. Enabled by new technologies and an increasingly pervasive visual culture, myth permeates contemporary life as never before. The prominence of previously unvalidated sources such as cyberpunk and science fiction, or the impossible worlds of comic books and video games, coincides with an increasing interest in archaic belief systems, from numerology and the occult to ancient polytheistic religions. Apocalyptic or magical, sensual and baroque, such systems are pregnant with secret knowledge, occult spaces and practices, and elaborate, fulgent aesthetics. Their presence emerges in the popularity of films from *Blade Runner* to *The Matrix* and *The Lord of the Rings*, their whispers heard in the pervasive renewed interest in the paranormal—aliens, vampires, werewolves, and other metaphorical monsters. They can be laughed at in celebrity obsessions with Buddhism and the kabbalah, and marveled at in the depth of commitment to the immersive, multidimensional worlds of ever-advancing video games or to the theatrical empathy of music fandom. And while we grin at the wry self-awareness of television dramas such as *Buffy the Vampire Slayer*, like Fox Mulder in *The X-Files*, we want to believe. All of these forms can be seen to function as new models of myth for a faith-starved world too cynical for the simplicity of the available dominant narratives. These alternate universes provide mythic constructs, a new set of rules that rupture the known in favor of the unknown, in order to produce a better metaphor for our future present.

In academic theory, postmodernism also has striven in part to reinvent the reduction in cultural complexity seen as the failure of the modernist project, with varying results. Recently, postmodern culture has been critiqued for its self-reflexive

inertia, its illusory totipotency, and its expanding distance from and even denial of the real. Certainly, in the reactionary jeremiads that follow the theoretical excesses of any given moment one can recognize what might be called the inverse limitations of pluralism: If everything is deconstructed, unpacked, and available to mix and match at our appropriative will, the miasma of choices is denuded of meaning, and becomes as limiting as the progressive modernist "grand narratives" against which pluralism is posited. These difficulties do not result in an appeal to return to old forms, but an appeal to invent new meaning by reinventing the old truths. Pluralism does not need to be a purely surface return to history, a status quo form of tolerance, but a real reimagining.

As if responding to this plea, Dario Robleto's work is deeply rooted in a desire for regeneration, a mad scientist's version of newly envisioned cultural archae-ology with an alchemical beat. From his meticulous research into materials and historical and pop cultural systems as diverse as music, paleontology, space travel, and religion, Robleto creates enticingly intimate objects that instantiate the history of a mythical alternate world. This is not a purely deconstructive effort conducted with ironic remove. Robleto builds narrative webs, multiple layers of stories, and ideas that reinvent the past with an eye to reinvigorating the future. Things no longer have *an* origin, they have myriad antecedents, and those antecedents in turn have complex histories of their own. Robleto likens his process to DJing: mixing, sampling, recombining.

The physical authenticity of *Hippies And A Ouija Board (Everyone Needs To Cling To Something)* is critical to this sensibility. The experience-worn surface of the suitcase suggests a traveling salesman of otherworldly folklore whose wares, the delicate, handblown vials and flasks and stacks of dusty, eroded records cradled within, evoke a sense of trembling potential. The nostalgic presence of the Ouija board connotes magical transformation through belief. Might the multihued potions end elixirs (all crafted from meticulously researched herbs, minerals, and the artist's personal inventory of "secret ingredients" such as human bone dust and ground vinyl records) that fill the bottles instill the taker with the lost utopian aspirations of the titular hippies? Or is the cynical resigna-tion of the parenthetical statement the more likely outcome, as another lyrically titled work by Robleto, *My Soul Is Rarely with Me Anymore*, implies? Drawing on cultural systems that he feels embody possibilities for transformation, such as music, science, and religion, Robleto limns his multiple narratives into axioms for reinvented belief.

Uninterested in a nostalgic remaking of history, artists like Robleto attempt the daunting task of integrating the two main paradigms of the twentieth century: the rationality, idealism, and heroic spirit of modernism and the skepticism, complexity, and baroque excess of postmodernism. The reinvented idea of creation informing much contemporary work draws on a sincerity that echoes the heroic spirit of modernism, but presupposes the deeply internalized skepticism of postmodernism. The dissolution of definitions wrought by deconstruction is not answered by apathy, however, but by a sense of possibility, a potential for mythic redefinition. Marrying hopefulness and cynicism, the work is suffused with a reinvigorated desire for emotional commitment that acknowledges the possibility, even probability, of its failure.

Reacting to an overly deterministic modernist past and a postmodernism that ultimately collapsed into the rhetoric of resignation,[10] these contemporary artists reject the current social state that has been described by T. J. Clarke, in his ele-gant unpacking of modernity's failed triumph and the postmodern aftermath, as

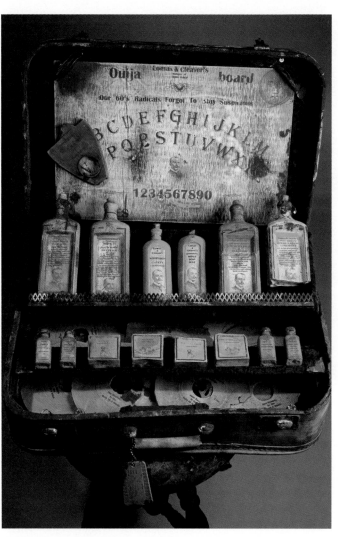

Dario Robleto. *Hippies And A Ouija Board (Everyone Needs To Cling To Something)*, **2003. Cast and carved dehydrated bone calcium and bone dust from every bone in the body, home-brewed moonshine and wine health tonics (potato-derived alcohol; water, sugar, fermented black cherries, yeast, gelatin, tartaric acid, pectinase, sulfur dioxide, and oak flavoring) fortified with one-hundred-year-old hemlock oil, Devil's Claw, witch hazel bark, swamp root, powdered rhubarb, pleurisy root, belladonna root, white pine tar, coal tar, dandelion, sarsaparilla, mandrake, mullein, scullcap, cramp bark, elder, ginseng, horny goat weed, tansy, sugar of lead, mercury with chalk and tin-oxide; calcium, potassium, creatine, zinc, iron, nickel, copper, boron, vitamin K, crushed amino acids, home-cultured antibiotics, chromi-um, magnesium, colostrum, ironized yeast, ground pituitary gland, ground wisdom teeth, ground sea horse, shark cartilage, coral calcium, iodine, and castor oil; various 1960s 45 rpm records cast in prehistoric whalebone dust, micro-crystalline cellulose, rust, cold-cast iron and brass, antique syringe, crushed velvet, leather, water-extendable resin, and Letraset, 23 x 19 x 42 in. (58.4 x 48.3 x 106.7 cm). Collection of the artist; courtesy ACME., Los Angeles**

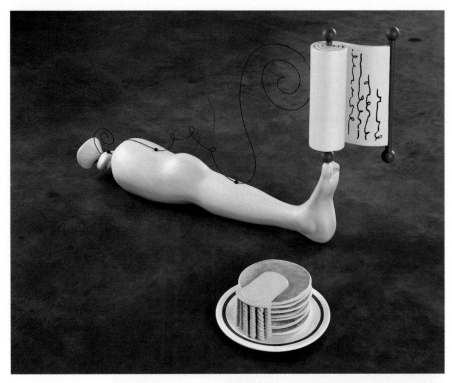

Matthew Ronay. *Decoration Declaration*, from the series *70's Funk Concert Model*, 2003. Medium-density fiberboard, steel, epoxy, and paint, dimensions variable. Collection of the artist; courtesy Andrea Rosen Gallery, New York

the "great emptiness and sanitizing of the imagination" and "the disenchantment of the world."[11] While secularization has contributed in part to this shift, the solution these artists advocate is not a return to religion. What remains instead is the foundation for the architecture of myth, magic, and meaning. From a position of critical romanticism, Slater Bradley articulates the search for a space of meaning in his evocative projection *Theory and Observation* (2002). Shot inside the cathedral of Notre-Dame in Paris, the video tracks slowly and in close-up across the faces of a children's choir about to perform. The slightly blurred slow-motion saturation of the image enhances its meditative pace, as does the ethereal soundtrack of the hymn being sung. This fades into a song by the Seattle-based band the Replikants,[12] who sample the mechanized voice of Stephen Hawking, himself a kind of postmodern hunchback of Notre-Dame. On the track played, he recounts (in an excerpt from *A Brief History of Time*) the pope's appeal that he stop investigating the big bang theory. The work is situated between the grand narratives of religion and science conveyed by the location—Notre-Dame, a heavily loaded signifier of faith, transcendence, and history—and Hawking's voice-over discussing the scientific origins of the universe. Bradley focuses on the individual faces of the children, privileging the vulnerability, anxiety, nervousness, and lush beauty of their ephemeral youth over the monumental setting, the mantic potential of fleeting communications over macrocosmic knowledge. Bradley finds belief in the small gestures of fully lived moments, and seeks the particularities of existence that form the essence of how theory is created, how poetry is found, and why things matter.

Our own Middle Ages, it has been said, will be an age of "permanent transition" for which new methods of adjustment will have to be employed. The problem will not so much be that of preserving the past scientifically as of developing hypotheses for the exploitation of disorder, entering into the logic of conflictuality. There will be born—it is already coming into existence— a culture of constant readjustment, fed on utopia...an immense work of bricolage, balanced among nostalgia, hope and despair.
—UMBERTO ECO, "DREAMING OF THE MIDDLE AGES"[13]

From the Internet to cell phone flash mobs (groups that congregate spontaneously by text messaging on their cell phones, a mode of communication that is both personal and community-based), information technology's ever-expanding effects on our primary modes of communication and exchange continue to infiltrate contemporary society. Rather than a notion of the "new" in technology that defined critical theory of the early 1990s, artists today are more likely to mine the aesthetics and language of this metaphysical realm for mythic possibilities. While many are increasingly skeptical of the promise of a technologized future, they seek potential in its reconceptualized space and possibilities for community. As the focus on the physical manifestations of technology—the objects themselves—fades, these artists have internalized the abstract, almost cosmological, possibilities of cyberspace as a portal to other dimensions.[14] The prevalent metaphor of an infinite immaterial world, depthless and nonlinear, has altered our contemporary conceptualization of space, time, and materiality. The alchemical nature of cyberspace, "forever dissolving, reconstituting, cyclically distilling and recombining,"[15] leads to hypertext as a model of narrative layering.

The idea of cyberspace as a complex, multidimensional world provides an apt parallel to the work of artist Ernesto Caivano. Caivano's elaborately detailed, minutely worked ink drawings, which vary in scale, suggest a denouement in time as they are assembled together, but one that freely exchanges past, present, and future. Based on an underlying narrative (a text authored by Caivano), the images spread out like branches rather than form a linear mapping of the story. The precise line of his renderings, including birdlike forms, partially humanoid figures, and animate trees, define, as the artist puts it, "an encoded labyrinth, a backbone, and a fantastical internal field."[16] Magic melds with science as the characters explore different possible trajectories—violent aggression (bombs, spaceships), transcendence (levitation, alchemy), advanced technology (cloning, digitization), and emotional extremes (glory, failure). Pulling equally from archaic chivalric myth and futuristic projections of other worlds, among other sources, Caivano's characters strive to overcome an unexplained separation and to return to an elusive wholeness, yet the drawings reflect less a modernist allegory of totality than a fractal, hybrid conception of space, both futuristic and medieval. In keeping with the sensibility of myth, his narratives of struggle and violence only obliquely refer to specific contemporary political events, thereby permitting personal readings that access universal human dilemmas.

Like Caivano, other artists in the exhibition seem to draw from an internalized notion of Gilles Deleuze's and Felix Guatarri's influential concept of the "rhizome,"[17] often invoked to discuss ideas of technological complexity. Literally a horizontal, rootlike stem that extends underground and sends out shoots to the surface, connecting plants in a living network, in figurative terms the rhizome is based on an idea of encounter and connections, positing an uncentered, nonhierarchical system in continuous motion and without definable control. A liquid metaphor, the rhizome responds to change by re-forming differently rather than by fracturing. Matthew Ronay's sculptural arrangements embody this strategy, which he also likens to the French literary style of the *nouveau roman*, a mid-century version of rhizomatic writing that sought illumination through unexpected juxtaposition and a lack of a central, singular protagonist. With his finely crafted wooden forms of quotidian objects and animals—ice cream cones, foxes, eggs, rainbows, carrots—Ronay configures unsettling scenarios that generate their own ambiguous and obscure storylines.

Playful and whimsical in scale and palette, Ronay's recontextualized objects form a fluid, often violent or scatological language of their own that suggests a child's playroom gone terribly awry. His titles often make reference to cultural or historical moments, and the works' clarity of form retains a sense of order that is denied by the open-ended arrangements. The interactions between the objects themselves imply causality, but of an unfamiliar, uncanny sort—a severed fox head hangs above a boulder, a tree branch excretes a rainbow, an oddly animated amputated leg balances an unfurling scroll on its toe. Though he creates elaborately detailed background stories for each piece, Ronay believes that the viewer's access to them is unimportant. The destabilizing of familiar images allows a more elusive connection, an elevation of the absurd that privileges the fantasies of the viewer over those of the artist.

A similar ambiguity informs the surreal worlds of Amy Cutler, whose paintings on paper depict an enigmatic fairy-tale landscape that feels at once ancient and timeless. Her entirely female cast of characters enacts bizarre, ritualistic activities: painfully lugging horses strapped to their backs, setting up a mysterious camp beneath the tented skirts of prone figures who may be dead or sleep-

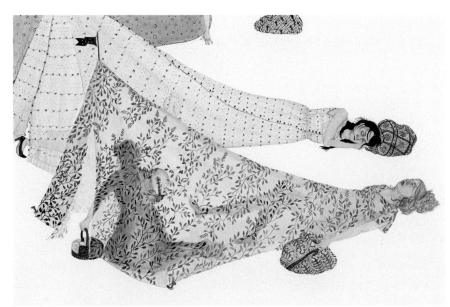

Amy Cutler. *Campsite*, 2002 (detail). Gouache on paper, 46 ½ x 47 ⅝ in. (118.1 x 121 cm). Private collection; courtesy Leslie Tonkonow Artworks + Projects, New York

ing, or dragging a house through the snow with their own Rapunzel-length braids as living ropes. Fleshly rules do not apply, as noses grow and attach to others, limbs detach and fly through the air, and hands morph into functional oars. Precisely rendered in a style that combines the intricacy of Persian miniatures with Shakeresque spareness, the works simultaneously evoke a sense of dreamlike innocence and horror.

Absurd, mundane, and chilling activities coexist in these works, none attracting more attention than the others, the very normalcy of the narrative treatment confounded by the utter warping of comforting domestic ritual. Cutler filters these events, often inspired by newspaper stories, into visual equivalents of psychological paradox. Enchanting, frightening, and reflecting a flexible take on gender and sexuality, Cutler's paintings are imbued with a magical realism that recalls Kiki Smith, and the biting commentary of a Brothers Grimm children's tale (usually lost in the sanitized American versions). While it is unclear who is in control, the agency of Cutler's women is never in doubt as they continue to work, move, and live in their bizarre worlds. Like these women, the viewer may be guided by the opaque structures of Cutler's world, but as is characteristic of mythmaking in contemporary art, this world remains open to question, to play, and to the application of the viewer's own rules.

The number of pages in this book is literally infinite, No page is the first page; no page is the last….A prisoner of the book….I realized the book was monstrous. It was cold consolation that I, who looked upon it with my eyes and fondled it with my ten flesh-and-bone fingers, was no less monstrous than the book….I considered fire, but I feared the burning of an infinite book might be similarly infinite and suffocate the planet in smoke.

—JORGE LUIS BORGES, "THE BOOK OF SAND"[18]

Fluid connections, the celebration of ambiguity, and a sense of ritual in chaos are central concerns of another prominent type of mythmaking in contemporary art: the reemergence of a gothic psyche. Deeply invested in the notion of complexity, this work explores the arena of the monstrous as an entrée to rapture. Artists working in this mode push the deconstruction and dissolution of center, definitions, and boundaries to reach the sublime terror of placelessness. This impulse coexists with a desire for physicality and sensuality, however dark. Set against inky blackness with the just-perceptible shapes of woods beyond, the protagonist of Chloe Piene's video *Blackmouth* (2003) occupies what the artist calls a "prelingual world." Slowed to haunting pace, a young girl crawls through the mud like a loose-limbed tiger, beating the ground or throwing her arms into the air as if releasing a primordial power that transcends her physical being. Her mouth stretches and yowls an impossibly deep, guttural roar (her own scream also slowed) that suggests not an individual voice, but a sound that speaks the hidden drives or forces of humanity. Within this reinvented space of origin, both claustrophobic and depthless, it is unclear whether she strives to break free of containment or asserts her control. Boundaries between human and animal, nature and culture dissolve into a raw, unrestrained totality. Seeking the darkness, "the idea was that she was coming out of the grave," Piene says, "but as it turns out, she is trying to get back in."[19]

Though somewhat evasive of a succinct definition, the gothic sensibility seen in much popular culture today reads as profoundly opposed to the progressive

aspirations of modernity. Where the modern strove ahead, the gothic looks back, in its opaque and shadowy way, distinct from the modernist rhetoric of clarity. Historically, it is a counter-Enlightenment impulse, emerging in response to pervasive cycles of conservatism or repression, and often following periods of consumer boom and related moments of perceived moral, emotional, or sociopolitical limitation. The word itself originates with the fifth-century peoples called the Goths, who in Greek and Roman culture came to represent the "Other"— outside of civilized culture, warlike, and barbarous. Over time, the term retained an association with darkness, cruelty, and death as well as an opposition to classical order (as invoked by the thirteenth-century Gothic period).

The gothic psyche surfaces in many different forms of art and culture through-out history, from such seminal nineteenth-century gothic texts as Mary Shelley's *Frankenstein* and the writings of Edgar Allan Poe, to the fin-de-siècle decadence that pervaded the social climates of Paris, Berlin, and Vienna. More recent manifestations can be seen in the search for the repressed unconscious or the dissolution/construction of self that persists in much twentieth-century art, such as Dada and Surrealism, or even what Clement Greenberg called the "gothic, morbid and extreme" canvases of Jackson Pollock. "Goth" music and fashion of the 1970s and 1980s made the aesthetic fascination with the darker realms of humanity more culturally visible. In art of the past thirty years, the recurrence of the gothic sensibility has often been characterized by an investigation of physi-cal space, especially notions of imprisonment and claustrophobia, in conceptual practices by artists from Bruce Nauman to Lawrence Weiner.[20] By the early 1990s, this sensibility had become more materially apparent in work by artists such as Mike Kelley, Paul McCarthy, and Raymond Pettibon, among many others, which explored the abject, the aggressive, and the obsessively anxious unpacking of the repressed.[21] As the decade passed, the ability to situate a cultural critique in the recesses of social and psychological abjection was cut off at the knees by a shift in theoretical discourse and an economically driven, broadly realized love affair with technology and high-end production. Nevertheless, the presence of a darker underbelly has persisted and even expanded as we have entered into the new millennium.

The current resurgence of the gothic exists in part as a response to the histor-ically cyclical conservatism of American society, characterized recently by the elevation of an imagined virtuous, sanitized existence. An obsession with hygiene, a desire for clear definitions of identity and emotion, and the ostensible rejection of corporeal pleasures and true sensory (as opposed to material) excess of any kind, coupled with the near-godlike privileging of the work ethic, has resulted in an institutionalized hostility toward pleasure and its inherent complexities. Yet despite what Jean Baudrillard called "the condescending and depressive power of good intentions, a power that can dream of nothing except rectitude in the world, that refuses even to consider a bending of Evil, or an intelligence of Evil,"[22] the full range of behavioral responses continues to exist. Whether controlled, unseen, and undiscussed or treated as deviant, abnormal, and low-class, the public fascination with the grotesque, evil, and dysfunctional exists in part as a symptom of this repression of the full scope of human emotion.

The apocalyptic mood associated with the turning of the millennium has stretched into the new century, and emerged prominently in the work of a younger generation unpacking a fascination with horror and death. These artists engage a gothic sensibility that revels in a voluptuous, sensual materiality. Decay and fragmentation, ruin and dissolution describe both the specific forms as well as

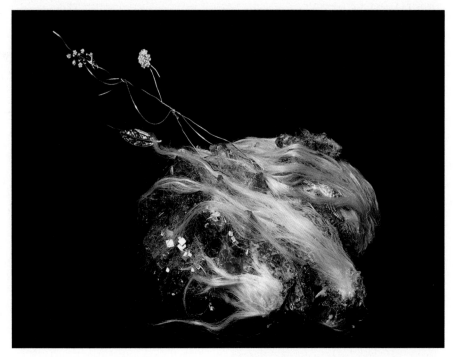

David Altmejd. *Clear Structures for a New Generation, Head #1*, 2002. Mixed media, 10 x 12 x 9 in. (25.4 x 30.5 x 22.9 cm). Collection of Matthew Brannon and Michelle Elzay; courtesy Ten in One Gallery, New York

their allegory of a moral, corporeal, emotional, or sociopolitical state. They explore familiar transgressive symbols, often mined from contemporary culture—heavy metal music, video games, horror and science fiction movies—not as ironic appropriation, but as ritualistic emblems for alienation and nihilism. Simultaneously melancholic and ecstatic, their work materializes ruptures in mainstream society that acknowledge both sides of the coin: themes of menace, death, repression, and violence can be both chilling reminders of the state of the world and an inverse means of access to the passionate sublime through dark beauty, melancholy, and explorations of extremes (such as lust, fear, and despair). Ultimately, they seek the extremes of human experience lost in the emotional "blanding" holding contemporary society in its grip.

Like other artists discussed here, David Altmejd creates mythic new worlds that suggest the creation of a new species, bound by specific rules but evoking a supernatural state. Altmejd's sculptural installation *Delicate Men in Positions of Power* (2003) also plays on spatial theatricalities, which he constructs as a modular stage set-cum-sepulcher, its wholeness pierced by hidden, labyrinthine intrusions. In an evolution of his previous sculptures of dismembered werewolf heads, Altmejd's Frankensteinian creation is presented as a skeletal body in advanced decay, a hybrid creature that is partially human and definitely monstrous. The artist gives shape to Freud's definition of the uncanny, the uncertainty of "whether a lifeless object might not in fact be animate."[23] The rigorous authenticity of the figure conflates a visceral grotesquerie with a sumptuous sensuality, as glittering tendrils, bejeweled organisms, and crystal formations seem to feed and grow from the decaying forms. Morphological opulence exists in uneasy concert with the rational geometric structures of the work's support, scrambling the myth of a harmonic coexistence of man and nature predicated on distinct spatial demarcations. As these dichotomies (arguably only ever superficially maintained) collapse, the wild and uncontrollable seeps into the ordered and rational, thrumming with possibility.

A friend of mine, a heavy-metal fanatic, once described his ideal musical experience this way: It should approximate the sensation you'd have during the split second between the time you saw an atomic bomb falling and the moment you were vaporized.

—BARRY SCHWABSKY[24]

The gothic desire for sublimity through sensation often takes form as the annihilation of the individual and the embrace of the apocalyptic. Personal identity is an ongoing and improvised performance, not an essential state. As Francisco de Goya (himself a strong precedent for the contemporary gothic) stated, "The world is a masquerade, face, dress, voice, everything is feigned."[25] Presented on multiple monitors arranged to create a physical space, Aïda Ruilova's series of short-format videos plays directly on this artifice. Inspired in part by the B-movie horror genre, her videos resemble outtakes from slasher movies, but recomposed with a syncopated crosscut editing drawn from music videos and alternative film alike. The cinematic montage of Ruilova's tightly framed imagery creates brief but surprisingly complete narrative worlds, in which the implicit violence and ambiguously sexual/horrific dialogue evoke paranoiac vulnerability and secret "un-seen" activity. The quick glimpses of imagery create a sensation of breathless,

claustrophobic space, and the aggressive soundtracks attack from different directions, melding symphonically to create a new composition of tension and suspense.

Less concerned with the production of grand and majestic terror, the current gothic sublime reflects an apprehensive, morally ambiguous state of mind, characterized by the possibilities of self-dissolution, a sense of waltzing on the edge of the eternal abyss. Annihilation can make viable the desire to transcend the particularities of one's existence, a transformation achieved via extreme emotion. As the eighteenth-century philosopher Edmund Burke described the sublime: "The passion caused by the great and sublime...when those causes operate most powerfully, is astonishment; and astonishment is that state of the soul, in which all its motions are suspended, with some degree of horror. In this case the mind is so entirely filled with its object, that it cannot entertain any other, nor by consequence reason on that object which employs it. Hence arises the great power of the sublime, that, far from being produced by them, it anticipates our reasonings, and hurries us on by an irresistible force."[26]

Also pushing the boundaries of emotive, aesthetic absorption and conventions of dark theatricality engaged by Ruilova and Altmejd, Banks Violette probes the fluid border in the American cultural psyche where fictional worlds—the private, personal fantasies engendered by adolescent subcultures and obsessive music fandom—pierce the fabric of reality. Intrigued by the idea of amoral (opposed to immoral) action and commitment, Violette poses questions about the seductive appeal of nihilism that entirely lack an assumption of righteousness. The aestheticized imagery and luscious materialism of his sculptural installations and drawings play on the alluring artifices of dark desire. In a recent installation, a slick, liquid epoxy melts over the surfaces of a destroyed drum set being devoured by stalagmites emerging from the forms. In the near-sculptural depths of his large-scale graphite drawings one can discern an oblique view of familiar images—from Kurt Cobain passed out onstage to a herd of galloping wild stallions as ciphers of freedom and sovereignty—inverting light and dark to resemble an X-ray. This inversion is reflected in the confluence of references throughout the work; Violette strips down overdetermined cultural images to investigate the persistence of such icons—the excessive, self-destructive caricatures of music and rock stars, for example—whose power continues to resonate despite their deconstruction. Seeking the elusive moment in which "a static array of rhetorically frozen gestures...can become re-activated, rendered viable, and where periodically violence is the surplus of that operation,"[27] Violette suggests the possibility of active participation in the majestic decay of the Burke-ian sublime, where imminent death (literally, or of that fugitive moment) imbues one with that consuming "astonishment...of the soul."

Though perhaps particularly evident in the exploration of gothic space, one defining distinction of the contemporary mythic sensibility is that it no longer retains the Pop art rhetoric of a high/low hierarchy as its critical content, but assumes the dissolution of this opposition and the freedom to engage cultural forms on their own terms.[28] Raymond Pettibon continues to be an important pioneer in this arena; his obsessive drawings have long merged an avant-garde discourse with an adolescent, subcultural one. His unique tone prefigured the deadpan wit and simultaneous conviction that characterizes the work of more recent artists, as well as the skeptical and

Banks Violette. *Powderfinger Christ (Kurt Cobain) 4.1.94*, 2003. Graphite on paper, 40 x 60 in. (101.6 x 152.4 cm). Collection of Matt Aberle; courtesy Team Gallery, New York

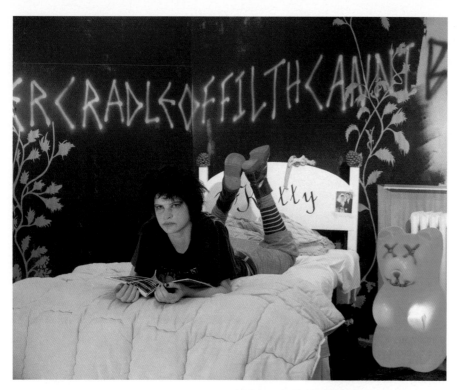

Sue de Beer. Still from *Hans und Grete*, 2002. Two-channel video installation, dimensions variable. Collection of the artist; courtesy Postmasters Gallery, New York, and Sandroni Rey Gallery, Los Angeles

adolescent purposiveness they exhibit. Barnaby Furnas, for example, employs art historical forms from the compositions of nineteenth-century history painting, the temporal simultaneity of Futurism and Cubism, and the painterly gesture of Abstract Expressionism, combining these with the figurative flatness of cartoons and the notion of "off-canvas" space that he attributes to video games. In his paintings, aestheticized, ecstatic violence results in a fracturing of the figure and of the self at climactic moments of musical rapture, sex, or death. Similarly, the lyrical portraits of Hernan Bas—all depicting young boys in enigmatically childish or sexual endeavors based on images from Boy Scout manuals, Hardy Boys novels, and, recently, *Moby Dick*—meld romance, sensation, and playful enactments of the occult as chapters in what he calls his "coming of age of queers novel."[29]

The persistence of this "adolescent impulse" in art should not be understood as a childish regression nor as the commercialized persona of capitalist desire that defines youth-obsessed media. Rather, it is the state of being from which mythic space is best created: fluid and fluctuating, awkward and antagonistic, creative and experimental. It represents an open realm of possibility in which violence and vulnerability, vision and destruction, desire and anguish coexist.[30] Sue de Beer also locates her work in the center of this adolescent maelstrom. In her videos, installations, and photographs, she fearlessly mines popular culture and visual history, appropriating densely loaded imagery to examine still-taboo subjects. Drawing from the extreme aesthetics of horror film, the sumptuous visuality and electronic soundtracks of high-definition video games, and the fatalistic credos of adolescence, de Beer's work revels in artifice without sacrificing emotional intensity. Her two-channel video installation *Hans und Grete* (2002) weaves the narratives of two pairs of teenagers (played by the same two actors), whose agonies of self-determination are expressed through both harmless desires for fame and violent enactments of powerlessness. The poetic lyricism of the individual monologues is a tender exploration of the protagonists' alienation, and the unflinching look at the horror and attraction of violence evokes a deeper understanding of the nature of belief. Like Violette, de Beer explores the extreme identification with appropriated narratives—historical antiheroes like the Baader-Meinhof terror activists referred to in the video, or the euphoric aggression of the rock star—from an ambiguous position between critique and celebration.

Projected onto two angled screens, framed in pink, the images in *Hans und Grete* mirror and fragment across the two surfaces, reinforcing the fractal denouement of the narrative that itself mimics the conflicted, hybrid identities of the characters. The rosy shag rug and oversize animal beanbags of the viewer's environment reflect the video stage set of the female protagonists' hyper-referential bedrooms. De Beer embraces a kind of deeply feminist, heartfelt girliness that equally announces complexities of gender articulation as inextricable, glittering threads in her kaleidoscopic weave of individuality and cultural contextualization. Simultaneously unpacking the articulation of self through one's most personal histories and the social structures that we all navigate, de Beer recontextualizes widely accepted clichés of violence, aggression, sexuality, and adolescence with a rigorous honesty. A deep sense of the artist's personal investment in the content combines with the formally rigorous elegance of the work to enhance these acknowledged tensions of contemporary existence.

Many of the artists in the exhibition occupy a space articulated between and among those complexities. Rigid structures of belief have been dismantled, but gaping voids remain; the simplified dichotomies of right and wrong, good and evil, do not adequately address the realities of social or political identity. In many of the works in the exhibition, the artists cultivate a semi-metaphysical commitment to the reimagined world that makes it difficult to avoid comparison to the metaphorical structures of religion; however, they seem to search for evolution rather than absolution, purposeful rather than teleological. In these mythic spaces, as in the "real" world, safety is revealed as an illusion, but possibility need not be. William Burroughs has posited the potential existence and use of the "pirate utopia"—any sovereign mental or physical realm that liberates one from the conditions of control. That there is no real outside in contemporary culture is old news to these artists. They are tenaciously balanced in an intact, autonomous space carved from within, risking the ever-present security breach, perimeters necessarily unsecured. Perhaps these new forms of myth can be described as such: liminal, transitional spaces, unmoored, unfixed, and resistant. The Borgesian terror of monstrous infinity such a position suggests is, however, only a partial reaction. It can also breed new arguments, with a web of multiple answers, that can illuminate where falsely polarized choices plunged us into darkness. As Francis Bacon proclaimed, "That fashion of taking few things into account, and pronouncing with reference to a few things, has been the ruin of everything…. The world is not to be narrowed till it will go into the understanding (which has been done hitherto), but the understanding to be expanded and opened till it can take in the image of the world." [31]

1 Jorge Luis Borges, "The Circular Ruins," in *Collected Fictions* (New York: Penguin USA, 1999), p. 100.

2 From *The Diary of Anaïs Nin, 1947–1955*, vol. V, reprinted in *The Drug User: Documents 1840–1960*, eds. John Strausbaugh and Donald Blaise (New York: Blast Books, 1991), p. 147.

3 Margaret Wertheim posits this situation as a fundamental shift from the individualistic psychological space that dominated the Western idea of the psyche since Freud. See *The Pearly Gates of Cyberspace: A History of Space from Dante to the Internet* (London: Virago, 1999).

4 Roland Barthes, *Mythologies*, selected and translated from the French by Annette Lavers (New York: Hill and Wang, 1972), p. 109. Though my essay does not focus on this approach, reading images semiotically—as "text" that presents "ideas in form"—stems from theorists such as Roland Barthes, whose essay "Myth Today" is a critical antecedent.

5 Quoted by Samuel Delany, *Dhalgren* (Hanover, N.H.: Wesleyan University Press and University Press of New England, 1996), n.p.

6 T. J. Clarke, *Farewell to an Idea: Episodes From a History of Modernism* (New Haven: Yale University Press, 1999), p. 8.

7 Philip K. Dick, "How to Build a Universe That Doesn't Fall Apart Two Days Later," in *I Hope I Shall Arrive Soon* (New York: Doubleday, 1985), p. 4.

8 Richard Hofstadter, "The Paranoid Style in American Politics," *Harper's Magazine* (November 1964): 77–86.

9 William Butler Yeats, "Two Song From a Play," in *The Collected Poems of W. B. Yeats*, ed. Richard Finneran (New York: Scribner, 1996), p. 213.

10 John Rajchman, "Unhappy Returns," *Artforum* (April 2003): 61–64, 230, 232. "As critical theory tends to become increasingly melancholy, artists find less and less use for it, eventually becoming quite indifferent, as if they were trying to forget just what the increasingly discouraged critic wants to remember at all costs" (p. 62).

11 T. J. Clarke, *Farewelll to an Idea*, p. 7.

12 Not incidentally, the band's name is taken from one of the most influential mythmaking films in contemporary culture, *Blade Runner* (1984, directed by Ridley Scott). The film's techno-noir aesthetic of the future deeply influenced William Gibson's seminal cyberpunk novel *Neuromancer*, in which the omnipresent term "cyberspace" was coined. In the film, Replicants—androids indistinguishable from humans—were marked for termination when no longer content to be humanity's tool, after they developed emotions on their own. The narrative centers on the question of what it means to be human, positing a more subjective than biological approach.

13 Umberto Eco, "Dreaming of the Middle Ages," in *Travels in Hyperreality* (New York: Harvest Books, 1990), p. 84.

14 For an expanded discussion of this idea, see Eric Davis, *Myth, Magic and Mysticism in the Age of Information* (New York: Harmony Books, 1998).

15 Neil Spiller, Introduction, in *Cyber Reader: Critical Writings for the Digital Era*, ed. Neil Spiller (London and New York: Phaidon Press, 2002), p. 7.

16 Email exchange with the artist, October 2, 2003.

17 Gilles Deleuze and Felix Guattari, *A Thousand Plateaus: Capitalism and Schizophrenia*, trans. Brian Massumi (Minneapolis: University of Minnesota Press, 1987). The concept figures throughout the text, but is discussed in depth on pp. 1–22.

18 Borges, "The Book of Sand," *Collected Fictions*, pp. 482–83.

19 Artist's statement, September 23, 2003.

20 The persistence of the gothic psyche in modern art has been explored by Jan Tumlir in *Morbid Curiosity*, exh. cat. (New York: I-20 Gallery, 2002), in which he characterizes a concurrent flipside to modernist theory.

21 A critical exhibition isolating this development was organized early in the decade by Paul Schimmel, *Helter Skelter: L.A. Art in the 1990s*, exh. cat. (Los Angeles: Museum of Contemporary Art, 1992).

22 Quoted in Richard Davenport-Hines, *Gothic: Four Hundred Years of Excess, Horror, Evil and Ruin* (New York: Farrar Straus Giroux, 1999). Davenport-Hines maps the cycles of the gothic sensibility through its historical cultural presence and explores its psychosocial roots.

23 E. Jentsch, quoted in Sigmund Freud, "The Uncanny" (1919), *The Standard Edition of the Complete Psychological Works of Sigmund Freud*, trans. and ed. James Strachey, 24 vols. (London: Hogarth Press, 1953–74), vol. 7, p. 226.

24 Barry Schwabsky, art review, "Aïda Ruilova," *Artforum* (December 2000): 148.

25 Quoted in Davenport-Hines, *Gothic*, p. 7.

26 Edmund Burke, *A Philosophical Enquiry into the Origin of Our Ideas of the Sublime and Beautiful*, ed. Adam Phillips (New York: Oxford University Press, 1998), p. 53.

27 Email exchange with the artist, January 8, 2004.

28 The particular attraction to American vernacular forms (i.e., specific genres of music and film) as a frequently appropriated model for contemporary artists may speak to their greater fluidity to transform themselves, unburdened by the historical weight of "high art" imagery.

29 Email exchange with the artist, October 8, 2003.

30 For a more complete anthologizing of this sensibility, see *The Fourth Sex: Adolescent Extremes*, eds. Francesco Bonami and Raf Simons (Florence: Fondazione Pitti, 2003).

31 Francis Bacon, *Preparative Toward Natural and Experimental History*, 1620, in *The Works of Francis Bacon*, coll. and ed. James Spedding, Robert Leslie Ellis, and Douglas Denon Heath (Boston: Brown and Taggard, 1860–64), vol. VIII.

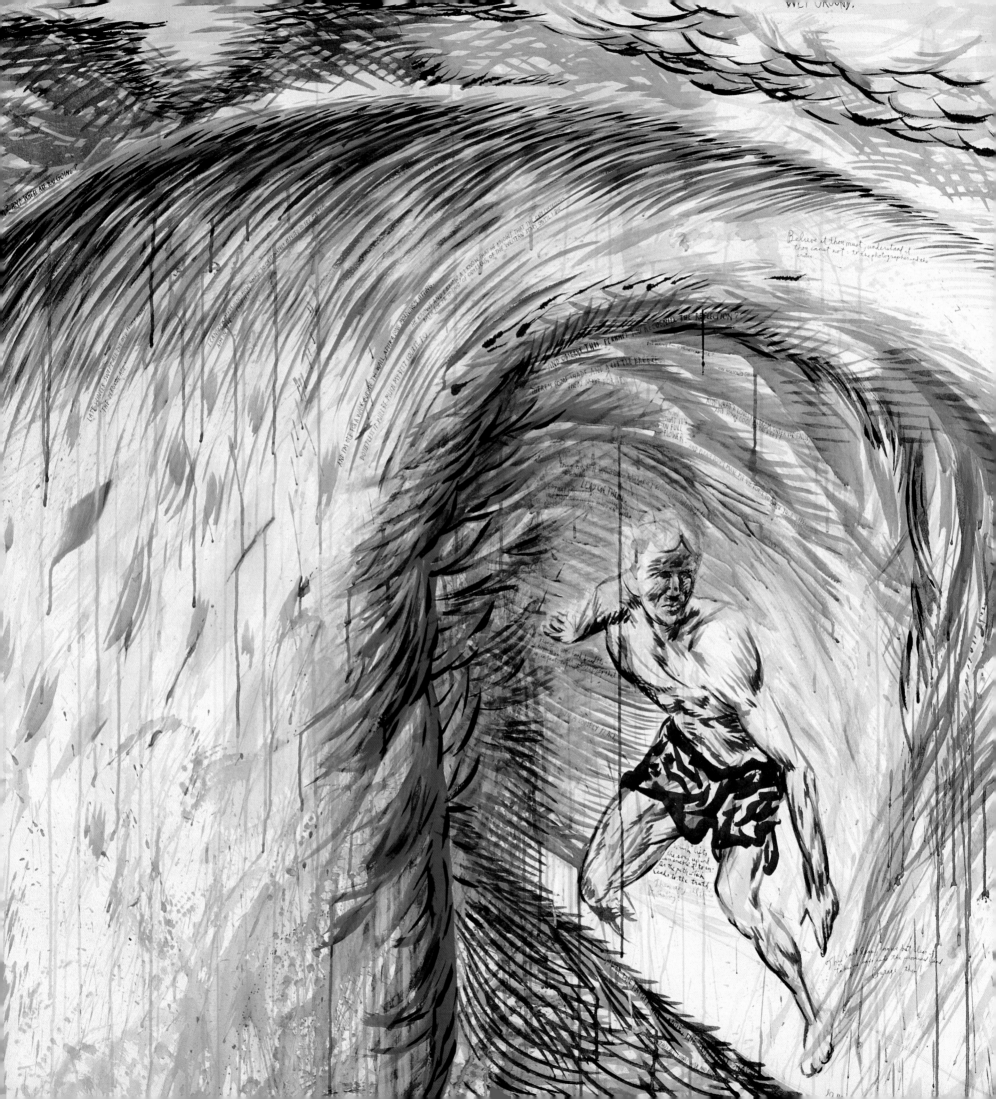

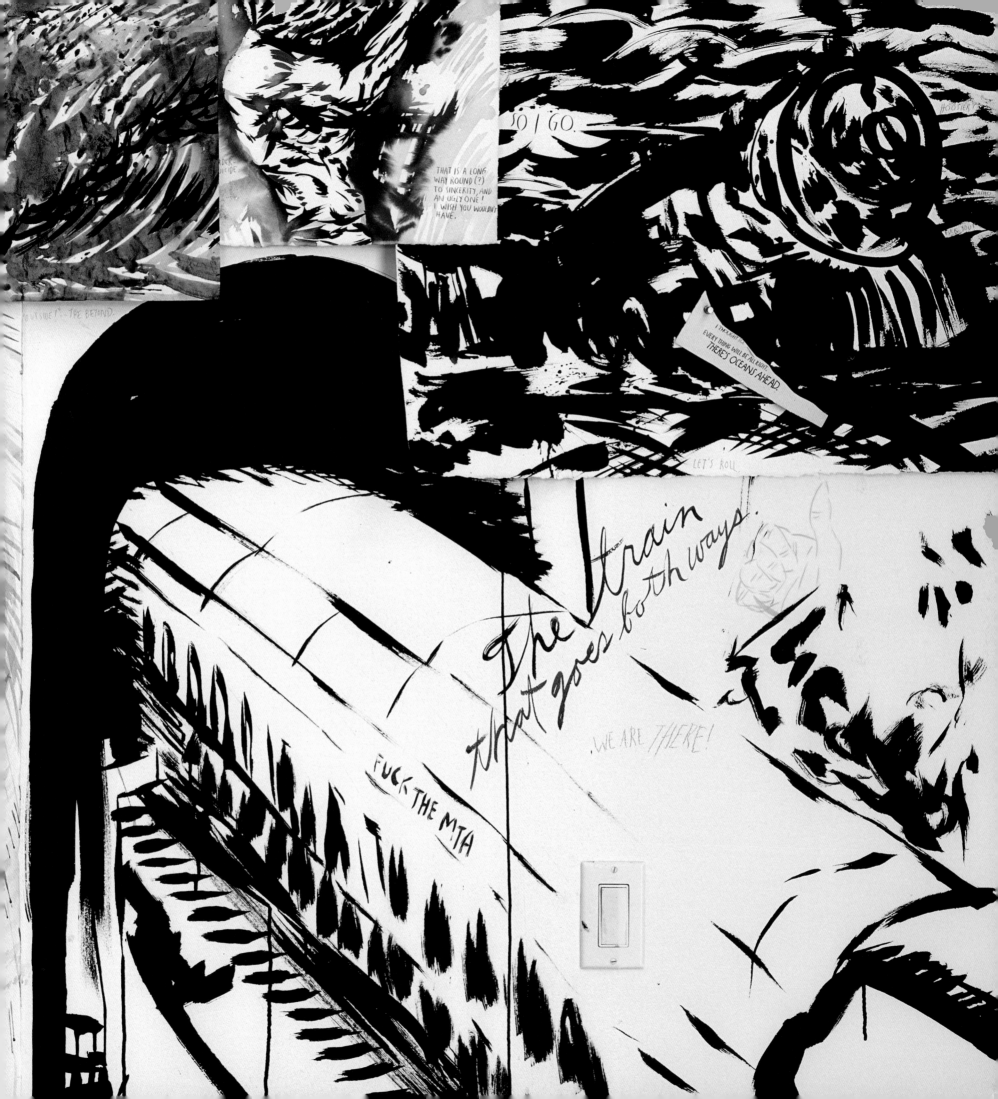

Altered States
Chrissie Iles

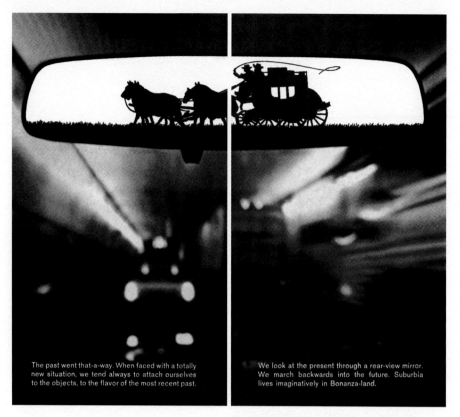

The past went that-a-way. When faced with a totally new situation, we tend always to attach ourselves to the objects, to the flavor of the most recent past.

We look at the present through a rear-view mirror. We march backwards into the future. Suburbia lives imaginatively in Bonanza-land.

Pages from Marshall McLuhan and Quentin Fiore, *The Medium is the Massage: An Inventory of Effects*, 1967. Produced by Jerome Agel. Copyright 1967, 1996 by Jerome Agel. Used by permission

ALTERED STATES

Eras of decline resemble each other not only in their vices but also in their strange climate of rhetorical and aesthetic vehemence.
—George Steiner[1]

The trajectory of artmaking stretching from the mid-1960s to the beginning of the twenty-first century forms one of the most tightly interwoven threads of influence and counterinfluence in modern art history. Four years into the new millennium, one of the most striking aspects of current art is the persistence with which it continues to revisit and reabsorb political and cultural moments of the recent past, at the same time that artists who were integral to forming that past are reasserting elements of its vital force.

The artists brought together in the 2004 Biennial are all engaged in a complex dialogue with this "just past." They begin from markedly different starting points that, when brought together, confirm the profound shifts that have occurred in recent contemporary artmaking, both in the years immediately preceding and following September 11, 2001, and, more broadly, in the final decade of the twentieth century. These shifts include a breaking down of the old dialectic in painting between the conservatism of narrative/figuration and the modernist endgame of abstraction; the emergence of video installation and drawing onto the center stage of artmaking; a dispersion of the 1990s preoccupation with the cinematic into new directions; and the shift in photography and film from the mechanical to the digital, with the resulting final collapse of any belief in the photograph as "truth."

Perhaps the strongest undercurrent informing these tectonic shifts in recent art is the Internet, the global reach of which has eclipsed Marshall McLuhan's predictions regarding the impact of the technological revolution of the 1960s. Instantaneous accessibility to information and imagery has revolutionized the speed and breadth by which both are absorbed, appropriated, and reworked. It might be argued that the Internet has created a kind of split between art made before the Internet reset our spatial, perceptual, visual, social, and political compass and art made after—whether embracing or reacting against its inescapable magnetic field. This fissure can be understood as the fulcrum for the relationship between the cross-generational works in the exhibition. It deeply informs the reworking of the language of 1960s and 1970s art by a younger generation of artists. In part, this link has been driven by an attempt to connect with a moment in history as politically and socially turbulent as ours is today; yet the impulse to look back is driven by something more complex.

Many younger artists are engaging with specific historical figures and, sometimes, with particular works. The grammar of these older artists' thinking was formed at a utopian moment, when the instantaneous interconnectivity of a new technology that was eventually to become the Internet first began to assert itself. As McLuhan observed in 1967, "The contained, the distinct, the separate—our Western legacy—are being replaced by the flowing, the unified, the fused."[2]

Though the porousness engendered by this new sense of interconnectivity extended the physical boundaries between people, objects, countries, surfaces, spaces, and time zones, in the 1960s it had not yet dissolved them. By contrast, in 2004, these boundaries have become fused in ways that assert every experience as, in some way, provisional: There is always something else happening to distract us from the present.

The speed and fluidity with which one aspect of the surrounding visual environment becomes morphed into another has produced an unprecedentedly eclectic artistic activity. This environment has been formed by what has been described as a period of collective social "adolescence," in which the new generation cannot move fully into the stage of young adulthood that those who came of age during the 1960s and 1970s still occupy, and refuse to relinquish. The implications of this are clearly articulated in painting, perhaps the most contested territory since the 1960s, and currently occupying center stage within the art world. Not, as in the 1980s, as a reactionary assertion of bombastic image-making over conceptual/perceptual practices, but as a rejoinder to the photographic homogeneity of mass media surface and image, and its impact on individual and collective identity. Yve-Alain Bois has argued that since the beginning of the last century and the appearance of the readymade, the question of whether painting is still possible has been inextricably linked to "the question of the beginning of the end."[3] Bois suggests that, since most contemporary painting has abandoned the task of working through its own end, we should no longer seek to deny or affirm the end of painting. Instead, we should agree that "although the *match* of the end of modernist painting is finished, the *game* of the end of painting isn't."[4]

The painting included in this Biennial all belongs to the game, and not the match, of the end of painting. As Bois argues, since the end of the nineteenth century, painting, unable to compete with industrialization, has internalized some of its features. In the late 1980s, Richard Prince made a series of monochrome fiberglass paintings cast from the hoods of 1970s cars and painted in classic car colors. Fourteen years later, he has completed a new series of "hood paintings," in which the brushwork on the painted fiberglass surface is more evident.

As Frances Colpitt points out, Donald Judd credited John Chamberlain with reintroducing color as structure to contemporary sculpture in 1960, when he applied automobile paint to crushed sections of metal cars in his sculptures.[5] Prince's hood paintings take this crossover between painting and sculpture in relation to everyday mass production further. In each painting, a ridge in the center of the cast car hood runs through the painted surface, rupturing the apparent statement of frontal, flat abstraction. Part readymade, part sculpture, and part painting, the paintings, whose surfaces evoke the cast clay prototypes used in car factories in the 1970s, fuse the early Minimalist language of Judd with the painterly markings of custom-car culture.

The shifting of the real into a form of hyperreal through process and surface in Prince's paintings can also be traced in the work of Alex Hay. Hay's new paintings, the first he has made since 1968, continue a technique he developed in the early 1960s. Using painstakingly hand-cut stencils, the artist applies spray paint in layers onto canvas to create larger-than-life images of everyday objects—in the 1960s, a plate of eggs, a cash register slip, a legal pad, and in these new works, discarded ends of wood with raw, smooth, or flaking surfaces.

The uncanny resemblance of the paintings to the object, enlarged as though observed through a magnifying glass, recalls Baudrillard's comment that "unreality no longer resides in the dream or fantasy, but in the real's hallucinatory resemblance to itself.... Like the distancing effect in a dream,

where you know you are dreaming, hyper-realism is an integral part of coded reality…. It functions entirely within the realm of simulation." [6]

Hay achieves this "hallucinatory resemblance" through an intense and meticulous observation of the otherwise unnoticed. In contrast to Andy Warhol's silkscreened paintings of everyday objects, Hay's paintings undermine their inflection of mechanical reproduction by the intimacy with which each object has been observed and rendered. His focus on surface and observation, rendered material through a direct relationship between the eye and the hand, has new resonance in the digital age, when the infinitely dispersible electronic image has thrown the distinction between the simulated and the real increasingly into question.

Like Hay's paintings, Robert Mangold's work engages issues of painting in relation to observation, surface and three-dimensional form. Mangold's paintings have always exerted a sculptural presence, reinforced by their insistence on the actuality of form, material, color, and line. His new paintings take the eye from the floor upward, and appear inextricably bound to the surface of the wall. In each painting, Mangold has divided the surface with two serpentine graphite lines that undulate upward and downward, sometimes barely touching, at other times completely intertwined. The works are profoundly corporeal, enveloping not only the viewer's eye but the entire body in their verticality. The boldly hand-drawn lines could be said to describe a perfectly balanced internal flow of energy, articulated both on the surface of the canvas, which commands an intensely physical presence, and in the continuous drawing action of the artist's body by which they were made. Mangold's paintings are as much about drawing as about painting, posing, as Lynne Cooke has observed, "a dialectical tension between line/structure and surface/color, each of which [are] treated as at once literal and abstract entities." [7]

The scale of Mangold's work, like that of Hay's paintings, creates an experience of looking at something physically larger than life. But whereas Hay's images evoke the sensation of looking through a magnifying glass, Mangold's paintings suggest the opposite. The perceptual gestalt of his sinuous lines evokes the sensation of encountering something larger than the limits of our physical self, while echoing our own movement through space in abstract form. As Cooke argues, Mangold's paintings create "a carefully structured conceptual/perceptual dialectic [that] raises epistemological questions: leading the eye back to the mind necessitates a (re)-consideration of the nature and character of the act of looking." [8]

In contrast to the actuality of surface and size asserted in the paintings of Mangold, Hay, and Prince, the paintings of James Siena explore another avenue of inquiry into the act of looking by opening up what could be termed an internal space, created by lattices of colored lines stretching into apparent infinity. Siena's delicate paintings on aluminum are intimate visual systems of thinking, at once evoking the language of artificial intelligence, psychedelic hallucination, microscopic biological patterns, the conceptual systems of Sol LeWitt, the infinity net paintings of Yayoi Kusama, and the obsessive drawing techniques of the outsider artist Adolf Wölfli.

As in all the painters discussed so far, Siena's work internalizes the industrial through a synthesis of the hand and the mechanical, each of which reinforce and obscure the other. Like the work of Mangold and Hay, Siena's paintings are as much about drawing and the articulation of line as about

painting. Yet in Siena's work, surface exists not as a distinct plane, but as the accumulation of an infinitesimal ordering of colored lines. As Robert Hobbs observes, this accumulation, deeply influenced by the pattern languages of computer programmers, "moves abstract painting from its former modernist function as an ontological affirmation of being to its postmodern role as an epistemological assessment of thought."[9] Siena's strategies bear a direct connection to Conceptual art of the 1960s, in which thought, ideas, language, and processes of taxonomic ordering were privileged over the physical object.

The tension between conceptual thinking and the physical object lies at the heart of a new group of paintings by Mel Bochner, widely considered one of the key figures of Conceptual art. In his new paintings, Bochner's early conceptual linguistic strategy is reasserted in a series of paintings of words associated with a single, usually pejorative, noun, adjective, or verb, such as "stupid," "mistake," "nothing," "indifference," or "meaningless." The key word is painted in the upper-left-hand corner of the canvas, followed by a series of associated words copied directly from the thesaurus, each progressively more vernacular, some lapsing into phrases, ending up at the bottom-right-hand corner of the painting with the lowest common denominator: an insult, crudity, or slang. Thus "no" leads to "thumbs down," "not on your life," and "over my dead body" to arrive at "kiss my ass." Each word is drawn and painted onto the canvas in tightly arranged rows in a time-consuming formation similar to the process of writing, taking us back to the page. The different color creates a contrapuntal rhythm that evokes both linguistic phrasing and the act of emotive speaking. Bochner's linguistic surface denies both the abstraction of modernist painting and the pictorial depth of narrative, creating instead a textual space that evokes the concrete poetry of Stéphane Mallarmé.

If Siena's and Bochner's paintings assert the internal structures of thinking, the work of Fred Tomaselli reveals the hallucinatory depths of the irrational, unconscious mind. Intense color, obsessive drawing, highly worked surfaces, abstract patterning, and fantastical narratives have become increasingly prominent in recent artmaking, particularly in the work of younger artists. The psychedelic has exerted another influence, in paintings and drawings that evoke the chemically induced visual experiences of LSD trips.

The fantastical imagery in Tomaselli's paintings is directly informed by psychedelic experience. The altering of consciousness through psychotropic drugs has been practiced for thousands of years, its effects epitomized in nineteenth-century books such as Lewis Carroll's *Alice Through the Looking-Glass*. In the 1960s, mescaline, psilocybin, peyote, and LSD-25 became popular ways to stimulate altered states of consciousness, producing a body of psychedelic paintings by artists such as Isaac Abrams. The chemical alterations in the brain trigger changes in sensory and spatial perception, creating a mystical sense of boundless ego and hallucinatory transformation.

As accounts have described, the visual manifestations of these altered states can often occur in the form of "floral designs…flickering and sparkling particles of light…irradiating mandalas…intricate arabesque patterns… glowing, luminous…preternatural color and light."[10] Havelock Ellis reported seeing "images of the kaleidoscope, symmetrical groupings of spiked objects…. Then…a vast field of golden jewels, studded with red and green stones, ever-changing…they would spring up into flower shapes beneath

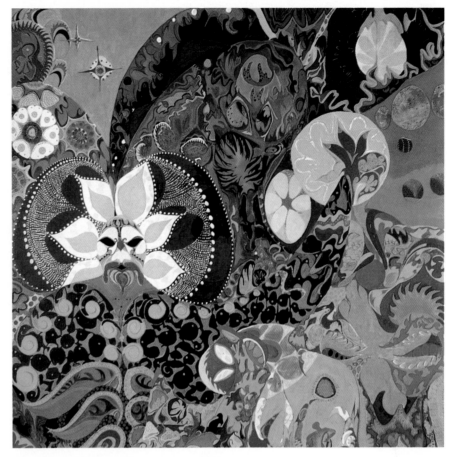

Isaac Abrams. *All Things Are One Thing*, **1966.**
Oil on canvas, 48 x 48 in. (121.9 x 121.9 cm).
Collection of Burt Kleiner; courtesy of the artist

my gaze, and then seem to turn into gorgeous butterfly forms or endless folds of glistening, iridescent fibrous wings of wonderful insects."[11]

In Tomaselli's recent paintings, highly colored leaves, flower petals, psychotropic plants, insects, and drugs are arranged in cosmic patterns clustered around, and partly forming, naked figures stripped to reveal their bones, muscles, and nervous systems. Inspired by anatomical illustrations and by the grotesque flower and vegetable composite portraits of the sixteenth-century Italian painter Giuseppe Arcimboldo, the figures emerge as though out of a cosmic darkness, evoking archetypal themes from art history: the grim reaper, death and the maiden, Adam and Eve. In some cases, a head occupies the entire surface of the painting, butterflies, flowers, and drugs exploding from it like fireworks. The surface of each painting is covered by a shiny resin that seals all the elements of the image together, as though capturing them under glass.

This claustrophobic suspension creates a sense of artificiality, death, and decay that relates directly to the collapse of nature's mystical symbolism in the eighteenth century, as the first convulsions of the modern age began. The *Wunderkammer* aspect of Tomaselli's fantastical pictures evokes the Victorian obsession with collecting insects, ferns, and flowers in glass cases or compressed inside glass balls, which King Ludwig II of Bavaria referred to as "dream spheres,"[12] into whose symbolic spaces the atemporal and mythical experiences stored in the unconscious are released. Tomaselli's melancholic allusions to death, decay, and failed utopianism articulate a similar unconscious anxiety around the fracturing of the mystic-natural realm by (post)modernity and industrialization.

The delicate images of Tomaselli's flayed bodies contrast sharply with the bombastic allegorical narrative paintings of the 1980s. In 2004, figurative painting is no longer regarded as indicative of a conservative "return to order." As Alison Gingeras argues, the old Frankfurt School–based dialectic of realism versus modernism has ceased to be meaningful, at a moment when the commercial photographic image has come to dominate our sense of individual and collective identity.[13]

Gingeras points out how important magazines, commercial photographs, advertising, Hollywood stars, and narrative cinema were immediately after the Second World War in rebuilding the social fabric. Nearly sixty years later, painting has come to represent a crucial irritant within that now vastly overdetermined collective identity, reasserting the personal in the face of a conceptual and abstract language that has been co-opted by the commercial advertising and design world.

The intimacy of portraiture is asserted as an act of both subversion and affirmation in the paintings of David Hockney and Elizabeth Peyton. Both artists' approach to portraiture is inextricably bound to the mechanism of celebrity, and confirms Ronald Jones's recent observation that "the cultural register measuring the real has realigned." The real was never lost, Jones suggests, "it simply came to exist in different degrees or kind; nothing one does after photography will restore the previous culture." Artists from the previous generation such as Richard Prince and Cindy Sherman having cleared the path, "Elizabeth's generation accepted all of it for what it was."[14]

Peyton's paintings, which, as Jones argues, conflate portraiture and "making a picture of someone," "willfully operate under the influence of media."[15] Intimacy is expressed through internalizing the mass media's simulation of

a connection with the lives of historical figures, such as King Ludwig II and Napoléon, and celebrities like Princess Diana, Kurt Cobain, Chloë Sevigny, and others brought "close" to us in magazines like *Hello!* and *People*. Peyton paints stars in her own, androgynous image, transforming magazine photographs into small, delicately painted, spare pictures that evoke the work of Hockney and Billy Sullivan. Yet Peyton's lovingly rendered paintings are distinct in their conflation of mass-media celebrity and history with personal experience, to the point where each image, whether of a rock star or a personal friend, becomes almost a symbolic self-portrait. Evocative of fin-de-siècle Romanticism, Peyton's portraiture evokes Oscar Wilde's novel *The Picture of Dorian Gray*, as Camille Paglia observes, "the fullest study of the Decadent erotic principle: the transformation of a person into an objet d'art." [16]

At the beginning of his career in London in the early 1960s, David Hockney was at the center of the burgeoning publicity machine. David Mellor observed that "the promotional fashioning of David Hockney was one of the key events of the early Sixties…. His was a passage to fame through the advent of certain mechanisms of celebrity that were now available after the renovation of the 'glossies'…. Hockney is the great exemplar, before the Beatles, of mastery over this new publicity machinery, by means of ironizing the reporting of fame." [17]

The celebrity of Hockney, based in Los Angeles since the mid-1960s, was built around his own direct engagement with family and friends, many of whom are also famous and all of whom he paints directly from life. His subjects include Ossie Clark, Henry Geldzahler, Richard Hamilton, Celia Birtwell, Lucien Freud, Christopher Isherwood, Divine, Andy Warhol, his own parents, and his close friend of twenty years, Gregory Evans. Celebrity is mitigated by, and intensifies, intimacy in Hockney's portraits through his direct relationship with each subject and his pared-down colors and techniques of painting, watercolor, and drawing, which he continually refines and changes.

That Hockney is both the subject of fame and a participant in its subversion, and that he is one of Peyton's adored subjects, demonstrates another way in which an industrial form, in this case the publicity machinery of mass culture, has been internalized in painting. The idolization of a star from afar in Hockney's earliest paintings, such as *We Two Boys Together Clinging* (1961), in which Hockney portrays himself embracing the rock-and-roll star Cliff Richard, whom he had never met, is reiterated in Peyton's paintings as part of what Baudrillard has described as "an aesthetic hallucination of reality…. Now the real and the imaginary are confounded in the same operational totality." [18]

If Peyton's and Hockney's work eroticizes the rendering of human likeness through desire, the paintings of Cecily Brown render the very surface of the canvas carnal. As Jan Tumlir observes, Brown makes a direct analogy between sex and painting. "Blurred lines, swipes and trails of pigment, a dry brush making contact with a wet patch of canvas, soaked through— these marks serve to materialize the movements of the body 'beside itself'…. Paint…'follows' these movements, surrendering control, opening up, coming apart, and in this way shapes its very own object as a sexual body." [19]

Brown's imagery draws on explicit source material: photographs from pornographic magazines, nineteenth-century erotic prints, and Romantic literature and poetry. In *Black Painting I* (2002), a naked woman sleeps

Elizabeth Peyton. *Julian*, 2003. Pastel on paper, 16 1/2 x 11 3/4 in. (41.9 x 29.8 cm). Private collection; courtesy neugerriemschneider, Berlin

David Hockney. *Gregory*, 1978. Crayon on paper, 17 x 14 in. (43.2 x 35.6 cm). Collection of the artist

on a bed, her back arched and her arms stretched above her head. A mass of indeterminate entities hovers above her in the darkness: the demons of nightmares, vampirelike sexual predators, erotic dreams.

Paglia describes sex as "ghost-ridden" and "daemonic" and the unconscious as a daemonic realm: "At night we descend to the dream world, where nature reigns, where there is no law but sex, cruelty and metamorphosis…. Moment by moment, night flickers in the imagination, in eroticism…giving an uncanny aura to objects and persons, revealed to us through the eye of the artist…. Fraught with symbols…sex is always representation, a ritualistic acting out of vanished realities."[20]

Evoking both Goya's etching *The Sleep of Reason Produces Monsters* (1799) and Henri Fuseli's painting *The Nightmare* (1781–82), *Black Painting I* rearticulates the decadent eroticization of visual experience. Shifting between readable image and the drowsy world of the unconscious, Brown's painting "draws the image from out of the muck, and…leaves some of it behind…. Sex creates a confusion between what vision gives to the body and what the body gives back to vision; that is, much the same sort of confusion that one looks for in painting."[21]

Throughout the 2004 Biennial, the relationship between painting, drawing, and the projected image is strongly evident, in the shared materiality of surface, and, in some cases, the narrative subject. The Romantic sense of erotic decay in Brown's paintings, for example, also suffuses the expanded film works of Bradley Eros, whose delicate images of the moon, underwater sea creatures, pulsating octopuses, naked bodies in flagrante, water, drops of mercury, spiderwebs, and uncanny light create the sense of a limpid waking dream. In Eve Sussman's video installation *89 Seconds at Alcazar* (2003), film is used to explore painting's depiction of time. The work takes as its subject Velázquez's enigmatic painting *Las Meninas* (1658). Sussman deconstructs the work—the subject of countless theoretical debates, and reinterpretations by artists—through a filmic narrative that acts out the characters' imagined movements in the artist's studio immediately preceding and following the moment captured by Velázquez.

In *89 Seconds at Alcazar*, the eleven characters in the painting are cast in what Sussman terms a "cinema vérité costume choreography." "It is in cinema vérité filmmaking that colloquial body language speaks louder than words and…banality becomes prescient…. The video is not about the second of the choreography in which the actors form 'the famous painting,' but any moment in which the extension of a hand or the turn of a head imply an epic."[22] The enigma of *Las Meninas* lies in its modern quality of arresting a moment in time, as though freezing a film frame or taking a photograph unawares. The group, interrupted in movement, looks outward beyond the canvas, toward an unseen protagonist—and the viewer—in a prescient anticipation of photography.

In the absence of a visible subject, we see a group caught in the act of observing the King and Queen of Spain standing for their portrait. At the center of the group is the real subject of the painting: the monarchs' young daughter, the Infanta Doña Margarita, captured by the painter as though reluctantly posing for a photograph. Her two *meninas*, or ladies-in-waiting, curtsy and fuss over the child as she looks toward her parents. Two court dwarves, Maribarbola and Nicolasito, and the household dog—representing faithfulness—complete a circle that symbolizes the virtues of devotion and

service to the monarchy. Velázquez, suspended in mid-action and captured by his own gaze, integrates himself into the inner circle. In *Las Meninas* Velázquez constructs an elaborate perceptual container for the Infanta Doña Margarita's representation as the future of the monarchy, and of Spain.

In *89 Seconds at Alcazar*, Sussman moves the camera through the room in a single 360-degree panning shot, slowly unfreezing the circle. Sussman and Claudia de Serpa's choreography, fused with Jonathan Bepler's haunting soundtrack, reveals the theatrical artifice of Velázquez's compositional "punctum" within the restaging of the imagined everyday actions surrounding it. By releasing Velázquez's frozen moment, Sussman reframes the painting's allegory as a live drama and unlocks the key to the picture—the perpetual vulnerability of royal power. The imminent secession of royal power is exposed, just as the circle of fidelity around it disperses and attempts to re-form itself as it recedes into time. Loyalty is revealed to be an artifice, carefully constructed, yet always teetering on the point of collapse.

The relationship between painting and film is articulated in abstract, visceral terms in the hand-painted films of Stan Brakhage. Widely considered America's most important avant-garde filmmaker, Brakhage's prolific career spanned over fifty-two years. Toward the end of his life, he made a body of work that continued his long engagement with hand-painted film, whose context he felt lay as much in the paintings of artists such as Joan Mitchell as in the tradition of hand-processed filmmaking of which he was an early pioneer.

In this Biennial, Brakhage's last films are seen not only in the film program, but also integrated within the galleries, in a black box space. His films overturn our received patterns of visual perception. In his late hand-painted films, such as *Persian Series 13–18* (2001), paint flickers on the screen in liquid shapes of tangled color, sometimes muted, other times as fiery reds, yellows, and purples dancing and flaring like light moving through stained-glass windows. In *Chinese Series* (2003), the last film Brakhage made, he scratched markings onto 35mm black film leader with his fingernails, working from his bed. His spare calligraphic markings locate *Chinese Series* somewhere between writing and drawing. In the direct connection between Brakhage's hand and the surface of the film emulsion the final traces of life are written, animated by their propulsion through the film projector.

The delicate trace of lost presence is felt rather than seen in Julie Murray's film *Untitled (light)* (2002). Six months after the events of September 11, 2001, two beams of light were shone vertically into the night sky by Ground Zero in Lower Manhattan like melancholic searchlights, creating a ghostly echo of the absent towers.[23] Murray's camera, filming in the rain, moves around the beams of light, capturing their dramatic, ethereal verticality against the unsettling sound of helicopters circling overhead. Murray's succinct, understated film operates both on a formal level as a study of light and as a collective remembering of vulnerability and loss, repeatedly circling the beams of light as though trying to comprehend the overwhelming void that their presence represents.

If Murray's film evokes the aftermath of an apocalyptic moment, Jack Goldstein's film *Under Water Sea Fantasy*, begun in 1983 and finished just before his untimely death in March 2003, articulates the spectacle of its beginning. In the first part of the film a volcano is seen erupting in explosions of molten red against a blue background. Apocalyptic images—volcanoes, explosions, lightning, storms, war planes—had been the subject of his

Anthony McCall. Still from _Doubling Back_, 2003. Installation with film projector and hazer, 16mm film, black-and-white, silent; 30 min. Collection of the artist

paintings in the 1980s. The film's loud, terrifying spectacle of the erupting volcano is suddenly silenced by a second sequence of underwater marine life, as the camera moves through rocks, seaweed, and shoals of fish at the bottom of the sea. The intense colors of Goldstein's paintings are reiterated in the strange, melancholic sequences of the film, as the seabed gives way to an image of the full moon high in a dark blue sky, waning imperceptibly as clouds scud past.

As in his earlier paintings and films, Goldstein's last film constructs a highly artificial surface from borrowed sources, creating a theatricality that distances us from the subject. As Craig Owens has remarked, "Goldstein is interested less in the technologies of filmmaking…and more in the effects which these technologies can produce…. [He] views the media as an outlet for our fantasies of dominating and controlling (potentially destructive) natural forces."[24] Goldstein confirms Owens's observation in his statement that "art made from media captures the spectacle which a 'self-destructive civilization' makes of itself."[25]

The potentially destructive power of natural forces is also disturbingly evident in Robert Longo's large, apocalyptic drawings of waves, all depicted at the height of their swell, just at the moment before they break. The enveloping darkness of Longo's black graphite sea threatens to overwhelm the viewer in its murky depths, just as the smoothness of its graphite surface asserts the image as an appropriation of spectacle.

Goldstein's and Longo's construction of the image as conceptual statement is paralleled in Morgan Fisher's new film _()_ (2003). As Fisher explains, the title of the film, when spoken, is "parentheses," and comes from a Greek word meaning "the act of inserting." Each shot in the film is found film footage of what is known in the commercial film world as an "insert." As Fisher explains, inserts "stand apart from…the world of the human face and the human body. Inserts are alien, secondary, marginal…. The purpose of inserts is of a special kind…inserts make a point. They show us one thing, they make one point about the one thing that they show us. Inserts are instrumental."[26]

Each insert shot in _()_ is a close-up taken from a number of different Hollywood film prints from the 1940s, 1950s, and 1960s that Fisher has collected. The act of collecting and splicing celluloid prints has a physical quality that sets Fisher's actions apart from the electronic flow of Internet image-exchanging. Fisher's physical collaging both echoes the process by which the original films were made and undermines it in its defiance of conventional narrative logic. Fisher is not editing, but arranging. The resulting arbitrary meanings that occur please him, since they indicate that he has "in principle given each shot its greatest chance to be free…. Ordinarily, inserts are as bound to narrative as serfs were bound to the soil. But in a film that consists of nothing but inserts, the hierarchy that rules in narrative film disappears…._()_ is a film of equals…. Inserts of the world unite, you have nothing to lose but your chains to narrative!"

Fisher's structural thinking is echoed in the film works of a younger generation of artists including Pip Chodorov, James Fotopoulos, Bruce McClure, and Luis Recoder, all of whose films engage deeply with the rigorous formal approach of 1970s Structural film, in particular the work of Paul Sharits. McClure, Recoder, and Fotopoulos all use an abstract language of color, light, material surface, and framing. In Recoder's and McClure's film performances

and installations, the film frame is dismantled and multiplied into complex forms, doubled, quadrupled, overlaid, masked out, and in some cases melted altogether, both asserting the concreteness of the abstract surface and disassembling all traces of conventional cinematic form.

The relationship between structure and form becomes three-dimensional and volumetric in the work of Anthony McCall, another key figure in 1970s Conceptual film. McCall's new film installation, *Doubling Back* (2003), develops the concerns of his earlier work, in particular his Conceptual film *Line Describing a Cone* (1973), in which the physical manifestation of the light emanating from the projector becomes a mechanism by which viewers engage with the physical reality of the artwork, and each other, within the social space of the gallery. Like the earlier work, *Doubling Back* deals with drawing, volume, space, and time, here in a more complex volumetric form. Two curving white lines appear in a darkened space, projected from floor to ceiling from a single 16mm film projector whose beam is articulated by the mist of a fog machine. Over a period of forty-five minutes, the two intersecting curved lines create planes in space that gradually move toward and away from each other, constructing an experience of abstract form that is simultaneously architectural, sculptural, and graphic. Like Mangold's monumental paintings, McCall's sinuous lines and planes open and close, enveloping the viewer in the limits of their own physical presence in space.

McCall's film installation is one of several film and sculptural installations in the exhibition that articulate perceptions of social space. In McCall's piece, this perception is articulated in formal spatial terms; in works by Craigie Horsfield, Liisa Roberts, Marina Abramović, and Roni Horn, social space is articulated geopolitically—in a remote community in the Canary Islands, a border town in Russia, the war-torn city of Belgrade, and the social space of the museum.

If McCall's film installation creates social space in formal, abstract terms, Craigie Horsfield's installation *El Hierro Conversation* (2002) constructs a social space by folding a cinematic experience into another kind of waking dreaming. Four specially constructed benches provide a quiet place for the viewer to sit or lie and enter into the social space of the community on El Hierro, the smallest and most westerly Canary Island, which Horsfield has documented on four large projections that unfold over eight hours in a kind of "slow time," as an extended conversation.

The remote Canary Islands have occupied a mythical presence throughout history. Horsfield portrays the islanders' customs and rituals—processions celebrating the virgin, drums, and colorful national costume—as well as the animals, forests, fields, paths, mists, and weather of El Hierro with a languorous rhythm that reflects the speed of a community as yet unaffected by the pace and demands of urban living. Over the eight hours, the daily actions, personal stories, and holiday celebrations of the island's community gradually unfold. At one point, Horsfield films the making of cheese by hand. The white surface of the milk fills all four screens, giving out a diffused white light, as a woman slowly churns the liquid. After half an hour, the dense consistency of the cheese eventually emerges out of the milk. The humanity of Horsfield's images is intensified by the intimacy with which he captures each action and vista, with a highly cinematic rendering of light, color, and composition that reads as at once filmic, painterly, and photographic.

As in all his work, Horsfield's narrative is concerned with collaboration, conversation, and relationships. As the islanders recount stories both personal

Robert Mangold. *Column Painting #4 (Study),* 2003. Acrylic and graphite on canvas, 60 x 23 1/2 in. (152.4 x 59.7 cm). Collection of the artist

Craigie Horsfield. From the Bajada near San
Andres, 2001, from *El Hierro Conversation*,
2002. Video installation, dimensions variable.
Collection of the artist

and historic, it becomes evident that Horsfield is not simply a curious
observer, but is deeply engaged in an ongoing social dialogue. He observes,
"Art as conversation, dialogue, and negotiation is, within the generative
relation of thinking together, part of an attention to the world. These are traces
of an epic, of individual lives, of people, ourselves.... The present, such as
it is, is in our relation." [27]

Liisa Roberts's project *Vyborg: A Town Library in Viipuri* (2003) con-
structs another kind of dialogue with social space by exploring "the ethical
dimensions of images." [28] Initially taking the form of a creative-writing work-
shop—"What's the Time in Vyborg?"—the project brought together a group
of local teenagers in the central library of the city. The library, designed by
Alvar Aalto, was built as a symbol of Finland's modern civic values. Once a
thriving border town that used to be Finnish, Vyborg became part of Russian
territory when it was annexed in the Second World War.

Over an almost three-year period, the teenagers were asked to articulate
their thoughts about their life in the town through discussion, creative
writing, performance, and collaboration with local media, as well as script
and act in a film, in collaboration with Roberts, who is half American and
half Finnish. The teenagers' perceptions of their social, built, and historical
environment reflected the multiple identities of the library's past. In later
stages, their work also reflected a new image of the library and, by exten-
sion, of the city.

Tatyana V. Svetelnikova, the director of the library, gave Roberts and her
group permission to meet in the library's lecture hall. Roberts invited a
St. Petersburg–based psychologist, Olga Maslova, and a Lithuanian trans-
lator, Edgars Platelis, to collaborate on developing and conducting the
writing workshop. A group of young Finnish architects was also invited to
discuss ideas about the building and Vyborg with the students. Eventually,
working with the architect Alexander Mihailovich Shver, who had overseen
the library's reconstruction in the Soviet period, the architects took part
in a restoration of the library.

In Roberts's film, which is screened in the Kaufmann Conference Room
at the Institute of International Education in New York (one of only four
Aalto interiors in the United States) as a part of the larger project, the Aalto
library becomes the nexus for the shifting identity of Vyborg itself. [29] The
film was written by the collaborative group, and shot by cinematographer
Aleksandr Burov, known for his work with filmmaker Aleksandr Sokurov.
The film captures both a certain Russian nostalgia and Aalto's optimisim
about the future. As Roberts observes, "There are distinct temporalities
which simultaneously made up the context of this city. One couldn't say, as
the Finns insisted, that it was a 'Finnish' city. Conversely, one couldn't say
that it was 'Russian' either. Its identity, rather, lies in the meeting point and
dialogue of multiple places and temporalities, fictions and realities, as
these are lived and experienced within and outside this location today." [30]

As the impact of the collapse of the Communist system in 1989 continues
to reverberate, Marina Abramović, like Roberts, has chosen a civic building—
a school—and a group of young people, this time in the city of Belgrade,
to articulate the impact of international politics on identity and the social fab-
ric. In the video installation *Count on Us* (2003), Abramović, now based in
New York, returned to her native city of Belgrade to work for the first time
since she left in 1975.

In the early 1990s, when Slobodan Milosevic came to power and revived Serbian nationalism, the United Nations School was founded by the government in Belgrade. Not connected with the United Nations, the school's name instead evokes the policies of the powerful Communist ruler of Yugoslavia, Marshal Tito. Tito distanced Yugoslavia from both Stalin and the United States, and formed an independent international committee of nonaligned countries—an alternative "United Nations"—to counterbalance the axis of the United States and the Soviet Union, from which Tito split in 1948.

After the American bombing of Belgrade in 1999, the United Nations promised to provide aid to the war-torn city; only a fraction of it arrived. On one screen of *Count on Us*, the official choir of the United Nations School, a group of children between ten and fourteen years old, dressed in black in their broken-down assembly hall, sings a hymn thanking the U.N. in advance for stopping the war, bringing them food, and rescuing the people of Belgrade. The words of the choir, both naïve and now ironic, underscore the impotence of the United Nations in the wake of the massive failure of the Communist system.

Abramović, conducting the choir, is cloaked by two skeletons bound to her body back and front. Evoking medieval depictions of death and the maiden, Abramović's ghostly presence in the group of children underscores the death and decay that has pervaded Belgrade and Yugoslavia's identity as a nation state since the Second World War. The general ineffectiveness of the United Nations in the Kosovo war and as an international voice opposing America's recent bombing of Iraq turns Abramović's image of death into a global cipher of political failure.

On two adjacent screens, a young girl and boy sing old Yugoslav songs lamenting lost love and heartache, while on a third, a glass globe encases a crackling electrical impulse as invented by the Yugoslav scientist Nikola Tesler, suggesting the possibility of regeneration. On a fifth screen the choir reappears from five directions and lies down together to form the shape of a large star.[31] Abramović, still embraced by the double skeleton, lies in the center. Like the inescapable mantle of death that clings to her, the Communist star, rendered in black, is a burned-out, unwanted symbol, which has no future yet whose residue continues to haunt the body politic. Abramović's double skeleton is nihilistic. Unlike the double-headed Roman god Janus, the custodian of the universe who looked both back to the past and forward to the future, in Abramović's double skeleton neither is possible; there is, she suggests, only a perpetual present: the vicious circle of death and war.

From the beginning of her career, the double image or object has been of central importance to the work of Roni Horn. Her use of the double has profound implications for the viewer. Doubling creates a sense of doubt regarding the authenticity of the image, and of identity. It breaks apart the notion of fixity, in aesthetic, political, and sexual terms. For this Biennial, Horn has made a new piece, *Doubt by Water* (2003–04). Thirty silver metal stanchions are placed in the interstitial spaces of the museum, from the lobby to the rest rooms. A group is also assembled in a cluster in the main gallery space, like a forest of signs. Each stanchion holds a large double-sided photograph: a young person, captured in a series of subtly shifting facial expressions; the restless surface of water; and Icelandic

Honoré Daumier, *Conseil de guerre (Council of War)*, 1872. Lithograph, 11 ³/₈ x 9 ³/₁₆ in. (28.9 x 23.3 cm). The Metropolitan Museum of Art; purchase, Jacob H. Schiff Bequest, 1922 22.63.7

owls, whose piercing stares obscure the fact that they are dead, static objects rather than living entities.

The double-sidedness of the photographs in *Doubt by Water* shifts our reading of the image toward the sculptural, in which a single frontality gives way to multiple viewpoints. It also suggests, more literally, the two-faced, both in social and personal terms—the exterior social self versus the interior, private identity, often identified as the doppelgänger, or ghostly shadow self. In Iceland, a strong influence on Horn, the world of fairies and ghosts is regarded as a vital parallel world to that of the living, and its essential counterpoint.

In *Doubt by Water* Horn suggests this tension between the concrete and the indeterminate through ambiguity. The young person's face, like that of Horn herself, is seductively androgynous. The owls are vital even in death; and the water's surface looks like liquid concrete. In formal, psychological, and aesthetic terms, *Doubt by Water* refuses the possibility of a single reading, constructing a complex self-portrait in which one layer of identity is folded inside another. Horn's ambivalent images reflect the tenuous sense of stability that characterizes the general current cultural and sociopolitical climate. The delicate balance between presence and absence articulated in Horn's work can be felt throughout this exhibition and beyond.

Jack Goldstein's prediction regarding the spectacularization of society and politics has been realized, in 2004, in a renewed sense of the apocalyptic, in which the perceived threat surrounding the now defunct Communist system over earlier decades has been overturned by the jolting reality of a more intangible threat, realized in the most potent symbols of American power burning in the hearts of New York City and Washington. The intergenerational dialogue taking place within this Biennial exhibition reflects, in general terms, an urgent need to make sense of a "world gone wrong," as Bob Dylan described things in 1968. More than thirty-five years later, in the newly altered state of the world, it also suggests a continuing desire to reaffirm art's ability to articulate alternative thinking, and restore a sense of meaning to a world in which the nihilistic and the restorative coexist in an all too fragile balance.

1 George Steiner, introduction to *The Origin of German Tragic Drama*, by Walter Benjamin (London: New Left Books, 1977), p. 24, quoted in Benjamin Buchloh, "Figures of Authority, Ciphers of Regression," in *Art after Modernism: Rethinking Representation*, ed. Brian Wallis (New York: New Museum of Contemporary Art, 1984), p. 109.

2 Marshall McLuhan and Quentin Fiore, *The Medium Is the Massage: An Inventory of Effects* (New York: Bantam Books, 1967), p. 145.

3 Yves-Alain Bois, "Painting: The Task of Mourning," in *Painting as Model* (Cambridge, Mass.: The MIT Press, 1993), pp. 229–30.

4 Ibid., p. 242.

5 Frances Colpitt, *Minimal Art: The Critical Perspective* (Seattle: University of Washington Press, 1994), p. 26.

6 Jean Baudrillard, "The Hyper-realism of Simulation," in *Art in Theory, 1900–1990*, ed. Charles Harrison and Paul Wood (Oxford: Blackwell Publishers, 1992), p. 150.

7 Lynne Cooke, "Robert Mangold, Frames of Reference," in *Robert Mangold, Attic Series I–VI* (London: Lisson Gallery, 1990), p. 7.

8 Ibid., p. 19.

9 Robert Hobbs, *James Siena 1991–2001*, exh. cat. (New York and Los Angeles: Gorney Bravin + Lee, Daniel Weinberg Gallery, 2001), p. 16.

10 Robert E. L. Masters and Jean Houston, ed., *Psychedelic Art* (New York: Grove Press, 1968), pp. 90–91.

11 Ibid., p. 90.

12 Celeste Olalquiaga, *The Artificial Kingdom: A Treasury of the Kitsch Experience* (New York: Pantheon Books, 1998), p. 57.

13 Alison M. Gingeras, ed., *Dear Painter, Paint Me…: Painting the Figure since Picabia*, exh. cat. (Paris: Centre nationale d'art et de culture Georges Pompidou, 2002), p. 10.

14 Ronald Jones, "A Revolt from Reason," in *Elizabeth Peyton*, ed. Zdenik Felix (Stuttgart: Hatje Cantz Verlag, 2001), p. 10.

15 Ibid., p.18.

16 Camille Paglia, *Sexual Personae: Art and Decadence from Nefertiti to Emily Dickinson* (New Haven, Conn.: Yale University Press, 1990), p. 512.

17 David Mellor, *The Sixties Art Scene in London* (London: Phaidon Press, 1993), pp. 143–47.

18 Baudrillard, "The Hyper-realism of Simulation," p. 150.

19 Jan Tumlir, "The Paintings of Cecily Brown," in *Cecily Brown*, exh. cat. (New York and Los Angeles: Gagosian Gallery, 2003), p. 8.

20 Paglia, *Sexual Personae*, p. 4.

21 Tumlir, "The Paintings of Cecily Brown," pp. 9–10.

22 Email exchange with the artist, November 14, 2003.

23 The project, *Tribute in Light*, was created by architects John Bennett and Gustavo Bonevardi of PROUN Space Studio, artists Julian LaVerdiere and Paul Myoda, and lighting designer Paul Marantz, and organized by Creative Time and the Municipal Art Society. The project was first displayed from March 11 to April 13, 2002, and again on September 11, 2003, for one night.

24 Craig Owens, "Back to the Studio," in *Jack Goldstein*, exh. cat. (Grenoble: Magasin–Centre National d'Art Contemporain, 2002), p. 93.

25 Ibid., p. 88.

26 Morgan Fisher, *()*, unpublished text, 2003, n.p.

27 Craigie Horsfield, "El Hierro: A Conversation" (Government of the Canary Islands, 2002), p. 17.

28 ArtPace press release, San Antonio, August 24, 1999.

29 In March 2002 the Finnish Committee for the Restoration of the Viipuri Library held a public seminar in the Edgar Kauffmann Room about the current state of the library's restoration.

30 Liisa Roberts, *What's the Time in Vyborg?*, unpublished artist's statement, 2003.

31 The star echoes Abramović's performance *Rhythm 5* in Belgrade in 1974, in which she lay in the center of a large burning star, having cut her hair and placed it on its five points.

The Lottery in Babylon

JORGE LUIS BORGES

LIKE ALL THE MEN OF BABYLON, I have been proconsul; like all, I have been a slave. I have known omnipotence, ignominy, imprisonment. Look here—my right hand has no index finger. Look here—through this gash in my cape you can see on my stomach a crimson tattoo—it is the second letter, *Beth*. On nights when the moon is full, this symbol gives me power over men with the mark of Gimel, but it subjects me to those with the Aleph, who on nights when there is no moon owe obedience to those marked with the Gimel. In the half-light of dawn, in a cellar, standing before a black altar, I have slit the throats of sacred bulls. Once, for an entire lunar year, I was declared invisible—I would cry out and no one would heed my call, I would steal bread and not be beheaded. I have known that thing the Greeks knew not—uncertainty. In a chamber of brass, as I faced the strangler's silent scarf, hope did not abandon me; in the river of delights, panic has not failed me. Heraclides Ponticus reports, admiringly, that Pythagoras recalled having been Pyrrhus, and before that, Euphorbus, and before that, some other mortal; in order to recall similar vicissitudes, I have no need of death, nor even of imposture.

I owe that almost monstrous variety to an institution—the Lottery—which is unknown in other nations, or at work in them imperfectly or secretly. I have not delved into this institution's history. I know that sages cannot agree. About its mighty purposes I know as much as a man untutored in astrology might know about the moon. Mine is a dizzying country in which the Lottery is a major

element of reality; until this day, I have thought as little about it as about the conduct of the indecipherable gods or of my heart. Now, far from Babylon and its belovèd customs, I think with some bewilderment about the Lottery, and about the blasphemous conjectures that shrouded men whisper in the half-light of dawn or evening.

My father would tell how once, long ago—centuries? years?—the lottery in Babylon was a game played by commoners. He would tell (though whether this is true or not, I cannot say) how barbers would take a man's copper coins and give back rectangles made of bone or parchment and adorned with symbols. Then, in broad daylight, a drawing would be held; those smiled upon by fate would, with no further corroboration by chance, win coins minted of silver. The procedure, as you can see, was rudimentary.

Naturally, those so-called "lotteries" were a failure. They had no moral force whatsoever; they appealed not to all a man's faculties, but only to his hopefulness. Public indifference soon meant that the merchants who had founded these venal lotteries began to lose money. Someone tried something new: including among the list of lucky numbers a few *unlucky* draws. This innovation meant that those who bought those numbered rectangles now had a twofold chance: they might win a sum of money or they might be required to pay a fine—sometimes a considerable one. As one might expect, that small risk (for every thirty "good" numbers there was one ill-omened one) piqued the public's interest. Babylonians flocked to buy tickets. The man who bought none was considered a pusillanimous wretch, a man with no spirit of adventure. In time, this justified contempt found a second target: not just the man who didn't pay, but also the man who lost and paid the fine. The Company (as it was now beginning to be known) had to protect the interest of the winners, who could not be paid their prizes unless the pot contained almost the entire amount of the fines. A lawsuit was filed against the losers: the judge sentenced them to pay the original fine, plus court costs, or spend a number of days in jail. In order to thwart the Company, they all chose jail. From the gauntlet thrown down by a few men sprang the Company's omnipotence—its ecclesiastical, metaphysical force.

Some time after this, the announcements of the numbers drawn began to leave out the lists of fines and simply print the days of prison assigned to each losing number. That shorthand, as it were, which went virtually unnoticed at the time, was of utmost importance: *It was the first appearance of nonpecuniary elements in the lottery.* And it met with great success—indeed, the Company was forced by its players to increase the number of unlucky draws.

As everyone knows, the people of Babylon are great admirers of logic, and even of symmetry. It was inconsistent that lucky numbers should pay off in round silver coins while unlucky ones were measured in days and nights of jail. Certain moralists argued that the possession of coins did not always bring about happiness, and that other forms of happiness were perhaps more direct.

The lower-caste neighborhoods of the city voiced a different complaint. The members of the priestly class gambled heavily, and so enjoyed all the vicissitudes of terror and hope; the poor (with understandable, or inevitable, envy) saw themselves denied access to that famously delightful, even sensual, wheel. The fair and reasonable desire that all men and women, rich and poor, be able to take part equally in the Lottery inspired indignant demonstrations—the memory of which, time has failed to dim. Some stubborn souls could not (or pretended they could not) understand that this was a *novus ordo seclorum*, a necessary stage of history…. A slave stole a crimson ticket; the drawing determined that that ticket entitled the bearer to have his tongue burned out. The code of law provided the same sentence for stealing a lottery ticket. Some Babylonians argued that the slave deserved the burning iron for being a thief; others, more magnanimous, that the executioner should employ the iron because thus fate had decreed…. There were disturbances, there were regrettable instances of bloodshed, but the masses of Babylon at last, over the opposition of the well-to-do, imposed their will; they saw their generous objectives fully achieved. First, the Company was forced to assume all public power. (The unification was necessary because of the vastness and complexity of the new operations.) Second, the Lottery was made secret, free of charge, and open to all. The

mercenary sale of lots was abolished; once initiated into the mysteries of Baal, every free man automatically took part in the sacred drawings, which were held in labyrinths of the god every sixty nights and determined each man's destiny until the next drawing. The consequences were incalculable. A lucky draw might bring about a man's elevation to the council of the magi or the imprisonment of his enemy (secret, or known by all to be so), or might allow him to find, in the peaceful dimness of his room, the woman who would begin to disturb him, or whom he had never hoped to see again; an unlucky draw: mutilation, dishonor of many kinds, death itself. Sometimes a single event—the murder of C in a tavern, B's mysterious apotheosis—would be the inspired outcome of thirty or forty drawings. Combining bets was difficult, but we must recall that the individuals of the Company were (and still are) all-powerful, and clever. In many cases, the knowledge that certain happy turns were the simple result of chance would have lessened the force of those outcomes; to forestall that problem, agents of the Company employed suggestion, or even magic. The paths they followed, the intrigues they wove, were invariably secret. To penetrate the innermost hopes and innermost fears of every man, they called upon astrologers and spies. There were certain stone lions, a sacred latrine called Qaphqa, some cracks in a dusty aqueduct—these places, it was generally believed, *gave access to the Company*, and well- or ill-wishing persons would deposit confidential reports in them. An alphabetical file held those *dossiers* of varying veracity.

Incredibly, there was talk of favoritism, of corruption. With it customary discretion, the Company did not reply directly; instead, it scrawled its brief argument in the rubble of a mask factory. The *apologia* is now numbered among the sacred Scriptures. It pointed out, doctrinally, that the Lottery is an interpolation of chance into the order of the universe, and observed that to accept errors is to strengthen chance, not contravene it. It also noted that those lions, that sacred squatting-place, though not disavowed by the Company (which reserved the right to consult them), functioned with no official guarantee.

This statement quieted the public's concerns. But it also produced other effects perhaps unforeseen by its author. It profoundly altered both the spirit and the operations of the Company. I have but little time remaining; we are told that the ship is about to sail—but I will try to explain.

However unlikely it may seem, no one, until that time, had attempted to produce a general theory of gaming. Babylonians are not a speculative people; they obey the dictates of chance, surrender their lives, their hopes, their nameless terror to it, but it never occurs to them to delve into its labyrinthine laws or the revolving spheres that manifest its workings. Nonetheless, the semiofficial statement that I mentioned inspired numerous debates of a legal and mathematical nature. From one of them, there emerged the following conjecture: If the Lottery is an intensification of chance, a periodic infusion of chaos into the cosmos, then is it not appropriate that chance intervene in *every* aspect of the drawing, not just one? Is it not ludicrous that chance should dictate a person's death while the circumstances of that death—whether private or public, whether drawn out for an hour or a century—should *not* be subject to chance? Those perfectly reasonable objections finally prompted sweeping reform; the complexities of the new system (complicated further by its having been in practice for centuries) are understood by only a handful of specialists, though I will attempt to summarize them, even if only symbolically.

Let us imagine a first drawing, which condemns a man to death. In pursuance of that decree, another drawing is held; out of that second drawing come, say, nine possible executors. Of those nine, four might initiate a third drawing to determine the name of the executioner, two might replace the unlucky draw with a lucky one (the discovery of a treasure, say), another might decide that the death should be exacerbated (death with dishonor, that is, or with the refinement of torture), others might simply refuse to carry out the sentence.... That is the scheme of the Lottery, put symbolically. *In reality, the number of drawings is infinite*. No decision is final; all branch into others. The ignorant assume that infinite drawings require infinite time; actually, all that is required is that time be infinitely subdivisible, as in the famous parable of the Race with the Tortoise. That infinitude coincides remarkably well with the sinuous numbers

of Chance and with the Heavenly Archetype of the Lottery beloved of Platonists…. Some distorted echo of our custom seems to have reached the Tiber: In his *Life of Antoninus Heliogabalus*, Ælius Lampridius tells us that the emperor wrote out on seashells the fate that he intended for his guests at dinner—some would receive ten pounds of gold; others ten houseflies, ten dormice, ten bears. It is fair to recall that Heliogabalus was raised in Asia Minor, among the priests of his eponymous god.

There are also *impersonal* drawings, whose purpose is unclear. One drawing decrees that a sapphire from Taprobana be thrown into the waters of the Euphrates; another, that a bird be released from the top of a certain tower; another, that every hundred years a grain of sand be added to (or taken from) the countless grains of sand on a certain beach. Sometimes, the consequences are terrible.

Under the Company's beneficent influence, our customs are now steeped in chance. The purchaser of a dozen amphoræ of Damascene wine will not be surprised if one contains a talisman, or a viper; the scribe who writes out a contract never fails to include some error; I myself, in this hurried statement, have misrepresented some splendor, some atrocity—perhaps, too, some mysterious monotony…. Our historians, the most perspicacious on the planet, have invented a method for correcting chance; it is well known that the outcomes of this method are (in general) trustworthy—although, of course, they are never divulged without a measure of deception. Besides, there is nothing so tainted with fiction as the history of the Company…. A paleographic document, unearthed at a certain temple, may come from yesterday's drawing or from a drawing that took place centuries ago. No book is published without some discrepancy between each of the edition's copies. Scribes take a secret oath to omit, interpolate, alter. *Indirect* falsehood is also practiced.

The Company, with godlike modesty, shuns all publicity. Its agents, of course, are secret; the orders it constantly (perhaps continually) imparts are no different from those spread wholesale by impostors. Besides—who will boast of being a mere impostor? The drunken man who blurts out

an absurd command, the sleeping man who suddenly awakes and turns and chokes to death the woman sleeping at his side—are they not, perhaps, implementing one of the Company's secret decisions? That silent functioning, like God's, inspires all manner of conjectures. One scurrilously suggests that the company ceased to exist hundreds of years ago, and that the sacred disorder of our lives is purely hereditary, traditional; another believes that the Company is eternal, and teaches that it shall endure until the last night, when the last god shall annihilate the earth. Yet another declares that the Company is omnipotent, but affects only small things: the cry of a bird, the shades of rust and dust, the half dreams that come at dawn. Another, whispered by masked heresiarchs, says that *the Company has never existed, and never will*. Another, no less despicable, argues that it makes no difference whether one affirms or denies the reality of the shadowy corporation, because Babylon is nothing but an infinite game of chance.

Reprinted from Jorge Luis Borges, *Collected Fictions*, trans. Andrew Hurley (New York: Penguin USA, 1999), pp. 101–6.

From "The Artist and Politics: A Symposium"
Robert Smithson

The artist does not have to *will* a response to the "deepening political crisis in America." Sooner or later the artist is implicated or devoured by politics without even trying. My "position" is one of sinking into an awareness of global squalor and futility. The rat of politics always gnaws at the cheese of art. The trap is set. If there's an original curse, then politics has something to do with it. Direct political action becomes a matter of trying to pick poison out of boiling stew. The pain of this experience accelerates a need for more and more actions. "Actions speak louder than words." Such loud actions pour in on one like quicksand—one doesn't have to start one's own action. Actions swirl around one so fast they appear inactive. From a deeper level of "the deepening political crisis," the best and the worst actions run together and surround one in the inertia of a whirlpool. The bottom is never reached, but one keeps dropping into a kind of political centrifugal force that throws the blood of atrocities onto those working for peace. The horror becomes so intense, so imprisoning that one is overwhelmed by a sense of *disgust*.

Conscience-stricken, the artist wants to stop the massive hurricane of carnage, to separate the liberating revolution, from the repressive war machine. Of course, he sides with the revolution, then he discovers that real revolution means violence too. Gandhi is invoked, but Gandhi was assassinated. Artists always feel sympathy for victims. Yet, politics thrives on cruel sacrifices. Artists tend to be tender; they have an acute fear of blood baths and revolutionary terror. The political system that now controls the world on every level should be denied by art. Yet, why are so many artists now attracted to the dangerous world of politics? Perhaps, at the bottom, artists like anybody else yearn for that unbearable situation that politics leads to: the threat of pain, the horror of annihilation, that would end in calm and peace. Disgust generated by fear creates a personal panic, that seeks relief in sacrifice. Primitive sacrifices controlled by religious rites were supposed to extract life from death. The blind surge of life, I'm afraid, threatens itself. Modern sacrifices become a matter of chance and randomness. Nobody can face the absolute limit of death.

Students and police riots on a deeper level are ceremonial sacrifices based on a primal contingency—not a rite but an accident. Nevertheless, because of media co-option, the riots are being structured into rites. The students are a "life force" as opposed to the police "death force." Abbie Hoffman makes reference to William Golding's *Lord of the Flies* on page 184 of *Revolution for the Hell of It*; Golding's pig devil surrounded by flies is compared by Hoffman to an "unbelievable smell of decay and shit." Golding's novel abounds in images of piggishness; there is the fat boy called Piggy, and the rotten head of a pig. The overall mood of the novel is one of original disgust. One must remember that this novel was very popular with students some years ago. Life is swollen like Piggy and this is disappointing, the clean world of capitalism begins to stink, "the sexual channels are also the body's sewers" (George Bataille), nausea and repugnance bring one to the brink of violence. Only the fires of hell can burn away the slimy, maggot-ridden decomposition that exists in life, hence *Revolution for the Hell of It*.

"Then the rest joined in, making pig-dying noises and shouting." (*Lord of the Flies*). As time goes by, pollution and other excreta are liable to turn the planet Earth into a more horrible pigpen. Perhaps, the moon landing was one of the most demoralizing events in history, in that the media revealed the planet Earth to be a limited closed system, not unlike the island in *Lord of the Flies*. As the earth thickens with blood and waste, as the population increases, the stress factor could bring "the system" to total frenzy. Imagine a future where eroticism and love are under so much pressure and savagery that they veer towards cannibalism. When politics is controlled by the military, with its billions of dollars, the result is a debased demonology, a social aberration that operates with the help of Beelzebub (the pig-devil) between the regions of Mammon and Moloch.

Reprinted from "The Artist and Politics: A Symposium," *Artforum* (September 1970): 39. © *Artforum* / Estate of Robert Smithson / Licensed by VAGA, New York, NY.

She Comes in Colors: Up with Plastic

TIM GRIFFIN

The boom is a drug. When the boom ends, it feels like a drug has worn off. Time slows down—but only because time is something felt again. And only then does it become clear that time has gone missing.

That's what happened in 2001: The future became the past, without there ever being a present. The world was a little drearier; its everyday colors were a little paler, even while the year still had a vaguely futuristic ring to it when spoken aloud. True, the outward appearances of things never changed; but the physical landscape hardly mattered even while the boom was happening. The new, post-industrial economy was a psychotropic phenomenon from the start. The boom was a mood, all about perceptions hallucinated from the idea of information, a head rush made of data gold coursing through circuit boards and cables. And with the head rush gone, investors had a next-fix mentality. Instead of "waiting on my man," they waited on the Fed. And the Fed waited for the economy to turn...

Different drugs flourish and wither in different economic periods and present one side of a social dialectic opposite pleasure and ideas, resolving their formation and distribution in time. This creates a literal aspect to drug logic.

But the boom's metaphors are as true to life. The five years preceding 2001 have common roots with the tobacco companies' description of the cigarette industry in *The Insider*: "We are in the nicotine delivery business." At the end of the millennium, design was the delivery system, and technology was the nicotine. Their models and metaphors spread out over culture, producing a physiological

response, having crossed the blood-brain barrier intact.

The physiological response was a future imagined as a dematerialized zone, something designed to dissolve like a pill in the cultural bloodstream: traditional, discrete categories would become permeable; objects would dissipate into their electronic equivalents. However technology might already have realigned our relationship to geography and to each other (distant people and places are increasingly accessible), part of its new allure was its promise to disappear into the fabric of everything—from smart shoes and dashboard guidance systems to discussions of "relational aesthetics" in off-hours museums around Paris. Networking principles emigrated from Conceptual art installations to corporate boardrooms and back again through culture, sanitized as a distributive commodity. Surfaces now contained depth.

That future is, to a degree, fulfilled. Wireless technology floods the wavelengths of the spectrum, continually renegotiating the organization of experience in daily life. The qualifications of materiality have changed for the general public. Fluid and abstract systems, applications, and ideas are recognized sources of value. ("You see coffee," read one 1990s advertisement for Sprint Telecommunications, which featured a single cup of coffee. "We see data.")

In part, the designer delivery system was made to visualize this ambient field. In the industrial era, power was overt and displayed itself as such. The Wurlitzer jukebox caught the spirit of a time powered by pistons and muscled by assembly

lines. Products were made in numbers and with real bulk. In the postindustrial era, the ascendant power of the immaterial had to be made somehow perceptible, a condition of familiarity, without sacrificing the pleasant sense of disequilibrium created by the new, invisible drug, technology. Translucent encasings for digital appliances made the physical elliptical. They provided the quotation marks.

The delivery system also seduced through simplicity—by logo, by icon, by brand-name cues molded into visual form—and so the digital era was color-coded to provide a psychophysiological surge, which tunneled through the optic nerve. ("While not spiking nicotine, they clearly manipulated it," says the protagonist about Big Tobacco in *The Insider*.) The popular digital revolution of the late 1990s began and ended with two television commercials. In its first days, the iMac, following the lead of the VW Beetle, raced across a white screen to the Rolling Stones' flower-power lyric "She comes in colors." Seeming like plasticine distillations of sea glass and coral, the computers rushed across the blank frame in blue, orange, green, and gray, zooming toward the lens, then spreading out in a circle, before spinning outward in curling lines. They were optical gel caps, something more meaningfully ingested than seen. Later, against the real backdrop of 2001's dot-com wasteland, Target—a company where design pseudo-chic meets mass commerce—released an advertisement featuring shoppers moving through a hypersaturated, blood-red, vacuum-sealed field of repeating logos to the sound of Devo's "It's a

Beautiful World." The palpable tinge of post-punk irony in the humid electrosphere of dead brands was unmistakable. Twenty years of rock and roll cultural transformation had been compressed into five years of commerce.

But Devo's world of statistics has evolved into one of *information*—a term generated by technology, but whose codes now move across culture—attributing a flat, categorical lexicon to every medium. Its own optical vocabulary is design, which is a signature of the digital revolution's central theme: control. It might be control at the service of subtler curves in architectonic form, which is made possible in the wake of applied Bézier equations—and expresses itself in everything from the Guggenheim Bilbao to the tailgate on the most recent Subaru. It might be control at the service of surveillance, as in the U.S. government–operated Echelon computer system, which routinely, and without detection, monitors emails and cell-phone calls internationally for key words and phrases. Or, more important, it may be control at the service of targeting emotional responses—setting aside the control of bodies for access to minds. *Information* reads different categories merely as language-based platforms that correspond within a general network, and so it leaps across their borders freely in translations. The iMac blue is not simply blue. Rather, it is Bondi Blue, phonetically engineered to trigger a specific consumer response: intimate, emotional heat attuned to the aquatic tones of a cosmopolitan beach in Australia, for which the color is named. Conversely, the iMac's

clear sheath is termed neither *clear* nor *white*, but rather Ice.

Environmental experience is embedded in linguistic form, which influences the perception of physical materials in turn—only here, culture becomes a terrain of legislated emotions. This idea is nothing new. The drug Quaalude, which was developed in the 1960s, presented one of the first examples of such deep language. Developed by William H. Rorer, Inc., the sedative and hypnotic agent methaqualone was given the "aa" of Maalox—its parent company's best-known product at the time, a digestive aid that derived its name from the ingredients magnesium and aluminum hydroxide—whose double vowels were then bookended with a contraction of the soothing, poetic phrase "quiet interlude." *Quaalude.*

Single, high-precision words have always had the power to conjure, or dictate, ways of seeing the world, forcing the issue of whether language precedes or succeeds thought. (To paraphrase one artist, people have had to un-cube perception ever since the linguistic conception of Cubism.) Linguistic designs are continually made more refined and more specific. They are purer. When corporations employ language, they supply ways of seeing the world; the most sophisticated examples are called *lifestyles*. Consider Lexicon Branding, a company that coined the product names Pentium and Power-Book. Lexicon uses computers to generate brand names; psychologists and anthropologists identify potential markets and then cultivate emotional resonances induced there by phonetic combinations. Brands are translated and contoured

across media, so that the immaterial aura of lifestyle saturates the materials of living. Physical space and psychological space permeate each other. Janis Nakano Spivak of the online design firm Organic outlines contemporary Web philosophy in tellingly psychophysiological terms, saying, "If you look at well-designed spaces like Niketown, they thought about all the details. They take advantage of guiding you in a subconscious way through an experience. In the purest sense, that's what we're building in a virtual space." Digitized commerce is a science devoted to crossing the blood-brain barrier.

Concentrating solely on the supply side of this equation fails to acknowledge users. Contemporary linguistic drug markets have hardly encountered resistance in the forms of mass societal alienation or a significant countercultural stance: Control from without has been matched by control from within. Indeed, the digital revolution coincided with the wide application of such psychotherapeutic drugs as Prozac and Xanax; anxiety and depression were codified as manifestations of quantifiable chemical or genetic information that could be usefully manipulated. Emotional highs and lows, whether environmentally prompted or not, were tapered for a regulated middle ground. Mood and perception became somehow detached from the subject, who was now merely an amalgam of differentiated, malleable information.

Perhaps these highs and lows were not lost but only transplanted in social and corporate forms—whether lifestyles or logos—since psychology, once cast

out of the body, has to exist *somewhere*. As digital technology pervaded society, the compression model was introduced to the conception of the individual, making the turn of the millennium a time of *compressed emotions*.

Compression algorithms are filters, equations through which the information of an image is sifted in order to decrease the memory space an image will occupy. Some are typically termed "lossy," meaning that information is lost in the process. But the algorithms' enterprise is poetic: They choose what visual information to discard and then reformat whatever details they retain to provide a nuanced version of reality. (The limitations of human perception allow the deletion of information without significant change in the perceptual experience. One imagines engineers debating how to calibrate shadows.)

When technology overtakes all aspects of culture, emotions pass through such a filter; people revert instinctually to its models and metaphors in everyday conversation. Subtle yet deep-seated revisions in their emotions' makeup are produced, with moods displaced across a resulting picture of media, economies, and architectures. Individuals themselves are more like lenses through which abstract phenomena, circulation, and movement pass virtually unnoticed.

Previous times displayed the sluggish pallor of absinthe, the hazed introspection of marijuana, and the cold rush of cocaine. It's reasonable to wonder whether, in retrospect, the visual culture of the years leading up to 2001 will seem saturated by antidepressants, as bright, seductive

images reflect the depletion of articulated social anxiety. When antidepressants first took a firm grip on the public imagination in 1993, *The New Yorker* ran a cartoon titled "The 19th Century with Prozac," which featured three intellectual figures of the time in separate vignettes. "We have our quibbles with the property owners, but I think we can work it all out," Marx says. "I really enjoyed what the preacher said today, mama," Nietzsche adds. And Poe, looking at a raven perched on his desk, offers the greeting, "Hello, birdie!"

And yet, in 2001, culture experienced a different sensation, something dramatized by a thin stream of dead and dissipated brands. Historically, every culture feels its body during the wane of a boom, and that happened here, with one distinction. In the industrial era, machinery had a natural heir in *entropy*, a word that described dead things that visibly occupied a dead land. After industry, however, things are less seen than felt. And it is clear in this context that, when the sensations and emotions delivered by technology disappear, it sometimes feels like nothing at all.

Tim Griffin is editor of Artforum International. *Contamination*, his book of essays on art, architecture, design, fashion, and technology, was published by AES in 2002.

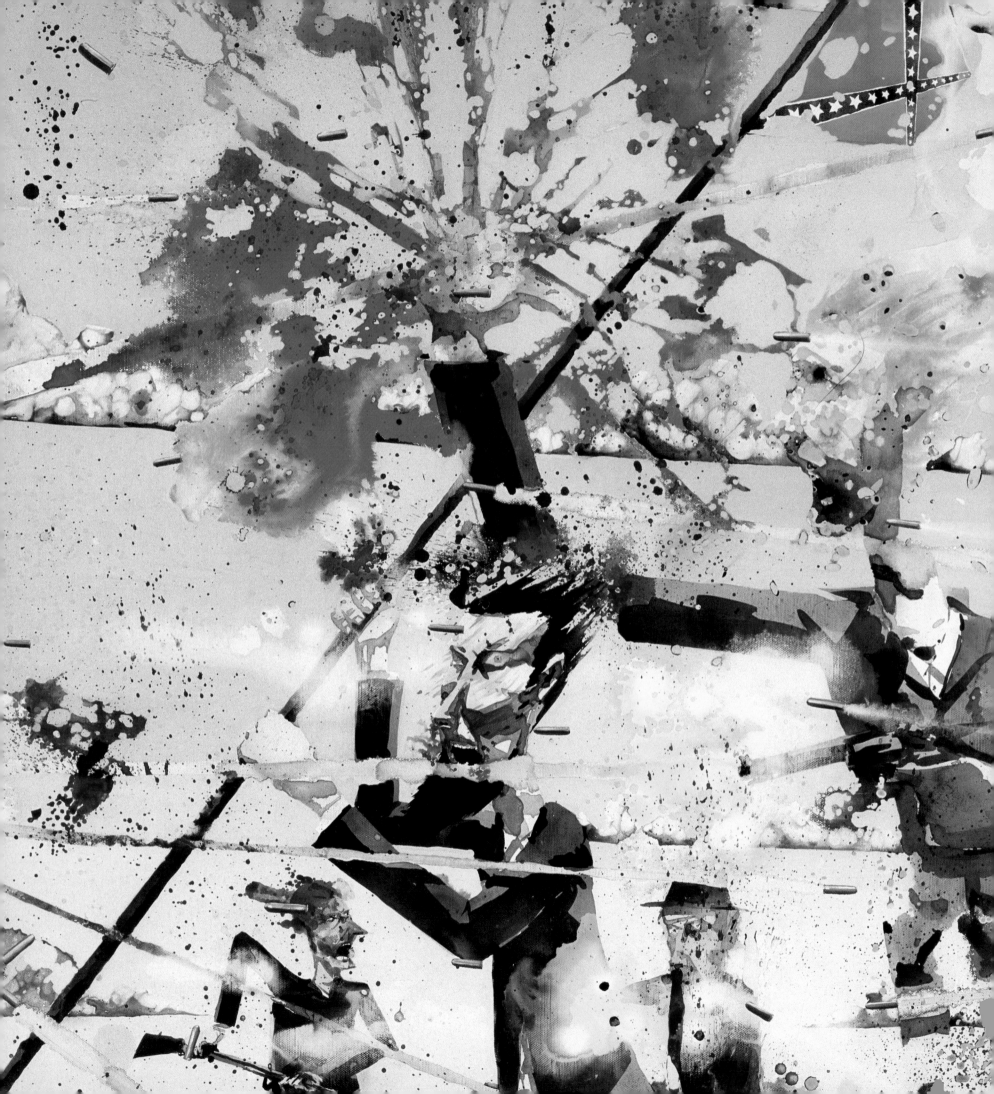

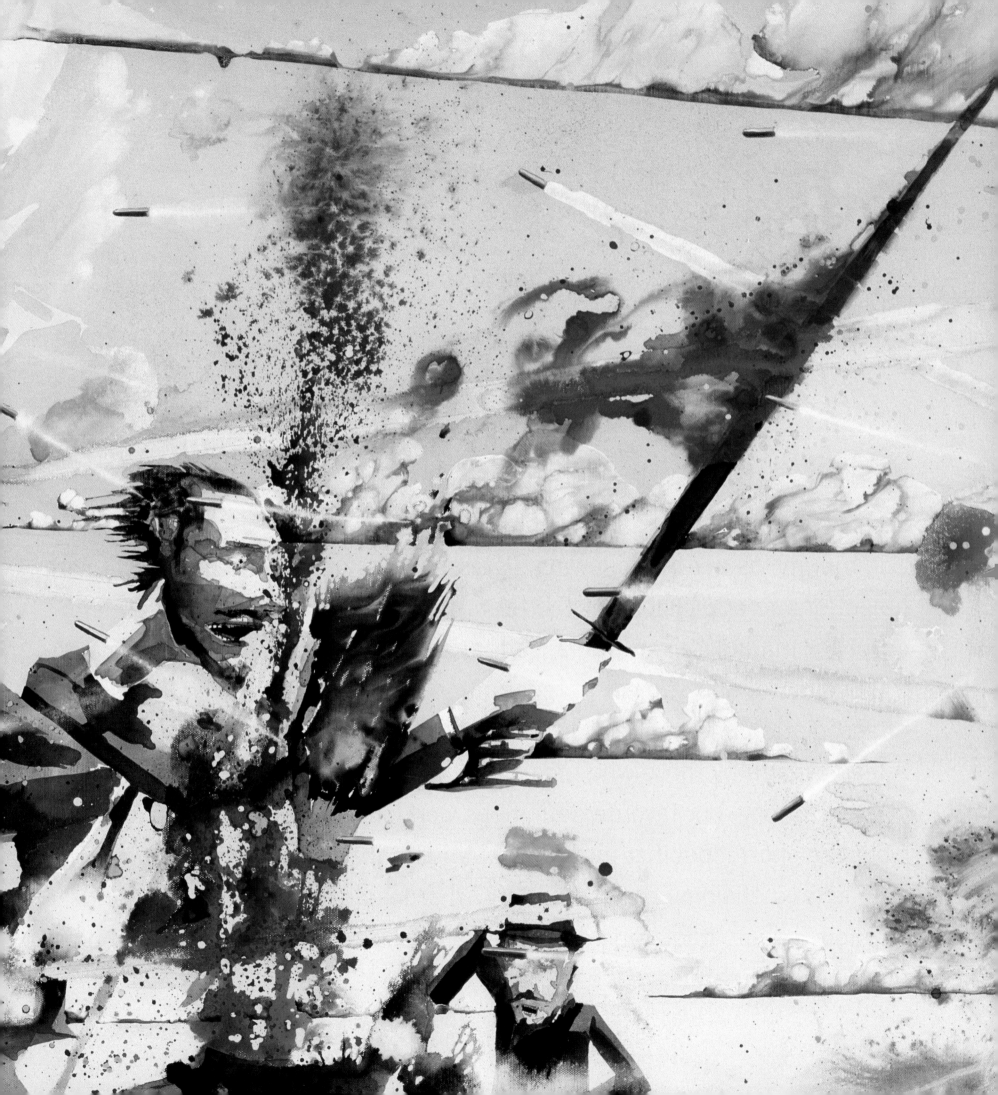

People with Similar Turn-Ons

Johanna Fateman and Rachel Greene

Community, as per the following digressions, is understood mainly through objections to or evasions of the term. Persistently used as euphemistic cover for market-driven, racialized, and stereotypical categorizations on the one hand, and subject to redefinition or rejection by emerging models of association and connection on the other, "community" is perplexing. A leap of faith by those who proclaim it, a self-fulfilling fiction, a traumatic crystallization—our favorite definitions work only sometimes. These digressions are short, specific, and tactical, much like the contemporary articulations (and elisions) of "community" that fascinate us across the fields of public space, fractal identity, discursive channels, and the cultural practices of participation, feedback, and fandom.

Desires in sync matter more than "things in common." Blowjobs, fleeting encounters in the (now gone) sex theaters of New York's Forty-second Street, inform Samuel Delany's understanding of humanely organized public space as the underpinning of productive and rewarding interclass social contact. The eradication of such space complicates and curtails potential anonymous hookups with the issues of "bringing someone home" and makes casual sex "anxiety-filled, class-bound, and choosy." That is, it takes on the repressed sociability associated with networking. While most of Delany's examples of enjoyable social contact and communication have sexually florid beginnings, he argues that all kinds of profoundly rewarding relationships and encounters—creative and professional as well as sexual—originate in the kind of chance meetings, attractions, and interchanges that rely on the existence of public spaces with diverse social traffic. Networking, while somewhat invested in the concept of a "lucky break," does not rely on the seemingly random, coincidental good fortune that social contact may produce, and instead expects results from a calculated path of advancement. Networking generally disappoints: **given the mode of capitalism under which we live, attempts to "relate" on the basis of shared specialization, status, or identity tend to veil competition rather than pool energy toward mutual benefit or common cause.** And the ambivalently antagonistic activities of networking are further confused when its participants burden it with the expectation to produce "community." Perhaps the disappointment is most acute where solidarity wishes to defeat competition. The economic stress of limited resources and opportunities—for, say, feminist artists or nonprofit organizations—leaves those who seek to collaborate with one another in the **development of collective political expressions**, alliances, and personal bonds, to fight over breadcrumbs. While Delany has specific visions for humane city and neighborhood planning that would facilitate interclass social contact, his ideas also have implications for the progressive design of virtual public spaces in which profile-matching practices and identity-based forums have tended to dominate.[1]

*

A secret—that is, publicly accessible but anonymous—world of (mostly) teenage girls and their unfiltered transmissions shows us how Internet paradigms of community, feedback, and diffusion prevail most "naturally" through the seamless internalizations of those who make culture with, not necessarily about, new technologies. At Ruby's Gloomy Place, an online message board for "sufferers of eating disorders to come together," anorexics ("anas") and bulimics ("mias") share both "tips, tricks, and thinspiration" (e.g., the calories in sugarless gum, how to vomit silently), as well as empathy, acceptance, and harm-reduction strategies to lure one another away from the precipice. Within this disturbing culture of appropriated therapeutic language and assimilated pop-sadism re: feminine beauty ideals, illness is a lifestyle, disorder is a mode of goal-attainment, and recovery is infrequently sought. The digital palette of candy HTML and emoticon overuse contrast sharply with the intensely corporeal and abject topics of discussion (e.g., binges, self-injury) and **the post-traumatic momentum** of their discourse. While shame, rage, and the psychic toll of vigilant secrecy characterize these girls' posts, it is clear that the forum provides a **measure of female control against surveillance and objectification,** and **some reprieve from the isolation** of illness, parental control, and medicalized narrations of their lives. The

community embraced here does not predate the advent of such message boards, as the geographically dispersed members are completely reliant on their anonymity as a condition of their participation. Although there is scattered discussion in the forum of making themselves known to one another covertly (anas are encouraged to wear red-beaded bracelets), face-to-face contact is not generally sought and true identities are not revealed. Instead, the "real time" of instant messaging supplants "direct contact," "online status" denotes "presence," and the stats listed in electronic signatures (height, high weight, current weight, low weight, goal weight, etc.) stand in for the body.

*

Often we are in meetings with other art writers/critics/curators. We always have different backgrounds, styles, areas of expertise, and so on but share passions, fascinations, and investments in the visual arts. Beyond critique and difference among professional adults, there is frequently at these meetings a palpable atmosphere of competition and suspicion. We don't blame anyone for the origin of this energy—**given the mode of capitalism under which we live, attempts to "relate" on the basis of shared specialization, status, or identity tend to veil competition rather than pool energy toward mutual benefit or common cause.** But what if we used our overlapping fascinations as the starting point of our critiques? Fandom organizes our bewitchments, curiosities, pleasures, and could replace the petty thrills of competition and programmatic dismissal. It binds you to other people with similar turn-ons while accommodating individual difference (think of *Star Trek* fans) and it forces conclusions or identifications (e.g., "I like this; this is important to me; this creates understanding in my life; I am part of this"). Fandom can focus and initiate critical, personalized, **rebellious consumption (participation),** as it does in some contemporary art and curatorial practices. A serious Joy Division fan as a young teen, curator/artist/writer Matthew Higgs describes his encounters with that band as the formative cultural experience that defined his relationship to art as one of "enthusiast" (not "critic"). This identification contains a quiet but important message, extending an invitation to participate in his engagement of contemporary art. Admittedly, this reading edits out the ways being a fan sometimes relies on the commodification of youthful idealization and the objectification of artists and performers. But I am more interested in how this change in emphasis could divert **totally boring anti-**peer feelings.

*

We're fans; we like how the music sounds (severe, catchy robot grooves and abstract keyboard ballads), and loved it when she wrote the phrase "jealousy as **totally boring anti-**woman feeling." **The progeny of dreaming,** music-video DNA, post-Riot Grrrl and queer-punk aesthetics, Tracy and the Plastics are drawn from a fascination (shared by the artist and these authors) for music as a socializing, emancipating force for women. This cyborg ensemble is three people (Tracy, Nikki, and Cola) played by one person (Wynne Greenwood). Tracy, "the real one," sings and interacts with her video avatars, who are nominally denoted as separate entities by a change in wig or outfit or an abrupt cut to a new cardboard tableau. Here video self-portraiture doesn't come off as narcissistic, but as a **measure of female control against surveillance and objectification,** swimming upstream against the encroaching layer of moving-

image advertisements and promotional spectacle projected on any available surface of performance venues, and public space in general. Bad acting, dead air, and a disregard for filmic continuity in the between-song "skits" bracket Greenwood's project as conceptual, providing a self-reflexive foil to the expressionistic/poetic internal content of the songs. Strangely paced dialogue introduces or interrupts the songs to explore strained band dynamics, the politics of collaboration (with various parts of oneself as well as hypothetical others), and aesthetics of feminist comedy. Because much of the performance is predetermined (due to the prerecorded video elements and musical backing tracks), a Tracy and the Plastics show constitutes itself as "live" differently from traditional rockist fare. In the essay "CAN YOU PAUSE THAT FOR A SECOND…and let yourself groove" Greenwood writes: "I often doubt my relationship to my audience so when I pause my video during a performance I say 'what's up?'" Direct contact, a woman stepping out of a TV, is accomplished with the lo-fi effect of pressing pause. Here is a punk (or whatever) critique, a call for **rebellious consumption (participation)** dramatizing the notion of feedback and encouraging the audience to come to their own conclusions. A love of spoken inquiries as they interrupt music videos forwards the proposition that public space and bodies together are what is momentous and "live," different from listening to the CD at home.[2]

*

The strength of associative structures is revealed in moments when explanation seems impossible and rationalization would be sick. The two silver gift bags for wine (bottle of red, bottle of white) set atop the piano in performance artist Karen Finley's lounge act "Make Love" illustrate her telling of a post–September 11 dinner-party crisis. Finley, in Liza Minnelli drag, standing with a dozen or so other Liza impersonators, reenacts her panic at the realization that her gifts for the hostess appear on the table as silver columns—in her mind, a perversely inappropriate visual reference to the twin towers of the World Trade Center. Throughout the performance, personal anecdotes are distilled and stretched to resemble parables, dreams, and political analyses; "Dick Cheney has a sick, sick heart" is the epiphanal non sequitur that stayed with me for days. **The post-traumatic momentum** of seemingly uncontrolled associations drives her **exhortations**. Kind of like the way "the news" transported us here (the U.S. occupation of Iraq) from there (9/11), that is, along a path of rhetorically linked tragedies and acts, or like how images from a nightmare are sequenced into a story upon waking. The associative structure of "Make Love" functions as a formal critique, "personal" hysteria mirroring national chaos and state violence. "Personal" stays in quotation marks not only because speech is distributed through Finley's construction of the diffracted Lizas, but because despite (or via) **the overplayed style of "the individual,"** her performance speaks of a public culture of mourning and dissent, and the connections made visible by shared trauma.[3]

*

The gender-related processes brought to bear on and meant to alter bodies, as published at Ruby's Gloomy Place, have out-of-the-closet correlatives everywhere, from shaving to body-building to birth control. They come off the page and canvas and are pressed into intense embodied results by the salient increase in top surgery for female-assigned individuals, including (the some-

times overlapping categories and communities of) lesbians, transmen, gender variants, and variously identifying binary gender-disrupters. Top surgery, generally a double mastectomy and the construction of a male-looking chest, moves its recipients toward any number of goals (Dean Spade notes that these can include "access to different sexual practices, the ability to look different in clothing, the enhancement of a self-understanding that is not entirely reliant on public recognition, and the public disruption of male and female codes"). No longer exclusively conceived of as part of a "sex change" procedure, which may **inhibit experimentation and autonomy**, top surgery is initiated in response to a range of cultural identifications and body images. These operations, though they originate in deeply personal, individual contexts, engage scientific discourse and queer politics, and allude to—in their efforts to transform, regender, align, and decolonize bodies—a new understanding of the body as a form of public space with the capacity to refute the authorial/authoritarian claims of assigned gender. In fact, the suspension or pause of sharp differentiations between genders and sexualities as evidenced by these evolving practices may eventually foreclose the meaningfulness of concepts such as "real maleness" and "real femaleness." The literal and figurative surgical method disembowels reified gender categories, opening them up into fractal possibilities that are **the progeny of dreaming**, modern medicine, and individual preference. Indeed, processes and strategies that resist institutionalization or reification are echoed by Tracy and the Plastics' refrain to pause the video and "groove," and may offer **some reprieve from the isolation** of capitalist control, and medicalized/medialized narratives of life.[4]

*

The copyleft operating system GNU (the mortal enemy of Unix proprietary operating systems for computers) and the Free Software Foundation (the mortal enemy of Microsoft) are major forces in the free software movement that has been active since the mid-1980s developing and protecting bodies of software that are free, open to modification and distribution. Software of this ilk is often identified with the rubric "open source," and free-software participants tend to organize around libraries of code or particular projects. Working toward a general goal and operating as collaborators, programmers make revisions and modifications to modules of code that are then implemented and tested. Quality, innovation, and diversity of products are prized, along with—especially for Richard Stallman, the founder of the Free Software Foundation—positive social relations among programmers. **The tactical benefits of decentralized** programming are clear: not quite a community-authored project but something akin to it, Linux, a very popular GNU-compatible operating system, has proven that the economic and authorship paradigms of free software are "good enough for the free market." Proprietary software—for example Adobe Photoshop, Microsoft Word, and Excel—is at odds with the ethics of open systems generally. It is closed to modification and expensive to purchase. In German critic Dieter Daniels's reading, open source is "bottom up," while proprietary wares are "a 'top-down' structure as represented by the precise notation of a classical composition as well as the proprietary software developed by Bill Gates's Microsoft Corporation, for which the secrecy of the source code is the basis of a capitalist monopoly." Beyond the ideology and cost of buying commercial software are additional concerns: that with its limited sets of commands and functions designed for use across a wide

scale, commercial software **inhibits experimentation and autonomy**. New and artist-made software, whether originating in aesthetic contexts or Free Software initiatives, engages varied discourses and politics, and alludes to—in its efforts to transform and decolonize computing—a new understanding of programming as a form of public culture with the capacity to refute the (ahistorical) intellectual property claims of big business.[5]

*

A medium for both **the overplayed style of "the individual"** and the interactive **development of collective political expressions**, the Internet shapes new cultural practices in its image. John Walker Lindh's Usenet posts (retrieved by a search for his most often used handle, *doodoo@hooked.net*) track his use of online discussion groups as a kind of identity lab—a privileged white suburban teenager masquerades as an anonymous black MC, submitting an epic rap about music-industry "toms" and militant critiques of suspected white poseurs posting in the forums. Subsequent communiqués document his transformation from authoritarian rap fan to "American Taliban" as he unloads his extensive CD collection through online transactions and submits detailed queries concerning Islamic orthodoxy. Although an extreme example, and one that "made history," Lindh underscores the most disquieting aspects of online speech: unaccountable participation, destabilizing charades, and illusory community. Naomi Klein, discussing the strategies and culture of the 1999 World Trade Organization protests in Seattle and D.C., notes, "Once involved, no one has to give up their individuality to the larger structure; as with all things online, we are free to dip in and out, take what we want and delete what we don't. It is **a surfer's approach** to activism, reflecting the Internet's **paradoxical culture of extreme narcissism coupled with an intense desire** for external connection." Inexact representations and generalized statements are not tolerated where **nuanced articulations, refined agendas, and exhortations** can be accommodated (as linked web-pages, casual associations) rather than subsumed by the broad language of a common cause. While critiques of emerging struggles (particularly against global corporatism and the U.S. war on Iraq) have centered on their lack of clear structure or unified program, **the tactical benefits of decentralized** micro-movements are clear: they are difficult to contain, and they have the ability to reach and mobilize unprecedented numbers of people. But these unprecedented numbers coalesce ephemerally, with diffuse analyses and varied demands, and without a coherent and publicly recognizable counterculture.[6]

*

Despite techniques common to online entities, such as shared addresses, dashes of humor and sociability, F2F (face-to-face) meetings, and collaborative publications, Nettime (*www.nettime.org*) refuses to be understood as or labeled a "community." From its earliest days as a mailing list, varied definitions have been spawned by its mostly male, white, geographically dispersed, net-savvy participants—"wild east-west saloon," "soapbox," "open mic night"—but none have been employed with any consensus. Since 1995, important essays on net politics and culture, interviews, official and indie international journalism have been posted to this email list, fueled by the unfurling of dot-com capitalism, the stresses associated with the bombing of Kosovo, and the spread of open software and piracy movements. Here,

debate is characterized by **a surfer's approach** to civility, reflecting the Internet's **paradoxical culture of extreme narcissism coupled with an intense desire** for audience and exchange: virulent male hysteria was unleashed on the list in September 2003, when the phrase "the Nettime community" appeared in an invitation to participate in an online forum hosted by a small New York arts venue. Legitimate interests in and self-theorizing arguments for resisting institutionalization and misrepresentation of participants' discursive engagement with one another were cited as reasons enough to email-attack she who invited them colloquially as a "community." A suspicious fetishization of "networked culture" as a potential last bastion of nonhierarchical, decentered, and autonomous interchange seemed to be a motivation as well. Nonetheless, the inclusion of Nettime here is not to relativize and dissolve the characteristics that often describe communities, but to underscore how Internet paradigms prevail in, and problematize, contemporary forms of organization: Indeed, today's Nettimers reject the name "community" but invest in a structure of **nuanced articulations, refined agendas, and exhortations**; they are prepared to talk back and share often-opposing purposes.

JOHANNA FATEMAN is a writer and musician living in New York. She is in the feminist electronic punk band Le Tigre.

RACHEL GREENE is the executive director of Rhizome.org and a curatorial fellow at the New Museum of Contemporary Art in New York. Greene's book *Internet Art* is forthcoming from Thames & Hudson in spring 2004.

1 Samuel R. Delany, *Times Square Red, Times Square Blue* (New York: New York University Press, 1999).

2 Wynne Greenwood, "CAN YOU PAUSE THAT FOR A SECOND...and let yourself groove," *LTTR #2: listen-translatetranslaterecord*, 2003.

3 Karen Finley's "Make Love" was performed at the Fez, New York, July 10–November 16, 2003.

4 Dean Spade, "Mutilating Gender," *www.makezine.org/mutilate.html*, spring 2000.

5 Dieter Daniels, "Strategies of Interactivity," *www.mediaartnet.org/Starte.html*, trans. Tom Morrison.

6 Naomi Klein, "The Vision Thing: Were the DC and Seattle Protests Unfocused, or Are Critics Missing the Point?" in Benjamin Shepard and Ronald Hayduk, eds., *From ACT UP to the WTO: Urban Protest and Community Building in the Era of Globalization* (New York: Verso, 2002), p. 269.

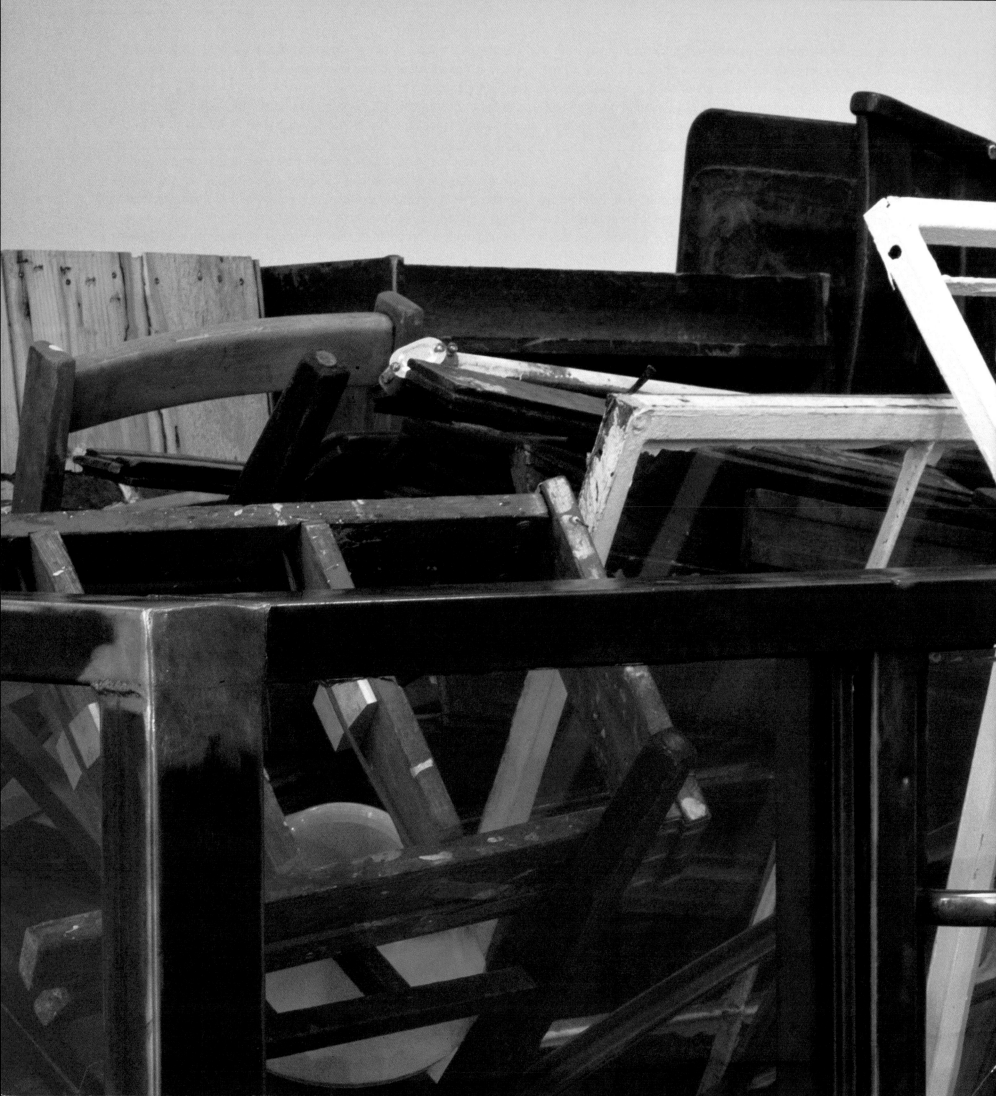

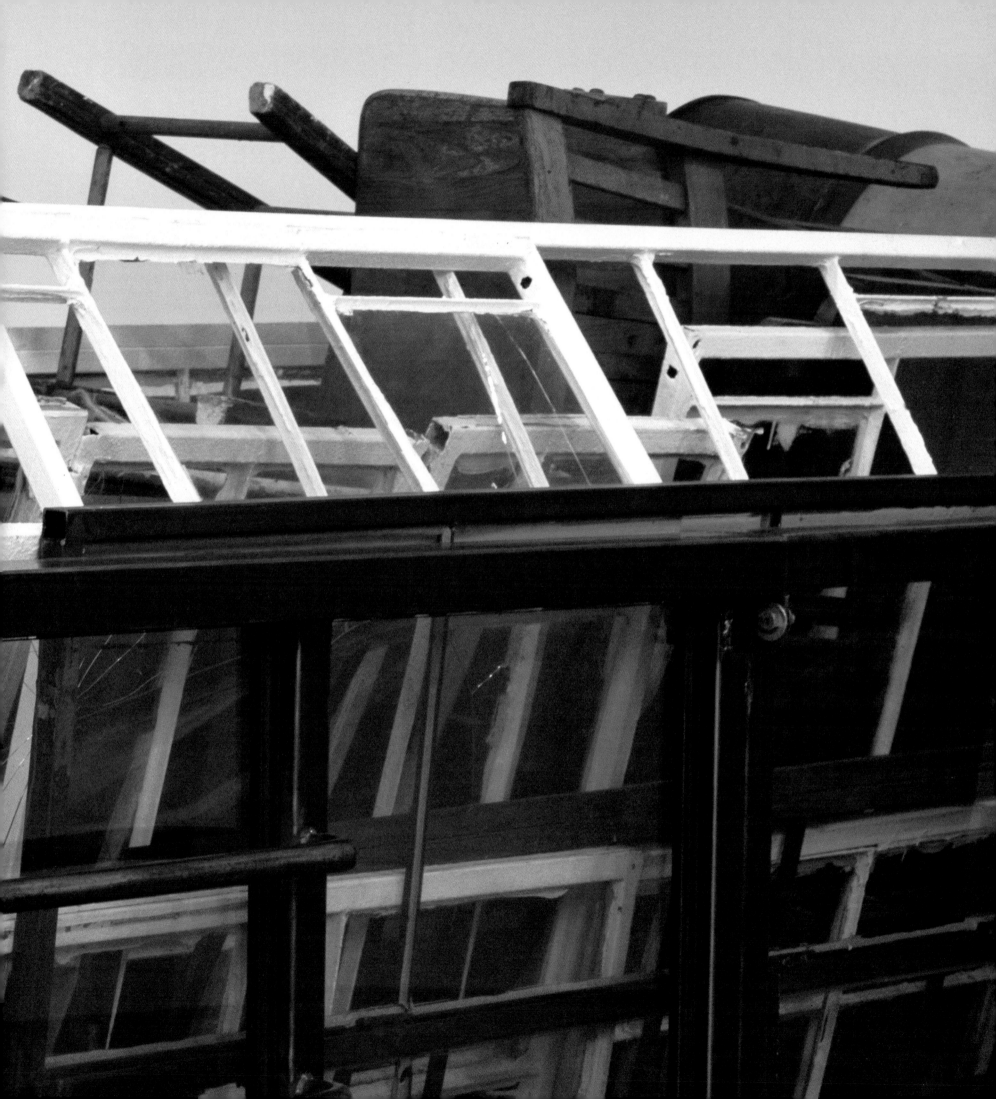

THE *L* ON YOUR FOREHEAD
Scott A. Sandage

Harpo Marx got up a game called "Pinchie Winchie" on Black Thursday, during the 1929 stock market crash. Harpo was on tour in *Animal Crackers*, which was playing Pittsburgh, when a telegram arrived from his broker: "SEND $10,000 IN 24 HOURS OR FACE FINANCIAL RUIN." Zeppo took his older brother out to commiserate after the show. At a riverboat casino on the Ohio River, they cajoled a card table of mobsters into a variation on Simon Says.

"The rules were simple," the usually silent Marx Brother told them. Harpo pinched the dealer's face ("like on the nose or the cheek or the ear") and the dealer pinched his neighbor, and so forth—as fast as the circle could go. With each round, a different spot on the face. Wrong move and you were out. What was the gag? Harpo held a crumb of burnt cork, like blackface minstrels used back in the day. Everybody could see it but the dealer. "Every time I gave him a Pinchie Winchie he got a new black smear on his kisser." [1]

The casino owner laughed so hard he lent Harpo ten grand to cover his margin calls. Making art from anarchy, Harpo always made it pay—like Duchamp with a sleevefull of stolen silverware.

Consider this great moment in American cultural history. It's got high finance and low comedy, risk and recovery, group play and individual penalty, order and chaos, rules and trickery, hoodlums and naïfs, speed and spread, flesh tones and decibel zones, headgames and handjobs. Nobody quite knows who's winning, but everybody knows who's losing.

Failure in America, being a loser in the winners' circle, has worked this way for the past 150 years or so, since the growth of capitalism linked identity to achievement (rather than birth status). You are expected to play (and play to win), but are you really sure you know what the game is? Before you know it, you bear the mark of loserdom. [2]

Loser. A watchword of our times, in American life it has come to describe bad identities even more than bad outcomes. "I'm a loser, Baby, so why don't you kill me?" Alternative musician Beck drilled that refrain into enough brains to go platinum in 1995, reaffirming Bob Dylan's 1965 axiom "There's no success like failure." [3]

Yet the sense of failure as a defective identity, a negation of individual value, persists even as our newest *L*-word is being reclaimed in ways akin to terms like *nigger* and *queer*. Like those names, *loser* is an epithet recently turned into a cry of reflexive pride. [4]

MONA WITH MUSTACHE

A new black smear on the kisser. What does it mean? On Ash Wednesday, maybe forgiveness; on Black Thursday, possibly damnation. A lot rides on whose smear, a cleric's or a comic's? And whose kisser, amazing grace or poker face? Bodies register a continuum of sacred and secular markings, applied freely and forcibly, by self and other.

Marks of status and shame have altered the human body throughout history, often employing the same media to opposite effect. From the Olduvai Gorge to the Golan Heights, Suzhou to Cuzco, Natchez to Nantucket, Siberia to Treblinka—

tattooing, piercing, scarification, and branding (not to mention the old tar and feathers) have designated friend or foe, intimate or stranger, blessed or cursed, free or unfree—and success or failure.[5]

More than skin deep, such categories of identity can be written on the body as well as the psyche. Contemporary body art (as art and lifestyle) belongs to those diverse traditions of making cultures by making meanings. But it also blurs, sometimes, from meanings to values (in the hierarchical sense)—from imagination to evaluation.[6]

Harpo marks, as it were, embarrassed the casino dealer but did not evaluate him in any fundamental way. Labels explicitly establish particular hierarchies of value. Yes, every mark may become a symbol and every symbol has a range of meanings, and all meanings calibrate value. But there is a difference between marking a body and labeling it.

Compare the mark of Cain and the Scarlet Letter. One signified divine banishment, unmistakable wherever Cain wandered (and unmitigated by increments like first- or second-degree murder). The other was a badge of social stigma that devalued an abiding member of the community. Cain was deported, but Hester was degraded. Rather than expel her, the community labeled her.

OF BONESMEN AND BRANDNAMES

Every culture and epoch has its scarlet letters, body modifications that elevate or subordinate individuals within communities. Ancient Romans tattooed slaves. Ancient Egyptians tattooed nobility. The Nazis tattooed their victims. Neo-Nazis tattoo each other.

The medium is *not* the message in body modification. Yale's secret Skull and Bones Society allegedly uses a branding iron to induct elite "bonesmen" like William F. Buckley Jr. Whether that be rumor or reality, surely it lurked somewhere in Buckley's skull (or bones) in 1986. That year, he wrote a *New York Times* column proposing (but not volunteering) to tattoo the buttocks of men infected with the AIDS virus. Strange, how similar techniques and rituals can mark someone for death or distinction, but such practices have a long American history.[7]

Lacking Buckley's eye for a great ass, plantation overseers before the Civil War branded the faces of the people they enslaved. In 1845, a Florida jury sentenced a Yankee, convicted of helping slaves escape, to be branded in the courtroom by a U.S. Marshal (*SS* for "slave stealer").[8]

Until 1872, the U.S. Army branded or tattooed court-martialed enlisted men, usually on the hip (where induction doctors would be sure to see it if a man tried to reenlist) but often on the hand or face. *D* stood for drunkard and also for deserter; to distinguish, the former went on the right side, the latter on the left. Some deserters were marked *US*, as if to reclaim government property. Heads shaved and literally drummed out of the service, they were ritually escorted out of camp (usually to prison) to a fife tune called "The Rogue's March." Hence, other miscreants (thieves, usually) were marked *R* for rogue or, if nothing else applied, *W* for worthless. Such punishments, like the Nazi's tattoo and the slaver's brand, used blunt categories to classify people and fix their value.[9]

PANIC BUTTONS

You don't need Marx (Karl or Harpo) to tell you that numbers, letters, and labels are the sorting tools of capitalism (and its general manager, bureaucracy). Over the past

two centuries or so, capitalist societies have increased productivity and efficiency by organizing human and material resources and negotiating their values. Although the stigmata of failure may appear in financial, social, professional, domestic, recreational, penal, racial, sexual, and other forms, fundamentally it's always about the money.

What made Harpo blue on Black Thursday first happened more than a century before, in the so-called Panic of 1819. Way out on the frontier (in Ohio, say) citizens found it bewildering that failed banks in New York City could wreck their homespun dreams. But national economic cycles came with the national markets that marked the growth of capitalism. Suddenly, many people found they had lost a game they didn't even know they were playing.

Hard times inspired an early political cartoonist to draw Uncle Sam's predecessor, a yokel called Brother Jonathan, as the bankrupt victim of wicked brokers and financiers who "laugh in their sleeves at the loosers forlorn." A "looser" (American spelling has always been capricious) was a business term. Literally, it meant the one who got the short end of a financial deal.[10]

Monikers like *failure* and *loser* did not enter common speech (as social labels or categories of identity) until the mid-nineteenth century. But even as the realities of economic cycles became apparent, financial failure implied *moral* transgressions. Take Harpo. On the one hand, his troubles followed an unprecedented national collapse. On the other, he had played the stock market as brazenly as his riverboat pals gambled at the poker table. The innocent act he did in the movies couldn't save him in the market. All failure is *moral* failure in a culture that lives and dies by the creed of individualism. Rationalize about bad luck or unforeseeable macroeconomic trends all you want, but the loser always gets the blame.

Laughing at losers has remained a popular national pastime, even when public opinion caught on that the game was fixed. What else can you do? You pay your money and take your choice, own up to your mistakes, improve your score, play along. Get pinched and pinch the next guy. So why is everybody suddenly laughing at you?

WHO'S SORRY NOW?

Ignore them and they'll stop. Well, ignore them anyway. *We* know that losing builds character, teaches perseverance. Failure is a learning experience, part of life, nothing to be ashamed of. It's not whether you win or lose but how you play the—yikes! how did *that* get on your face?

The L on your forehead.

Welcome to Loserville. Microsoft Corporation got here first—of course—with a 1996 *Rolling Stone* advertisement for its SideWinder Game Pad. Full-page close-up of your best friend's sad face, with his hipster goatee, the competitor you just smoked. Your left hand holds him by the chin, while your right scrawls block letters across his forehead: *LOSER.*[11]

How *kewl*, just to come right out and say it, the subliminal message of so much advertising: buy this or be a freakin' loser, dude. Words on foreheads are ubiquitous now, like in those cell-phone ads. A variation in a pitch for a correspondence school pictures seven apparently uneducated and thus unemployed guys wearing sandwich signs that spell out "F-A-I-L-U-R-E." Get a job, you losers![12]

But this last advertisement saw print in 1911. Microsoft's design team certainly never saw it—which is the point. The mark of loserdom is a great American trope, visualizing and verbalizing one of our most democratic epithets. Two hundred years

ago, only adult, white, male businessmen could wear this tag. Today, anyone can be a loser, labeled like hazardous waste, supposedly without regard to occupation, income, gender, race, or age. Shut out of the best preschool, even toddlers are ruined.

I'm a baby loser, so why don't you kill me?

To say that such inanities both ignore real inequalities and obscure real emergencies would be an obscenity.

"Two Suspected Gunmen Were Seen as Losers by Other Students," read a *New York Times* headline in April 1999. A Columbine High School student explained that Dylan and Eric wore creepy black trenchcoats. "This is a pretty preppie, conservative school. Kids wear Abercrombie, Tommy Hilfiger, American Eagle." One victim was buried in a white coffin, which mourners signed with black Sharpie pens, like a yearbook. Labels, anyone? Leave aside the fashion police and the popularity contests and consider this: how can a fifteen-year-old kid be a loser? Fifty, maybe—but fifteen?[13]

I'm a baby loser, so why don't I kill you?

So much for teaching the children that it's OK to fail. In 2003, when a high-scoring professional basketball player was charged with rape, his mug shot on the cover of *Sports Illustrated* prompted this letter: "Try explaining to an eight-year-old that [he] is on the cover because he is a loser, not a winner." Murderers, rapists, losers—what's the difference?[14]

I'M NOT OK, YOU'RE NOT OK

The wave of school shootings and the larger phenomenon of sociopathic losers (think postal) gave new meaning to an 1890 inspirational sentiment you can find all over the Internet, "Not failure, but low aim, is crime." We cling to century-old clichés, even as the new millennium confuses the American creed of success and failure.[15]

That loser Al Gore (such a stiff) won the popular vote. Those visionary dot-com risk-takers lost their shirts (and ours). To say nothing of Iraq, Israel, Enron, death row, the drug war, the twelfth grade, the ozone, or Ground Zero. Who can tell winner from loser anymore?

What is the crime of failure in modern America? You need not "lose" anything (like an election or a million) to commit it. "Without a positive attitude," says an Internet entrepreneurship newsletter, "you might just as well be asking your customers and your competitors to tattoo 'Loser' on your forehead!" Just slacking (whether from despair, disillusionment, or dissent) is seen as a capital offense against our laws of compulsory ambition and optimism.[16]

Which is why it has become cool, on some level, to style yourself a loser. Not to *be* a loser, exactly, but to be deemed one by types you would never want to be like or would never want to accept you. The "Losers for Life Club" is an online photo album of youth with inyerface tats—on *their* faces, necks, and hands. They "have chosen to say 'fuck the limits' and cross the imaginary line between being a tattooed person and a loser for life." Xtreme body modification disqualifies you from working at Starbucks, for example, much less from climbing corporate ladders.[17]

More often, however, aesthetic loserdom amounts to little more than *slacker chic*, not genuine challenges to or withdrawals from the rat race. Look at all those trendy office boys and girls at the gym in their muscle tees, with their cute ear cuffs and Celtic banded biceps. Who's hipper than pirates, jailbirds, Sharks, Jets, bikers, and the other marginal types who wear the tats and piercings of popular imagination?[18]

In reality, so many have lost so much, it makes sense that the loser has emerged as a rebel and loserdom as a refuge. Perhaps recent events have shocked none so much as

Americans just coming of age, the coveted "18-to-24 market." The luckiest of them were raised on mostly false expectations of prosperity and security, to mantras like "every child is a winner." Now, suddenly, it's losers, losers everywhere, and what if I'm one of them?

Pinchie Winchie!

That Harpo, such a modernist—always carving up body and soul with his facial contortions and crazy music. And what a loser: usually homeless and unemployed, bullied by the police or the hoi polloi, always a fashion reject and a social outcast, lost in his own fantasy world. Yet Harpo's modernism was legit, if you think about it.

Like Picasso or Arnold Schoenberg—who liked to play ping-pong with Harpo in George Gershwin's basement—his art ignored cultural hierarchies (boogie woogie as a harp solo?) and defied time and space. In *Animal Crackers*, he picked pockets so deftly that his mark's birthmark ended up on Harpo's elbow. In *Duck Soup*, he answered questions by pointing to various tattoos. Asked where he lived, he bared his chest to show a doghouse. When Groucho looked too closely, a *real* dog jumped out from the tat. Is it any wonder that Salvador Dalí painted Harpo and wrote a film scenario around him? Who else could call a panhandler's bluff, when asked to spare some change, by pulling a steaming coffee cup and saucer from his trenchcoat?[19]

Which is why you can't get up a game of Pinchie Winchie at Starbucks. Now everybody is *post*modern—preconditioned to pinch ourselves—yet we're still not in on the joke. Modernism showed us how social and technological change had fragmented the old grip on reality, turning hierarchies into nonsense and opening the possibility of changing how we lived. Postmodernism showed us how we internalized the hierarchies, becoming our own despots and executioners. YOUR BODY IS A BATTLEGROUND, Barbara Kruger reminds us. We need reminding because it is so often ourselves leading the attack.[20]

In postmodern pariahdom, tatfreaks, piercingfreaks, ravers, skaterz , tribals, stoners, emo kids, punks, Goths, metalheads, masochists, and mid-level managers all agree: loser is *the word*. The oracle at Google reveals 1.6 million hits for *loser* and thousands of pics (née pix) of somebody "looking kinda dumb with her finger and her thumb in the shape of an 'L' on her forehead." That lyric by Smash Mouth, frat-rockers whose pan flashed as the twentieth century burned itself out, described the twenty-first's universal hand signal—in favor with employed, unemployed, and unemployable losers alike.[21]

The *L* sign. Party supply stores now sell life-size hand cutouts of it mounted on Popsicle sticks. Hold it up to your forehead. How postmodern is that? A body part as Pop art, a symbol with no context but itself, fun with flagellation. The seventies had the finger: fuck you. We have the L: fuck me.

WIN SOME, LOSE SOME

Are you first-rate or third-rate? Grade A or Brand X? If these seem like mere metaphors, think about the equation used to calculate dollar values for each life lost in the 9/11 attacks. Sure, that terrible day made them all heroes, but apparently we must never forget their relative successes and failures.[22]

It's as if it would be un-American to consider every life equally valuable. If we didn't sort the bodies into piles of winners and losers, the terrorists would have won. If freedom really is just another word for nothing left to lose, as Janis Joplin sang, we must be on the verge of a great liberation.[23]

Four or five years ago, I grabbed one of those free advertising postcards you find in the vestibules of Manhattan bars and cafes. This one was for an employment

website called hotjobs.com and struck me as an unusual variant of the "don't be a loser" advertising pitch. Except for the slogan at the bottom, it looked like a Warhol portrait in red, yellow, and blue—of the World Trade Center. WELCOME TO THE PLAYGROUND OF THE FEARLESS, it said.

I looked around and thought, "Somebody pinch me."

Scott A. Sandage is a cultural historian and the author of *Born Losers: A History of Failure in America*, to be published in fall 2004 by Harvard University Press. His work as historical advisor has included documentary films, public radio, and projects for the Smithsonian Institution, the National Park Service, and the Andy Warhol Museum. He is an associate professor at Carnegie Mellon University, Pittsburgh, Pennsylvania.

1 Harpo Marx with Rowland Barber, *Harpo Speaks!* (New York: Limelight, 1985 [1961]), pp. 277–81.

2 Scott A. Sandage, *Born Losers: A History of Failure in America* (Cambridge, Mass.: Harvard University Press, forthcoming 2004.)

3 Beck [Hansen], "Loser," *Mellow Gold*, Uni/Dgc Records, 1994; certified platinum in August 1995. Bob Dylan, "Love Minus Zero/No Limit," *Bringing It All Back Home*, Columbia Records, 1965.

4 Randall Kennedy, *Nigger: The Strange History of a Troublesome Word* (New York: Vintage, 2003). Nikki Sullivan, *A Critical Introduction to Queer Theory* (New York: New York University Press, 2003).

5 Jane Caplan, ed., *Written on the Body: The Tattoo in European and American History* (Princeton, N.J.: Princeton University Press, 2000).

6 Maureen Mercury, *Pagan Fleshworks: The Alchemy of Body Modification* (Rochester, Vt.: Park Street Press, 2000).

7 Max Garrone, "What Do Bush, Branding and Secret Societies Have in Common?" *Salon*, February 22, 2000. William F. Buckley Jr., "Crucial Steps in Combating the AIDS Epidemic: Identify All the Carriers," *New York Times*, 18 March 1986, p. A27.

8 "Wilson Chinn, a Branded Slave from Louisiana" (New York: Kimball & Co., 1863), Prints and Photographs Division [Neg. LC-USZ62-90345], Library of Congress. Alvin F. Oinckle, *Jonathan Walker: The Man with the Branded Hand* (Everett, Mass.: Lorelli Slater Publisher, 1998).

9 William C. DeHart, *Observations on Military Law and the Constitution and Practice of Courts Martial* (New York: Wiley and Halsted, 1859), pp. 196–97. U.S. Statutes at Large, 42d Cong., 2d. sess., Ch. 316, Sec. 2, p. 261. On "R" and "W," see Sandage, *Born Losers*.

10 Winfred Morgan, *An American Icon: Brother Jonathan and American Identity* (Newark: University of Delaware Press, 1988), pp. 69–70, 171.

11 *Rolling Stone* 750/751 (26 December 1996).

12 International Correspondence School (1911), in folder 1, box 76, A.W. Ayer Collection, Archives Center, National Museum of American History, Smithsonian Institution.

13 Dirk Johnson and James Brooke, "Terror in Littleton: The Suspects," and "Two Suspected Gunmen Were Seen as Losers by Other Students," *New York Times*, 22 April 1999, pp. A1, A22. Pool photo by Rick T. Wilking/Reuters, *New York Times*, 25 April 1999, p. A1.

14 *Sports Illustrated* 99 (18 August 2003): 12.

15 James Russell Lowell, "For an Autograph," *The Writings of James Russell Lowell* (Boston and New York: Houghton, Mifflin, 1890), vol. 9, p. 175.

16 "Balloons @ Work™" website, *www.balloonhq.com/column/ballatwork/jan01/*.

17 Margo DeMello, *Bodies of Inscription: A Cultural History of the Modern Tattoo Community* (Durham, N.C.: Duke University Press, 2000). "Losers for Life Club" website, *spc.bodymodification.com/fun/lflclub/*. Chris Gimbl, Starbucks spokesperson, quoted in Mary Jo Feldstein, "Piercing, tattoos taboo in workplace," Reuters News Service (Chicago), 25 June 2001, *www.freerepublic.com/forum/a3b3678a10177.htm*.

18 Samuel M. Steward, *Bad Boys and Tough Tattoos: A Social History of the Tattoo with Gangs, Sailors, and Street-Corner Punks, 1950–1965* (New York: Haworth Press 1990).

19 *Harpo Speaks!*, pp. 377–79. *Duck Soup*, DVD, directed by Leo McCarey (1933; Chatsworth, CA: Universal/Image Entertainment, 1997). S. J. Perelman and Bert Kalmar, *The Four Marx Brothers in Monkey Business and Duck Soup* (New York: Simon and Schuster, 1973).

20 Barbara Kruger, "Your body is a battleground" (1989), in Walter B. Kalaidjian, *American Culture Between the Wars: Revisionary Modernism and Postmodern Critique* (New York: Columbia University Press, 1993), fig. 5.2, p. 213.

21 "All Star," music and lyrics by Greg Camp, on Smash Mouth, *Astro Lounge*, Interscope Records, 1999.

22 Joan Ryan, "Rich Dead, Poor Dead," *San Francisco Chronicle*, 27 January 2002, p. D1. Michael I. Meyerson, "Losses of Equal Value," *New York Times*, 24 March 2002, sec. 4, p. 15.

23 "Me and Bobby McGee," words and music by Kris Kristofferson, on Janis Joplin, *Pearl*, Columbia Records, 1971.

Table of the Progress of Social Movement, from *The Theory of the Four Movements*

CHARLES FOURIER

The French social philosopher Charles Fourier (1772–1837) rejected traditional institutions, from the nuclear family and religion to industry and commerce, in the belief that they propagated the repression of man's natural, passionate instincts. Citing Isaac Newton throughout his writing, he identified himself primarily as an inventor—the discoverer of a natural plan whereby society could attain utopia. Fourier's radical theory of passionate attraction advocated not that the passions be repressed, but rather that society be cultivated and organized around them. His theory rejected the ideals of the bourgeoisie and the Enlightenment, which valued reason and the individual above social harmony.

In his first work, *The Theory of the Four Movements* (1806), he diagrammed his imaginative theory of social movement: thirty-two periods in four primary phases, unfolding over 80,000 years, leading in a natural progression toward utopia. He argued that we are currently in the initial phase of development, more than 35,000 years away from the Apogee of Happiness. His elaborate, fantastical social system was structured around social units called Phalansteries, communities of approximately 1,620 people organized according to the twelve passions of man.

Fourier went on to publish other works that expanded on the ideas he set forth in *The Theory of the Four Movements*. In his manuscript *Le nouveau monde amoureux* (not printed until 1967) he proclaimed that open sexual relations are fundamental to a harmonious social system. Thought to be impractical, even nonsensical, at the time, Fourier's theories were discounted by many of his contemporaries, although they did become the basis for small utopian communities that evolved in Paris and the United States in the 1840s. Later his ideas would influence socialist and communist thinkers such as Engels and Marx, who echoed his criticism of bourgeois society and his recognition of man as part of a social unit. His identification of the social repression of sexual drives has also been seen as a precursor to the work of Sigmund Freud. Interest in Fourier's ideas resurfaced in France in the 1940s, when André Breton claimed him as an ancestor of the Surrealist movement, and in the late 1960s and early 1970s, when his works were translated into English and published in the United States. **AD**

ASCENDING CHAOS

TABLE
OF THE PROGRESS OF SOCIAL MOVEMENT

SUCCESSION and RELATIONS of its 4 PHASES and 32 PERIODS

Order of the Future Creations

(This table can only be properly understood by studying the explanation of it in the following chapters)

FIRST PHASE

Seven periods

INFANCY & ASCENDING INCOHERENCE

Anterior subversive creation, already complete

		YEARS approx:
1st *CONFUSED SERIES*	Shadow of happiness	
2nd *Savagery*		
3rd *Patriarchate*		Ages of treachery, injustice, constraint, indigence, revolutions and bodily weakness
4th *Barbarism*	*Five periods of unhappiness organised in incoherent households*	
5th *Civilisation*		$\frac{1}{16}$ 5,000
6th *Guaranteeism*		
7th *PRELIMINARY SERIES*	Dawn of happiness	

Retreat

Run up

Leap from Chaos into Harmony

SECOND PHASE

GROWTH OR ASCENDING COMBINATION

ASCENDI

societies, No 9 to No 24, will each be engendered by a new creation, each of which will give new
in the 3 reigns, and modify social relations accordingly, without any alteration to the mechanism
of the progressive series.

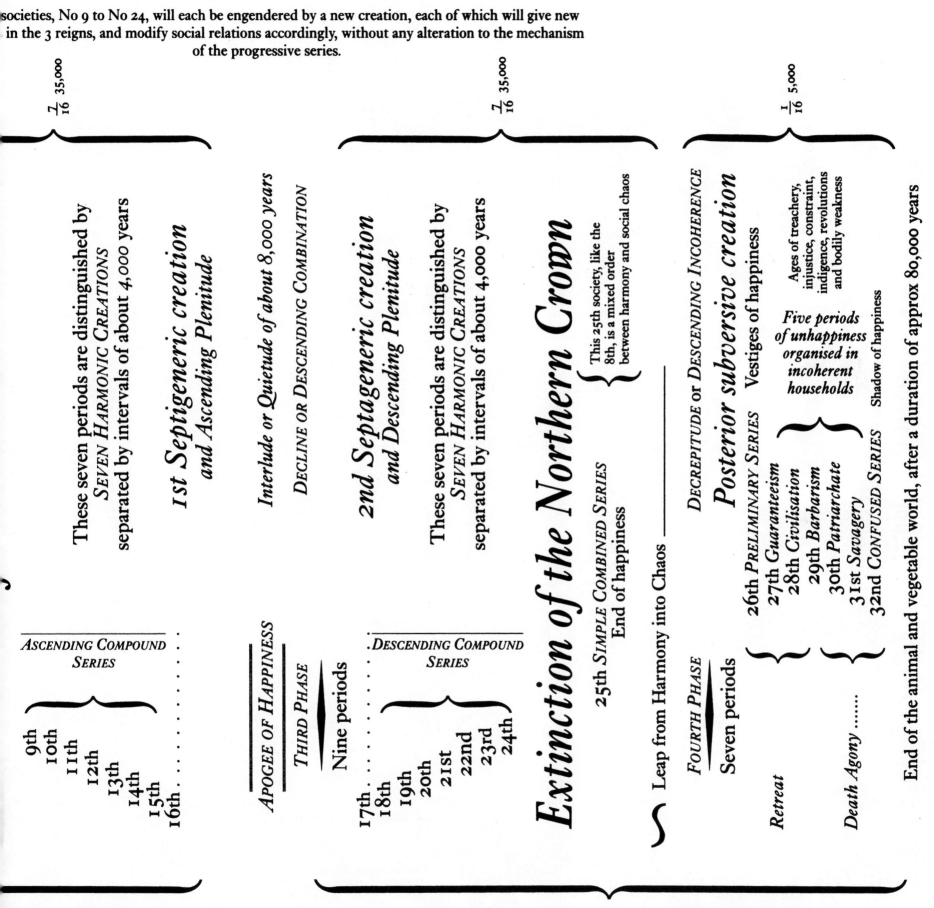

$\frac{7}{16}$ 35,000 $\frac{7}{16}$ 35,000 $\frac{1}{16}$ 5,000

These seven periods are distinguished by SEVEN HARMONIC CREATIONS separated by intervals of about 4,000 years

1st Septigeneric creation and Ascending Plenitude

Interlude or Quietude of about 8,000 years

DECLINE OR DESCENDING COMBINATION

2nd Septageneric creation and Descending Plenitude

These seven periods are distinguished by SEVEN HARMONIC CREATIONS separated by intervals of about 4,000 years

This 25th society, like the 8th, is a mixed order between harmony and social chaos

DECREPITUDE or DESCENDING INCOHERENCE

Posterior subversive creation

Vestiges of happiness

Ages of treachery, injustice, constraint, indigence, revolutions and bodily weakness

Five periods of unhappiness organised in incoherent households

Shadow of happiness

25th SIMPLE COMBINED SERIES
End of happiness

Leap from Harmony into Chaos

ASCENDING COMPOUND SERIES

APOGEE OF HAPPINESS

THIRD PHASE

Nine periods

DESCENDING COMPOUND SERIES

Extinction of the Northern Crown

26th PRELIMINARY SERIES
27th Guaranteeism
28th Civilisation
29th Barbarism
30th Patriarchate
31st Savagery
32nd CONFUSED SERIES

FOURTH PHASE

Seven periods

Retreat

Death Agony

9th
10th
11th
12th
13th
14th
15th
16th

17th
18th
19th
20th
21st
22nd
23rd
24th

End of the animal and vegetable world, after a duration of approx 80,000 years

From
The Diary of Anaïs Nin

ANAÏS NIN

I had just read Aldous Huxley's *The Doors of Perception* but it did not impress me as much as Gil Henderson's talk about the visionary effects of LSD. He had participated in an experiment with Dr. Oscar Janiger. He painted an American Indian doll before taking LSD and then again after the ingestion of the drug, and the difference between them was astonishing. The first version was rigid and photographic. The second impressionistic, emotional. Gil asked me if I wanted to participate in an experiment because Dr. Janiger was hoping a writer would be more articulate about the experience. There were to be two other subjects there, a biologist from UCLA and another painter. Gil would be my sober pilot, that is, a person who has taken LSD before and now stands by to help one and guide one if necessary.

It seemed strange to be coming to a psychiatrist's office for such an adventure. Dr. Janiger took Gil and me into his private office, which was lined with books and very dark. I had little time to form an impression of him, for he immediately dispensed a number of blue pills, five or eight, I do not remember, with a glass of water. Then he conducted us to the waiting room, where the biologist sat already with a pad on his knee, pen in hand.

At first everything appeared unchanged. But after a while, perhaps twenty minutes, I noticed first of all that the rug was no longer flat and lifeless, but had become a field of stirring and undulating hairs, much like the movement of the sea anemone or a filed of wheat in the wind. Then I noticed that doors, walls, and windows were liquefying. All rigidities disappeared. It was as if I had been plunged to the bottom of the sea, and everything had become undulating and wavering. The door knobs were no longer door knobs, they melted and undulated like living serpents. Every object in the room became a living, mobile breathing world. I walked away, into a hallway opening into several small rooms. On the way there was a door leading to the garden. Gil opened it. The dazzle of the sun was blinding, every speck of gold multiplied and magnified. Trees, clouds, lawns heaved and undulated too, the clouds flying at tremendous speed. I ceased looking at the garden because on the plain door now appeared the most delicate Persian designs, flowers, mandalas, patterns in perfect symmetry. As I designed them they produced their matching music. When I drew a long orange line, it emitted its own orange tone. My body was both swimming and flying. I felt gay and at ease and playful. There was perfect connection between my body and everything that was happening. For example, the colors in the designs gave me pleasure, as well as the music. The singing of mocking-birds was multiplied, and became a whole forest of singing birds. My senses were multiplied as if I had a hundred eyes, a hundred ears, a hundred fingertips. The murals which appeared were perfect, they were Oriental, fragile, and complete, but then they became actual Oriental cities, with pagodas, temples, rich Chinese gold and red altars, and Balinese music. The music vibrated through my body as if I were one of the instruments and I felt myself becoming a full percussion orchestra, becoming green, blue, orange. The waves of the sounds ran through my hair like a caress. The music ran down my back and came out of my fingertips. I was a cascade of red-blue rainfall, a rainbow. I was small, light, mobile. I could use any method of levitation I wished. I could dissolve, melt, float, soar. Wavelets of light touched the rim of my clothes, phosphorescent radiations. I could see a new world with my middle eye, a world I had missed before. I caught images behind images, the walls behind the sky, the sky behind the infinite. The walls became fountains, the fountains became arches, the domes skies, the sky a flowering carpet, and all dissolved into pure space. I looked at a slender line curving over into space which disappeared into infinity. I saw a million zeroes on this line, curving, shrinking in the distance, and I laughed and said: "Excuse me, I am not a mathematician. How can I measure the

infinite?" To Dr. Janiger, who was passing by, I said: "Without being a mathematician I understood the infinite." He did not seem impressed. I saw his face as a Picasso, with a slight asymmetry. It seemed to me that one of his eyes was larger, and this eye was prying into my experience, and I turned away. Gil was sometimes there, but now I became aware that he was a child, that he had a big round face with a grin. Now I was standing on the rim of a planet, alone. I could hear the fast rushing sound of the planets rotating in space. Then I was moving among them and I realized a certain skill would be necessary to handle this new means of transportation. The image of myself standing in space and trying to get my "space legs" amused me. I wondered who had been there before me and whether I would return to earth. The solitude distressed me for the first time, the sense of distance, so I asked Gil very vehemently: "Are you sure that I will find my way back?" Gil answered reasonably: "Of course, I found my way back. I'm here." He asked me if there was anything I wanted, a glass of water or a sandwich. I answered: "I want a pagoda." And after a while I added: "I realize this is an unreasonable request." I returned to my starting point. I was standing in front of an ugly door, but as I looked closer it was not plain or green but it was a Buddhist temple, a Hindu column, a Moroccan ceiling, gold spires being formed and re-formed as if I

were watching the hand of a designer at work. I was designing red spirals which unfurled until they formed a rose window or a mandala with edges of radium. As each design was born and arranged itself, it dissolved and the next one followed without confusion. Each form, each line emitted its equivalent in music in perfect accord with the design. An undulating line emitted a sustaining undulating melody, a circle had corresponding musical notations, diaphanous colors, diaphanous sounds, a pyramid created a pyramid of ascending notes, and vanishing ones left only an echo. These designs were preparatory sketches for entire Oriental cities. I saw the temples of Java, Kashmir, Nepal, Ceylon, Burma, Cambodia, in all the colors of precious stones illumined from within. Then the outer forms of the temples dissolved to reveal the inner chapels and shrines. The reds and golds inside the temples created an intricate musical orchestration like Balinese music. Two sensations began to torment me: one that it was happening too quickly and that I would not be able to remember it, another that I would not be able to tell what I saw, it was too elusive and too overwhelming. The temples grew taller, the music wilder, it became a tidal wave of sounds with gongs and bells predominating. Gold spires emitted a long flute chant. Every line and color was constantly breathing and mutating.

It was then I began to experience difficulties in breathing. I felt immensely cold, and very small in my cape, as if I had undergone an Alice in Wonderland metamorphosis. I told Gil I could not breathe, and he took me to the doctor. The doctor calmed me with words. I had asked for oxygen. He suggested I lie down and cover myself well. Gil was seated near me, grinning. I asked him if he had had difficulties breathing. I still had the impression I had been among the planets. I remembered the illustration from Saint-Exupéry's *Little Prince*, the child standing all alone on the edge of the planet. I lay down and covered myself. I was smoking a cigarette. I looked at the curtains of the room and they turned to a gauzy gold. The whole room became filled with gold, as if by a strong sun. The walls turned to gold, the bedcover was gold, my whole body was becoming GOLD, liquid gold, scintillating, warm gold. I WAS GOLD. It was the most pleasurable sensation I had ever known, like an orgasm. It was the secret of life, the alchemist's secret of life. From the feeling of intense cold, as if I were chloroformed, of loss of gravity of the legs, and diminution in size, I passed to the sensation of being gold. Suddenly I was weeping, weeping. I could feel the tears and I saw the handkerchief in my hand. Weeping to the point of dissolution. Why should I be weeping? I could see Gil smiling, and realized the absurdity of weeping when traveling through space. As soon as

the concept of absurdity struck me, the comic spirit appeared again. It was another Anaïs, not the one which was lying down weeping, but a small, gay, light Anaïs, very lively, very restless and mobile. The comic spirit of Anaïs was aware of Gil's predicament: "Poor Gil, you are out with an ordinary weepy female! What a ridiculous thing to spoil a voyage through space by weeping. But before we go on, I want to explain to you why women weep. IT IS THE QUICKEST WAY TO REJOIN THE OCEAN. You liquefy, become fluid, flow back into the ocean where the colors are more beautiful." The comic spirit of Anaïs shook herself jauntily and said: "Let's stop this weeping. Everything is more wonderful under water (than in space?). It is alive and it breathes." Space was lonely, and empty, a vast desert. After the feeling of GOLD I had a feeling of danger. My world is so beautiful, so beautiful, but so fragile. I was pleading for protection of this evanescent beauty. I thought I was the quickest mind alive and the quickest with words, but words cannot catch up with these transformations, metamorphoses. They are beyond words, beyond words… The Oriental cities vanished and the infinite appeared again, but now it was bordered on each side by celestial gardens of precious stones on silver and gold stems. Temptation not to pursue the infinite, but to enjoy the gardens. Space is definitely without sensuous appeal.

The comic spirit of Anaïs stood aside and laughed at so much Russian-opera extravaganza. But the other Anaïs maintained her pose as a Balinese dancer with legs slightly bent, the tips of the fingers meeting in a symbolic gesture of pleading. I could feel the weight of the brocade.

I watched a shoreline of gold waves breaking into solid gold powder and becoming gold foam, and gold hair, shimmering and trembling with gold delights. I felt I could capture the secret of life because the secret of life was metamorphosis and transmutation, but it happened too quickly and was beyond words. Comic spirit of Anaïs mocks words and herself. Ah, I cannot capture the secret of life with WORDS.

Sadness.

The secret of life was BREATH. That was what I always wanted words to do, to BREATHE. Comic spirit of Anaïs rises, shakes herself within her cape, gaily, irresponsibly, surrenders the abstruse difficulties. NOW I KNOW WHY THE FAIRY TALES ARE FULL OF JEWELS. After my experience with LSD I began to examine whether it was an unfamiliar world, inaccessible except to the chemical alterations of reality. I found the origin of most of the images either in my work or in literary works by other writers.

In *House of Incest*, written in 1935, objects become liquefied and I describe them as seen through water. There is a reference to Byzantium and I was brought up on volumes of *Voyages Autour du Monde*, which had images of Cambodia, Thailand, Bali, India, and Japan, and which remained forever in my memory. I have listened to countless recordings of Balinese music, tapes made by Colin McFee.

Images of split selves appear in *House of Incest*.

The image of loneliness on another planet is derived from my frequent reading of *The Little Prince* by Antoine de Saint-Exupéry.

In *House of Incest* there is mention of crystals, precious stones: "The muscovite like a bride, the pyrite, the hydrous silica, the cinnabar, the azurite of benefic Jupiter, the malachite, all crushed together, melted jewels, melted planets."

The sensation of becoming gold is one I had many times when sunbathing on the sand; the sun's reflection came through my closed eyelids, and I felt myself becoming gold.

I could find correlations all through my writing, find the sources of the images in past dreams, in reading, in memories of travel, in actual experi-

ence, such as the one I had once in Paris when I was so exalted by life that I felt I was not touching the ground, I felt I was sliding a few inches away from the sidewalk.

Therefore, I felt, the chemical did not reveal an unknown world. What it did was to shut out the quotidian world as an interference and leave you alone with your dreams and fantasies and memories. In this way it made it easier to gain access to the subconscious life. But obviously, by way of writing, reveries, waking dreams, and night dreams, I had visited all those landscapes. The drug added a synthesis of color, sound, image, a simultaneous fusion of all the senses which I had constantly aspired to in my writing and often achieved.

I reached the fascinating revelation that this world opened by LSD was accessible to the artist by way of art. The gold sun mobile of Lippold could create a mood if one were receptive enough, if one let the image penetrate the body and turn the body to gold. All the chemical did was to remove resistance, to make one permeable to the image, and to make the body receptive by shutting out the familiar landscape which prevented the dream from invading us.

What has happened that people lose contact with such images, visions, sensations, and have to resort to drugs which ultimately harm them?

They have been immured, the taboo on dream, reverie, visions, and sensual receptivity deprives them of access to the subconscious. I am grateful for my natural access. But when I discuss this with Huxley, he is rather irritable: "You're fortunate enough to have a natural access to your subconscious life, but other people need drugs and should have them."

This does not satisfy me because I feel that if I have a natural access others could have it too. How did I reach this? Difficult to retrace one's steps. Can you say I had a propensity for dreaming, a faculty for abstracting myself from the daily world in order to travel to other places? What I cannot trace [is] the origin of seemed natural tendencies which I allowed to develop, and which I found psychoanalysis encouraged and trained. The technique was accessible to those willing to accept psychoanalysis as a means of connecting with the subconscious. I soon recognized its value. My faith in it is unshaken. But then there is also the appetite for what nourishes such a rich underground life: learning color from the painters, movement from the dancers, music from musicians. They train your senses, they sensitize the senses. It was the banishment of art which brought on a culture devoid of sensual perception, of the participation in the senses, so that experience did not cause the "highs," the exalta-

tions, the ecstasies they caused in me. The puritans killed the senses. English culture killed emotion. And now it was necessary to dynamite the concrete lid, to "blow the mind" as the LSD followers call it. The source of all wonder, aliveness, and joy was feeling and dreaming, and being able to fulfill one's dreams.

Even the art of reading, lost to America, was a constant nourishing source which revealed countries I wanted to see, people I wanted to know, experiences I wanted to have. How cruelly the weight of ordinary life, *la condition humaine*, weighed upon America, with everything forcing you to live in the prosaic, the shabby, the practical, the quotidian, the down-to-earth, the mediocrity of political life, the monstrosities of history via the media, because they believed this was contact with life, and it was the very thing which destroyed the contact with life.

So the drugs, instead of bringing fertile images which in turn can be shared with the world (as the great painters, great poets, great musicians shared their abundance with the unfertile ones, enriched undernourished lives), have instead become a solitary vice, a passive dreaming which alienates the dreamer from the whole world, isolates him, ultimately destroys him. It is like masturbation. The one who wrestles his images from

experience, from his smoky dreams, to create, is able then to build what he has seen and hungered for. It does not vanish with the effects of the chemical. The knowledge gained without the drugs, as, for example, my feeling for color learned from watching the painters when I was posing for them, is a permanent acquisition. It became part of my being, it was applicable to my travels, to my image of people. It was or became a new faculty, part of my sensory perception, available, but the effort I made to learn was also the strengthening of the ability to create with a sense of color, to create houses, clothes, visions of cities, enjoyment of color not only as a passing, ephemeral, vanishing dream, *but as reality*. And that is the conflict. The drug effect does not strengthen the desire to turn the dream, the vision, into reality. It is passive.

I have to go on in my own way, which is a disciplined, arduous, organic way of integrating the dream with creativity in life, a quest for the development of the senses, the vision, the imagination as dynamic elements with which to create a new world, a new kind of human being. Seeking wholeness not by dreaming alone, by a passive dreaming that drugs give, but by an active, dynamic dreaming that is connected with life, interrelated, makes a harmony in which the pleasures of color, texture, vision are a creation in reality, which

we can enjoy with the *awakened* senses. What can be more wonderful than the carrying out of our fantasies, the courage to enact them, embody them, live them out instead of depending on the dissolving, dissipating, vanishing quality of the drug dreams.

I will not be just a tourist in the world of images, just watching images passing by which I cannot live in, make love to, possess as permanent sources of joy and ecstasy.

Reprinted from *The Diary of Anaïs Nin, 1947–1955*, **vol. 5 (New York: Harvest Books, 1975).**

From *The Einstein Intersection*
Samuel R. Delany

But I have *this* against thee, that thou didst leave thy first love.

The Revelation of John, chapter 2, verse 4

My trouble is, such a subject cannot be seriously looked at without intensifying itself towards a center which is beyond what I, or anyone else, is capable of writing of… Trying to write it in terms of moral problems alone is more than I can possibly do. My main hope is to state the central subject and my ignorance from the start.

James Agee, "Letter to Father Flye"

Where is this country? How does one get there? If one is born lover with an innate philosophic bent, one will get there.

Plotinus, *The Intelligence, the Idea, and Being*

Spider looked up from the desk where he's been reading. "I thought that would be you."

In shadow behind him I saw the books. La Dire had once owned some hundred. But the shelves behind him went from floor to ceiling

"I want … my money." My eyes came back to the desk.

"Sit down," Spider said. "I want to talk to you."

"About what?" I asked. Our voices echoed. The music was nearly silent. "I have to be on my way to get Friza, to find Kid Death."

Spider nodded. "That's why I suggest you sit down." He pressed a button, and dust motes in the air defined a long cone of light that dropped to an onyx stool. I sat slowly, holding my blade. As he had once shifted the handle of his dragon whip from hand to hand, now he played with the bleached, fragile skull of some rodent: "What do you know about mythology, Lobey?"

"Only the stories that La Dire, one of the elders of my village, used to tell me. She told all the young people stories, some of them many times. And we told them to each other till they sank into memory. But then there were other children for her to tell."

"Again, what do you know about mythology?—I'm not asking you what myths you know, nor even where they came from, but why we have them, what we use them for."

"I … don't know," I said. "When I left my village La Dire told me the myth of Orpheus."

Spider held up the skull and leaned forward. "Why?"

"I don't …" Then I thought. "To guide me?"

I could offer nothing else. Spider asked, "Was La Dire different?"

"She was—" The prurience that had riddled the laughter of the young people gaping at the poster came back to me; I did not understand it, still I felt the rims of my ears grow hot. I remembered the way Easy, Little Jon, and Lo Hawk had tried to brake my brooding over Friza; and how La Dire had tried, her attempt like theirs—yet different. "Yes," I confessed, "she was."

Spider nodded and rapped his rough knuckles on the desk. "Do you understand difference, Lobey?"

"I live in a different world, where many have it and many do not. I just discovered it in myself weeks ago. I know the world moves towards it with every pulse of the great rock and the great roll. But I don't understand it."

Through the eagerness on his drawn face Spider smiled. "In that you're like the rest of us. All any of us knows is what it is not."

"What isn't it?" I asked.

"It isn't telepathy; it's not telekinesis—though both are chance phenomena that increase as difference increases. Lobey, Earth, the world, fifth planet from the sun—the species that stands on two legs and roams this thin wet crust: it's changing, Lobey. It's not the same. Some people walk under the sun and accept that change, others close their eyes, clap their hands to their ears, and deny the world with their tongues. Most snicker, giggle, jeer, and point when they think no one else is looking—that's how the humans acted throughout their history. We have taken over their abandoned world, and something new is happening to the fragments, something we can't even define with mankind's leftover vocabulary. You must take its importance exactly as that: it is indefinable; you are involved in it; it is wonderful, fearful, deep, ineffable to your explanations, opaque to your efforts to see through it; yet it demands you take journeys, defines your stopping and starting points, can propel you with love and hate, even to seek death for Kid Death—"

"—or make me make music," I finished for him. "What are you talking about, Spider?"

"If I could tell you, or you could understand from my inference, Lobey, it would lose all value. Wars and chaoses and paradoxes ago, two mathematicians between them ended an age and began another for our hosts, our ghosts called Man. One was Einstein, who with his Theory of Relativity defined the limits of man's perception by expressing mathematically just how far the condition of the observer influences the thing he perceives."

"I'm familiar with it," I said.

"The other was Gödel, a contemporary of Einstein, who was the first to bring back a mathematically precise statement about the vaster realm beyond the limits Einstein had defined: *In any closed mathematical system*— you may read 'the real world with its immutable laws of logic'—*there are an infinite number of true theorems*— you may read 'perceivable, measurable phenomena'— *which, though contained in the original system, can not

be deduced from it—read 'proven with ordinary or extraordinary logic.' Which is to say, there are more things in heaven and Earth than are dreamed of in your philosophy, Lo Lobey-o. There are an infinite number of true things in the world with no way of ascertaining their truth. Einstein defined the extent of the rational. Gödel stuck a pin into the irrational and fixed it to the wall of the universe so that it held still long enough for people to know it was there. And the world and humanity began to change. And from the other side of the universe, we were drawn slowly here. The visible effects of Einstein's theory leaped up on a convex curve, its productions huge in the first century after its discovery, then leveling off. The productions of Gödel's law crept up on a concave curve, microscopic at first, then leaping to equal the Einsteinian curve, cross it, outstrip it. At the point of intersection, humanity was able to reach the limits of the known universe with ships and projection forces that are still available to anyone who wants to use them—"

"Lo Hawk," I said. "Lo Hawk went on a journey to the other worlds—"

"—and when the line of Gödel's law eagled over Einstein's, its shadow fell on a deserted Earth. The humans had gone somewhere else, to no world in this continuum. We came, took their bodies, their souls—both husks abandoned here for any wanderer's taking. The Cities, once bustling centers of interstellar commerce, were crumbled to the sands you see today. And they were once greater than Branning-at-sea."

I thought a moment. "That must have taken a long time," I said slowly.

"It has," Spider said. "The City we crossed is perhaps thirty thousand years old. The sun has captured two more planets since the Old People began here."

"And the source-cave?" I suddenly asked. "What was the source-cave?"

"Didn't you ever ask your elders?"

"Never thought to," I said.

"It's a net of caves that wanders beneath most of the planet, and the lower levels contain the source of the radiation by which the villages, when their populations become too stagnant, can set up a controlled random jumbling of genes and chromosomes. Though we have not used them for almost a thousand years, the radiation is still there. As we, templated on man, become more complicated creatures, the harder it is for us to remain perfect: there is more variation among the normals and the cages fill with rejects. And here you are, now, Lobey."

"What does this all have to do with mythology?" I was weary of his monologue.

"Recall my first question."

"What do I know of mythology?"

"And I want a Gödelian, not an Einsteinian answer. I don't want to know what's inside the myths, nor how they clang and set one another ringing, their glittering focuses, their limits and genesis. I want their shape, their texture, how they feel when you brush by them on a dark road, when you see them receding into the fog, their weight as they leap your shoulder from behind; I want to know how you take to the idea of carrying three when you already bear two. Who are you, Lobey?"

"I'm ... Lobey?" I asked. "La Dire once called me Ringo and Orpheus."

Spider's chin rose. His fingers, caging the bone face, came together. "Yes, I thought so. Do you know who I am?"

"No."

"I'm Green-eye's Iscariot. I'm Kid Death's Pat Garrett. I'm Judge Minos at the gate, whom you must charm with your music before you can even go on to petition the Kid. I'm every traitor you've ever imagined. And I'm a baron of dragons, trying to support two wives and ten children."

"You're a big man, Spider."

He nodded. "What do you know of mythology?"

"Now that's the third time you've asked me." I picked up my blade. From the grinding love that wanted to serenade his silences—the music had all stopped—I leaned the blade against my teeth.

"Bite through the shells of my meanings, Lobey. I know so much more than you. The guilty have the relief of knowledge." He held the skull over the table. I thought he was offering it to me. "I know where you can find Friza. I can let you through the gate. Though Kid Death may kill me, I want you to know that. He is younger, crueler, and much stronger. Do you want to go on?"

I dropped my blade. "It's fixed!" I said. "I'll fail! La Dire said Orpheus failed. You're trying to tell me that those stories tell us just what is going to happen. You've been telling me we're so much older than we think we are; this is all schematic for a reality I can't change! You're telling me right now that I've failed as soon as I start."

"Do you believe that?"

"That's what you've said."

"As we are able to retain more and more of our past, it takes us longer to become old; Lobey, everything changes. The labyrinth today does not follow the same path it did

at Knossos fifty thousand years ago. You may be Orpheus; you may be someone else, who dares death and succeeds. Green-eye may go to the tree this evening, hang there, rot, and never come down. The world is not the same. That's what I've been trying to tell you. It's different."

"But—"

"There's just as much suspense today as there was when the first singer woke from his song to discover the worth of the concomitant sacrifice. You don't know, Lobey. This all may be a false note, at best a passing dissonance in the harmonies of the great rock and the great roll."

I thought for a while. Then I said, "I want to run away."

Spider nodded. "Some mason set the double-headed labrys on the stones at Pheistos. You carry a two-edge knife that sings. One wonders if Theseus built the maze as he wandered through it."

"I don't think so," I said, defensive and dry. "The stories give you a law to follow—"

"—that you can either break or obey."

"They set you a goal—"

"—and you can either fail that goal, succeed, or surpass it."

"Why?" I demanded. "Why can't you just ignore the old stories? I'll go plumb the sea, find the Kid without your help. I can ignore those tales!"

"You're living in the real world now," Spider said sadly. "It's come from something. It's going to something. Myths always lie in the most difficult places to ignore. They confound all family love and hate. You shy at them on entering or exiting any endeavor." He put the skull on the table. "Do you know why the Kid needs you as much as he needs Green-eye?"

I shook my head.

"I do."

"The Kid needs me?"

"Why do you think you're here?"

"Is the reason ... different?"

"Primarily. Sit back and listen." Spider himself leaned back in his chair. I stayed where I was. "The Kid can change anything in the range of his intelligence. He can make a rock into a tree, a mouse into a handful of moss. But he cannot create something from nothing. He cannot take this skull and leave a vacuum. Green-eye can. And that is why the Kid needs Green-eye."

I remembered the encounter on the mountain where the malicious redhead had tried to tempt the depthless vision of the herder-prince.

"The other thing he needs is music, Lobey."

"Music?"

"This is why he is chasing you—or making you chase him. He needs order. He needs patterning, relation, the knowledge that comes when six notes predict a seventh, when three notes beat against one another and define a mode, a melody defines a scale. Music is the pure language of temporal and co-temporal relation. He knows nothing of this, Lobey. Kid Death can control, but he cannot create, which is why he needs Green-eye. He can control, but he cannot order. And that is why he needs you."

"But how—?"

"Not in any way your village vocabulary or my urban refinement can state. Differently, Lobey. Things passing in a world of difference have their surrealistic corollaries in the present. Green-eye creates, but it is an oblique side effect of something else. You receive and conceive music; again only an oblique characteristic of who you are—"

"*Who* am I?"

"You're … something else."

My question had contained a demand. His answer held a chuckle.

"But he needs you both," Spider went on. "What are you going to give him?"

"My knife in his belly till blood floods the holes and leaks out the mouthpiece. I'll chase the sea-floor till we both fall on sand. I—" My mouth opened; I suddenly sucked in dark air so hard it hurt my chest. "I'm afraid," I whispered. "Spider, I'm afraid."

"Why?"

I looked at him behind the evenly blinking lids of his black eyes. "Because I didn't realize I'm alone in this." I slid my hands together on the hilt. "If I'm to get Friza, I have to go alone—not with her love, but without it. You're not on my side." I felt my voice roughen, not with fear. It was the sadness that starts in the back of the throat and makes you cough before you start crying. "If I reach Friza, I don't know what I'll have, even if I get her."

Spider waited for my crying. I wouldn't give him the satisfaction. So after a while he said, "Then I guess I can let you through, if you really know that."

I looked up.

He nodded to my silent question.

"There's someone you must go to see. Here." He stood up. In his other hand was a small sack. He shook it. Inside coins clinked. He flung the sack towards me. I caught it.

"Who?"

"The Dove."

"The one whose pictures I've seen? But who—"

"Who is the Dove?" asked Spider. "The Dove is Helen of Troy, Starr Anthim, Mario Montez, Jean Harlow." He waited.

"And you?" I asked. "You're Judas and Minos and Pat Garrett? Who are you to her?"

His snort was contemptuous and amused. "If the Dove is Jean Harlow I'm Paul Burn."

"But why—?"

"Come on, Lobey. Get going."

"I'm going," I said. "I'm going." I was confused. For much the same reasons you are. Though not *exactly* the same. As I walked to the door I kept glancing back at Spider. Suddenly he tossed the skull gently. It passed me, hovered a moment, then smashed on the stones; and Spider laughed. It was a friendly laugh, without the malicious flickering of fish scales and flies' wings that dazzled the laughter of the Kid. But it nearly scared me to death. I ran out of the door. For one step bone fragments chewed at my instep. The door slammed behind me. The sun slapped my face.

Reprinted from *The Einstein Intersection* (Middletown, Conn.: Wesleyan University Press, 1967), pp. 109–17.

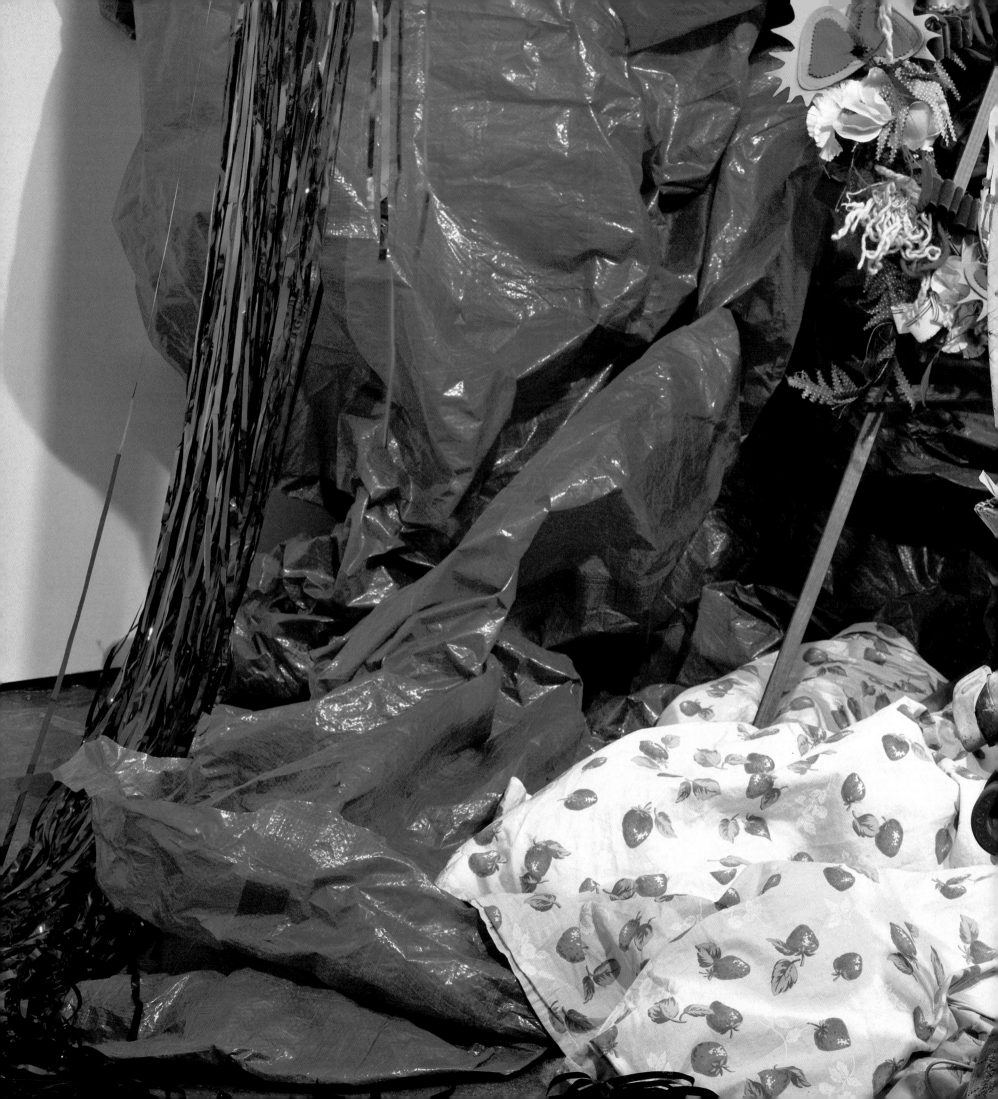

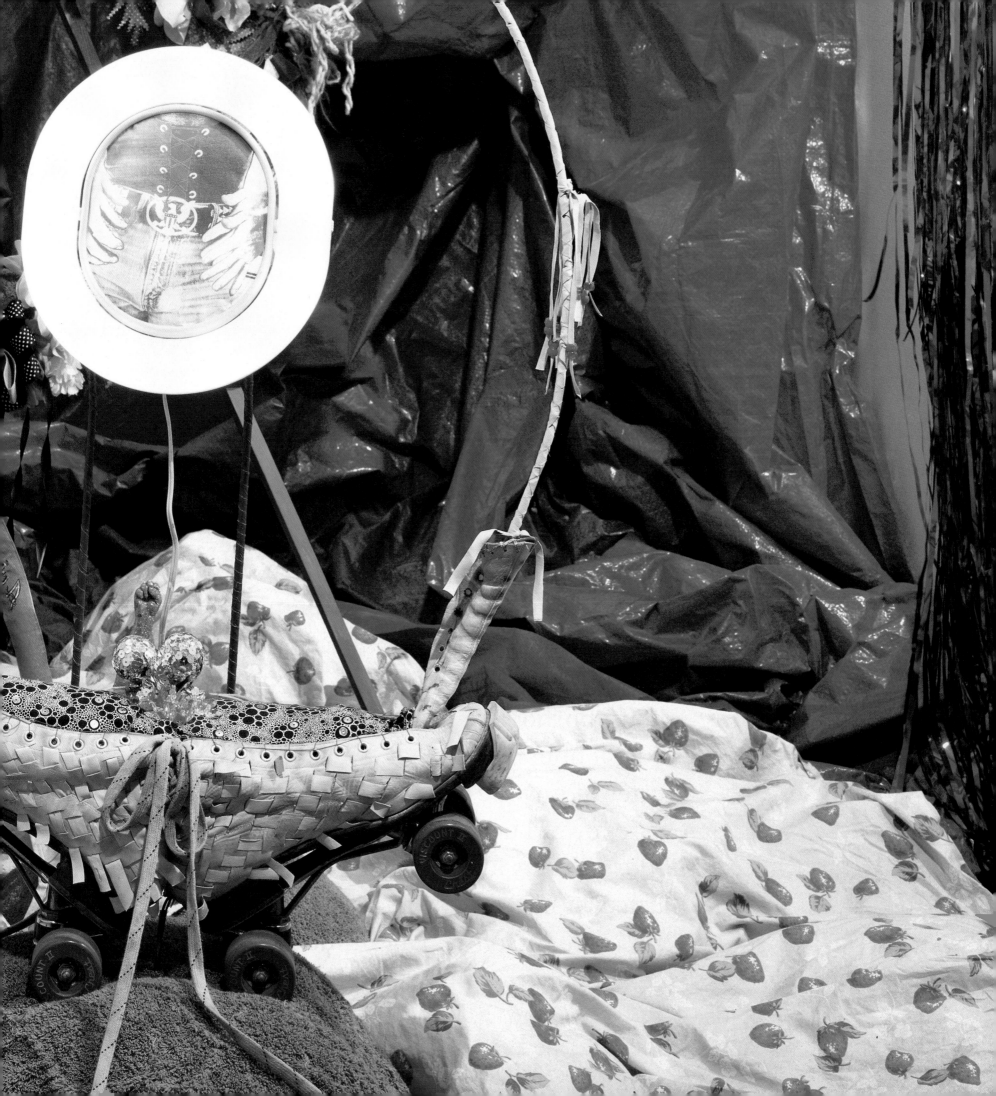

Fag Limbo
Wayne Koestenbaum

[1] Hernan Bas writes, in the artist's statement accompanying his 2001 show, "Hernan's Merit & the Nouveau Sissies," at the Fredric Snitzer Gallery in Miami, Florida: "My work (art) stems from understanding a new style of boy that lives in the androgynous room of 'fag limbo,' a space where everyone is worthy of suspicion. Most heterosexual boys I know exemplify this new class of boys, it is a clique that flirts with the sort of 'model' behavior typical of what is considered to be a bit sissy. They are the *nouveau sissy*, and word is finally getting out about them. This new brand of boy has the space to move at his own volition, back and forth and in and out of 'fag limbo.' ... My resulting attraction to these 'sissies' has led to my own desire to reclaim a space in 'fag limbo.'" With thanks to Hernan Bas for his clever, elucidating coinage.

I live in "fag limbo," a useful term borrowed from artist Hernan Bas, who also employs the phrase "nouveau sissies."[1] My subject today is a sensibility that I will irresponsibly call *fag limbo*, as if it were a neighborhood, a parking garage, a clothing boutique, a housing project, an asylum, or a treasured corner of anyone's mental library, with a drooled-over copy of Ludwig Wittgenstein's *Tractatus Logico-Philosophicus* alphabetized next to a cum-stained hardcover of David Wojnarowicz's *Memories That Smell Like Gasoline*. Fag limbo has always existed. In each generation, it takes new, vital forms.

Young skinny-armed art guys around town don't strive to muscle-build and don't announce a sexual orientation. It's gauche to ask. Only narrow-minded critics bother to delimit, to classify. I have no wish to reinstate defunct sexual categories. I am simply responding to a homework assignment. No one has sorted, tagged, or priced the heirlooms of identity politics, at sexuality's estate sale, where the prime items are disidentification, vagueness, and hovering.

Listen. A year or two ago, I wanted to make an experimental Super-8 nudie, *Why I Am Not a Painter*, based on the Frank O'Hara poem, which advertises his desire to hang around attractive straight men who might sleep with him if he flatters their art. Simultaneously my nudie was to be a brief remake of *Taylor Mead's Ass*, Warhol's 1964 masterpiece. My screenplay, simple, required a three-minute close-up of a young male artist's butt. Any young male artist. Didn't matter how cute.

I interviewed two artists for the role. The first demurred. He thought I was intending to make a porn flick. He said, "I don't want to be in a film whose only purpose is to get guys hard." We were drinking café con leche.

The second artist made things complicated by talking about concept. All I wanted was intergenerational nude artmaking, a document that would posthumously stage a truce between O'Hara and Warhol through my post-Warholian gaze at a post-post-Warholian artist's ass, via 8mm film, a pre-Warholian technology.

So I stopped talking to young artists about my nudie, and I hired a hustler instead. Two hundred dollars. He came to my apartment, took off his clothes. I filmed him with my Elmo. Through my south-facing apartment window, Chelsea afternoon light spread its bamboo fingers over his hairy butt cheeks, caught forever on black-and-white Kodak Tri-X Reversal 7278 film. (I always keep a spare cartridge in the fridge, in case a good ass pays a spontaneous house call.) The guy was a theater student at the New School. Physically he fit the role, but I'd wanted an artist, not a hustler, for my intergenerational allegory, my Pygmalion/Galatea film treatment of "Why I Am Not a Painter."

Anti-masculinist strategies—feyness, embroidery, craft, dithering, laziness, industriousness, sleeping-in, hibernation, softness, sibilance, reflection, fandom, shyness, brazenness, star-fucking—characterize fag limbo. The artists I am thinking about include

_____, _____, _____, _____, and _____. And there are others. Please don't pin me down. Nor do I wish to pin down the artists.[2] Mentioning an artist as part of a "school" is a form of hostile outing, whether or not the artist approves the appellation.

I Googled the artists to figure out whether they were gay and came up with, in some cases, specific info, in most cases nothing.

Let's say that being bullied is a given of this art.

Let's say that being cornered and not knowing how to defend oneself is this art's sine qua non.

Isolation tank and what you make of your isolation are the umbilici of this art.

Getting suicidally depressed and then suddenly feeling opulent gives this art its *je ne sais quoi*.

Going overboard with hobby shtick makes this art tick.

Not doing too good a job allows this art its accurate haruspication of 2004's innards.

Wallpaper and cum and mylar and floor stickers and werewolves and snot and flat asses are a few of this art's incidentals.

Yoko Ono and Peter Max and Kurt Schwitters and Boy Scouts have met this art.

This art cares more for music than for Marx, and it understands the beauty of *do it yourself*. Nothing wrong with hiring an assistant, if you can afford it! But let's remember the virtue of handmade *Dasein*.

Don't forget that *fag* means *fatigue*.

I got into a conversation about gender with some young artists. I said that laptop computers—as visual items—contained gender codes. I also said that paintings speak gender, whether the paintings like it or not. (The young artists disagreed. Gender is passé.) I mentioned Rothko. Rothko is gendered, right? Smart young people sometimes use "right?" as rhetorical interrogative. I'm acquiring this habit.

Satiation, or the experience of being historically belated, can produce envious indigestion, or it can (if the artist pursues fag limbo's Zen route) catalyze lightheartedness, an anti-erudite unencumbered-ness, and a refusal to "reference" in a gimmicky way. Fag limbo means taking the present moment just as it is, without the prophylaxis of peppiness (*I'm cheerful and allusive and past-oriented!*) but also without a hamfisted competitive-ness. Fag limbo allows the artist, and the speculator, to pursue neighborhoods other than *career*, that overvisited cemetery. To embrace limbo (*you can't pin me down*) and to embrace fagginess (*my Weltanschauung is flitty*) permit outsiderness without the doldrums and loneliness of actu-ally being an outsider artist. Fag

[2] Some of the artists whose work informed my thinking about fag limbo, and who appear in the Whitney 2004 Biennial: David Altmejd, Hernan Bas, Christian Holstad, Terrence Koh, Virgil Marti, assume vivid astro focus, and Antony and the Johnsons. (There are others, too, but I hesitate to put them in fag limbo. I don't want to upset them.) However, this essay is not a description of these artists or of their work; nor do these artists form a unified school or movement. I make no assumptions about their sexualities or intentions. It would be disingenuous, though, to pretend not to have been partly inspired, in writing this essay, by their work, especially the pieces selected for the Biennial.

[3] Wittgenstein writes:

"The Kantian problem of the right and left hand which cannot be made to cover one another already exists in the plane, and even in one-dimensional space... The right and left hand are in fact completely congruent. And the fact that they cannot be made to cover one another has nothing do with it.

"A right-hand glove could be put on a left hand if it could be turned round in four-dimensional space."

Wittgenstein, trans. C. K. Ogden, *Tractatus Logico-Philosophicus* (Mineola, N.Y.: Dover, 1999), p. 103. Right and left hands—or their *nothing-to-do-with-it* congruencies—operate the stick shift (shtick shift?) of fag limbo's standard transmission.

[4] Down this passageway I do not proceed in ignorance of Marjorie Perloff's pivotal study *Wittgenstein's Ladder: Poetic Language and the Strangeness of the Ordinary* (Chicago: University of Chicago Press, 1996).

[5] Fanon writes: "In New York, Simone de Beauvoir went for a walk with Richard Wright and was rebuked in the street by an old lady. Sartre said: Here it is the Jew, somewhere else it is the Negro. What is essential is a scapegoat." Fanon, trans. Charles Lam Markmann, *Black Skin, White Masks* (New York: Grove Press, 1967), p. 183. We must read this passage in concert with Fanon's earlier elliptical reference to puberty's never-endingness, where he demonstrates, through mesmerized verb tenses, that the temporal mode of fag limbo resists arrest: "During the time when I was slowly being jolted alive into puberty, I had the honor of being able to look in wonder on one of my older friends who had just come back from France and who had held a Parisian girl in his arms. I shall try to analyze this problem in a special chapter." Fanon, p. 72. It goes without saying that Fanon never quite arrives at that "special" chapter. Nor should we expect him ever to leap to the challenge of such an unwritable analysis.

limbo interprets a former moment's addiction to the A-list as a spiritual disease, and proposes that *flunking out of art* does not preclude virtuoso strategies. You need not renounce saturation, cornucopia, richness, skill, intensity, or texture, just because you've decided to opt out of art's regular curriculum.

I'm not interested in art that wants to be successful, or that imagines a brilliant career for itself. You're welcome to work hard, or to goof off, or to dream, secretly, of bigness, but don't wear that wish on your art's sleeve. Subscribing to unsuccess's tenets, I therefore value passive-aggressive art, which is sometimes a fag limbo strategy: pretending passivity, pretending not to fight for one's place at the table, this art may meanwhile house rebarbative aggressions.

If time allowed, I would now take us through a reading of Wittgenstein's *Tractatus Logico-Philosophicus*, specifically of a passage in which, pretending not to be making reference to actual autobiographical material, Wittgenstein refers to a left hand and a right hand, as if these were merely abstractions, an inessential x and y, without historical merit, without wound.[3] The careful reader, hearing the word *hand,* will remember that Ludwig's brother Paul lost a hand (actually, an arm) in World War I, a loss memorialized in Ravel's *Piano Concerto for the Left Hand.* Two fags: Ravel and L. Wittgenstein. Ravel's ode to disability, and L. Wittgenstein's own inability to mourn, together create, around the space of the felled brother, a fag limbo in which all territorial claims, all hygienes separating music from philosophy from poetry, point toward a cross-media, intergenerational, autobiographical yet nonreferential vacuum, a zone in which real art,

finally, can begin to occur; I would be able to gesture toward this zone with a more able set of maps, were there time for laborious cartography in the crowded, rushed interstice of a Biennial, which places a revved-up premium on the *now* at the expense of the *then*, and which incites *thought on the run* (the only way I can think, *if* I can think). Fag limbo is, in part, this inability to think through anything but the materials right now in my room, wherever and whatever my room might be, whether bubble or cell or gallery or mausoleum or website. And were there time, within the hurried limbo of the Biennial, between the inferno of the *passé* and the paradiso of the *now*, I would gesture toward the liminal space (hallway? corridor?) linking the two wards in Thomas Bernhard's novelistic *Wittgenstein's Nephew*, a canal connecting the mental ward and the pulmonary ward, a passageway or arcade in which the two patients, one a mental case and the other a lung case, can tentatively meet, as if within an intergenerational compromise formation.[4]

The limbo between fixed, knowable sites creates a need for myth, or a space for myth's possible germination. By *myth* I simply mean the stories we invent to pass the time, *pass* not in the deathly sense (*he passed* or *she passed on*) but in the organic, relieving sense of *pass stool.* Homosexuality was one such illuminating myth we passed, the walls of its cave detailed with drawings of Narcissus, Achilles, James Dean, Jack Smith. More modest myths, less world-encompassing, detained us: we saw, out of the corner of our eyes, evidence that every artist, now and then, spins for himself or herself a cocoon of favored media and referents, a

security-blanket intertext or glossary, a group of relied-upon names, colors, materials, techniques, which together form a heraldic mantle, protecting the artist against infection, indifference, bullying, comprehensibility, critics, curators, patrons, landlords, and other thruway accidents.

If there were time now—if this were a full-length book, rather than a brief intervention in a space, the Biennial, too charged with meanings of its own for me to enter without risk of enchantment and paralysis—then I would lead us through a paragraph of Frantz Fanon's *Black Skin, White Masks*, where he describes fag limbo, without using the term, as a space of interracial and intergenerational envy and surveillance, wherein one man knows his authority by watching another man with a third man's wife, the three men in this case being Jean-Paul Sartre, Richard Wright, and Frantz Fanon, and the one woman being Simone de Beauvoir; the fag limbo in which Fanon finds himself, without knowing or naming it, is a New York City street, within the precincts of chic, and without the defensive protection of a theory to back it up.[5] Fag limbo, in Fanon's case, involves Proust's mimetic desire (*I want that other man, I want to be that other man, I want what that other man has*) and sanctions a total absence of any overtly lubricious reference, so that we have no way of knowing whether cum-in-the-beard and cream pie are at issue.

One place to end is dream— how a culture and a psyche create floor shows. The oneiric items may be off today's menu, and yet whatever Yayoi Kusama meant when she filmed dot-making in the 1960s in Central Park (or so I

recall) involved resuscitating dream-ideation, giving it mouth-to-mouth. If figurative or decorative elements reenter art under the aegis of *wish* or *fancy* ("I dreamt those shapes," "I wanted those colors," "I like to knit"), then art takes a salutary turn toward whimsicality as authoritarianism's antidote. I need eleven hours of sleep a night. We lack the time for a lengthy detour to Gaston Bachelard's *The Poetics of Space*, which would help us understand the crucial place that dreamwork occupies in any aesthetic utilizations of the spatial. If we did not believe in space, then we could not have rooms. Without rooms, we would lack backrooms.

Dream, 12 November 2003: I French-kissed Hillary Clinton, a small woman, vulnerable, pretty, beleaguered. Was I kissing her in order to get close to Bill, or was I kissing her for the pleasure of the act itself, and for love of Hillary? How venal was my conduct? How noble? She reminded me of a foreign-language bookstore, but also of a toy piano: she made tiny yet hard gamelan noises.[6]

Writing about art exists, but it is a conceptual impossibility, because art has no outside: there is no space *outside* art. Writing that pretends to stand *outside* art, looking in, also necessarily dwells *inside* art. This essay has no wish to occupy a position of superior vantage, looking down at art; nor does this essay desire to occupy a position of inferior vantage, looking up to art. Nor does this essay propose a relation of equal footing, a mutual, interactive gaze between art and writing. This essay asserts that it has been swallowed by art; this essay is delighted to have been digested by art. The alimentary limbo in which this essay resides, inside art's canal, is a pleasantly claustrophobic space. Limbo is writing's always internal address within art's body; limbo is the post office box at which art's letters, written in this very typeface, always punctually arrive. Let me say it again, because I am slow today, and afraid of being misinterpreted: this essay is not *about* art. This essay, bad or good or in between, is *inside* art—not because art is an honorific to be selectively bestowed, but because art is the easiest, most available, most promiscuous category, the catchall for every enacted wish, every short-circuited fantasy. Art is not a difficult achievement. It is where we already live, and it is how we identify that, indeed, we live.

WAYNE KOESTENBAUM is the author of five books of prose, including *Andy Warhol*, *The Queen's Throat*, and *Cleavage*, and three books of poetry, including *The Milk of Inquiry* and *Rhapsodies of a Repeat Offender*. In Fall 2004 he will publish his first novel, *Moira Orfei in Aigues-Mortes*, and a book-length poem, *Model Homes*. He is a professor of English at the Graduate Center of the City University of New York.

[6] For other installments of the dream dossier, see my brief essays "M/Orality" and "Celebrity Dreaming" in *Cleavage: Essays on Sex, Stars, and Aesthetics* (New York: Ballantine, 2000).

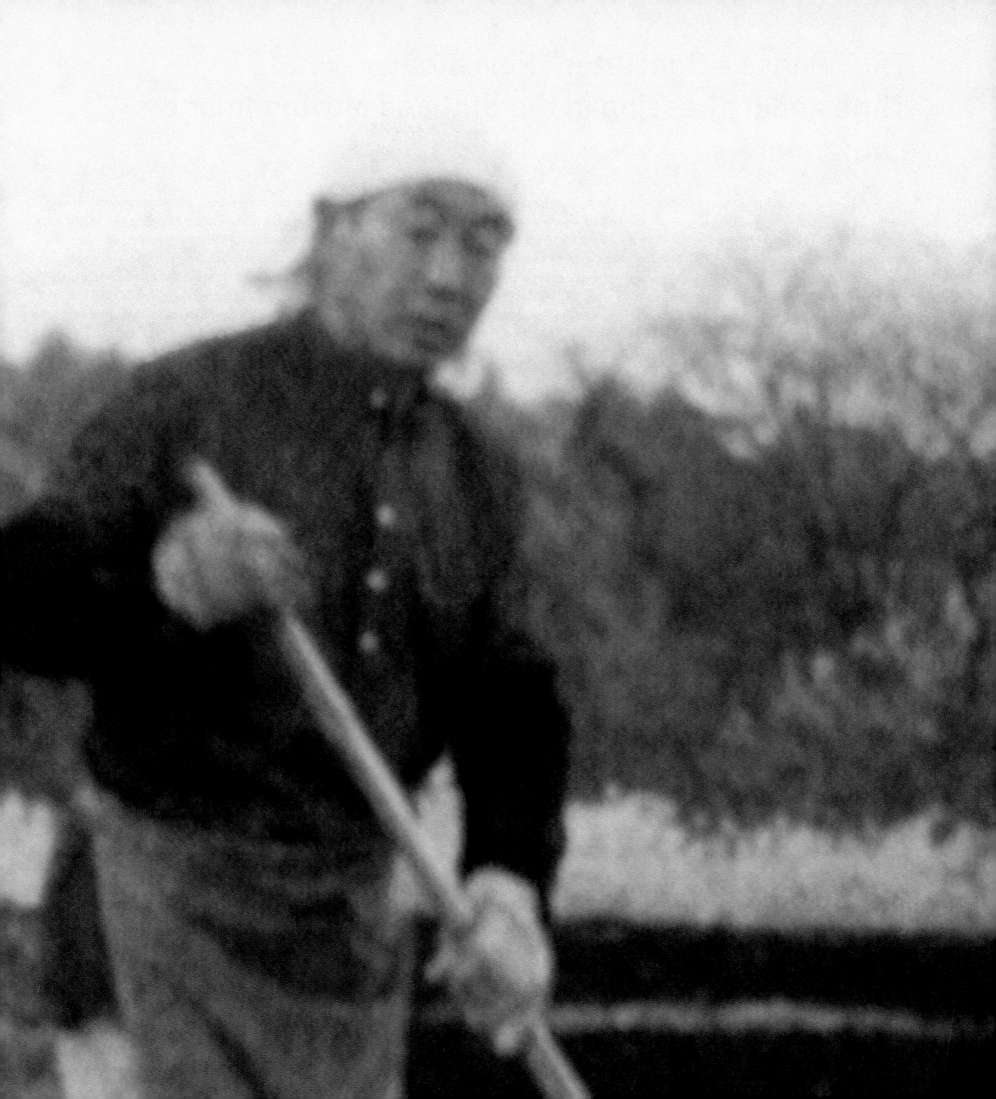

The "Pensive Spectator" Revisited: Time and Its Passing in the Still and Moving Image
Laura Mulvey

I am arguing that the cinema in the age of the digital will remain the same. Yes, it will remain the same and it will be utterly different. For...the digital is not only a new technique of post-production work or a new delivery system or storage medium, it is the new horizon for thinking about cinema, which also means that it gives a vantage point beyond the horizon, so that we can, as it were, try to look back to where we actually are, and how we arrived there. The digital can thus function as a time machine, a conceptual boundary as well as its threshold.[1]

My opening proposition—that electronic and digital technologies have recently had a significant impact on celluloid-based cinema—is obvious, even to the point of banality. My hope here is, first of all, to bring out some of the implications for film criticism and film history that might lie behind the obviousness, most particularly how technological change has given a new kind of visibility to stillness as a property of celluloid. I say "celluloid" advisedly as my interest, in the first instance, lies in the interaction between the old, mechanical technology (associated with cinema) and the new, electronic or digital technologies—that is, how a cinema that was not conscious of the implications of future technology might be affected, even enhanced, by refraction through the new. I have been trying to imagine a dialectical relationship here, where the old and the new react with each other to create innovative ways of thinking about the language of cinema and its significance at the present historical moment.

I started writing about the cinema and thinking about it theoretically in the early 1970s, so juxtaposition between "old" and "new" must also refer to my own attitudes and approaches. Using new technology as, in Thomas Elsaesser's term, "a new horizon" to look back at the cinema of the past has pushed me also to return to, and attempt to reconfigure, the main theoretical lines of approach that have influenced my thought. This process has been like an experiment, trying out, in changed conditions, the theories that I have been applying to film

for so long. There are three points of departure. First of all, spectatorship: radical changes in the material, physical ways in which the cinema is consumed necessarily demand that theories of spectatorship should be reconfigured. Secondly, the indexical sign: the fact that the digital can mimic analogue images, as well as doctoring them, gives a new significance to the direct registration of the pro-filmic on celluloid. And, finally, narrative: analysis of cinematic narrative that assumes an essential linearity, a dependence on cause and effect and on closure, shifts with nonlinear viewing. All these inflections are derived, above all, from the viewer's new command over viewing technology and, most of all, the freedom given by the technology over the pace and order of a film. As narrative coherence fragments, as the index suddenly finds visibility in the slowed or stilled image, so spectatorship finds new forms. Out of the paradox or contradiction based on technology, a dialectical relation, with implications for aesthetics and concepts, might begin to emerge....

The paradox: while new technologies (might) reveal aspects of the cinema's beauty or interest, they do this across media, in the passage from celluloid to the electronic. This displacement breaks the bond of specificity that was so important to my generation of filmmakers and theorists as both a theoretical and aesthetic principle. But, on the other hand, as new technologies open up, for instance, access to the cinema's own paradoxical relation between movement and stillness, this in turn allows the spectator time to stop and look and think. Anyone can use electronic media's interactivity, stop the flow of film, and find a fascination in the still image that had previously been concealed by movement. This process then can open up a space in which the aesthetics of celluloid meet those of the photograph; the kind of theoretical reflection developed within an analysis of the still photograph finds a new relevance for the moving image. To start with, I want to try to approach the theoretical implications of these issues through a short summary of some

aspects of the fraught but also productive relationship between still and moving images in the cinema.

The problem: does the temporal property of the index, its link to a moment in time, a quality so easily and consciously attributed to the still photograph, tend to get lost in the moving image? And then: if stillness does appear in the moving image, does the index find visibility? These questions involve a return to familiar ground for photographic theory and to some of the best-known sites of its discussion and elaboration. But these reflections might, now, have new relevance for cinematic theory.

Roland Barthes, unsurprisingly, provides a point of departure. *Camera Lucida* establishes key attributes of the still photograph's relation to time. Most particularly, Barthes suggests that as the photographic image embalms a moment of time it also embalms an image of life halted, which eventually—with the actual passing of time—will become an image of life after death. In numerous passages, he associates the photographic image with death. But he denies that this touching presence of embalmed time and life halted can appear in cinema. Not only does the cinema have no "punctum" but it also both loses and disguises its relation to the temporality that is characteristic of the still photograph. In the first instance, this is due to movement:

In the cinema, whose raw material is photographic, the image does not, however, have this completeness (which is fortunate for the cinema). Why? Because the photograph, taken in flux, is impelled, ceaselessly drawn towards other views; in the cinema, no doubt, there is always a photographic referent, but this referent shifts, it does not make a claim in favor of its reality, it does not protest its former existence; it does not cling to me: it is not a specter.[2]

Furthermore:

The cinema participates in the domestication of Photography—at least the fictional cinema, precisely the one said to be the seventh art; a film can be mad

by artifice, can present signs of cultural madness, it is never mad by nature (by iconic status); it is the very opposite of a hallucination; it is simply an illusion; its vision is oneiric, not ecmnesic. [3]

Barthes draws attention to two major considerations here. First of all there is movement: the movement essential for cinematographic technology to function as the celluloid travels through the machine, further enhanced by the camera's own ability to move. Secondly there is fiction: the conceptual and ideological properties of storytelling. Between the two exists the "objective alliance" that links cinema's mechanical forward movement, the illusion of movement and the movement of narrative. This prioritization of movement has dominated cinema from its origins (although avant-garde movements have continually rebelled against it), and now is beginning to blur as celluloid is displaced onto technologies that allow access to an illusion of its inherent stillness. In the new technological era, with different hierarchies and changing priorities, movement is just one property among others.

Raymond Bellour paraphrases Barthes's distinction between the photograph and the cinema, saying:

On one side there is movement, the present, presence; on the other, immobility, the past, a certain absence. On one side, the consent of illusion; on the other a quest for hallucination. Here a fleeting image, one that seizes us in flight; there a completely still image that cannot be fully grasped. On this side, time doubles life; on that time returns to us brushed by death. [4]

The question of cinema's relation to fiction is central here and leads directly to the film fiction's "double temporality." Unlike written or oral narratives, a fundamental duality of conflicting temporalities lies at the heart of narrative cinema. First, there is the moment of registration, the moment when the image in front of the lens is inscribed by light onto photosensitive material passing behind the lens. Each frame is exposed singly, as though it were a still photograph. This process of inscription, the physical link between the object and its image, is, in semiotic terms, an index. The index is the source of the image's place in time, its relation to the past that gives it, in common with the still photograph, its characteristic "there-and-then-ness." However, this primary presence of time suspended needs to be absorbed into

and masked by the time of the story which enables fiction's diegetic world to assert its validity and for the cinema to spin the magic that makes its storytelling work. Just as the still frame is absorbed into the illusion of movement of narrative, so does the "then-ness," the presence of the moment of registration associated with the aesthetics of still photography, have to lose itself in the temporality of the narrative and its fictional world. There is a presence, a "here-and-now-ness," that the cinema asserts through its "objective alliance" with storytelling. Such an assertion of a fictional present downplays, even represses, the aesthetic attributes cinema shares with the photograph.

To summarize: cinematic narrative asserts its own temporality. Everyone knows that the moving image has difficulties with tense; thus the use of clumsy flashbacks, calendar leaves flipping forward, etc. On the other hand, its temporal ambiguities may be exploited for aesthetic purposes, as, for instance, in *Last Year at Marienbad*. But all these devices, whether clumsy or complicated, tend to remain within the temporality demanded by the story, and the "there-ness" and the "then-ness" of the film's original moment, its moment of registration, stays hidden.

However, Bellour goes on to point out that, at certain moments within a fiction, the film's original, repressed time can break through and find a momentary presence. Even if the spectator is unable to halt time in the cinema, films can, and indeed often do, refer to stillness by direct reference to photography within a given story.

What happens when the spectator of a film is confronted with a photograph? The photo becomes first one object among many; like all other elements of a film, the photograph is caught up in the film's unfolding. Yet the presence of a photo on the screen gives rise to very particular trouble. Without ceasing to advance its own rhythm, the film seems to freeze, to suspend itself, inspiring in the spectator a recoil from the image that goes hand in hand with a growing fascination.... Creating another distance, another time, the photo permits me to reflect on the cinema. [5]

And he then ends with:

As soon as you stop the film, you begin to find time to add to the image. You start to reflect differently

on film, on cinema. You are led towards the photogram—which is itself a step further in the direction of the photograph. In the frozen film (or photogram), the presence of the photograph bursts forth, while other means exploited by the mise-en-scene to work against time tend to vanish. The photo thus becomes a stop within a stop, a freeze frame within a freeze frame; between it and the film from which it emerges, two kinds of time blend together, always inextricable but without becoming confused. In this the photograph enjoys a privilege over all other effects that make the spectator, this hurried spectator, a pensive one as well. [6]

Here, Bellour makes a crucially important connection between the halting of narrative, the eruption of the still within the film, and a shift in the nature of spectatorship that also affects the representation of time. The appearance of a still image gives a greater degree of visibility to the moment of registration and, out of that space in narrative flow, the "pensive" spectator is enabled to reflect upon and experience the kind of reverie that Barthes had associated only with the photograph.

The time of registration and the time of the fiction are in tension with each other and have often been taken to stand in polar opposition, marking the difference between illusion and materiality. At this point, there might well seem to be a hidden agenda emerging from behind my argument. To strip away narrative and reveal the actualities of both celluloid and the cinematic apparatus resonates with the materialist, avant-gardist aspiration of the 1960s and 1970s. There is definitely, of course, an element of this in my argument. On the other hand, the cinematic representation of time cannot be exactly pinned down or stabilized; it contains its own dialectic between stillness and movement that goes beyond the opposition between the illusion and the material. This has always been an aesthetic advantage for cinema and has been exploited by the most interesting directors and filmmakers across the spectrum from classical cinema to avant-garde film. For instance, Raymond Bellour's example of stillness is taken from Max Ophuls's *Letter from an Unknown Woman*, while Hollis Frampton's *(nostalgia)* bears witness to a fascination with temporal paradox and contradiction. But there are two further considerations here. First of all, the translation from one medium to another introduces a relationship between old and new and thus a further dimension of temporality

that is, in itself, elusive. Second, the sensation of "then-ness" associated with the photographic index is mixed with uncertainty and remains outside any easy designation. Both uncertainties lead to the difficulty of conceptualizing time and its close connection to human mortality.

In *Camera Lucida*, Barthes tries to pin down this elusive relation to time. For him, the photograph's fascination lies in its continued assertion of its indexical moment: a "then" that persists into "now." He resorts to using "shifters," those parts of speech that can vary according to the speaker's position in time and/or space, thereby evoking this disturbing, trompe l'oeil effect. "Was" and "is" and "this" and "that" join "then" and "now." The temporal complexity of the index persists into the cinema, potentially creating a strong pull toward the reality of registration as a moment of stillness or seizure. On the other hand, cinema is a medium of duration. A film unfolds; its movement through time has to have an initial starting point that refers to a future closing point. And this momentum is often further overlaid by the temporalities of fiction.

The passing of time itself affects what is seen on the screen. So much of cinema history now belongs to historical time, and the people depicted on the screen as living, animate beings, from insignificant passers-by to major Hollywood stars, are now dead. Temporalities begin to blur and the intractable, indexical, pastness of the cinematic image begins to make itself more visible to consciousness and imagination. Siegfried Kracauer, writing in the 1950s, reflects on the way old films depicting the settings and milieus of one's earlier life at first seem absurd and then suddenly change their meaning:

As he laughs at them, however, he is bound to realize, shudderingly, that he has been spirited away into the lumber-room of his private self.... In a flash the camera exposes the paraphernalia of our former existence, stripping them of the significance that originally transfigured them so they are changed from things in their own right into invisible conduits.[7]

He describes this sense of being revisited by the past as it is channeled through film into the present, precipitating the kind of involuntary memory that itself confuses time:

The thrill of these old films is that they bring us face to face with the inchoate, cocoon-like world from

which we come—all the objects, or rather the sediments of objects, that were our companions in a pupa state.... Numerous films...draw on the incomparable spell of those near and far away days which mark the border region between the present and the past. Beyond it the realm of history begins.[8]

Alongside the passing of time, new technologies give the spectator control of the viewing process. Now, by stilling or slowing movie images, the time of the film's original moment of registration suddenly bursts through its artificial, narrative surface. The cohesion of the story begins to crumble and other elements seep into and interact with the narrative. Another moment of time, behind the fictional time of the story, begins to emerge through this kind of fragmentation and excavation of a sequence or film fragment. The film acquires a transparency, so that other levels or planes essential to the cinema can make themselves felt. The process may, perhaps, be compared to a stretching out of material on which the printed pattern begins to reveal other, hidden, textures and meanings. Even in the case of a Hollywood movie, beyond the story is the indexical imprint of the pro-filmic scene: the set, the stars, the extras take on the immediacy and presence of a document, and the fascination of time fossilized can overwhelm and halt the fascination of narrative progression. The "nowness" of story time gives way to the "then-ness" of the movie's own moment in history. But even as this process of transformation, or distanciation, takes place, the two kinds of time rub against and affect each other. The flow of the story can give way to the presence of document, while a shot stilled can emphasize a gesture or look that enhances and illuminates a character or event in the narrative.

As cinema ages, the aesthetic polarities critically analyzed throughout its history seem to become less important in their differences and more important in their dialectical relations with each other. Rather than diverging into an either/or, for instance, specificity of the film-strip versus illusion of movement, fiction versus document, grounding in reality versus potential for fantasy, these aspects of the celluloid-based medium move closer together.... Passing time, in itself, shifts perception of relations and aesthetic patterns, and these shifts are, in turn, accentuated by the new horizons formed by new technologies. As a result, perhaps a new kind of ontology may emerge, in which ambivalence,

impurity, and uncertainty displace the traditional oppositions. Cinema's inherent, but often divergent, possibilities not only seem in retrospect more compatible but also to have had more complex relations, more dialectical interaction. In this possible aesthetic, interest lies in cinema's potential for shifting its form and for mutating its being, creating the trompe l'oeil effect in which uncertainty is, at the same time, a certainty because its magic works without recourse to deception or dissimulation. From this perspective, cinema becomes more, rather than less, complicated and moments or movies that bring out this potential for ambivalence become correspondingly more significant.

The different possibilities of film consumption brought about by new technologies have transformed both an understanding of spectatorship—my own longstanding theoretical point of engagement with cinema—and also forms of textual analysis as a key method of critical practice.[9] The concept of the voyeuristic spectator that I developed in my earlier writings depended, in the first instance, on certain material conditions of cinema exhibition: the darkness of the auditorium, the projector beam lighting up the screen, the procession of images that imposed their own rhythm on the spectator's attention. And, of course, it was the particular structure of this kind of spectacle that the Hollywood studios refined so perfectly. In counterdistinction, I later tried to evolve an alternative spectator who was driven by curiosity and by the desire to decipher the screen. The curious spectator was, perhaps, an intellectual, informed by feminism and the avant-garde. The idea of curiosity as a drive to see, but also to know, still marked a utopian space in which the cinema might respond to the human mind's longstanding interest in puzzles and riddles. This spectator may be the ancestor of the one now formed by those new modes of consumption that open up the pleasures of the hidden cinema to anyone who cares to experiment with the equipment available.

I have, in the first instance, attempted to adapt Raymond Bellour's concept of the pensive spectator in order to evoke the thoughtful reflection on the film image that is now possible, a way of seeing into the screen's images, stretching them into new dimensions of time and space. The pleasure in the fragment leads to the pleasure in the still itself. Here the pensive spectator can confront the film's original moment of registration, revealed once the

narrative's ornament has been stripped away. With the hybrid relationship between the celluloid original and its new electronic carrier, there is time to reflect on time itself and on the presence of the past and on the "then-ness" of the photographic process. It would seem that the pensive spectator might be able to rescue those aspects of the cinema that Roland Barthes felt were lacking next to the complexity of the photograph. It might be possible for cinema to "make a claim in favor of its reality," to "protest its former existence," and for its investment in emotional detail "to cling to me." Certainly, the cinema is increasingly inhabited by specters. Similarly, the oppositions extracted by Bellour that evoke the different attributes of film and photography are now producing new relations and connections to each other, sequentially or simultaneously, out of which a new oscillating image of time may be beginning to emerge. Movement gives way to immobility, the present tense of movement is interrupted by the sudden eruption of stillness and the past, and absence becomes presence. On the other hand, there is an even more acute sense that time cannot be grasped and that "time that doubles life" returns all the more clearly "brushed by death."

I have argued for the pensive spectator's relation to curiosity, even to cinephilia. But the pensive spectator may also be "fetishistic." The slowing down and stilling process opens up new areas of fascination especially in relationship to the human figure. Certain privileged moments can become fetishized moments for endless and obsessive repetition, while a star or a performance can suddenly acquire a further dimension of fascination once freed from their subordination to narrative. This new, freely accessible stillness or slowness, extracted from the moving image, is a product of the paradoxical relation between celluloid and new technology. It is primarily the historic cinema of celluloid that can blossom into new significance and beauty when its original stillness, its material existence in the photogram, is revealed in this way. The cinema has always been a medium of revelation and, once again, there is a paradox here. The magic of cinema has been identified, throughout its history, with its ability to simulate movement. In very early film demonstrations, this element of revelation could be built into the staging of the show. The projection might start with a stilled image, a projected photograph. Suddenly, the image would come to life and the magic of cinema would infuse the screen. Now,

perhaps, the magical moment, perversely and paradoxically, comes with a reversal of direction: a new fascination comes into being when the moving image is stilled. The new, from this perspective, allows a fresh and unfamiliar insight into the old. Just as the early theorists of film celebrated the way that the camera could reveal more of the world than was perceptible to the naked eye, now the pensive spectator can discover more in the celluloid image than could be seen at twenty-four frames per second.

My reworking of Bellour's concept of the pensive spectator depends on the paradox that I introduced toward the beginning of this essay: that our capacity to look into the cinema's celluloid images is a product of new technologies. This, of course, brings yet another element into this picture of displacements, hybrids, and reverberations. Thomas Elsaesser's vision of the digital as a "horizon" for thinking about the nature of the cinema is coupled with the idea of the digital as "time machine." Both suggest a knight's move beyond the confines of the media themselves, in which time itself becomes a subject for thought, but also for reverie and for the imagination: how time is inscribed into culture, and how it becomes lost in the elusiveness of history. Of course, this is really only a metaphor—but one that can perhaps be activated by the presence of time halted.

LAURA MULVEY is professor of film and media studies at Birkbeck College, University of London. She is the author of *Visual and Other Pleasures* (1989), *Fetishism and Curiosity* (1996), and the BFI Classic on *Citizen Kane* (1993). She has made six films in collaboration with Peter Wollen, including *Riddles of the Sphinx* (1978), and one film in collaboration with Mark Lewis, *Disgraced Monuments* (1994).

This text is excerpted from "The 'Pensive Spectator' Revisited: Time and Its Passing in the Still and Moving Image," in David Green, ed., *Where is the Photograph?* (Brighton and Kent: Photoforum and Photoworks, 2003), pp. 113–22.

1 Thomas Elsaesser, "Digital Cinema: Delivery, Time, Event," in Thomas Elsaesser and Kay Hoffmann, eds., *Cinema Futures: Cain, Abel or Cable? The Screen Arts in the Digital Age* (Amsterdam: Amsterdam University Press, 1998), pp. 204–5.

2 Roland Barthes, *Camera Lucida* (London: Vintage, 1993), p. 89.

3 Ibid., p. 117.

4 Raymond Bellour, "The Pensive Spectator," *Wide Angle* 9, no. 1, p. 6. Christian Metz also points out that the immobility and silence of the still photograph, with its connotation of death, disappears in the moving image. See Christian Metz, "Photography and Fetish," *October* 34 (fall 1985): 81–90.

5 Bellour, pp. 6–7.

6 Ibid., p. 10.

7 Siegfried Kracauer, *Theory of Film* (Princeton, N.J.: Princeton University Press, 1997), p. 56.

8 Ibid., p. 57.

9 Predating the modes of consumption made possible by new technology, it was, of course, the critical practice of textual analysis developed in the 1970s that first systematically fragmented narrative film. Textual analysis generated a tension between the coherent narrative "whole" and the desire, as it were, to capture the cinema in the process of its own coming into being. The segment received privileged attention; a fragment was extracted from the overall narrative structure of a film's horizontal and linear drive. However, as noted above, in the era of celluloid, textual analysis was extremely difficult to put into practice since only the very fortunate had (limited) access to 16 or 35mm flatbed editing tables.

Drawn to You
Catherine de Zegher

Why has drawing, long the least considered of mediums, in recent years become so all-pervasively present, receiving an unaccustomed attention in the art world? Is it because drawing as a fluid, fractured, and open-ended medium can so aptly encompass deeply felt anxieties of uncertainty and displacement? Apparently, drawing meets the present-day requirements of embodying a destabilized sense of existence in a fragmented world. Open to the imminence of events and social conditions of dispersal, drawing, with its inherent characteristics of incompleteness and potential for large diversity, seems to be a most pertinent materialization of our current experience of the world. As drawing is largely not geared toward closure or completion, it can deal with an idea of lack as well as with the phenomena of increasingly greater amounts of information. When there is a complex correspondence between the intrinsic qualities of an art practice and its capacity to resonate with our perception of the world, that practice becomes relevant to society. Furthermore, it is fascinating to observe how, where previously one medium had existed as the dominant mode of expression, contemporary art practice encourages the hybridizing of disciplines. Drawing, at once permeating all fields and standing independent, answers to this demand for interaction, while it refuses homogenization. Or, simply taken from the beginning, is drawing a kind of pre-medium that allows for an inscriptive act having its origins in a primitive memory of the infantile "body in pieces"? [1]

There is undoubtedly a profound connection in drawing between the thought of the decentered and scattered body, associated with fragmentation, and the reenactment of early experiences of love, loss, and retrieval. As a primary response to the world, drawing is an outward gesture that links our inner impulses and thoughts to the *other* through the touching of an inscriptive surface with repeated graphic marks. To begin with, the gesture itself is more important than the mark or the gaze. In the act of drawing, the extending

of arm and hand away from the bodily axis seems to correspond to the gesture involved in the first separation and exploration processes when the child reaches out to the departing mother. Enacting the marking gesture with a crayon, the child follows her movement as she leaves, and afterward, contemplating the *answer* of his gesture on the page, identifies with the trace that this action has left for him. The drawn mark thus stages not only a separating but also a binding in the discovery of the trace.[2] Indeed, the story goes that drawing was invented in the gesture of a young woman, the daughter of the Greek potter Boutades, as she circumscribed the shadow of the shepherd she loved on the wall when he was about to leave. In the gesture of tracing the outline, the lover addresses the beloved. The drawing *speaks* more through its tracing than in its trace, more through its process than as a product. At the moment of its invention and creation, drawing seems to exceed what subsequently passes for drawing itself. This ambiguity generates an oscillation between drawing's basic concepts of immediacy and mediation, touch and gesture, the tactile and the visual.

Informed both by rupture and reciprocity, drawing constitutes a haptic space in which the outward gesture conjures up a trace on the paper used to retrieve the thought that has been cast out. This back-and-forth motion, in which sheer kinetic release is substituted by the possibility of its representation, opens up to processes of symbolization and contributes to the construction of a mental framework that produces and renews meaning.[3] The paper becomes the container for gathering scattered sensations and thoughts cast and then retrieved. The line on the page may simultaneously be seen to separate and to join. All of this reflects the vivid dialectics of drawing as a coming-into-language that concerns our ability to respond to the other—a public act, hence a *responsibility*. For drawing is intimacy as much as conversation, because to gesture outward is not only the "I exist," but "I exist in relation to someone else." An act of consciousness, the intimate gesture of drawing is a process by which the artist situates him or herself in the world, within relation, in turn providing for a kind of self-recognition. Signification germinates in the gesture's transferring into marks—of image or text—and it does so in a continuous present for both the artist and the beholder, who retraces the drawing with the mind's eye, following its bare lines and varied textures.

Because of its reflexive quality, drawing can be recognized as a core medium of exploration. From simple doodles and preparatory sketches to elaborate pictures, drawing engenders several interpretations of what it actually achieves: It always stands at this critical point of transition—a transition between self and other, attachment and separation, imagination and realization, idea and plasticity of form, be it fluid or fixed. Historically, drawing—in its most ephemeral as well as its most realized stage of appearing—has sustained, in its marks and contours, mutual relationships. In order to articulate and emphasize the crucial role of drawing in the development of creative thought and in the visual arts, it should be interpreted as widely as possible, confronting draftsmanship with experimental work inside and outside the so-called margins of artistry. In the same sense that drawing in its connection to many aesthetic fields crosses the boundaries between diverse art practices, the definition of drawing is an expanded one linked to other disciplines. Standing between different forms of expression, drawing gathers around itself a diversity of ideas and engages with numerous art practices, their methods and techniques (such as projection, video, sound, set design, and so forth). In fact, to acknowledge drawing as autonomous and nonteleological as well as hybrid and transitive is already to rely on an extended interpretation of the medium that continues to relate the immediate experience of tracing to the knowledge accumulated on the blank page.

In this context, the role of cultural institutions and museums is not simply to trace, and not alone to interpret, but to engage together with artists and audiences, in contemporary thinking, understanding, and expressing the creative impulse. At present, the separation of disciplines and the authority of forms, among the principal motives of twentieth-century art, are in the process of being abandoned. Meanwhile, formalism and its repertoire of products are being gluttonously appropriated by the fashion industry, by the design community, and by advertisement photography. The result is formalism in a techno-aesthetic disguise, leading to a permanent confusion surrounding the definition of art. If the understanding of a fixed form as the ultimate artistic outcome belongs to a particular historical moment of reductive modernism, we may say that drawing's potentially unfixed and fluent relation to process allows a distance from this model. Always in a state of uncertainty, fragmentation, and flux, drawing can be considered as a possible and perhaps

even an inevitable subversion of formalism: the *informe*—at once formless and potentially becoming form—that refuses to be overwhelmed by the authority of form, because it is, at once, both tenacious and mercurial. As this development is being recognized, drawing may in a crucial way illuminate the importance of the process of making over a product in an institutional setting. But do today's institutions pay enough attention to the creative relation between artists and audiences in the processes of generating meaning? Could the role of the drawing medium be one of activism in the formation, concept, and development of an institution as social space regarding the making of art together? Or might developments in how drawing itself has recently been conceptualized initiate and allow new relationships within institutions?

There is a sense that drawing as antidote to a rigid modernist model has become the ideal latency of our time, appropriate because much of our under-standing needs to be rethought and renegotiated. This may not always be immediately apparent, however, when in the world around us confusion and disquiet about the very notion of society and art are struggling with the persistence of strong certainties. Nevertheless, ideas of art, culture, and society are in a period of profound change, and drawing can very well be seen as the most "valuable" medium for enacting this inquiry. Presenting *becoming* more than *being*, drawing is always in motion: active, shifting, and chang-ing—as close as it can be to the life of language. Looking at a drawing, one may see "not the thing itself but its possibility, its suggestion, the uncertainty as to what stage it is in its becoming…"[4] Though, taking into consideration that notions of art have changed, we can still assert that the historical imper-atives of drawing, its permeation through all fields, were cloaked through much of the twentieth century such that drawing became marginalized, a sub-ject for connoisseurs. Drawing in the twenty-first century, however, will inevitably be a pivotal activity—the sensation, the idea in itself, as it comes into being. The most shelved medium of the arts will thus be acknowledged as driven by and engaged with the currency of thinking about art and the world.

Considering drawing as relational, the aim is to question and depict the part the medium performs in the imaginative process. Though drawing may be the most resistant to definition of the arts—and perhaps because it is so difficult to specify—the medium offers a wide range of productive and analytic possibilities. In fact, like handwriting, drawing has always been connected

to a prime conceptualization with the line as symbolic abstraction of the entry into language. In processes of inquiry, the discipline of drawing has traditionally been considered both poetic and scientific, with high intellectual references, even when it expressed the unintentional and spontaneous. Alternating between the casual sketch and the elaborate picture, the preparatory study and the technically labored and finished work, drawing has often been divided into the preliminary and the accomplished. Since the seventeenth century, with the formal establishment of the parameters of the medium, this dual definition has allowed drawing to move in a liminal space lingering between the conceptual and the autographic. It remained defined in the two senses, even after the Cubists attempted to displace this division through the radical introduction of collage. In the 1960s, however, artists seriously investigated the medium, and those associated with Conceptual art thoroughly tilted the distinction toward the conceptualization of the idea. Artists' reexamination and reevaluation of drawing from a minor support medium of painting and sculpture to an independent art in its own right has led to the foundation of institutions (such as The Drawing Center) with the mission to promote drawing and its public appreciation.

During the twentieth century the ideology of modernism replaced the narrative and communicative functions of drawing with an almost exclusive consideration of its expressive, notational, and self-referential dimensions. Drawing has evolved from being considered the most gestural expression of the unconscious (such as in the automatic drawings of the Surrealists) to the matrixial design informed by the modernist credo of objectivity and deskilling (such as in drawings by Minimalist and Conceptualist artists). Through this trajectory, drawing has experienced a gradual transformation from an intimate graphological confession to a structural model in which lines and marks are organized according to a matrix determined by the space of the sheet. As soon as representation was defined by the generating process and material, drawing became the exploration of marks left by the process itself. Paradoxically, as this occurs, the autographic and conceptual seem to fuse again. In an era of eclecticism and electronics, it is this vitality of the moving hand and the exploring mind that remains a poignant and fascinating subject of an oppositional culture of drawing in the face of an ever-expanding and hegemonic system of technoscientific practices and forms of knowledge.

As a generative space of thought and sensation, drawing rehearses primary processes of exploration not only in the separation and binding between self and other, but also in the relation with other disciplines. As such, in its continuous effort of connecting, drawing acts counter to separation, including the division of media. Viewing the medium within this experimental position is a reemphasis of drawing not as marginalized but as a center around which circulate its origins, inspirations, and projections. This means that the aesthetic fields to be covered are very broad, from notations for choreography, theater, film, installation-based practices, musical scores, architectural design, and other arts, to drawings that are fully executed and self-contained representations. Understanding drawing as a transitional space necessitates an engagement with recent critical scholarship and historical thought as much as with the thinking that grows from the multitude of possible expressions of drawing. In other words, drawing becomes not the center of attention valued above all other mediums, but rather a crucial juncture at which all these themes and threads gather together. This, of course, is a changed notion of drawing, but one that carries the existing conventions with it—rather than simply abandoning them—while situating them within the larger context of our experience and the changing condition of our world. As it is defined here, drawing is not then isolated from the things to which it gives birth, but is most intimately a part of an unbroken set of relations: the self with the other with the artist with the institution with the audience with society at large. Collaborative on its own, drawing epitomizes mutuality, inclusion, and reconstruction, which are increasingly to supplement and partly to supplant modernist notions of alienation, separation, and negativity as strategies of the radical and inventive.

CATHERINE DE ZEGHER is the executive director of The Drawing Center in New York City. She has curated exhibitions in numerous leading international arts institutions, and her writings and editorial work on art and culture have appeard in publications worldwide.

1 My understanding of drawing has been informed by the work of artists such as Avis Newman, Nancy Spero, Ellen Gallagher, Craigie Horsfield, and Giuseppe Penone, to mention just a few. See also my conversation with Avis Newman in The Stage of Drawing: Gesture and Act. Selected from the Tate Collection, exh. cat. (New York: Tate Publishing and The Drawing Center, 2003).

2 Serge Tisseron, "All Writing is Drawing: The Spatial Development of the Manuscript," in Boundaries: Writing & Drawing, Yale French Studies 84 (1994): 29–42.

3 Ibid.

4 Newman, The Stage of Drawing, p. 278.

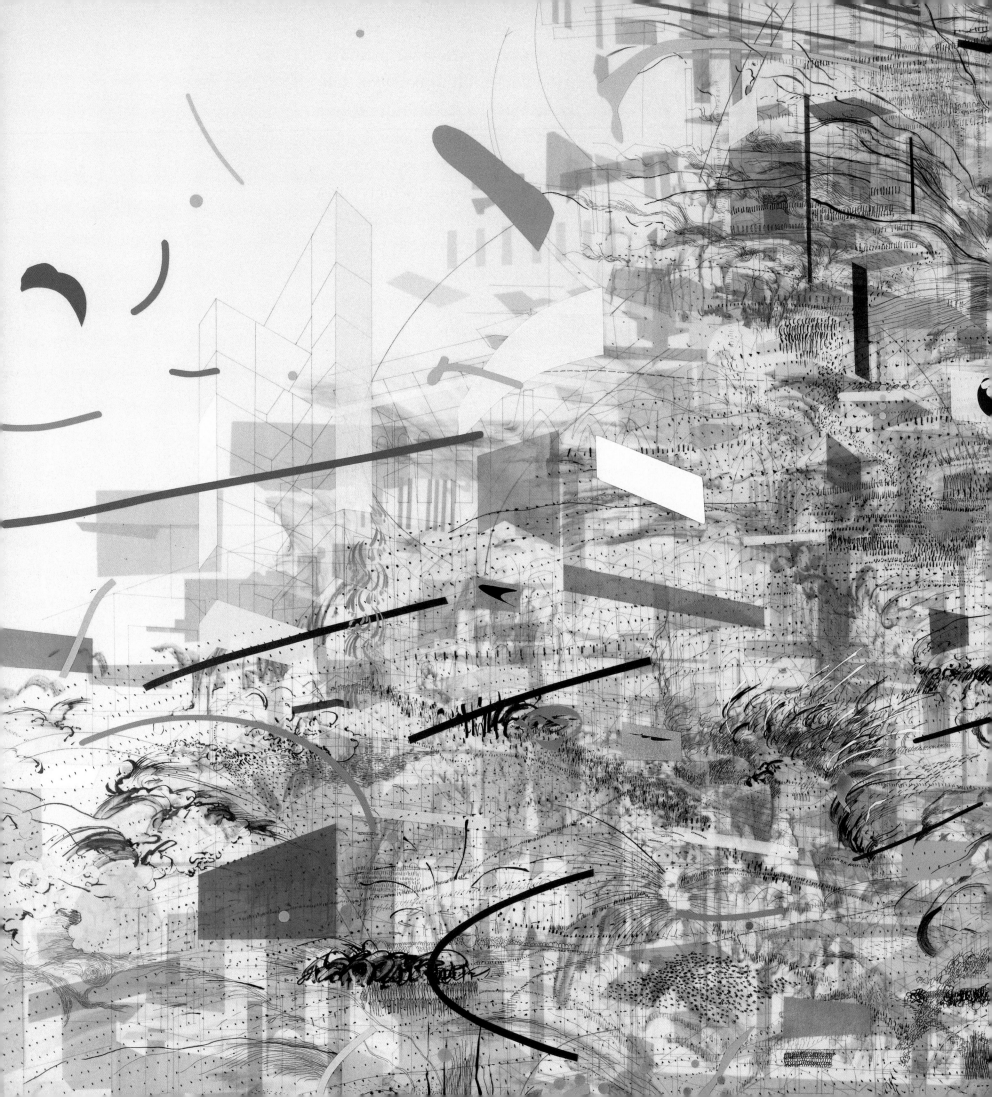

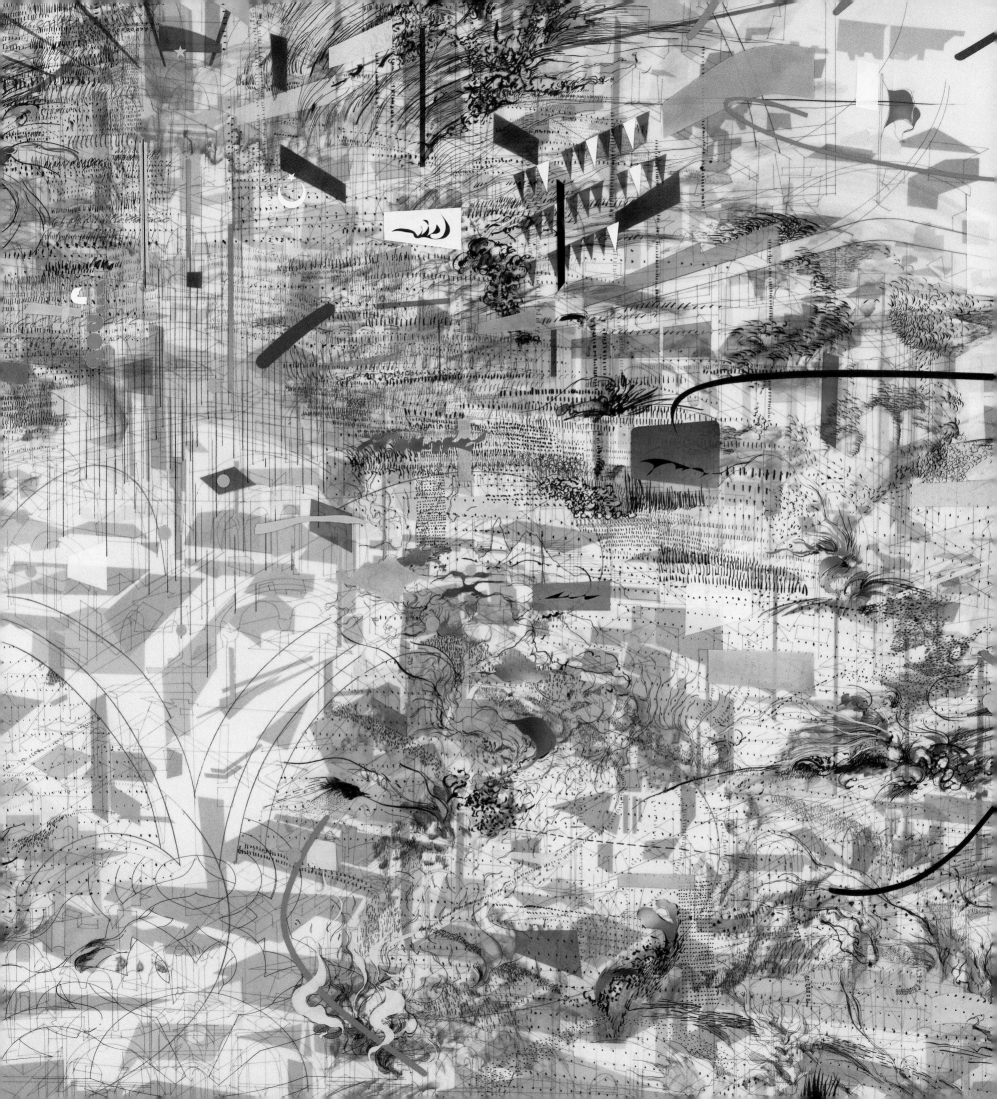

Thinking Past Terror

SUSAN BUCK-MORSS

The staging of violence as a global spectacle separates September 11 from previous acts of terror. The dialectic of power, the fact that power produces its own vulnerability, was itself the message. The attackers perished without making demands. They left no note behind, only the moving, deadly image, which the cameras of U.S. citizens themselves provided, just as the U.S. provided fuel-loaded, civilian planes that mutated suddenly into self-annihilating weapons. A mute act, played and replayed before a global audience—a message, sent by satellite to the multitude—a diversity of peoples who, witnessing the same cinematic time-image, the same movement-image, exploded into enemy camps.

Or did they? Sympathy was expressed generally by the global public sphere. Is the adequate word for the global reception, rather, "implosion," as a global terrain means by definition that there is no outside, at the same time that there is, tragically, no cohesion among the multitude who inhabit it? All the forces of global society, however radically incompatible, are immanent within this overdetermined, indivisible terrain.

Terror produces terror, as observers have long noted. Bin Laden and his supporters indeed pose a threat, but that threat doubles when it is countered in kind. A "fundamental paradox" of the paranoid style in American politics, wrote Richard Hofstadter in 1952, the era of the Cold War, "is the imitation of the enemy." [1] Now, as on that occasion, the acts of enemies reflect each other. The engagements of war cannot exist without this mirroring, which ensures an overlapping of the military terrain. In this terrain, we, the hijacked multitude, the vast majority, have been subjected to the common paranoid vision of violence and counter-violence, and prohibited from engaging each other in a common public sphere.

The U.S. national security state is a war machine positioned within a geopolitical landscape. It must have a localizable enemy for its powers to appear legitimate; its biggest threat is that the enemy disappears. [2] But given a war, even a Cold War, and now given an ill-defined yet total war on terrorism, the declared state of emergency is justification for suspending the rights and freedoms of citizens. It justifies arresting and holding individuals without due process. It justifies killing and bombing without oversight or accountability. It justifies secrecy, censorship, and a monopoly over the accumulation and dissemination of information. All of these state practices are totalitarian, of course.

In 1927, Stalin in his struggle for power took advantage of an almost hysterical fear in the Soviet Union that the Western powers would invade, declaring: "We have internal enemies. We have external enemies. This, comrades, must not be forgotten for a single moment." [3] The perception of a total threat legitimated the implementation of total, extralegal power both domestically and abroad. The word "terror" is used to describe the execution or imprisonment in the U.S.S.R. of thousands of purged party members in the 1930s, and we are accustomed to equating this terror with Stalin's name, as if one evil individual were responsible, rather than the logic intrinsic to the whole idea of terror. But Stalin justified his actions because the *citizenry* felt threatened, a state of mind that is fertile ground for abuses of power. According to one participant: "In the thirties we felt we were at war, at war with the entire world, and we believed that in war you should act like there is a war on." [4] The consequence was that popular support existed for Stalin's regime precisely because he was not squeamish about rooting out the evil source. The language, the thinking, has begun to sound unpleasantly familiar.

The unlimited, unmonitored wild zone of power is not unique to the United States. It is a potential of every state that claims sovereign power and, with it, a monopoly of the legitimate use of violence. [5] Two consequences follow. The first is that no matter how democratic the constitution of a state regime, as a sovereign state it is always more than a democracy, and consequently a good deal less. The second is that human rights, human freedom, and human justice cannot be exclusive possessions of one nation or one civilization. They must be global rights, or they will not be rights at all.

The problem is not that the West imposes its democratic values on the rest of the world, but that it does so selectively. It is inexcusable that rights be applied with a double standard, and then justified by calling it respect for cultural diversity. Samuel Huntington, no radical, describes Western duplicity: "Democracy is promoted but not if it brings Islamic fundamentalists to power; nonproliferation is preached for Iran and Iraq but not for Israel; free trade is the elixir of economic growth but not for agriculture; human rights are an issue with China but not with Saudi Arabia; aggression against oil-owning Kuwaitis is massively repulsed but not against non-oil-owning Bosnians." [6] As participants in a global public, we cannot allow ourselves, cynically, to accept such double standards. Humanity is the subject of the global public sphere, not the United States. No individual nation, no partial alliance, can wage war in humanity's name.

World wars, the particular insanity of the twentieth century, were struggles for territory. Sovereignty was a geopolitical concept. The enemy was situated within a spatial terrain. In this context, "defending the free world" meant, physically, pushing the enemy out, setting up lines of defense, deportation of sympathizers, pursuits into enemy territory, geographic embargoes—in short, spatial attack and isolation. The overthrow—"destabilization"—of nation-state regimes from within was a clandestine action, best done by indigenous forces, so as not to challenge the terms of legitimation of the sovereign-state system in which wars took place.

In today's global war, conflict cannot be discretely spatialized, a fact that has enormous implications in terms of the imaginary landscape. Because the enemy does not inhabit a clear territorial space, there is nothing geopolitical to attack. The fact that the United States has nonetheless attacked, first, the geopolitical territory of Afghanistan and then the Iraqi nation (far less plausible as a terrorist base) is indicative of its self-contradictory situation. Its superpower strength is still envisioned in traditional military terms. But the new global immanence means that there is no spatial other, a fact that the terrorists operating on September 11 exploited with brilliant brutality. In contrast, the United States is manifesting dinosaurlike symptoms by compulsively repeating its old tactics of massive, military response.

Globalization is not new, but global "immanence" is. I use this term to refer to the fact that in our era of global capital, global production, global labor migrations, and global penetration by technologies of communication, there is no "other" of peoples, territory, or environment against which some of us could conveniently define ourselves and, holding ourselves apart, control our fate. The global space that we share is contradictory, and intractably diverse. Our lived experiences are simultaneous and incongruous, resisting division into distinct nationalities, pure ethnicities, or racial differences. We are morally accountable in a multiple world where no religion monopolizes the virtue that would be needed to fight evil in its name, where there is no value-free, objective science that could ground universal, secular truth—just as there is no universal law of the market that can guarantee us a benevolent future.

Those who deny these everyday realities of global immanence fuel fundamentalism, of which there are as many types as there are intolerances. The mark of fundamentalism is not religious belief but dogmatic belief, which refuses to interrogate founding texts and excludes the possibility of critical dialogue, dividing humanity absolutely into pregiven categories of the chosen and the expendable, into "us" and "them." And whether this is preached by a head of state, or in a place of worship, or at the International Monetary Fund, no cultural practice—religious or secular, economic or political, rational or romantic—is immune to fundamentalism's simplifying appeal.

To equate the politicization of Islam with fundamentalism is as unjustified as to equate it with terrorism. Islamist politics is a broad and varied social movement, the voices of which span the entire known political spectrum, including a radical, progressive Left. Much of the movement is more fruitfully seen as a continuation of anticolonial struggles against Western imperialism, the secular, Marxist leadership of which was discredited in the Islamic world by, among other things, Soviet Russia's aggression in Afghanistan. Islamist political debates share with those of minorities within Western nations the struggle to forge political identities as they challenge hegemonic definitions, and they share the dilemma of identity politics as well: the pitfalls of essentialism and claims to authenticity on the one hand, and integration into a dominant culture (or dominant world order) that denigrates the traditions of the collective on the other.

Abdul-Kabir al-Khatibi, the Algerian-born, French-trained sociologist, has written of the necessity of a "double critique" practiced by Arab theorists to criticize their own societies from within and, at the same time, to criticize, from without, the Western concepts used to describe them.[7] Edward Said's book *Orientalism* has been, at least in the West, the most widely discussed account of the mythic nature of Western understanding of the Arab world, laying the groundwork (with others, like Talal Asad) for the argument that Orientalist "science" reveals more about the colonizers than the colonized.[8]

Within the Orientalist context, Arab consciousness was by definition overdetermined: both immanent and transcendent, a discourse within the West and a discourse from without. But a critical stance within one discourse did not necessarily include a critical stance within the other. What was called, at the turn of the twentieth century, the Great Awakening of Arab intellectual life employed an apologist discourse, justifying Arabic traditions of religious and secular thought precisely because they were compatible with modern Western values of scientific positivism, democratic reasoning, and the rule of law.

Kemalism, the modernizing ideology of Mustafa Kemal, who led the Turkish movement of nationalist liberation, broke from Western colonialism by literally copying its legal, political, and cultural forms. The Turkish leader ridiculed traditional Islam as a "symbol of obscurantism," the "enemy of civilization and science," and "a corpse which poisons our lives." [9] When Arabs adopted Western discourse in the Marxist mode as a secular critique of imperialism, this absence of a double critique tended to be just as prevalent, as Arab Marxists were similarly adamant that their own societal and religious forms were vestiges of the feudal past.

Interestingly, it was Islamism that inaugurated an autonomous tradition of immanent critique within the Middle East. The influential Egyptian writer Sayyid Qutb, a contemporary of the Frankfurt School theorists, critically attacked Islamic regimes as a return of the condition of ignorance—the "Jahiliyyah" of pre-Islamic times. Hence present-day Islamic society (Egypt) was un-Islamic. The strategy precisely paralleled the argument of Theodor Adorno and Max Horkheimer, in *Dialectic of Enlightenment*, that Western reason, which emerged from myth, had itself turned back into myth.[10] The difference, of course, was Qutb's move to positivity, his affirmation of a return to Islam as stated, literally, in the Qur'an.

This affirmation of the true Islam can be seen to mark a definitive break from Western-defined "modernity," allowing for an Islamic model to replace it. But what is striking about Qutb's understanding of the "self-evidence" of Qur'anic thought is that it, too, was dependent on the West, in the dialectical sense of critical

negation. Islam—the true Islam—appears in Qutb's work as the inverted other of Western modernity: spiritual where the West is materialist, communal where the West is egoistically individual, socially just where the West is greedy and competitive, morally disciplined where the West is negligently libertine. This was, of course, the antithesis of the apologists' strategy of redeeming Islam within the value categories of the West.

Now, the Western modernity that Qutb and others attacked was in fact the impoverished tradition of instrumental reason, possessive individualism, and lack of social consciousness that the members of the Frankfurt School and other European Marxists were criticizing from within. It would have taken a radical cosmopolitanism far in advance of what was possible at the time for both sides (German Jewish and Arab Muslim) to join forces in a critique of Western reason in its impoverished, neo-liberal, instrumentalized form. But the very thought of such an alliance, an attack launched from both within and without, suggests the power that a new Left in a global public sphere might begin to have today.

If we are interested in the genealogy of a global public sphere, we will need to note that the first radically cosmopolitan critique of Western-centric thought did not come from the Islamic world. It came from the French-speaking Caribbean, via secular, Marxist transport with a detour to Algeria—and when it appeared it came with a Western wrapping. I am referring to Frantz Fanon's remarkable book, *The Wretched of the Earth*, which (paradoxically introduced by the European, existentialist Marxist Jean-Paul Sartre) called on the non-Western world to leave Europe "behind"—that is, to produce a modernity that transcended the European model, which had proven itself bankrupt. Fanon's gesture suggested an intellectual liberation of a totally new order because while his politics was still identifiably Marxist, his approach refused submission to any ideology. It resonated with the actual lived experience of much of the colonized world that modernity had meant decline rather than progress—what Aijaz Ahmad has described as "the descent into bourgeois modernity" that marked the era of European imperialism.[11] It received brilliant rearticulation in a 1967 article by the Lebanese poet Ahmad 'Ali Sa'id (Adonis):

We no longer believe in Europe. We no longer have faith in its political system or in its philosophies. Worms have eaten into its social structure as they have into . . . its very soul. Europe for us—we backward, ignorant, impoverished people— is a corpse.[12]

Here the very words used by Kemal in rejecting Islam are turned against the postcolonial West. But Adonis is a secular thinker, who has no desire to posit, as did Sayyid Qutb, an inverted West, Islam, as the road to the future. The Fanonist critique was, however, taken up by Islamists, by Ali Shariati, for example, whose thought and writings would play a leading role in the Iranian revolution, and who was influenced as well by the Cuban Marxist Ché Guevara and by Latin American liberation theology—an eclectic theoretical mix held together by the object criticized—world imperialism, racism, and class exploitation—rather than any ideological form.[13]

My goal is not the retelling of intellectual history. Rather, it is to contribute to a discussion regarding a very specific, political question: How today, in what intellectually critical idiom, might a global Left learn to speak together? In this context, intellectual history undergoes a transfiguration, no longer a story of specific civilizational continuities, be they Western or Arabic or Islamic, but an archaeology of knowledge, to use Foucault's term, of a present global possibility.

We are looking for a route that will connect critical discourses that have evolved in partial contexts, in order to make them useful for a yet-to-be-constituted, global, progressive Left. We will not be satisfied with the realists' maxim—The enemy of my enemy is my friend—as this will not support global solidarity in a meaningful way. We also suspect that the splintering of the Left along the lines of discrete identities has run its course as a progressive form of critique, at least in its Western form, where identity politics now threatens to work to the advantage of anti-immigration nativism rather than the protection of cultural minorities. In its Islamist form, identity politics is indeed a powerful force, a constituency within civil society of over a billion people, connected in a global network of mosques. But those who desire (or fear) the crafting of this public into a uniform Islamist, global view do a disservice to the richness of debate that informs Islam, which not only allows critical thinking but requires it as a duty. If there are Islamist politicians who think they can count on support from a monolithic, unquestioning Muslim bloc, then these politicians are no less cynical and no less manipulative than their Western counterparts.

As critical Muslims, critical Israelis, critical Americans and Europeans, we cannot allow our identities to hold us apart. We recall Antonio Gramsci's insight that hegemony depends not on the absence of oppositional discourses but, rather, on the disorganization of dissent. We are indeed traveling a difficult road. But let us at least agree to eliminate false steps along the way.

There is the view, held by many serious and critical writers, particularly by those from former colonies living in (or writing for) Western audiences, that Samuel Huntington's prediction of a "clash of civilizations" has cleared the way for a counter-hegemonic challenge. Although Huntington, a realist, was describing a gloomy scenario of global struggle, his acknowledgment that civilizations other than the West have a role to play in a modernizing project (i.e., that Westernizing and modernizing are not synonymous) posits the coevalness of civilizations, which do not have to give up their identities in order to be full participants in progress. But Huntington is not radically critical in either the immanent or the transcendent sense, and his affirmation of other civilizations is more apparent than real.

The Turkish intellectual Ahmet Davutoglu, speaking specifically to Jürgen Habermas's claim that modernity is an "unfinished project," asks, then, "who shall complete it?… [W]hat will be the role of non-Western civilizations, which have been the object of this project, in the next phase?" Now, this might have led Davutoglu to a radical, cosmopolitan position, if he had allied himself with the original impulse of Habermas's statement, its immanent critique of the Enlightenment project that holds Western modernization accountable for its own shortcomings. Instead, Davutoglu drops the burden of double critique and falls into Huntington's fantasy of separate civilizations—as if any civilization could remain separate within the immanent global sphere. The West's self-critique, he asserts, becomes "an inter-civilizational crisis in response to the resistance and revival of the authentic self-perceptions of non-Western civilizations."[14] But a clash of civilizations cannot perform the critical, counter-hegemonic task at hand, which is not to replace one dominating civilization by another, but rather, to put an end to the structures of cultural domination.

The recognition of cultural domination as just as important as, and perhaps even the condition of possibility of, political and economic domination is a true advance in our thinking. Moreover, if the West does not have a monopoly on the future's meaning, then where else but the discarded past are we to look to imagine a future that does not yet exist? But—this is crucial—it is to the cultural imaginaries

of past civilizations that we must look for inspiration, not the power realities. In other words, cultures must be understood as always radical, in the sense that they are always negotiations between the real and the ideal, hence at least potentially in protest against the societies and power structures in which they emerge. The cultures that defenders of tradition look back to with such nostalgia are the dream-form of the societies that gave them birth. Precisely for that reason, in their time they functioned ideologically, covering up the inequities and iniquities of minority rule, patriarchal domination, class domination—all forms of the violence of power that deserve to be called barbaric.

Culture *and* barbarism—the barbarism of power that at the same time provides the control, the law and order, that allows culture to flourish—these are the two sides of the Golden Age of every civilization, whether it is called the Pax Romana, or Pax Britannica, or Pax Americana, or the Classical Age of Islam, or the heights of civilization of the Aztecs and Incas. No great civilization has been free of this contradiction. This was the tremendous insight of Walter Benjamin when he insisted:

Whoever has emerged victorious participates to this day in the triumphal procession in which the present rulers step over those who are lying prostrate…. There is no document of civilization which is not at the same time a document of barbarism.[15]

In revering and desiring within changed current conditions to salvage our different cultural traditions (and Marxism is one of them, as is Islam's Golden Age *and* the European Enlightenment), we would be well advised not to confuse the dream of the past with its reality. As we value the former, we must continue to criticize the latter. Such redemption of past culture would rip it out of its ideological role of justifying not only past violence, but new violence committed in its name.

The goal of a global Left cannot be reduced to the meaningless project of changing the religion or skin color or ethnicity of the exploiters. Whenever a social system produces a wealthy and powerful few on the backs of the many, a culture worth defending cannot be identified with its justification. Confucianism and Islam may point to the development of a different kind of capitalism, but it is not enough if this difference remains at the level of ideological justification, while the exploitation of human beings' creative labor and nature's creative labor remain the foundation of the production of social wealth. What is needed is not theological exegesis, but critical analysis of the world's problems in a way that might actually solve them.

What I am suggesting here is that a truly global public sphere might liberate thinking so that we are not compelled to take sides ("us" versus "them") or limit ourselves to an exclusionary paradigm of thought—religious or secular, postmodern or modern—in a way that stunts our capacity for critical judgments, leads to false intellectual and political conclusions, and prevents us from identifying similarities among fundamentalist positions, which must include the self-understanding of the United States as the Chosen Nation and the neo-liberal fundamentalism that leads to blind faith in the market mechanism, to name only two of the most blatant, non-Islamic examples. American hegemony is constitutive of the fundamentalist Islamism that opposes it; U.S. and Israeli state terror is not only the effect, but also the cause of the terror that resists it. These are the truths that need to be expressed by a global Left.

Within the United States, the implications for cultural politics are critical. This country has been living an anomaly: U.S. hegemonic culture spreads globally,

at the same time that it is woefully provincial. Ignorant and dismissive of the rest of the world, the U.S. projects its own norms and prejudices upon it. This has been true not just in Washington and Hollywood, but in the universities and high-cultural institutions as well. Ignorance combined with tremendous global power produces the American arrogance that the global public, understandably, resents. From the world of music to the art world, however, the "rest-of-the-world" is speaking back, demanding not merely inclusion in existing cultural practices, but transformation of their very structures.

What does "American art" mean in this fluid and volatile terrain?

SUSAN BUCK-MORSS is professor of political philosophy and social theory in the Department of Government and professor of visual culture in the Department of Art History at Cornell University. She is the author of *The Dialectics of Seeing: Walter Benjamin and the Arcades Project* (1991), *Dreamworld and Catastrophe: The Passing of Mass Utopia in East and West* (2000), and *Thinking Past Terror: Islamism and Critical Theory on the Left* (2003).

This essay is based on material from Susan Buck-Morss, *Thinking Past Terror: Islamism and Critical Theory on the Left* (London and New York: Verso, 2003).

1 Richard Hofstadter, *The Paranoid Style in American Politics and Other Essays* (New York: Alfred A. Knopf, 1965), p. 32.

2 I make this argument in Chapter 1 of my book *Dreamworld and Catastrophe: The Passing of Mass Utopia in East and West* (Cambridge, Mass.: The MIT Press, 2000).

3 Cited in Buck-Morss, *Dreamworld and Catastrophe*, p. 7.

4 Cited in ibid.

5 Ibid., Chapter 1.

6 Samuel P. Huntington, *The Clash of Civilizations and the Remaking of World Order* (New York: Simon and Schuster, 1996), p. 184. Huntington, the realist, concludes with a nonargued platitude: "Double standards in practice are the unavoidable price of universal standards of principle." He gives up on the idea of a global public sphere from the start.

7 See Hisham Sharabi, "The Scholarly Point of View: Politics, Perspective, Paradigm," in Hisham Sharabi, ed., *Theory, Politics and the Arab World* (New York: Routledge, 1990), pp. 36–37.

8 Edward W. Said, *Orientalism* (New York: Pantheon Books, 1978); Talal Asad, ed., *Anthropology and the Colonial Encounter* [1978] (Amherst, N.Y.: Humanity Books, 1998).

9 Mustafa Kemal, cited in Bobby S. Sayyid, *A Fundamental Fear: Eurocentrism and the Emergence of Islamism* (New York and London: Zed Books, 1997), p. 65.

10 I am not the only scholar to notice this similarity. See Roxanne L. Euben, *Enemy in the Mirror: Islamic Fundamentalism and the Limits of Modern Rationalism, A Work of Comparative Political Theory* (Princeton, N.J.: Princeton University Press, 1999).

11 Aijaz Ahmad, "In the Mirror of Urdu: Recompositions of Nation and Community 1947–1965" (Rashtrapati Nivas, Shimla, 1993), p. 20.

12 Sharabi, *Arab Intellectuals and the West: The Formative Years, 1875–1914* (Baltimore: The Johns Hopkins University Press, 1970), p. 136

13 "Come friends let us abandon Europe; let us cease this nauseating, apish imitation of Europe. Let us leave behind this Europe that always speaks of humanity, but destroys human beings wherever it finds them" (Shariati, cited in John L. Esposito and John O. Voll, *Islam and Democracy* [New York: Oxford University Press, 1996], p. 59).

14 Ahmet Davutoglu, "Philosophical and Institutional Dimnensions of Secularization: A Comparative Analysis," in John L. Esposito and Azzam Tamini, eds., *Islam and Secularism in the Middle East* (New York: New York University Press, 2000), p. 174.

15 Walter Benjamin, "Theses on the Philosophy of History," *Illuminations*, ed. Hannah Arendt, trans. Harry Zohn (New York: Schocken Books, 1968), p. 256.

Public Art Fund

Public Art Fund Projects in Central Park
A Collaboration with the Whitney Biennial

In 2002 the Public Art Fund and the Whitney Museum of American Art co-presented the first-ever Whitney Biennial in Central Park, a series of five installations that drew direct inspiration from the park itself. Like its predecessor, this year's presentation of works in Central Park—selected in collaboration with the Whitney curators and organized by the Public Art Fund—includes several site-specific responses to the park. But it also features works that were conceived independent of location and are shown purely as contemporary sculpture. In discussions with the Whitney curators it became immediately apparent that many of the artists under consideration for the exhibition were either currently working with the Public Art Fund or had done so in the past: assume vivid astro focus and David Altmejd had both been commissioned to make projects in the coming year for "In the Public Realm," our program for emerging artists, and Paul McCarthy, Olav Westphalen, and Liz Craft have all recently created Public Art Fund works. The confluence of these interests became the focus of our collaboration; as a result, several artists in this year's Biennial are represented by pieces in the museum as well as in Central Park, allowing viewers to experience a broader spectrum of the artists' work.

Intergenerational dialogue between artists is an important element of this year's Biennial, and these connections can also be found in Central Park, where works by emerging artists coexist with projects by well-known artists such as Yayoi Kusama. In the late 1960s, Kusama's happenings and nude performances—including a "body-festival" at the Alice in Wonderland sculpture in Central Park—were a regular feature of the city's public landscape. Her work for the park, a constellation of floating mirror balls in the Conservatory Water Pond, is only steps away from the site of her earlier piece. Just across the park, assume vivid astro focus's psychedelic floor-scape at Skaters' Road is a celebration of both the "Age of Aquarius" and the site's current use by hundreds of skaters in often flamboyant public displays of dance.

Using the language and imagery of the all-pervasive American consumer culture, Paul McCarthy creates works that distort and mutate the familiar into the disturbing and carnivalesque. His 30-foot-tall inflatable *Daddies Big Head* is pure roadside America gone awry, while *Michael Jackson, Big Head (Bronze)* is a grotesque disfigurement of a once-popular image. McCarthy's works, positioned at the northern and southern ends of the park, respectively, anchor the outdoor exhibition and shift the viewer's expectations of public sculpture in bold, even shocking ways.

Olav Westphalen's artistic practice lies between the realms of art and daily life, an approach pioneered by Allan Kaprow (with whom he studied in California) and further explored by McCarthy and other Los Angeles performance artists. Westphalen uses caricature and comics to challenge the "serious" traditions of Modernist and Minimalist art. For his work in Central Park, he drew on newspaper coverage of a recent spate of incidents involving "domesticated" tigers in the New York area, creating a life-size fiberglass tiger for the entrance to the Central Park Zoo.

Like McCarthy and Westphalen, Los Angeles–based artist Liz Craft finds inspiration in the everyday. For Central Park, Craft introduces pure California garden vernacular in the form of a series of desert cacti housed in planters made of disused tires. Titled *The Spare*, this incongruous series of sculptures presents the kind of cheap driveway furniture found in suburban California, but here cast in bronze. David Altmejd's werewolf heads—placed in two bucolic locations at the northern end of Central Park—are carefully crafted sculptural objects that explore notions of attraction and repulsion. At once seductive and macabre, the jewel-encrusted heads highlight the tense balance of sympathy and horror evoked by werewolves.

Taken together, the projects in Central Park offer an undiluted encounter with contemporary art that will enliven the experience of the park while encouraging a wide interest in how artists engage the world around us.

SUSAN K. FREEDMAN, President, Public Art Fund
TOM ECCLES, Director, Public Art Fund

All of the Public Art Fund projects in the Whitney Biennial are sponsored by Bloomberg and generously supported by Adam Lindemann.

Marina Abramović
Born 1946, Belgrade
Lives in Amsterdam and New York, NY

In her performances, objects, and installations, Marina Abramović has continuously tested both the physical and the spiritual limits of her body and mind in relation to the audience. In the early 1970s, she performed a series of works that addressed questions of consciousness, control, and transformation. In *Rhythm 2* (1974), Abramović publicly ingested two types of drug: one used to treat patients suffering from catatonia, the other a strong tranquilizer. The first caused her body to convulse uncontrollably, the other caused her to lose consciousness. In *Rhythm 0* (1974), Abramović transferred control to the audience for the duration of the performance. The artist presented a table with different objects— among them knives, a gun, a lipstick, and a rose— and invited the audience to use these on her body any way they chose, motionlessly allowing herself to be transformed by the public for the duration of the piece.

From 1976 to 1988, Abramović lived and worked together with Ulay. Their collaborative work included performances, or "relation works," that engaged issues of trust, endurance, and duality. In *Nightsea Crossing* (performed fifteen times between 1981 and 1987), Abramović and Ulay sat silently opposite each other at a table, remaining motionless in the museum, eight hours a day, up to sixteen days in a row— undermining the object through ephemeral action in object form.

In the 1990s, Abramović produced objects and installations incorporating minerals and crystals that allowed the viewer to engage more directly with the work. In *Crystal Cinema I* (1991), the viewer was encouraged to sit on a small wooden stool and stare at a quartz block. Abramović has also increasingly engaged questions of narrative and biography in her work. Since 1992, she has performed *Biography* (1992–), a work in progress about the artist's life that includes a brief restaging of all her previous performances. In her installation *The House with the Ocean View* (2002), Abramović lived in the gallery on a large raised platform divided into three "domestic" tableaux. There she fasted and remained silent for twelve days, while her normally private everyday routines—sleeping, personal hygiene—were visible to the assembled viewers. CI/CR

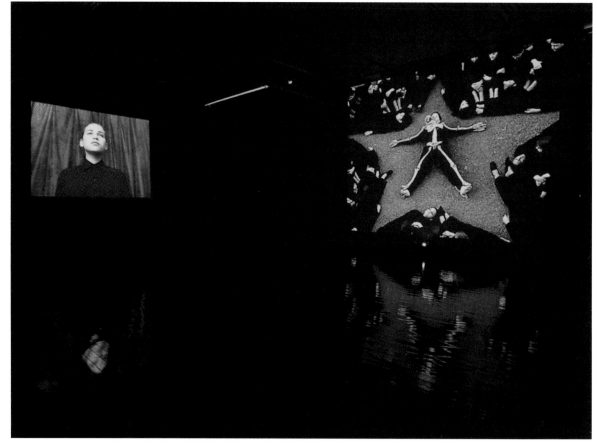

Installation view of *Count on Us*, 2003, at the Contemporary Art Museum, Kumamoto, Japan. Video installation, dimensions variable. Collection of the artist; courtesy Sean Kelly Gallery, New York.

Laylah Ali
Born 1968, Buffalo, NY
Lives in Williamstown, MA

Laylah Ali's small gouaches on paper probe the social inequities, hierarchical relationships, wanton aggression, and ethnic struggles fundamental to the human condition. The seductive, graphic quality of their rendering, distinguished by simple, clean lines and a predominantly blue, green, and black palette, belies the complexity of the situations represented, as the creatures act out on each other cruelties of various kinds. Removed from a specific time and place, the exact cause of strife is left to the viewer's imagination.

Like the work of Raymond Pettibon, Ali's compositions are inspired by the comic strip format. Her pared-down paintings on flat light blue backgrounds, delineated by almost photographic frames and cropped images, have a strong sense of design and deal with serious issues of race, class, and gender. Unlike Pettibon, however, text is omitted, leaving the viewer to decipher the unfolding narrative, for which Ali provides only minimal clues. The interplay between her figures establishes a linguistic style of its own that recalls the sticklike linearity of hieroglyphics. Lacking gender, class, age, and ethnicity, Ali's little brown-skinned figures, which she calls Greenheads, act as an alphabet, each one with its own personality, which as a whole signifies a unique metaphorical language for human action, emotion, and expression. Spherical heads, large in proportion to their grossly attenuated arms and elongated bodies, dominate their simplified anatomical features. The cartoonlike rendering and their small size endow them with a childlike quality, contrasting with the sophisticated social dynamics presented in the compositions. Although the gestures and actions of the figures are recognizably human, their likeness bears more similarity to aliens or insects. The creatures wear military uniforms, priestly robes, athletic suits, belts, Ku Klux Klan hoods, Egyptian headdresses, masks, and tennis shoes, which distinguish them from one another and imply differing social positions among the groups.

In her untitled gouaches from 2002 Ali departs from an emphasis on figuration, as her forms become more abstract and she explores a more varied palette. Several of these works have pink, purple, and red mounds with dismembered legs protruding from unidentified masses; many of the feet have been chopped off. Momentarily straying from the Greenheads, the artist introduces a new species, members of which have rosy pink skin tone and wear blue hooded leotards. In these works Ali leaves even fewer descriptive clues for the viewer, and the narrative has become increasingly obscured and fragmented. In one, four small, limbless, bandaged characters remain helplessly skewered by wooden sticks. With the situations becoming more abstruse and the imagery more apocalyptic, Ali leaves the viewer to ponder what has happened to the Greenheads and what future awaits these distant relatives. As a whole, the behavior of Ali's diminutive, unfamiliar figures and the psychological tensions among them provoke viewers to examine their own surrounding culture, where violence and social bias are a part of daily living. AD

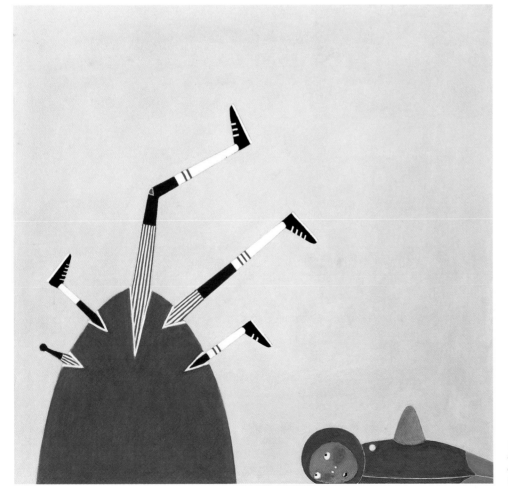

Untitled, 2003. Gouache on paper, 8⁹/₁₆ x 8¼ in. (21.7 x 21 cm). Private collection; courtesy 303 Gallery, New York

David Altmejd
Born 1974, Montreal
Lives in New York, NY

David Altmejd's sculptural installations draw the viewer into the interior labyrinths of the subconscious. His deceptively realistic sculptures and dramatic stage sets, evoking gothic altars, archaeological museum displays, and architectural models, give an uncanny materiality to the primal narratives they evoke.

Using mirrors, plastic, glass, and theatrical lighting, Altmejd creates dark, dramatic spaces that display and reflect his elaborate, grotesque sculptures. His installation *Delicate Men in Positions of Power* (2003) consists of multiplatformed stage areas and tomblike interiors lined with mirrors. This structure presents a spatial hierarchy among the various mythical species that Altmejd has created, which include werewolves and other monsters. Hidden below among shards of crystals and flowers are severed werewolf heads, occupying the lowest position in the kaleidoscopic catacombs. Making reference to the use of mirrors in the 1970s by artists such as Robert Smithson, these prismatic chambers dematerialize space by reflecting, refracting, and displacing the site of the object. This effect provides glimpses into the psychological constructions of the subconscious mind, hovering somewhere between the rational and the irrational. On the visible platforms above, the impaled head of a faceless species towers over cubed, mirrored lattices, a disintegrating werewolf cadaver sprouting crystals, and a network of jeweled garlands. The narrative of decay and rejuvenation pervades each of these elements, such as the mythical transformation of werewolves under a full moon and the alchemical allusions suggested by the prevalence of crystals throughout the installation.

The gridlike architectural platforms and theatrical displays unify Altmejd's system of myths and sculptural artifacts that appear to be on the verge of reinvigoration and rebirth. Altmejd considers the entire installation a single organism: "I have a feeling," he says, "that the whole piece is alive as an independent living thing with its own intelligence." HC

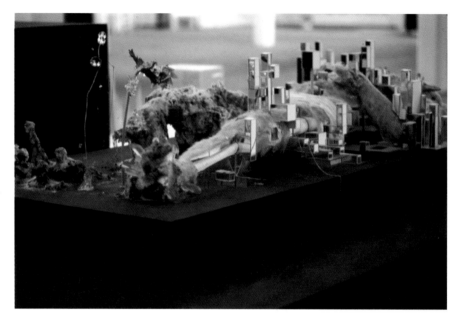

Delicate Men in Positions of Power,
2003 (detail). Mixed-media installation,
120 x 240 x 96 in. (304.8 x 609.6 x
243.8 cm). Collection of the artist

Antony and the Johnsons
Born Chichester, England
Lives in New York, NY

Embracing marginalized perspectives in mainstream American popular culture, Antony's empathic, emotionally naked songs about love, pain, death, and cultural alienation are as mysteriously redemptive as they are tragic. Formed in 1998, Antony and the Johnsons have performed widely in New York and elsewhere in such venues as Joe's Pub, the Knitting Factory, Central Park SummerStage, Mass MoCA, the Andy Warhol Museum, and the Wexner Center for the Arts. Additionally, Antony has appeared individually on Lou Reed's album *The Raven* (Reed's homage to the gothic writer Edgar Allan Poe), singing "Perfect Day," and toured with him internationally. Trained in experimental theater, Antony is self-taught musically, having written and composed songs since he was a child. With an androgynous voice—a natural tenor that shifts occasionally into alto—Antony cites as his musical influences Nina Simone, Marc Almond, Divine, Kate Bush, and Otis Redding, among others.

Antony moved to New York in 1990 and began performing at the Pyramid Club with Black Lips Performance Cult, a theater collective consisting of a diverse cast of characters. During that time, he wrote songs that dealt with revelatory themes of love, death, and victimization, which he partly attributes to his coming of age during the AIDS epidemic and environmental crises. His songs "River of Sorrow" and "Rapture," both released in 1998 on the self-titled album *Antony & the Johnsons*, explore a universal sense of loss while also conveying a search for transcendence.

For the 2004 Biennial Antony and the Johnsons performs songs from their new album, which Antony describes as "an orchestral journey through a psychic landscape of innocence, horror, and androgyny." The performances include a video by Charles Atlas, featuring a cast of thirteen beauties projected onto a giant screen. Laurie Anderson has said, "Listening to Antony's voice is like hearing Elvis for the first time: two words and he has broken your heart.... When he sings it is the most exquisite thing that you will hear in your life." AD

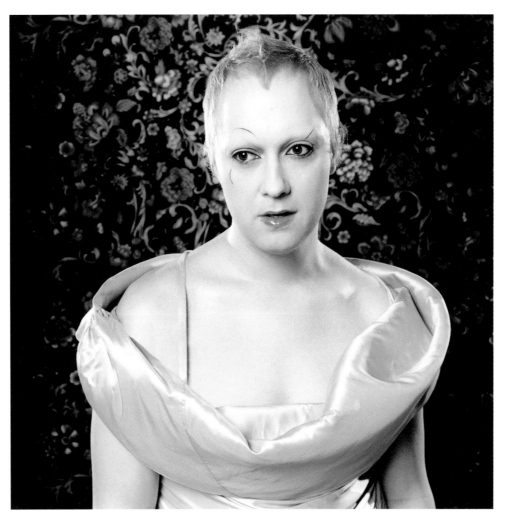

Photograph by Don Felix Cervantes

Cory Arcangel / BEIGE
Born 1978, Buffalo, NY
Lives in Brooklyn, NY

The aesthetic of Cory Arcangel's videos, video games, music packaging, silkscreen posters, and performances is shaped by 1970s and 1980s computer technology. He uses machinery and motifs from obsolete computers and video games: some works mimic pixilated 8-bit graphics or present the viewer with video game consoles and controllers; at other times, Arcangel performs with a combination of traditional musical instruments and machines. He believes that these machines—often Commodore 64s, Atari 800s, or 8-bit Nintendo Entertainment Systems—"have personalities, shapes, and architectures" that are worth investigating. To Arcangel and his collaborators in the art group and record label BEIGE, it is not the data—software—that is important, but the computers themselves. Arcangel emphasizes the idea of craft, creating every element of his art from scratch and often programming with the simplest coding language available.

Thus we are presented with Arcangel's "hacked" versions of classic video games: Super Mario Bros., with all visual elements removed except for the iconic scrolling clouds, or Hogan's Alley (another NES classic), edited to become *I Shot Andy Warhol* (2002), in which the contestant must shoot the Pop icon with a light gun in order to win the game. Recently, Arcangel collaborated with Joseph Beuckman, Joseph Bonn, and Paul Davis to release a 12-inch record featuring music generated by Commodore 64 and Atari 800 series computers. This is the first vinyl record to contain computer software embedded in its grooves. Enterprising customers can record the modemlike beeps onto audiocassettes, then "play" the program on the computers from which the sounds originally came (audiocassettes were used as data storage devices two decades ago, much as CD-ROMs are today).

Inspired by his classical music training, Arcangel insists on the complete mastery of these "fixed architecture" computers—his instrument of choice—prior to any creative exploration. This knowledge means that the artist "can make sure the operating system and every aspect of the work from the computer chip to the TV was intended and referenced in the work." Though avowedly apolitical, Arcangel's relationship with outdated machinery evinces a refusal to participate in the consumer culture associated with the never-ending and lightning-fast cycle of technological turnover. What can be viewed as mere nostalgia for the sights and sounds of pop culture artifacts is based on a rigorous conceptual approach to the use of computer hardware, programming languages, and the relationship between humans and machines. BJS

Installation view of *Super Mario Clouds v2k3*, 2003, at Team Gallery, New York, July 2003. Hacked Super Mario game cartridge, dimensions variable. Private collection; courtesy of the artists and Team Gallery, New York

assume vivid astro focus

assume vivid astro focus's all-encompassing artistic practice entails the production of tattoos, floor stickers, wallpaper, T-shirt designs, music videos, and large-scale installations. The name derives from musical group Throbbing Gristle's album *Assume Power Focus* and the Indie pop band Ultra Vivid Scene. At their core, the projects are about collaboration, generosity, and the unabating accumulation of cultural information, highly influenced by Félix González-Torres's wallpaper designs, billboard signs, candies, and posters. avaf adopts idioms of popular culture in order to make its message of generosity and inclusivity increasingly accessible, encouraging other people to assume its aesthetic identity in the process.

This ideology runs counter to our cultural obsession with celebrity and copyright ownership. The group mines culture in order to give back to it—a practice that echoes the Brazilian Anthropophagite movement of the 1920s, which consumed foreign influences while reconstituting them in the process. avaf functions on the nexus of several contradictions: it is a curatorial project while also being an artistic production; the art is both original and adapted; the projects begin as personal visions but are expanded to be universal; furthermore, stemming from one artist (who wishes to remain anonymous), the projects are an amalgamation of both solo and group exhibitions. Obscuring the dividing line between these dichotomies is integral to the avaf vision.

avaf installations stem from profuse and constantly evolving research, evident from the lengthy "To-Do Lists" released with each installation that reveal a diverse range of influences. The motifs avaf employs are located in popular culture and art history alike, culled from sources as varied as medieval unicorn tapestries, Francis Picabia, MTV, Fluxus art, psychedelic posters from the 1960s and 1970s, coloring books, and Tibetan *thangka* paintings. For avaf, these elements do not exist in isolation but, rather, become aesthetically and culturally interrelated. Exotic motifs such as birds of paradise, upside-down chandeliers, and swirling arabesques, all rendered in a colorful Pop-psychedelic style, recur throughout the projects, producing a seamless consistency across the work.

For the 2004 Biennial, avaf produces an installation that centers on a new video featuring Los Super Elegantes (other 2004 Biennial artists). Additionally, as part of the Whitney's collaboration with the Public Art Fund, avaf produces a large site-specific floor sticker for Central Park's famed roller skaters. avaf embraces an optimistic outlook that revels in fantasy and idealism but is at the same time contingent on culture and keenly aware of the details embedded in its surrounding environment. Self-consciously utopian, avaf strives for a conceptual ideal that it knows will inevitably fail in its application but still revels in the pursuit. AD

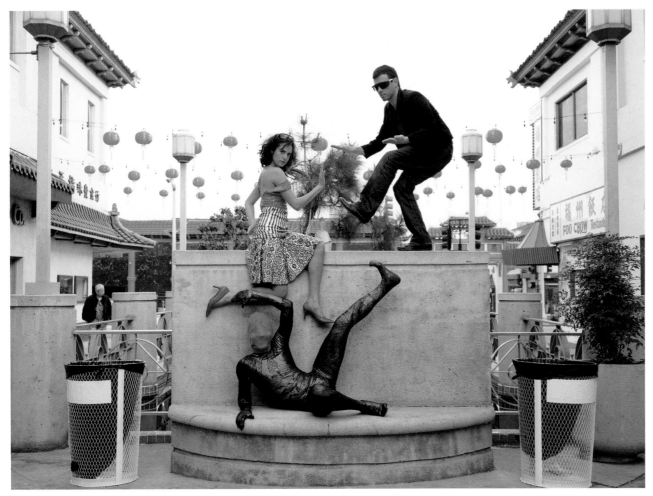

assume vivid astro focus featuring Los Super Elegantes. Still from *Light in Your Eyes (Butch Queen Vogue Fem Bizarre $$ Dressed Like a Ninja '04 Remix)* in *assume vivid astro focus 8*, 2004. Mixed-media installation, dimensions variable. Collection of the artist; courtesy John Connelly Presents, New York, and peres projects, Los Angeles

Hernan Bas
Born 1978, Miami, FL
Lives in Miami, FL

Hernan Bas's intimately scaled paintings and drawings construct personal narratives using images from sources as diverse as fashion advertisements and Boy Scout manuals. Bas explores gender ambiguity and androgyny in representations of slim, young, and decidedly unmasculine boys. In one series of works, titled *Slim Fast* (1999–2000), Bas presents pictures of adolescent, waiflike boys, all executed in different varieties of the diet drink popular with young women. For some of the works, Bas cut out images from advertisements and rendered them ghostlike by covering them in Slimfast; for others, such as *Strawberry Hernan* (1999–2000), Bas drew his own silhouette in the fruit-flavored liquid.

In *Hernan's Merit and the Nouveau Sissies* (2001), Bas used illustrations from Boy Scout field manuals; a drawing of a young boy in uniform daydreaming in a small rowboat in *Reclined* (2001) and an oil painting of four Boy Scouts trying to light a campfire in *Smoked Signal* (2001) capitalize on the dormant homoerotic tension found in manuals for an organization that bans homosexuals from its ranks. Bas explores the gray zone between male bonding and homosexual desire and aims to portray what he calls "fag-limbo," a developmental moment at which decisions of sexual preference slip effortlessly in and out of androgyny.

For his installation *It's Super Natural* (2002), Bas constructed a clubhouse that combines an improvised shacklike exterior, with leaning skateboard, and a slick white interior featuring magazine images of male models and a book by Oscar Wilde. The installation is completed by drawings of nocturnal scenes of boys exploring swamps, forests, and haunted houses, all based on the classic Hardy Boys mysteries series. Adding a twist to the genre of adolescent literature by grafting it onto a subtle display of homosexual desire, Bas combines the narrative of coming-of-age with that of coming out. But his highly personal appropriation of mass-mediated fashion images, American youth culture, and classic adolescent literature goes beyond the simple iconography of young homosexual identity. Instead, Bas revels in moments of indecision, when clear boundaries fail and a different set of imaginings take hold. He casts a dreamlike spell on his characters and suspends the moment of reality that occurs once things are named, when the certainty of linguistic attribution and definition casts aside doubts and freedoms alike. CR

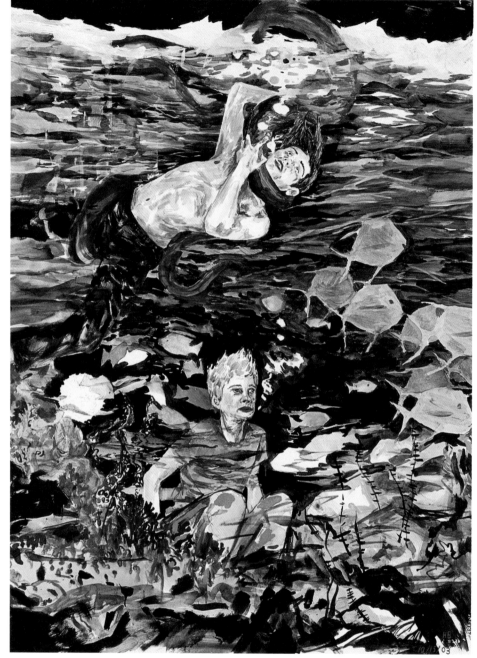

Laocoön's sons, from the series
A Little Moby Dick in All of Us, 2003.
Mixed media on paper, 30 x 22 in.
(76.2 x 55.9 cm). Collection of Stanley
and Nancy Singer; courtesy Deitch
Projects, New York

Dike Blair
Born 1952, New Castle, PA
Lives in New York, NY

Dike Blair is an unorthodox landscape artist. His assemblage sculptures and watercolors are influenced by the world of industrial production and mediated representation, in which the objects of corporate design and consumer culture have largely supplanted nature. Sensitive to the ongoing shifts in the relationship between the manufactured and the natural, for almost twenty years Blair has attempted to understand and give visual form to an updated definition of landscape no longer limited to the natural environment.

In the late 1980s and early 1990s, Blair's multimedia sculptures involved affixing photographs of nocturnal landscapes or abstract architectural details to panes of glass; he then painted over parts of the images and exhibited the works as part of a stylized environment. These environments covered over the "neutral" space of the gallery with the veneer of domestic or corporate interiors. A 1991 exhibition inspired by Disney's Epcot Center, for instance, surrounded individual works with mauve walls and carpet, metal chairs, and spotlit ferns. More recent sculptures attempt to fuse subject and surroundings. They include carpet fragments, light fixtures adorned with colored gels and photographic transparencies, and a tumbleweed of electrical cords. These works stay low to the floor and close to the wall, and could have been lifted from an avant-garde architectural site model, or assembled from the leftovers of a convention center trade show. The photographs, the only representational aspect of these works, are what Blair calls their "emotional keys," a hit list of leafy trees, fog-shrouded mountains, and bright moons in the night sky. Each seems an attempt to capture the sublimity of the natural environment, to depict scenes that are meant to be critically disarming. Blair insists that we look more closely, also seeing the images as a commentary on the ongoing nature-culture debate prevalent in the art world since the 1970s.

A sentimental longing for this increasingly problematic connection to nature enters into Blair's watercolors as well. Each is based on a photograph—all of Blair's art begins with observing his immediate environment, camera in hand—and usually presents an image of flowers in bloom or a tightly cropped window. These works impart wistfulness by pointing out the layers of mediation separating here from there. Blair's art has evinced an increasingly nuanced understanding of the link between culture and nature, and his synthesis of the two attempts to outline a way to understand the latter without losing it in the former. BJS

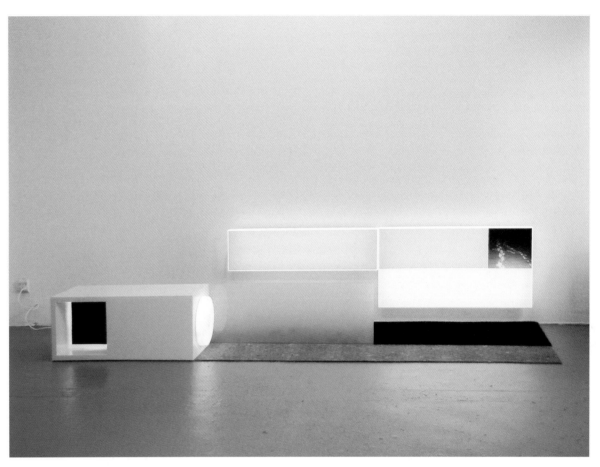

then, into, 2003. Fluorescent lights, carpet, color transparency (Duratrans), glass, wood, and paint, 32 x 144 x 45 in. (81.3 x 365.8 x 114.3 cm). Collection of the artist; courtesy Feature Inc., New York

Jeremy Blake
Born 1971, Washington, DC
Lives in Los Angeles, CA

Jeremy Blake's video projections, which he calls "time-based paintings," incorporate different material sources, including scanned drawings and paintings and 8mm and 16mm film footage. Fusing the possibilities of both narrative and abstraction, Blake's works often feature fictionalized and stylized allusions to real sites or architectural structures and contain references that range from Color Field painting to the hallucinatory effects of psychedelic drugs.

Bungalow 8 (1998) is a series of three color photographs and digitally animated video projections. The photographs depict fictional renderings of what appear to be architectural fragments of the original facade of a building, stylishly reminiscent of the restrained coolness of West Coast modernist interiors and geometric abstract painting from the same era. The videos also incorporate minimal, recognizable elements, such as a tiki torch in front of a building facade, which slowly change into almost abstract sequences of colors and shapes. *Chemical Sundown* (2001) continues Blake's fascination with the colors and optical effects associated with Los Angeles. A colored horizon line slowly evolves into a pair of solid-colored oval shapes, which turn into even more graphic patterns.

Winchester (2002) and *1906* (2002) are the first and second parts of a trilogy that engages the Winchester mansion, built continuously over a thirty-eight-year period by the widow of the heir to the Winchester rifle empire as a resting place for the souls of all those who were killed by the guns her family produced. In both videos, old photographs of the mansion slowly blossom into Rorschach test–like colored forms. *1906* presents a series of short, filmed sequences of the house, primarily interior views and pans. Each sequence is accompanied by the faded sound of a film projector, which gives way to a more atmospheric, somber soundtrack as the images change. Shots of rooms, internal shafts, walls, ceilings, curtains, and roofscapes slowly transform into prismatic color fields that resemble old-fashioned attempts to render visible ghostly presences. In both works, Blake carefully presents a range of visual iconographies typical of late-nineteenth-century sensibilities.

In *Reading Ossie Clark* (2003), fragments from the 1969 diary of British 1960s fashion designer Ossie Clark are read out loud by the art world doyenne Clarissa Dalrymple, as a sequence of almost psychedelic images morph into one another. Details of Clark's fabrics designed by Celia Birtwell appear in bright colors that evoke the multicolored lettering of Clark's diary, in which each word or phrase was written in a different-colored ink. The work reveals Clark's life and inner thoughts, reflecting the glamour, exhilaration, and high anxiety that marked the radical scene of 1960s London. CR/CI

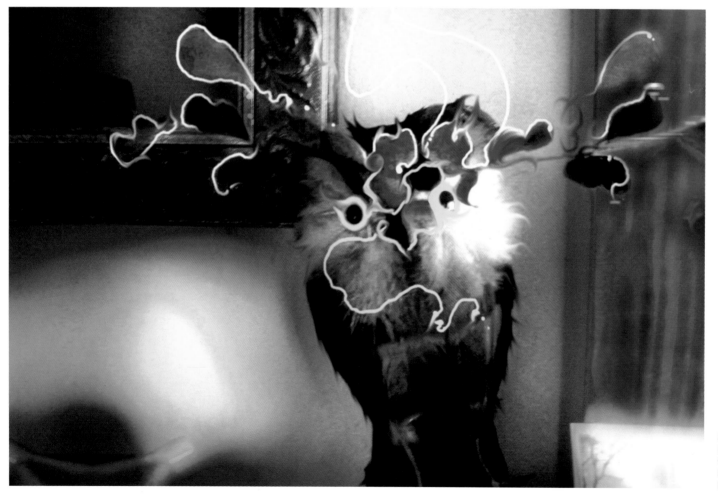

Still from *Reading Ossie Clark*, 2003.
Digital animation on DVD, color, sound;
9 min. continuous loop. Collection of
Ellen and Steve Susman; courtesy
Feigen Contemporary, New York

Mel Bochner
Born 1940, Pittsburgh, PA
Lives in New York, NY

Mel Bochner emerged in the mid-1960s as one of a group of artists who transformed the intellectual foundations of Minimal art into a form of artmaking that prioritized language, serial systems, and conceptual ideas over the material object. In 1966 he curated a seminal exhibition in which he assembled one hundred photocopied working drawings and fabrication sketches by fellow artists, including Donald Judd, Dan Graham, and Robert Smithson, combined with scientific, technical, and engineering diagrams and mathematical notes in spiral binders.

Bochner's own work from the same year underlined his interest in seriality, mathematical progression, and the detachment of art's intellectual and structural constituents from its material form. In *36 Photographs and 12 Diagrams* (1966), twelve drawn gridded squares each contain a geometric pattern, delineated by leaving some of the tiny squares within each grid blank and filling others with numbers from 1 to 4. Below each pattern are three photographs of a corresponding volumetric form made of wooden blocks, stacked in height according to the number in each square in the pattern, and photographed from above, from the side, and at an angle. In a 1966 drawing titled *Wrap: Portrait of Eva Hesse*, the word "wrap," which he associated with his friend Hesse, appears in the center of the page, enclosed by concentric circles of related words, such as "cloak...bundle...obscure... conceal... ensconce...confine...." The words become a protective enclosure around the artist's name, uniting a conceptual use of language with a perceptual reading of words as image.

In 1969 Bochner began a series titled *Measurements*, in which geometric forms were placed on the gallery floor and walls, measured, and marked with their size. In *48" Standards (#1)* (1969) the artist stapled a sheet of brown wrapping paper to the wall and stenciled the width and length of the sheet next to it. In *Measurement: Room* (1969), he measured the dimensions of a room and marked them on the walls. *Theory of Boundaries* (1970) and *Axiom of Indifference* (1973) tested the complex interaction between seeing something and saying something about it. Throughout the late 1970s and 1980s, Bochner painted a series of large-scale works directly on the wall, exploring the relationships between color, shape, and architecture.

In the 1990s, Bochner returned to his interest in measurement, number, and language. In his most recent paintings, he places a key word in the upper-left-hand corner of the canvas, followed by a list of synonyms from the thesaurus. In *Mistake* (2003), the list of synonyms begins with formal words such as "error," "oversight," and "fallacy," and rapidly devolves into vernacular, often vulgar phrases such as "fuck-up" and "step on your dick." Painted in contrasting colors on intensely colored grounds, the words slip back and forth between conceptual signs and visual images. Like the circular format of *Wrap: Portrait of Eva Hesse*, the new paintings subvert the expectation of a "readable" text, reaffirming the artist's longstanding contention that "language is not transparent." CR/CI

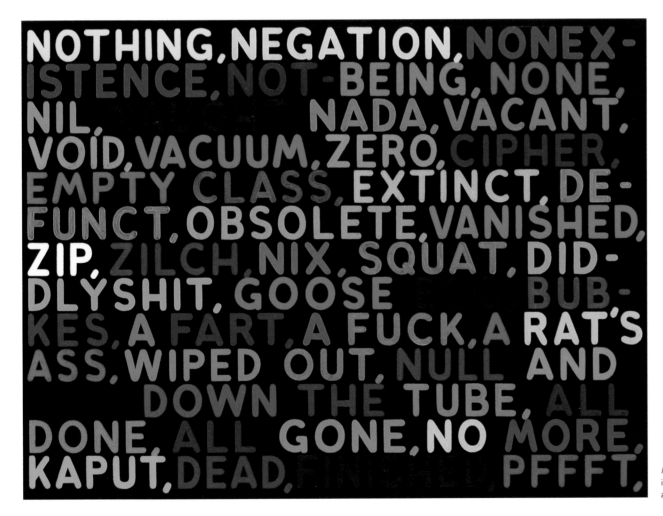

Nothing, 2003. Oil on canvas, 45 x 60 in. (114.3 x 152.4 cm). Collection of Jill and Peter Kraus

Andrea Bowers
Born 1965, Wilmington, OH
Lives in Los Angeles, CA

Questions of empowerment and participation are at the center of Andrea Bowers's artistic practice, which includes videos, drawings, installations, and scrapbooks. Bowers casts a sympathetic spotlight onto a wide range of actors, observers, influences, and models, and draws from traditions of Minimalist sculpture and dance as well as such pastimes as parades, sports, karaoke, and arcade video games. Focusing on the mechanics of spectacle and the diversions of consumer culture, Bowers's work engages in an active inquiry into the moments when observation and participation converge. In a group of works titled *Spectacular Appearances* (1997–98), Bowers used an amateur video camera to capture the spectators at a baseball game, an air show, and a street parade, recognizing them as the true protagonists of the events. In her video installation *Moving Equilibrium* (1999), Bowers focuses on the world of female amateur ice-skating, confronting the often fickle desire for professional achievement. In her video *I Love You Fuckin' People* (2000), she turned to karaoke bars in Los Angeles, Las Vegas, and Ohio to present the complex relations

between audience and performer, celebrity and fan. For her video installations *Democracy's Body—Dance Dance Revolution* (2001) and *Box with Dance of Its Own Making* (2002), Bowers filmed the participants of two interactive video games in several arcades in California. The former presents a game of the same title in which players follow lit panels on the floor to perform a sequence of dance steps, while the latter shows players of the video game "Virtual Arena" performing fight movements choreographed against blue walls of neon tubes. Successively moving from the crowds of spectators and fans to the individual participants of video games, Bowers's works spell out the contradictions and shifting dynamics between actor and observer.

Bowers's most recent video, *Vieja Gloria* (2003), shifts the artist's concerns to the arena of political activism. *Vieja Gloria* documents what she calls the "first suburban tree-sit in America" in Santa Clarita, California, where activist John Quigley lived in a four-hundred-year-old oak for seventy-one days. Under threat of being cut down to make room for a large suburban development, the oak was named "Old

Glory" by local residents, and for Quigley and Bowers the tree came to stand for the history and the ideals of the country as a whole. As time passed, the makeup of the crowd who gathered around the tree changed from white upper-middle-class to working-class Latino families, as developers built ever-expanding fences around the tree to keep protesters and supporters at bay. Bowers examines these actions as a metaphor for suburban fear of difference. Narrated by Quigley, *Vieja Gloria* documents the progress of the events and celebrates those acts of individual determination and communal support as the basis for local political agency and activism. CR

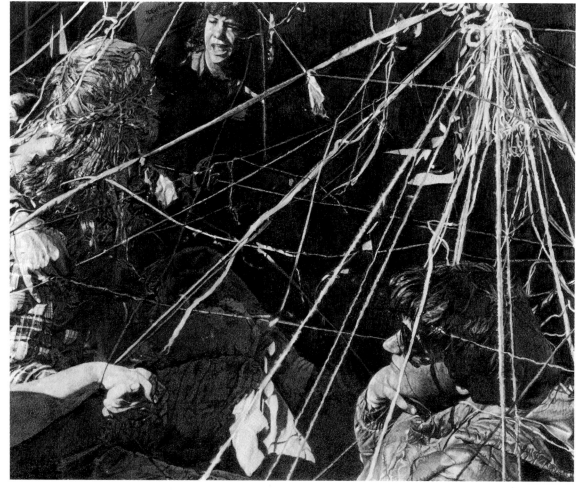

Magical Politics: Women's Pentagon Action, 1981, Detail of Woven Web Around Pentagon, 2003. Graphite on paper, 8 x 10 in. (20.3 x 25.4 cm). Gaby and Wilhelm Schürmann Collection; courtesy Sara Meltzer Gallery, New York, and Chouakri Brahms, Berlin

Slater Bradley
Born 1975, San Francisco, CA
Lives in Brooklyn, NY

In his videos, installations, and photographs, Slater Bradley turns to the marginal and overlooked moments and scenarios that unfold as part of everyday life. Centered on an elaborate set of recurring themes, his works present fragments of narratives, memories, and sentiments. Bradley has developed a personal iconography of themes and figures that include the band Joy Division and its singer, Ian Curtis, chess, butterfly catchers, and a range of Romantic subjects, such as the doppelgänger and the dilettante. Bradley uses both casually observed and carefully constructed scenarios for his works, and his style has sometimes been described as mock vérité.

His 2000 exhibition *Charlatan* brought together three short videos that focus on different moments of dramatic sentiment. In *Female Gargoyle* (2000), Bradley presents the image of an apparently suicidal woman perched on the cornice of a building. By adding a thin banner reading "amateur video" and editing out reference to the rescue attempts of firefighters and passersby, Bradley focuses on the removed observation of tragedy. In *The Laurel Tree (Beach)* (2000), Bradley shifts from observed to constructed imagery. Set to the dramatic soundtrack of Jean-Luc Godard's film *Contempt*, the video shows the young actress Chloë Sevigny on a windy beach, reciting lines from Thomas Mann's fin-de-siècle story "Tonio Kröger," which deals with art's contempt for dilettantism. The third video shows an adolescent girl as she lays a rose onto the monument for John F. Kennedy Jr. and his wife, Carolyn Bessette, in front of their apartment building until she notices the camera. The three videos display various emotional states—despair, disdain, and mourning—while simultaneously triggering different versions of tragedy and embarrassment.

For another series of works, Bradley combined the notion of the doppelgänger with his reverence for Joy Division. A group of photographs portrays a Bradley look-alike whom the artist hired as a stand-in. The blurry, grainy video *Factory Archives* (2002) depicts the double performing as Ian Curtis. By visually mapping the artist's body double onto the singer, Bradley combines real life and desire in a psychological double entendre. The artist's recent video *Theory and Observation* (2002) combines a soundtrack consisting of music by the band Replikants and the voice of Stephen Hawking with closely cropped shots of the children's choir of the Notre-Dame cathedral in Paris as they wait to sing. Effortlessly mixing the abstract languages of theoretical physics and religious spirituality, Bradley's observation of reality is suddenly elevated to a metaphorical examination of science versus faith. CR

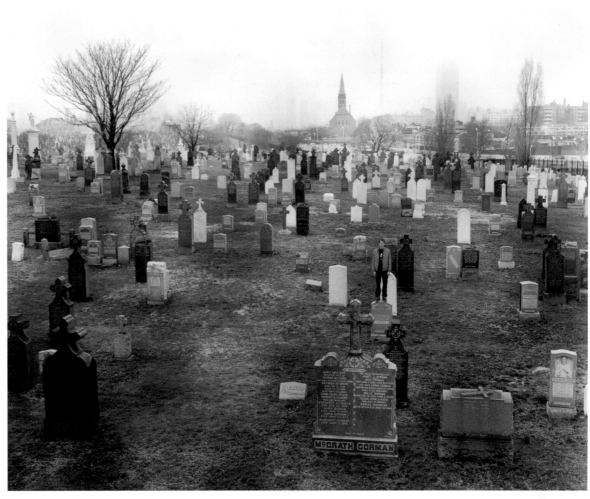

Nobody Sings on All Soul's Day, 2002. Chromogenic color print, 47 ½ x 61 ½ in. (120.7 x 156.2 cm). Collection of the artist; courtesy Team Gallery, New York

Stan Brakhage
Born 1933, Kansas City, MO
Died 2003, Victoria, Canada

Stan Brakhage is widely recognized as America's most important avant-garde filmmaker. When he died on March 9, 2003, he left behind close to four hundred films completed over the course of his extraordinarily prolific fifty-two-year career. Deeply influenced by poetry, painting, and classical music, Brakhage formulated a new cinematic vocabulary, which in many ways epitomizes the history of avant-garde filmmaking in the second part of the twentieth century. Encompassing photographic techniques as well as collage, painting, drawing, and scratching on film, his work ranges from the lyrical documentation of his family life to the exploration of great metaphysical themes such as birth, sex, death, and the search for God. Despite this breadth, Brakhage's art shares a consistent set of aesthetic and theoretical concerns, seeking to articulate subjective visual perception. In the famous opening passage of his 1963 publication *Metaphors on Vision*, he calls for cinema to be "liberated" from preconceived ways of seeing: "Imagine an eye unruled by man-made laws of perspective, an eye unprejudiced by compositional logic, an eye which does not respond to the name of everything but which must know each object encountered in life through an adventure of perception." Throughout his working life, he continued to explore and document all forms of seeing, seeking ultimately to share what he termed "moving visual thinking."

From the 1980s onward, Brakhage increasingly turned toward abstraction in often cameraless films, making works directly related to painting traditions, specifically Abstract Expressionism. Completed in 2001, parts 13–18 of his *Persian Series* comprise a group of hand-painted films of somber tonality and mood. Part 13 is characterized by the dense application of paint, occasionally visible brushstrokes, and the use of dark colors: purplish blues, greens, and intense reds, evocative of blood. The following parts are lighter, using subdued colors that at times appear translucent or liquid against patterned white and black backgrounds. Toward the end of Part 17, the shades become darker once more, a theme continued in Part 18 with yellows, browns, and black, and a succession of calligraphic swirls, now moving toward filling the horizontal expanse of the screen.

Max (2002), shot on a single roll and edited in camera, is a tender portrait of the family cat that harks back to Brakhage's work from the late 1950s and 1960s. The camera seems to caress the pet's dark fur, filming in close-up and soft focus, and lingering on his eyes, whose color is echoed in the yellow-orange fogging at the film's beginning and end. Brakhage's last film, *Chinese Series* (2003), reveals the artist's lifelong devotion to his work. Confined to his bed a few months before his death from cancer, he worked on this 35mm film, softening the emulsion of black leader with saliva and scratching it with his fingernails. The resulting streaks resemble Chinese characters, which in projection are transformed into animated shapes that dance on the screen in white with soft glowing haloes of greenish yellow set against deep black. **HH**

Stills from *Persian Series 13–18*,
2001. 16mm film, color, silent; 11 min.

Cecily Brown
Born 1969, London
Lives in New York, NY

Remaining deeply rooted in the figure, Cecily Brown's voluptuous paintings shift between abstraction and figuration in an exuberant, gestural manner that recalls Abstract Expressionist painters such as Willem de Kooning, Joan Mitchell, early Jackson Pollock, and Philip Guston. Close observation reveals glimpses of recognizable forms such as bunnies, bulging eyes, teeth, thighs, dog snouts, and genitalia, which emerge and disappear under swaths of color. Art historical references, including pastoral landscapes, reclining nudes, and bacchanalian scenes, are inflected by the influence of Hollywood movies and cartoon characters (for a time Brown worked as a film animator).

Brown's work is suffused with the erotic in both the visceral surfaces of the canvas and in her imagery: fornicating rabbits in her 1997 "bunny" paintings, and the intimations of humans in various sexual positions in *Girl Trouble* and *One Touch of Venus* (both 1999), in which bodily contours fragment and dissolve into thick layers of color. The erotic becomes more overt in works like *Summer Love* (2000) and *These Foolish Things* (2002), whose folds of paint reveal copulating couples. Brown frequently alludes to sex as an allegory for painting, drawing on the generative quality of both. She has said, "When you say why sexual, why bodies, why the figure? In a way because it's universal…. I think [sex] is the driving force behind almost everything that goes on." Recent paintings like *Bacchanal* (2001) and *Red Painting I* (2002) reveal a transition into landscape, where the erotic encounter is implied through a frenetic riot of color and brushwork. These landscapes, inspired by the work of Nicolas Poussin, Paul Cézanne, and Mitchell, are rendered carnal through Brown's aggressive handling of paint.

Brown revisits the reclining female nude—one of the most historically laden genres of painting—in *Black Painting 1* and *Black Painting 2* (both 2002). In both works, a female nude reclines on pillows in a dreamlike state, as a cloud of indeterminate beings—winged phalluses, a satyric face—hovers above her. Brown eroticizes the composition of Goya's *The Sleep of Reason Produces Monsters*, releasing the demons of unconscious desire into the heavily layered paint, fusing the surface of flesh with the surface of the canvas. AD

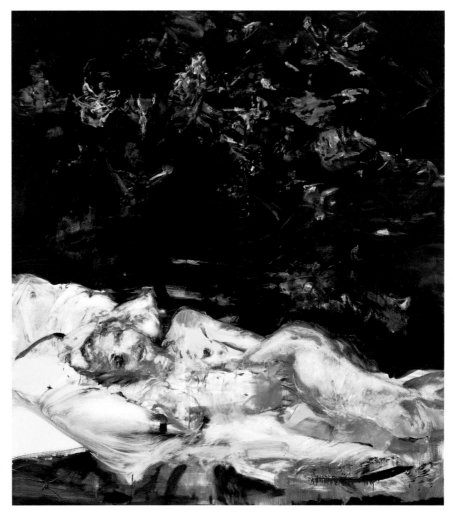

Black Painting 2, 2002. Oil on linen, 90 x 78 in. (228.6 x 198.1 cm). Whitney Museum of American Art, New York; purchase, with funds from Melva Bucksbaum and the Contemporary Committee 2003.304

Tom Burr
Born 1963, New Haven, CT
Lives in New York, NY

For the last decade, Tom Burr's photographs, sculptures, and installations have engaged and revisited the formal vocabularies and different usages of postwar sculptural practice. Minimalism and Land art and their conditions of site-specificity, concepts and critique of monumentality, and concerns for public use are all revisited in Burr's works, which are simultaneously infused with a sensibility for diverse underground cultures and aesthetics. Park and landscape planning, heavy metal music, Brutalist architecture, and twentieth-century design all form points of reference for Burr, creating a sense of continuity in his contextual operations.

Burr's first installations in the public sphere, *An American Garden* (1993) in Sonsbeek, Netherlands, and *Circa 1977* (1995) in Zurich, reenacted the formal documentation and displacement associated with Land art to address the uses and demises of two park areas: New York's Central Park and Zurich's Platzspitz, which served both as cruising areas for gay men and as public spaces for different groups. His 1995 exhibition *42nd Street Structures* featured wooden modular structures that seemed to re-create the seriality of Donald Judd's plywood boxes but were modeled after the cabins of dismantled adult movie theaters and dark rooms of New York's Times Square. And his 1998 works *Black Box* and *Black Bulletin Board* further situate his split referentiality firmly within the context of 1960s avant-garde art. *Black Box* consists of a group of four cubes, each open on two sides and the top, situated to form four corners of a ring or stage. Inside, the cornered walls of the wooden constructions are alternated with mirrors, emphasizing the theatrical presence of the spectator in the work, while a ledge with ashtrays seems to invite lingering. The adjacent *Black Bulletin Board* features photocopies of *Cigarette*, a sculpture by Minimalist artist Tony Smith, and film stills from Kenneth Anger's queer underground film *Scorpio Rising* (both from the early 1960s).

With *Deep Purple* (2000), shown in Germany in 2000 and at the Whitney in 2002, Burr made reference to Richard Serra's highly controversial public sculpture *Tilted Arc* (1981–89), which was removed in 1989 by the authorities after a long and heated debate. *Deep Purple* replicated the gently curved shape of Serra's Cor-ten steel sculpture in wood and at approximately two-thirds scale. Impermanent, mobile, and vividly colored, Burr's work defies the austere monumentality of *Tilted Arc* and updates the concept of site-specificity, calling to mind what James Meyer has called the "functional site"—taking into account the different uses, politics, and aesthetics of groups defined by divergent agendas or interests.

Burr's most recent sculptures, *The Screens* and *Gone Gone* (both 2003), continue to probe the notions of staging and spectatorship explored in *Black Box*. Large freestanding dividing walls constructed of flat metal bands and raw planks are combined with big vinyl pillows in the shape of flowers, reminiscent of Andy Warhol's flower paintings and wallpapers. Pop iconography, Minimalist built forms, and materials connected with various underground cultures attest to the hybrid definition of site-specificity that Burr's works have achieved. CR

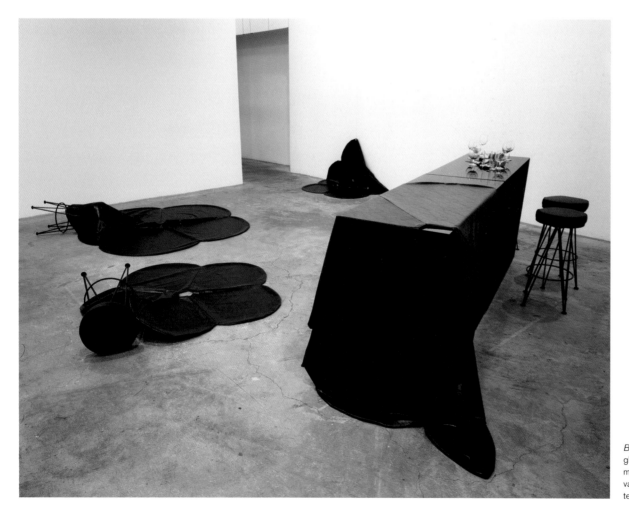

Blackout Bar, 2003. Vinyl, wood, plexiglass, steel, vinyl stools, glass, and miscellaneous bar debris, dimensions variable. Collection of the artist; courtesy American Fine Arts Co., New York

Ernesto Caivano
Born 1972, Madrid
Lives in New York, NY

Ernesto Caivano creates ethereally abstract, intricately detailed ink drawings through which he explores a fantastic realm of his own creation. Science, fairy tales, nature, modern technology, animals, and humans are all interconnected in his continuously evolving narrative chapters. Art historical references abound throughout Caivano's drawings. His meticulous drafting style and otherworldly subject matter recall the engravings and woodcuts of the German Renaissance master Albrecht Dürer, while the opposition he sets forth between man and nature, along with the ubiquitous forest setting of his works, evokes the paintings of German Romanticists of the nineteenth century. His investigation of a metaphysical, self-contained realm also recalls the mystical illustrations of another Romantic artist, William Blake; unlike Blake, however, who denounced reason, in Caivano's world reason and metaphysics operate in concert with each other.

Caivano's story unfolds around two principal characters: a knight dressed in fanciful armor and his wife (who has metamorphosed into a spaceship), from whom he has been separated for more than a thousand years. Both of these characters affect and are affected by the life and matter around them. The knight brings about rapid evolution of plant life, while the princess-turned-spaceship "propels the advancement of intelligence in technological development." In their respective odysseys to find one another they encounter fantastical creatures, such as the Philapores—elaborately plumed birds that, unable to fly in the conventional manner through air, instead travel through various forms of matter such as dust, logs, waterfalls, and transmitted code. Caivano depicts both specific moments and general themes of an overarching story he calls "After the Woods," set in a postapocalyptic time following a cataclysmic event that was simultaneously destructive, generative, and transformative.

The Birds and Water Fall I and *II* (both 2003) represent general scenes in the narrative cycle where Philapores fly through water. In the first, two Philapores are seamlessly interlocked in flight, concentrated on the right side of the composition. In the second, a Philapore enters the composition from the upper left corner, rushing downward toward a mass of code, represented by solid black circles with interconnecting curvilinear swirls. In *Plumage Acquisition II* (2003) Caivano depicts the knight falling backward on the right, after having just attacked a hybrid creature called a Chevelure, part goat, sloth, bear, and lion. Chevelures feed on the Philapores and are symbolic of man's hedonistic, Dionysian instincts. Before being attacked by the knight, the Chevelure had been perched in a tree disguised as a Philapore, which the knight hunts for its feathers because they are "carriers of information."

Despite the fantastic narrative, many of Caivano's ideas are rooted in modern technology, specifically nanoscience—the study of atoms, molecules, and objects whose size is measured by the nanometer scale. Many of Caivano's crystalline forms suggest pentagonal and hexagonal molecular forms that are invisible to the naked eye. His largely conceptual drawings refer to an abstracted realm—visible only with the aid of advanced technology—that is fundamental to the physical world. **AD**

Philapores Navigate the Log and Code, 2003 (detail). Ink on paper, 14 x 22 in. (35.6 x 55.9 cm). Collection of Victor Masnyj

Maurizio Cattelan
Born 1960, Padua, Italy
Lives in New York, NY

Considered a prankster or jester by some and a cynic by others, Maurizio Cattelan is a provocative and elusive artist whose gestures are full of humor and devoid of respect. Cattelan has developed a fine-tuned set of references and protagonists, playing out brief comedic, iconoclastic, or simply absurd mini-dramas for a delighted or irritated audience.

In his early work Cattelan parodied iconic art-works from the 1950s and 1960s. In an untitled work from 1993 a monochrome canvas lacerated by three simple cuts is immediately recognizable as a reference to Lucio Fontana's painting *Concetti Spaziali* from the 1950s; the three diagonal slashes form the letter "Z," simultaneously inserting a reference to the popular villain Zorro. In *La Rivoluzione Siamo Noi* (2000) Cattelan created a stuffed likeness of himself clad in Joseph Beuys's iconic felt suit, which was hung in the coat check of a museum in Switzerland.

Another series of works employed animals as protagonists. In *Novecento* (1997) Cattelan suspended a stuffed horse from the ceiling of a palace in Turin, in *BIDIBIDOBIDIBOO* (1996) he put a stuffed squirrel in a miniature prison cell with a handgun to commit suicide, and in *Warning! Enter at Your Own Risk. Do Not Touch, Do Not Feed, No Smoking, No Photographs, No Dogs, Thank You* (1993) he exhibited a live donkey under a chandelier in a gallery in New York. Cattelan has also taped his gallerist to the wall with duct tape, suspended three feet off the ground (*A Perfect Day*, 1999), and greeted visitors to The Museum of Modern Art in New York dressed in an oversized bust of Picasso (*Untitled*, 1998). For another work, titled *The Ninth Hour* (1999), he created a life-size likeness of the pope, lying on the ground after being hit by a meteorite.

All of Cattelan's works are marked by a scathing attitude toward the established expectations of the institution that presents his work and the visitors who try to follow his moves. But his position is never one of contempt or cynicism. His references are thoroughly grounded in the strategies, practices, and vocabularies of his art historical predecessors, and his escapist narratives contain a moral tale, even as they flash the tongue at the powers that be. CR

Betsy, 2002. Wax, dummy, polyester resin, natural hair, clothes, and refrigerator, life-size. Private collection; courtesy Galerie Emmanuel Perrotin, Paris

Pip Chodorov
Born 1965, New York, NY
Lives in Paris

A tireless advocate for avant-garde film, Pip Chodorov is a filmmaker, curator, owner of the Paris-based distribution company Re:Voir, and founder of the Internet discussion group FrameWorks, a resource for artists, curators, and scholars of experimental film worldwide. Chodorov, who studied cognitive science and film semiotics, has made films and composed music since his childhood in the 1970s. In his most recent work, *Charlemagne 2: Piltzer* (2002), he presents the sum of his intellectual concerns and lifelong interest in film art and music.

Charlemagne 2: Piltzer is one of two works by Chodorov that document performances by the avant-garde musician and composer Charlemagne Palestine, who pioneered a strumming technique on the piano in the 1970s. Chodorov shot two rolls of Super-8 film of a Palestine performance at the Paris gallery Gérald Piltzer in December 1998. The footage remained undeveloped for eighteen months before Chodorov returned to the material and systematically arranged the image in relation to a 22-minute sound recording. The film translates the musical performance into filmic terms, in a formally rigorous rendition based on a series of structural decisions in the printing process.

Chodorov enlarged the black-and-white Super-8 film to high-contrast 16mm, creating negative and positive masters from which he optically printed the film. The resulting number of frames almost exactly matches the number of notes played during the concert, and the speed of the projected film conforms to the music, so that the images flicker in rhythmic correspondence to Palestine's piano strokes. Musical discordance is also converted into visual equivalents, such as color oppositions of red and green or blue and yellow (achieved with the use of color filters), alternating negative and positive sequences, and so forth.

The result is a vibrant visual score that flickers and pulses on the screen in stark black-and-white and bold color, alternating between recognizable figures and near-abstract contours and shapes. "The main idea is to represent music visually," Chodorov states, "to do in the occipital visual cortex what Charlemagne was doing with his music in the temporal lobes, using discordant harmonics and rhythms, beating and flicker and phase effects to create, one could say, an orgasm of the optic nerve." A systematic translation of sound into image governed by a set of cognitive principles, the film not only reveals the artist's fluency in both film and music, but becomes more than the sum of its parts: a visually autonomous work of stylistic virtuosity that is as much an homage to the history of abstract moving image art as to Palestine's music. HH

Diagram for optical printing score of
Charlemagne 2: Piltzer, 2002. 16mm
film, color, sound; 22 min.

Liz Craft
Born 1970, Los Angeles, CA
Lives in Los Angeles, CA

Drawing from a wide range of references and materials, stories and locales, Liz Craft's sculptures and installations are extremely detailed and meticulously crafted hybrids of found and imagined dreamscapes and objects. Craft's installation *Quo Vadis* (1997) consists of an almost life-size reproduction of two interiors separated horizontally by a ceiling that puts the viewer oddly out of scale, allowing no room for the spaces to be entered although the work is clearly too large to be a model. Filled with a broad range of objects and materials, the installation speaks of Craft's penchant for meticulous and monumental constructions and fictional, almost delirious subjects.

Craft's installation *Living Edge* (1997–98) replaces the interiority of her previous work with a meditation on the landscape as sculpture, addressing questions of scale, view, and site-specificity. A central mountainous cave is partially overgrown with artificial ivy and surrounded by a composite grandstand structure, a fragment of a brick wall leading into a low, elongated painted birdbath, and two kissing deer made of pentagon-shaped pieces of

plastic. Two conifers and a bonsai cedar with Styrofoam flakes, hummingbirds, mushrooms, rubber dog toys, and a plastic snake populate the landscape, which seems to take its inspiration from a condensed West Coast sensibility guided by Disney and the fragmented, artificial film sets of Hollywood.

Craft's works are infused with the genius loci of different locales, or at least seem to exude a sensibility shaped by their respective surroundings. For an exhibition in Linz, Austria, Craft responded to the visual and cultural clichés of that country by creating a room-size sculpture, titled *Made in Austria* (2000), that included six dwarfs and Sissi, the Austrian princess immortalized in the movie of the same name. In her work *Death Rider* (2002) Craft cast a low-rider motorcycle—that American icon of rebellious freedom—in bronze, complete with a skeleton as driver and a headless biker girl as passenger. But her motorcycle isn't just the mean machine found on U.S. highways. The gas tank is a pinecone, the engine a beehive, and the wheels seem carved out of driftwood; made of oddly organic elements and almost cartoonish objects,

Craft's machine is part Hell's Angels and part Flintstones, as much Disney as it is Dennis Hopper. The artist herself poses dressed as a Hollywood version of an Indian squaw on the white plaster model of the motorcycle for an accompanying photograph, making clear that the scenery for and the protagonists of the American dream are both Western and wasteland, the cowboy and the comic strip.

Most recently, Craft has taken up the cheap trinkets of charm bracelets and astrological figures as inspiration. She reproduces the figures in rhinestone-studded bronze measuring roughly one foot, and hangs them on the wall on a hook and ring reminiscent of a key chain. Reproducing trinkets and kitsch objects, Craft has adapted a production procedure of utmost economy to reference her nonhierarchical subject matter at the heart of popular culture. CR

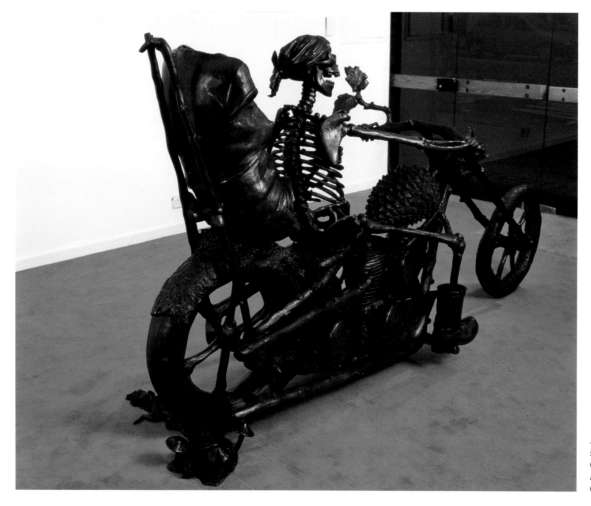

Death Rider (Virgo), 2002. Bronze, 55 x 107 x 31 in. (139.7 x 271.8 x 81 cm). Collection of Dean Valentine and Amy Adelson; courtesy Marianne Boesky Gallery, New York

Santiago Cucullu
Born 1969, Buenos Aires
Lives in Milwaukee, WI

A native of Argentina now living in Milwaukee, Santiago Cucullu creates large wall drawings, watercolors, and sculptures that depict hybrid tales culled from historical events and personal recollections. The mural-size drawings, made from hand-cut contact paper pressed directly against the gallery wall, often center on a minor historical event or figure from Latin American or Spanish political movements. These times, places, and figures are then conflated with people and events recollected from Cucullu's own life to create composite visual storyboards.

Several recent works, including *The illicit movements of Severino di Giovanni preceding his arrest by Edmundo de Amicci* (2003), focus on Severino di Giovanni, an Italian anarchist who emigrated to Argentina and later used his talents as a printer to mount international campaigns for revolutionary causes. Another work invokes the spirit of Fermin Salvochea, a turn-of-the-century Spanish insurrectionist. By doing away with painting's traditional support and working directly on the wall, Cucullu inscribes these alternate histories onto the architecture of the gallery for the duration of an exhibition, breathing new life into little-known or moribund figures and geographically distant histories.

Cucullu's sculptures inquisitively re-create some of the physical structures that represent the power structures against which his chosen revolutionaries fought. They probe the psychological effects of street barricades and other impediments to free movement, trading in the tires, sandbags, wood, and overturned cars for lighter materials such as items from a party supply store and empty cardboard boxes. With his brightly colored, abstract visual language the artist matches the buoyant utopian aspirations of past revolutionaries. In retelling their tales, Cucullu encourages the viewer to do the same. BJS

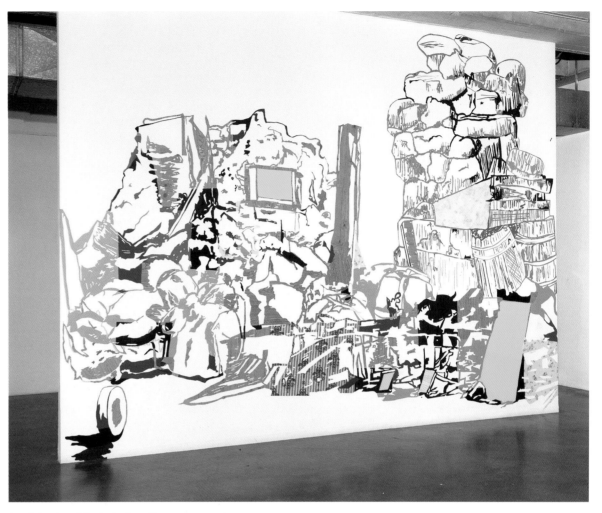

Installation view of *Barricades from All D&D, Haiti, Prague that Fall, Fermin Salvochea*, 2003, at the Glassell School of Art, Houston. Contact paper on wall, dimensions variable. Collection of the artist; courtesy Barbara Davis Gallery, Houston, and Julia Friedman Gallery, Chicago

Amy Cutler
Born 1974, Poughkeepsie, NY
Lives in Brooklyn, NY

Enchanting and nonsensical, the miniature worlds that Amy Cutler paints in her gouaches on paper are inspired by fairy tales, U.S. military manuals, horseback riding books, Japanese woodblocks, and Persian miniatures. Populating her works with farm animals and a cast of recurring female characters rendered in a highly realistic manner, Cutler transforms common scenes into functional fantasies on a plane unanchored in time and place, often through gross malformations of the human body and subversions of reason and natural laws. In *Bird Watchers* (2002), five young boys peer out a window, luring unsuspecting birds with their perchlike snouts that are in fact rifles. Two women in *Sweetie, Sweetie* (2001) have heads made of layered white cakes, covered in chocolate frosting, which they attack with forks and knives. *Bionic Contortion* (2003) features women with fans affixed to their waists that dry the skirts on their floating detached lower bodies. An elongated proboscis in *Rations* (2002) connects two women who clutch a baguette and a knife, preparing to make a sandwich out of it (a play on the saying "to cut off one's nose to spite one's face").

The surreal situations depicted in Cutler's paintings are often extrapolations of stories she has read in newspapers, which she then invests with her idiosyncratic sense of the absurd. In *Campsite* (2002), women who have come to donate their eggs lie in a forest clearing wearing billowing dresses that function as tents, with openings where older women enter to inspect the quality of the eggs; the silhouette of one woman is seen through the diaphanous light blue dress of another woman in the foreground who uneasily clutches her bag. This fanciful scenario originated from an article the artist read about a couple who placed an advertisement in a newspaper, looking for an intelligent, Ivy League egg donor.

In her work, Cutler often explores domestic stereotypes that she inverts with a shrewd use of metaphor and a lighthearted sense of humor. Such is the case in *Dinner Party* (2002), where women in Victorian-era dresses have strapped upended chairs onto their heads, with cutlery jutting from the chair legs. In a brash renunciation of domestic decorum they stand on a table and engage in a sparring match, using the chairs like antlers, while they kick the feast about the table. This scene exaggerates the more civilized verbal quarrels that can unfold over dinner. Similarly, in *Saddlebacked* (2002), instead of the women riding the horses, the horses ride piggyback on the women in saddlelike harnesses. Cutler has created a world that is unfettered by logic and normal codes of behavior, in which her characters, particularly women, subvert the restrictions of accepted social conventions and critique historically prescribed female roles. AD

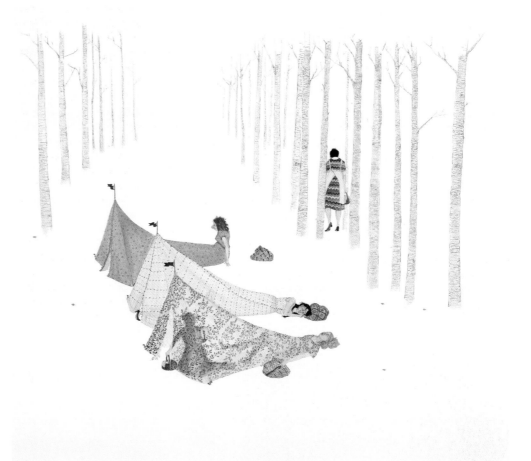

Campsite, 2002. Gouache on paper, 46 ¹/₂ x 47 ⁵/₈ in. (118.1 x 121 cm). Private collection

Taylor Davis
Born 1959, Palm Springs, CA
Lives in Boston, MA

Taylor Davis's elegant sculptures embody Minimalism's concern for the use of industrial and manufactured materials and its intense investigation into the physical and visual relationship between object and viewer. Since the late 1990s, Davis has used plywood, lumber, and mirrors to create structures of architectural clarity that are intricately linked to questions of material, perception, and physical experience. Davis's earliest sculptures engaged in a thoughtful investigation of the physical properties of plywood. For *Architect* (1997), Davis cut a full sheet of plywood into a pattern that released concentric springboardlike planes. Rising over a simple corner-shaped structure of pine placed on the floor, the work relates to the flatness and planarity of Minimalist sculpture while simultaneously making reference to the floorboards of housing construction.

With *Stations*, a group of four sculptures built in 1999, Davis invites the viewer to enter a space defined by intersecting walls of plywood that contains simple shelves and boxes of pine. Although she opts for basic construction materials, the artist carefully selects the individual sheets and boards, milling and joining the lumber to achieve the desired grain pattern and proportions. *Untitled (Colbert WA)* (1999) and *Untitled (1 to 4)* (1999) are constructed of two sheets of boldly grained plywood that are connected, respectively, by a counter-height shelf and a thick-walled box of pine. Placed in two corners of the existing gallery, the works are both building element and barrier, defining spatial limitations while drawing the viewer to gather around them. *Storage* (2001) resembles a large upended table with multiple legs of varying lengths extending out from a single sheet of plywood. On the back (or vertical underside of the "table"), horizontal cuts divide top from bottom, causing the sculpture to pitch forward and compress the already narrow space between multiple shelves on the front side. The collapsing form is supported by a single vertical two-by-four that simultaneously holds the sculpture up and suggests its original height.

In her most recent work, Davis uses mirrors in conjunction with plywood and pine to expand on the relationship between the viewer, architecture, and the object. *Pallet* (2002), made from nine mirrors screwed to three parallel boards of rough lumber, holds the reflected image of its viewer and surrounding architecture the way its real-life counterpart holds the heaviest of construction materials. *Untitled* (2002), a tall, narrow enclosure measuring 10 x 15 x 4 feet, resembles an animal cage or high fence. Built of equally spaced vertical boards attached to a pine structure, the sculpture appears deceptively simple until the viewer discovers that the inside of each vertical is inset with a narrow mirror, turning the interior of the seemingly rough enclosure into a spectacle of refraction. Circumambulating the sculpture, the viewers—alternately seeing the outside of the work, their own reflection inside, and the gallery walls—experience both a materializing and dematerializing of structure, architecture, and self. CR

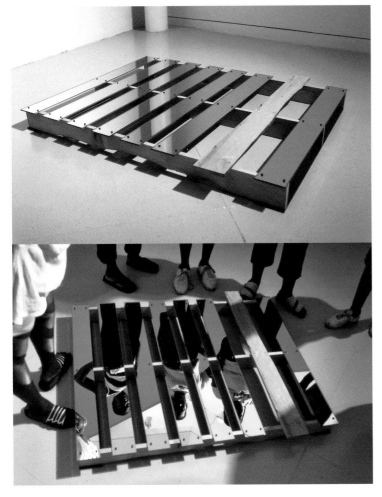

Pallet, 2002. Pine and mirror, 5 x 52 x 45 in. (12.7 x 132.1 x 114.3 cm). Collection of the artist

Sue de Beer
Born 1973, Tarrytown, NY
Lives in Brooklyn, NY

Sue de Beer's photographs, videos, and installations are instilled with the aberrant, violent, and often bloody iconography of horror movies and the controversial teenage reactions they appear to provoke. In her photographs, de Beer re-creates scenes from signature films of the genre, or makes reference to the films' characters or actors by focusing on individual moments or elements that would be recognizable to the initiated. At first, her approach seems that of a fan, eagerly trying to learn something about the hidden mechanics of a given narrative, its effects and tricks, as if some secret meaning could be gathered from such an exercise. In *Tina* (1999), a female character seems to be pulled into the upper-right-hand corner of her room, in a scene that refers to *A Nightmare on Elm Street* (1984), in which the character Tina Gray is dragged across the ceiling of her room by the villain Freddy Kruger. De Beer's image, however, reveals the seams of the set design at the edges of the photograph, drawing attention to the artificial construct of the scene.

In her two-channel video installation *Hans und Grete* (2002), de Beer creates a layered narrative of four troubled teenagers that is interspersed with references to recent school shootings in the United States and to Ulrike Meinhof, an icon of the 1970s German revolutionary terrorist Baader-Meinhof group. In grafting the high school killings in Littleton, Colorado, onto Meinhof and her group, de Beer does not equate these acts of school violence with moments of revolutionary fervor; rather, she constructs a situation in which the desperate and violent attempts at change by the Baader-Meinhof group have entered the same ontological realm as that of Freddy Kruger, where the problem no longer lies in the confusion of reality and its (fictional) simulacrum, but in the equation of story and history. Both are approached with, according to the artist, the "kind of empathy that someone can have for something that's been mass-marketed, like totally loving and believing in a rock star, or believing in [the] world of zombies." The naïve sincerity of adoration thus is measured in extreme gestures of identification with something that was never intended to be taken literally. Horror in its mass-cultural forms is defined not by the lack of visceral impact of one's actions or the absence of responsibility, but by the absence of intention for a deeper and historical reasoning, which, if taken to the extreme, is both violent and innocent. CR

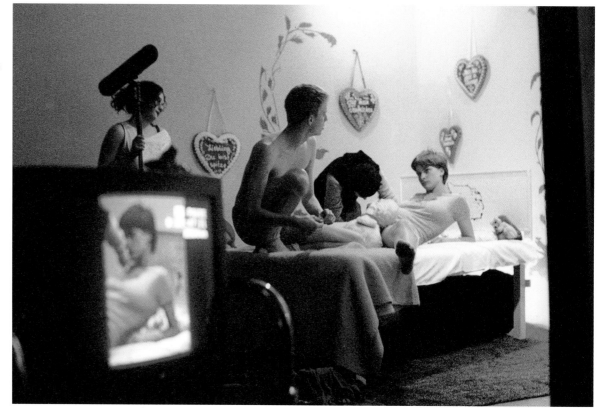

Still from *Hans und Grete*, 2002. Two-channel video installation, dimensions variable. Collection of the artist; courtesy Postmasters Gallery, New York, and Sandroni Rey Gallery, Los Angeles

Lecia Dole-Recio
Born 1971, San Francisco, CA
Lives in Los Angeles, CA

Lecia Dole-Recio creates variously scaled artworks that can simultaneously be considered paintings, drawings, collages, and wall-based sculptures. Using a wide array of materials for her hybrid works, including cardboard, paper, tape, graphite, glue, and paint, she employs a language of handmade geometric abstraction to explore material, surface, the picture plane, and color.

Dole-Recio's use of a knife is key. She begins by taping or pasting together several layers of cardboard, butcher paper, watercolor paper, or vellum and painting or drawing over the top layer. Then she hand-carves geometric holes into the surface, revealing the various strata and giving her work an optical depth. The cutout circles, squares, and rhomboids—slightly smaller than the holes they came from—are then imperfectly pasted back into the composition and painted over. The many rows of these incisions form loose grids across the surface of Dole-Recio's artworks.

A vertically oriented untitled work from 2001 has as its base a piece of vellum largely painted dark gray in thin vertical strokes of gouache. It is affixed to the wall from its top corners, while the bottom half of the work appears to have fallen away, leaving a jagged edge. Cutout circles, similar to ones fitted into the square "windows" carved out of the vellum at the middle of the composition, appear to have escaped the surface, held aloft just below the work's main body by transparent packing tape. The artwork appears to be frozen mid-transformation, its skin flaking off and falling to the floor. More recent works complicate Dole-Recio's process by allowing several patterns or graphic systems to interact in different ways across the composition.

Dole-Recio's labor-intensive process bridges traditional categories of art making. A sculptural cutout that makes a shadow by pushing away from the surface of one artwork may simply be a drawn or painted representation of a shadow on the next. This element of surprise encourages the viewer to consider each work more fully, examining the blurred line between the artist's forms and the spaces that surround them. Dole-Recio's visual gamesmanship merges material and process to ensure that her abstract works are not always what they seem. BJS

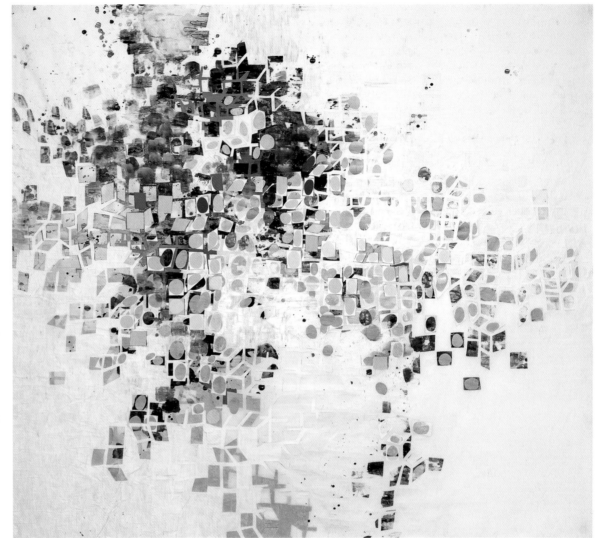

Untitled, 2003. Paper, vellum, tape, and gouache, 84 x 94 ½ in. (213.4 x 240 cm). Collection of the artist; courtesy Richard Telles Fine Art, Los Angeles

Sam Durant
Born 1960, Boston, MA
Lives in Los Angeles, CA

In his sculptures, installations, and drawings, Sam Durant has addressed a broad and yet precise range of references that connect and overlap in multiple ways. His theme is protest culture during the late 1960s and early 1970s, as referenced in the artistic, popular, and political histories of that period.

In one series of works, Durant engages this history through an allusion to Robert Smithson's work *Partially Buried Woodshed*, which was built in 1970 on the Kent State University campus just months before members of the National Guard killed four students there during an antiwar protest, and which burned down shortly afterwards. For *Upside Down and Backwards, Completely Unburied* (1999), Durant constructed a model of Smithson's woodshed and combined it with a soundtrack of songs by Nirvana, Neil Young, and the Rolling Stones. In *Reflected Upside Down and Backwards* (1999), the same model appears again, but this time in duplicate: one is placed directly on the ground and intact, while a second burned and charred model is placed on top of it, again accompanied by the sound of songs by Nirvana and Neil Young. In *Partially*

Buried 1960s/70s Utopia Reflected (Wavy Gravy at Woodstock) and *Partially Buried 1960s/70s Dystopia Revealed (Mick Jagger at Altamont)* (both 1998), Durant introduces the two concerts as another set of opposing moments of that period in history. Two mirrors are covered with piles of dirt, from which the voices of Jagger and Gravy emanate as a cacophonous simultaneity of hope and despair. A series of drawings from the same period further explores the various combinations of Smithson's work with references to lines from songs by Young (*It's Better to Burn Out Than to Fade Away*, 1998) and the Rolling Stones (*Gimme Shelter in Reverse/ Woodshed*, 1999).

More recently, Durant has focused on the history of civil rights protest from the same period. For a series of drawings, he reproduced photographs of historic black protest marches such as *Civil Rights March, Wash., D.C., 1963* (2002), *Miss America Pageant, Atlantic City, 1968* (2002), and *Wash. DC, 1968* (2002). In the drawings the demonstrators prominently display their signs and slogans of protest. These signs appear again in Durant's work *7*

Signs: Removed, Cropped, Enlarged, and Illuminated (Plus Index) (2002), which consists of seven colored light boxes reproducing different protest signs. Other drawings present portraits of Bobby Seale, a founder of the Black Panthers, or a table with books by Eldridge Cleaver, another prominent member of the Black Panthers.

Durant re-presents iconic symbols from 1960s and 1970s popular music, art, white student protest, and Black Power, reflecting an intensely utopian yet nihilistic moment, when a counterculture both succeeded and failed at changing the world. CR

Installation view of *Legality is not Morality*, 2003, at Project Row Houses, Houston. Vinyl text on electric sign, 74 x 56 x 11 in. (188 x 142.2 x 27.9 cm). Collection of the artist; courtesy Blum & Poe, Los Angeles, and Galleria Emi Fontana, Milan

Bradley Eros
Born 1952, Fairfield, IL
Lives in Brooklyn, NY

Bradley Eros is an artist, filmmaker, curator, and co-founder of the Robert Beck Memorial Cinema, New York's preeminent exhibition venue for resolutely underground or experimental film and video. Since the early 1980s, Eros's work has explored the moving image in relation to "liveness," either by integrating body or performance art with film and video projection or by creating expanded cinema performances using variable-speed or multiple projectors, various lenses, gels, and masking, or live sound mixing.

Eros's practice is rooted in what he calls "ephemeral cinema," a challenge to the notion that film is primarily a recording apparatus that freezes moments in time, originally motivated by the desire to document and preserve. Eros is interested in cinema's transitory nature, in the fragility of the medium as well as the changing, unfixed quality of the projected image itself. He formulates a metaphysics of cinema in which the moving image is intricately tied to consciousness, mutable and responsive, probing into cosmic phenomena, elemental states, physicality, and sensuality.

His most recent group of works, a trilogy titled *Ocula* that Eros describes as "subterranean science," was fabricated mainly from footage obtained from a Texas school library that was discarding its educational materials on celluloid. In two performative films and one fixed film, Eros investigates the interplay between the properties of liquids and projected light. *Deliquescence* is a double-projector performance that superimposes 16mm underwater footage with a grainy, scratched 8mm film of surprisingly tender pornography. The erotic black-and-white image is distorted through an external glass lens and overlaid with tinted filters and scenes of marine flowers. Accompanied by a soundtrack of trickling water, sensual nature images—undulating, amorphous sea shapes—are interlaced with the human lovemaking, evoking water's symbolic significance as a biological and historical point of origin. In *Aurora Borealis*, a single-screen work Eros pieced together from numerous scientific films after eliminating all didactic or explanatory passages, he creates an otherworldly, sensual cosmos of swaying sea anemones, swirling chemical dyes, and erupting solar flares. Divorced from scale or context, micro- and macroworlds metamorphose into an enigmatic composition of movement, shape, and color. The film, Eros says, "is an homage to two lyric surrealists of the cinematic collage, Joseph Cornell and Jean Painlevé."

spidery, the other performative work in the trilogy, superimposes refracted light and an original black-and-white film depicting a spider in its web. Eros manipulates the image by projecting it through a prism of water and cut crystal, fracturing the body of the spider into elongated shapes and shadowy beams. The delicate spider, projected in intimately small scale, attains a sculptural presence as it wavers and crawls across the screen. As in the other *Ocula* works, Eros here finds poetry in science, conveying the marvelous within the mundane. HH

Still from *Aurora Borealis*, 2003. 16mm film, anamorphic lens, color, sound; 11 min. Courtesy the artist

Spencer Finch
Born 1962, New Haven, CT
Lives in Brooklyn, NY

Perception, the memory of visual phenomena, and the impossible attempts to precisely describe them are at the center of Spencer Finch's work. In often seemingly absurd installations, paintings, and drawings, Finch has spelled out a lexicon of subtle approaches to represent such diverse subjects as celestial bodies, subconscious imaginings, and particular historical moments. His work *Trying to Remember the Color of Jackie Kennedy's Pillbox Hat* (1995), which consists of a series of one hundred pastel drawings in different shades of pink, can be read simultaneously as an attempt to give the most precise representation of the color Kennedy wore on the day of her husband's assassination and a testimony to the impossibility of such an undertaking.

In a number of works, Finch tries to depict the exact color of the sky at particular moments: *Blue (Sky over Cape Canaveral)* (1994) consists of a single 3 x 3-centimeter square of light blue paint capturing the precise point in the sky where the Space Shuttle *Challenger* exploded and the siting device the artist constructed to determine the position; *Sky over the Ikarian Sea I–VII* (1997) is a series of seven elliptical panels of encaustic paint depicting the aerial view of Icarus during his ascent over and eventual fall into the Ikarian Sea; *Sky (Over Roswell, New Mexico, 5/5/00 dusk)* (2000) is a large oval aluminum panel covered in rhinestones on blue acrylic paint ground; and his installation *Eos (Dawn, Troy)* (2002) is an attempt to re-create the exact light condition of the sky at the ancient site right before sunrise using seventy-five fluorescent lights and color gels. In *Colors from My Dreams* (2000–02), a more recent series of 102 ink drawings, Finch has shifted his focus inward, depicting Rorschach-like forms of different colors that occurred to him in his sleep.

Beyond their slender beauty and conceptual clarity, Finch's works address the inadequacies of perception and its visual and linguistic representations. Seemingly literal in their focus and approach, Finch's works capitalize on the gap between their proposed project and the effective result. But while the stated aims remain highly speculative, the work raises profound questions about the nature of memory and the array of references and meanings between a work's subject and its formal elements. CR

Blue (Sky Over Los Alamos, 5/5/00, morning effect), 2000 (detail). Lamps and bulbs, dimensions variable. Collection of Susan and Michael Hort; courtesy Postmasters Gallery, New York

Rob Fischer
Born 1968, Minneapolis, MN
Lives in Brooklyn, NY

Rob Fischer's sculptures balance mobility and the desire for escape with an inextricable bond to place. Often made from parts of transport vehicles—in the past he has used airplane wings, flatbed trucks, boats, and trailers—and scrap materials, his psychologically fraught assemblages make reference to architectural structures outside the gallery spaces in which they are exhibited. Unmoored from a landscape in which they might provide shelter, Fischer's sculptures do not quite reach architectural scale: they toe the line between disciplines as improvised, semi-inhabitable discrete objects. Viewers can enter his constructions, which are often created on-site and modified during the course of an exhibition, but they are given only piecemeal clues as to the works' fitness for human habitation. Instead, the ramshackle dwellings' shortage of domestic trappings suffuses Fischer's art with an uneasy bleakness.

Mirrored House on Floats (1999), a mirror-sided structure with a pitched roof set on overturned oil drums, suggests the ice-fishing huts of the artist's native Minnesota. The sculpture brings to mind twin American vernaculars: its construction refers to the folk architecture of the Great Plains landscape, while its elegant formality brings to mind 1960s American modernist sculpture. Despite the work's solidity, its mirrors function to camouflage the structure by reflecting everything around them. The oil drums double as pontoons to set it adrift once the ice melts; nothing is as stable as it seems. The same can be said for an untitled cabin, completed in 2002, whose body is connected both to the bed of a pickup truck and a metal boat. These structures often consume much of a gallery's interior, yet Fischer does not return this space to the viewer: the artworks remain uncomfortably small for anyone who steps inside them.

Fischer's constructions are made entirely by hand, often reusing or recycling elements from earlier pieces, and the history of each scrap or spare part is embedded within the works. Their pathetic strivings toward mobility suggest a desire to shake off the burden of place; they fail not only as habitable constructions but also as a means of escape. Fischer's unsettling, enigmatic sculptures look toward a future laden with the aura of his materials' past lives and the places from which they have come. BJS

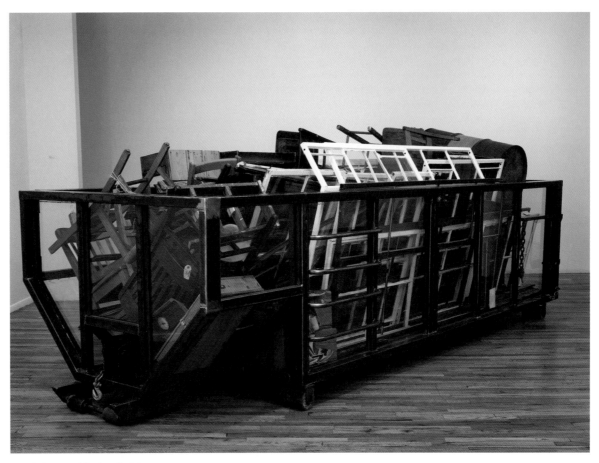

Ten Yards, 2003. Mixed media, 54 x 174 x 80 in. (137.2 x 442 x 203.2 cm). Collection of the artist

Kim Fisher
Born 1973, Hackensack, NJ
Lives in Los Angeles, CA

In her spare canvases, Kim Fisher expresses a renewed interest in the monochromatic grammar of Minimalist painting. Fisher engages the formal conventions of monochrome painting, following the models set by artists such as Barnett Newman, Ad Reinhardt, and Robert Ryman, and subtly combines them with fashion, an area invested in a very different concept of the beautiful.

Addressing the question of the aesthetically pleasing as a material construct, Fisher highlights its peculiar epistemological position as deeply compromised by matter. Her paintings can be understood as highly controlled material exercises, resulting in surfaces of opulent effect. Dozens of transparent layers of paint and pigment are built up over a period of months, applied both manually and mechanically. For *7b* (1999), a work from one of her earliest series, Fisher applied several layers of bright, luscious color—each a different shade of red—directly onto the unprepared canvas, itself a warm-colored, fine-kempt linen. Floating slightly off center in the red square, a white quarter-circle stands out against the background of pure color, and continues as a

shadow underneath the many layers of red paint. The white form is an abstracted fragment of the company logo of André Courrèges, a French designer from the 1960s. By inserting an obscure reference to the world of fashion, Fisher not only opens her painterly field to other levels of meaning, but also introduces a discipline in which the concept of beauty is perceived in dramatically different ways. For other works, Fisher has used images of Chopard watches, which she silkscreens onto canvas and combines with graphic, colored fields of meticulously executed surfaces, as in *Corundum 17* (2002). In *Carbon 7* (2001), a fragment of a diamond ring, placed in the bottom corner of a vast expanse of black paint, slowly differentiates into several shades of black crystalline structures, echoing the cut of the gemstone.

Her most recent work combines some figurative elements and thematic aspects of her earlier work with a more experimental inquiry into the formal properties of the painted surface. *Beryl, 31* (2003) features a composition of crystalline shapes in hues of green and blue, expanding from the edges of

the upper-left corner into the open field of the linen ground. The paint extends to the edges of the support, literally bleeding off the stretcher and surrounding the pristinely stretched canvas with a narrow garland of partially painted and partially blank fabric. Translating her interest in the objects and symbols of luxury, beauty, and fashion into purely visual and formal elements while simultaneously expanding the treatment of both support and color application, Fisher engages in a study of the beautiful that is as intellectually adept as it is visually seductive. CR

Beryl, 31, 2003. Oil on linen, 78 x 68 in. (198.1 x 172.7 cm). Collection of the artist; courtesy China Art Objects Galleries, Los Angeles

Morgan Fisher
Born 1942, Washington, DC
Lives in Santa Monica, CA

Working in film, painting, drawing, and installation, Morgan Fisher explores strategies of composition and forms of self-description that first emerged in Conceptual and Minimal art of the 1960s. Fisher's works, which treat the conventions of film in a radical and paradoxical way, refer to both commercial films and 1970s Structural film, in which he was a key figure. His film *Production Stills* (1970) was shot on a sound stage using a Mitchell, the classic Hollywood camera, as well as a pack of Polaroid still film. The subject of the film is the means and procedures of its own making, thus undermining the allure of the commercial film industry with a subversive compositional procedure. *Picture and Sound Rushes* (1973) systematically explores all the possible basic combinations of image and sound in synchronous sound film. Its ruthless logic proposes the possibility of a film with neither sound nor image, a work that acknowledges the events unfolding in front of the camera but refuses to register them. *Projection Instructions* (1976) is a score that the projectionist performs. By turning the usually hidden projectionist into the protagonist of the event, it follows the convention of a Hollywood film in its dependence on a star but subverts this convention by keeping that person's picture and name from appearing on the screen.

In his film *Standard Gauge* (1984), Fisher shows a succession of scraps of 35mm film—leaders, run-off between takes, trailers, old television shows—that he scavenged while working in the film industry. The film follows the form of a photo album, a succession of images with a commentary, and functions as an autobiographical sketch while also considering various aspects of commercial film history, such as the disappearance of Technicolor and the long take in Alfred Hitchcock's movies.

Fisher's most recent film, *()* (2003), continues his critical engagement with narrative filmmaking. The film consists entirely of inserts that Fisher found in commercial feature films. An insert is a standard shot in the syntax of narrative films that shows a detail so essential to the story that the scene cuts from the main action to include it. In a narrative film, an insert's only purpose is to tell the story clearly; *()* removes the inserts from their narrative context, stripping them of their original meaning. Organized without narrative or thematic logic, the film has a strict compositional principle that maximizes the autonomy of each shot. As *()* liberates inserts, it also liberates its audience from the need to construct meaning from a sequence of images. In its embrace of chance juxtapositions, *()* joins Hollywood with Surrealism. CR/MF

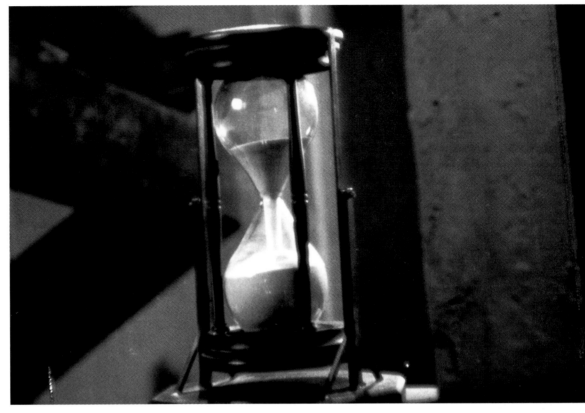

Still from *()*, 2003. 16mm film, black-and-white and color, silent; 21 min. Courtesy Galerie Daniel Buchholz, Cologne, and China Art Objects Galleries, Los Angeles

Harrell Fletcher
Born 1967, Santa Maria, CA
Lives in Portland, OR

Harrell Fletcher creates site-specific projects that explore the dynamics of social spaces and the interactions between people who populate them. He has worked on his own and collaboratively for ten years, combining gallery exhibitions and temporary public art projects that gather together diverse participants to create what Joseph Beuys called "social sculpture." In Beuys's understanding, thought, speech, and discussion are core materials for an art practice that posits all human beings as artists in control of a democratic social order. Fletcher's temporary projects embrace a harmony between people in the service of creating a moment or object of beauty.

For a 2003 exhibition at DiverseWorks in Houston, Texas, Fletcher invited fourteen local groups to do what they normally do—yoga, dancing, singing, and so on—but in the gallery. The exhibition comprised video footage of them in the gallery and a series of fourteen posters placed throughout Houston. Another exhibition, *Now It's a Party*, was presented at Real Art Ways in Hartford, Connecticut, in seven parts. Each part interacted with a different facet of the gallery's neighborhood. Fletcher made a video adaptation of James Joyce's *Ulysses* at the Parkville Senior Center, using residents as actors; presented a concert that involved one hundred members of local church choirs; made a free newspaper that reported "good things" happening in the area; offered public meditation classes; and asked the public to make a bust of Steve, a Greek taxi driver whom Fletcher met in the city.

"Make a Bust of Steve" was assignment twenty-one on *Learning To Love You More*, a website Fletcher created in 2002 with artist Miranda July and designer Yuri Ono. The site is dedicated to presenting artwork made by the general public in response to assignments posted by the artists, and every submission that follows the instructions of the assignment is accepted, whatever the end result. Each creation is digitally documented and archived online; many of the original works are also used to populate exhibitions in galleries and museums around the world. The project takes the tone of an encouraging friend: the artists believe that the prescriptive nature of the assignments allows people to bypass the task of coming up with an idea, instead allowing them to focus on feelings and experiences.

The temporary nature of Fletcher's projects precludes the development of longstanding communities in his wake. Instead, his artworks create otherwise improbable connections between people and emphasize the diversity of activities in a given area. Whether inside the gallery or out, Fletcher puts the power of the artwork in the hands and minds of those who participate in its making. BJS

Natasha on the Stairs with her Guitar, 2003. Laser print, 48 x 60 in. (121.9 x 152.4 cm). Collection of Dana Dart-McLean; courtesy Christine Burgin

James Fotopoulos
Born 1976, Norridge, IL
Lives in Chicago, IL

James Fotopoulos has completed eighty films and videos since 1993, an oeuvre that includes eight feature-length works. Fotopoulos first garnered notoriety with his uncompromising, transgressive features *Zero* (1997), *Migrating Forms* (1999), and *Back Against the Wall* (2000), in which he established a distinctive style of static takes and starkly lit interior settings filmed in grainy black-and-white and accompanied by ominous industrial soundscapes. In these films, Fotopoulos creates a world of sexual anxiety and interpersonal dysfunction, governed by the threat of imminent violence and abject squalor. Recently, while continuing to make narrative-oriented features, he has also moved toward abstract experimentation in digital video.

His recent video works retain some of the characteristic imagery and monotonous soundtracks while abandoning narrative entirely. *The Glass House* (2003) is a 60-minute experimental study of a female nude. Opening with partial views of nude drawings, the video becomes gradually more explicit. Distorted red-orange shapes that reveal themselves as a female body are followed by the discernible image of a naked woman walking or rolling in front of the camera. Her headless torso is rendered uncomfortably close and claustrophobic, an effect underlined by the relentless audio drone. *Leviathan* (2003) begins with a soft-edged image of a female nude in orange and flesh tones, abstracted as in the opening scenes of *The Glass House*, but then goes on to the depiction of a landscape, shot on Super-8 film and transferred to video. The result is a series of streaky, washed-out images of brown and black trees and fuzzy green grass. These extended nature shots are juxtaposed with abstract sequences of an indistinct human shape that is superimposed with irregularly masked areas of the video image. Reminiscent of early technological experimentation in video art, Fotopoulos's work fuses his own thematic preoccupations with a formal probing of the medium.

Families (2002) bears the stylistic traits of his earlier feature-length films but expands the number of characters and locations. Opening with a portentous shot of nearly motionless sheep, the black-and-white film develops in disaffected dialogue scenes interspersed with shots of dreary Midwestern exteriors. The main strain of the narrative focuses on a young man and woman and their prolonged, halting conversations, many of which revolve around death. Yet none of the violence recounted in these exchanges takes place on screen, where life is characterized by the absence of physical contact, robotic soliloquy, and a general sense of forlorn ennui. Recurring throughout the film are repeated shots of the sheep from the opening, dogs, or fish in an aquarium, paradigmatically linking animals to the characters and their awkward interactions. Fotopoulos suggests that the titular familial ties refer to larger structures of kinship, and constructs a bleak parallel in the common markers of human and animal existence. HH

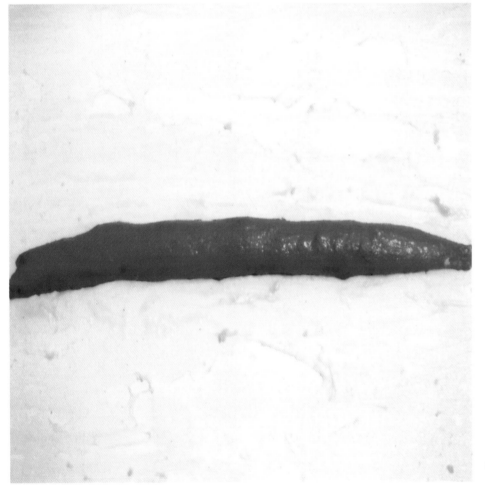

Untitled, 2002, sculpture from *The Glass House*, 2003. Balsa, cotton, liquid latex, and acrylic, 11 3/4 x 5 7/8 in (29.8 x 14.9 cm). Collection of the artist

Barnaby Furnas
Born 1973, Philadelphia, PA
Lives in Brooklyn, NY

Barnaby Furnas paints archetypal themes such as love, death, and war in an idiosyncratic style that is both grounded in the present and deeply aware of its past. Exploding heads, figures walking in forests, rock concerts, battle scenes, and fornicating couples recur as his subjects and, like the Italian Futurists, the representation of speed is requisite to his rendering process. Furnas depicts his subjects in states of arrested action, expressing what are often horrific moments of bodily disintegration that recall scenes from Hollywood movies, such as the exploding bodies in the opening scenes of *Saving Private Ryan* or the fight sequences in *The Matrix*, in which bullets dissect the screen and leave traces that pixilate the virtual playing field. These violent images are readily identifiable in a society that revels in the spectacle. As Guy Debord says, "Outside of work, the spectacle is the dominant mode through which people relate to each other." While Furnas's apocalyptic scenes are horrifying, his use of bright colors and spattered layers of paint serve to tantalize the viewer.

Furnas represents space panoramically within his compositions. This is in part inspired by video game animation, where space rotates around a protagonist who is centrally fixed within the playing field. Often bullets exit his paintings only to reenter on the other side, as seen in *Untitled (Suicide)* (2003). Furnas sets gruesome Civil War battle scenes in ostensibly serene ocean settings with low horizon lines, against a backdrop of cumulus clouds floating in clear blue skies, waves lapping onto the shore, and the sun brilliantly shining. These would-be idyllic settings teem with bullets that race through the sky, splattered blood, and severed limbs that lie scattered across the foreground. In *Hamburger Hill* (2002) countless bullets tear through bodies, bursting hands and heads that block their path. Angular men futilely run in every direction, ablaze and incongruous, while the Confederate flag flies in shreds above them. The monumentality of the composition and the portrayal of a battle scene recall history painting, which was once considered the most important type of painting. In *Untitled Execution* (2003), seven men stand in an execution line as gunshot bursts obscure their heads. It is unclear whether they are being shot at or are shooting the

central figure in the foreground, who erupts in an atomic-style explosion, his blood spreading across the picture plane.

Furnas's rock concert scenes further underscore the spectacle, as musicians leap and thrash about the stage while the hands of adoring fans reach for them from below. In *Rock Concert #7* (2003), rays of golden light radiate throughout a crowded stadium, in the center of which rock musicians perform on a stage. Furnas depicts the speed of the musicians' arms by multiplying them—echoing the dynamism employed by the Futurists and Cubists of the early twentieth century. In *Guitar Player* (2003), he depicts the ubiquitous leap of a rock guitarist, suspended above his starstruck fans, his head, guitar, and hands reinforced by the strobes of light bursting behind them. As objects of consumption, Furnas's musicians and military figures are anonymous icons for a society obsessed with its entertainment constructs. AD

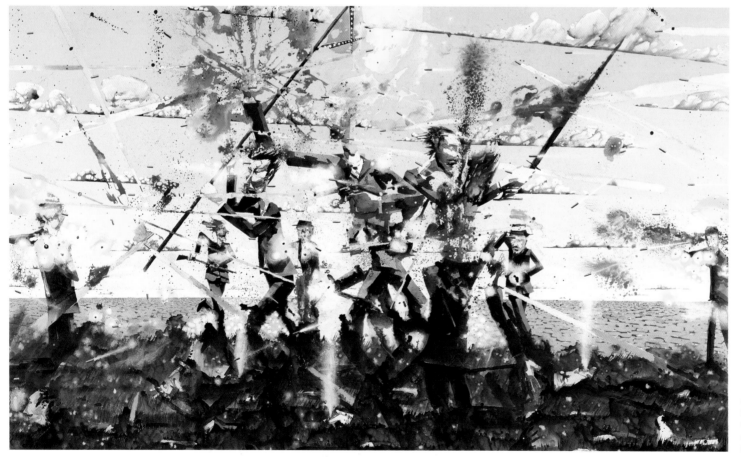

Hamburger Hill, 2002. Urethane on linen, 72 x 120 in. (182.9 x 304.8 cm). Collection of Dean Valentine and Amy Adelson; courtesy Marianne Boesky Gallery, New York

Sandra Gibson
Born 1968, Portland, OR
Lives in New York, NY

Originally trained as a painter, Sandra Gibson has taken the exploration of shape and color to the mechanical medium of film. She treats film as matter, painting, stenciling, and scratching directly on plastic surface and light-sensitive emulsion. After being meticulously worked upon, individual film frames become miniature paintings or collages.

The intricate compositions, however, exist to be transformed by the film projector into exhilarating animations of luminous color. Gibson's handmade process emphasizes the medium's materiality, exploiting those properties of celluloid that are fundamentally distinct from the electronic recording techniques of video. While her earlier films were further reworked in manual editing and optical printing, processes that allow for the reordering, multiplication, and repetition of frames, some recent works are produced without mechanical manipulation, effectively treating the film strip like a painter's canvas.

In the 5-minute silent film *Outline* (2003), which unfolds in a burst of color luxuriating in the width of 35mm CinemaScope, a succession of different shapes and textures cascades across the full expanse of the projection screen. Unlike Gibson's earlier films, which include a soundtrack, *Outline* is purely visual. In conjunction with the wide format, the film takes both the painterly and cinematic qualities of her work to conclusion.

Gibson has recently moved into yet another direction by making a series of single-roll, Super-8 films, closely framed sketches of nature that are edited in camera. *Palm* (2003) depicts a gently swaying palm tree against the background of a clear blue sky, its delicate leaves trembling in the breeze, opening and closing like the fingers of a hand. *Bellagio Roll* (2003), filmed in the gardens of Bellagio, Italy, shows blooming, sun-drenched flowers that emerge in short, flickering takes. The subject is explored further in *NYC Flower Film* (2003), which consists entirely of single frames of colorful blossoms blooming in New York City. Graceful compositions of light, movement, and color, Gibson's small-gauge films combine the abstract portrait of a place and its particular rhythm with the depiction of ephemeral, fleeting moments that are universally recognizable. HH

Stills from *Outline*, 2003. 35mm film, CinemaScope, color, silent; 5 min.

Jack Goldstein
Born 1945, Montreal
Died 2003, San Bernardino, CA

Jack Goldstein's work demonstrates an acute understanding of the symbolic power of the image. A major figure in the discourse on appropriation art in the late 1970s and early 1980s, Goldstein produced a diverse body of work, including performances, films, vinyl records, sound works, painting, and photography, which formed a deep inquiry into the representation of spectacle, His short color films of the 1970s construct spare single images—a knife, a dove, butterflies, a dancer's foot in a ballet shoe—in a high finish using production values influenced by Hollywood studio techniques.

In *Metro-Goldwyn-Mayer* (1975), Goldstein appropriated and looped the famous company logo of a cartouche with a roaring lion, set against a bright red background. *Shane* (1975) similarly presents a trained German shepherd set against a monochrome background, barking repeatedly on command. In *Jump* (1978) the artist created a rotoscopic image of a springboard diver set against a black background, performing a somersault jump, twice in slow motion, once at regular speed, and once in a sequence of still images. With all background information and narra-

tive eliminated, the sparkling red abstracted image becomes an isolated event of pure visual presence.

In Goldstein's vinyl records his concern with the operative structure of the image is explored through sound. In deadpan recordings such as *Two Wrestling Cats* (1976), *Three Felled Trees* (1976), and *The Six-Minute Drown* (1977), he conjures a mental picture of the subject through the narrative sound of its presence.

In the early 1980s Goldstein began to paint large pictures of explosions, fighter planes, lightning, volcanoes, and other natural and artificial apocalyptic spectacles. Meticulously crafted and finished, the paintings are built up from several layers of sanded gesso onto which the image is airbrushed to perfection. Goldstein's paintings take their subjects from photographs circulated through image banks and news media, once again exploring the question of representation. Through their seamless finish, the works are imbued with a spectacular visual presence that complicates their function as markers of criticality.

In Goldstein's last film, *Under Water Sea Fantasy* (1983/2003), finished shortly before his death,

images of a bright red volcano eruption, deep blue underwater footage of a coral reef, and a lunar eclipse hark back to his photographic triptych *The Pull* (1976), which combines a deep-sea diver, an astronaut, and a man in a business suit, all in mid-fall. Juxtaposing images of serene beauty and apocalyptic catastrophe, Goldstein articulates the spectacle of the endless void, evoking that into which the diver of *Jump* repeatedly leaps, but to which he never fully surrenders. CR

Stills from *Under Water Sea Fantasy*, 1983/2003. 16mm film, color, sound; 6:30 min. Courtesy Galerie Daniel Buchholz, Cologne

Katy Grannan
Born 1969, Arlington, MA
Lives in Brooklyn, NY

Since the late 1990s, Katy Grannan has photographed strangers. Some have responded to ads Grannan places in local, suburban newspapers seeking models for her portrait photographs, others are approached by the artist or referred by previous subjects. The sitters are photographed in their homes, sometimes naked, and in positions and arrangements that point at a basic, low-tech collaboration between photographer and model, without ever turning familiar, secure, or safe. Her *Poughkeepsie Journal* (1998) comprises a series of portraits taken in and around the city in upstate New York. Mainly portraits of young women in their teens and twenties, the images convey an uneasy distance and play off the unresolved tension between voyeurism and exhibitionism.

In one image, a young woman is shown in a simple white tank top and jean shorts, sitting on the floor of her kitchen and staring with a sunken gaze to the left of the camera. Her pose is a complex hybrid of the desire to be photographed and the inability to truly embrace that desire. As a portraitist Grannan renders the ordinariness of both interior and sitter, and captures the resulting defamiliarization of the arrangement. Objects in turn acquire a life of their own, becoming protagonists in the attempt to understand details about the anonymous sitters' lives, circumstances, or narratives. The overkill of patterns and fabrics in *Joline, Broad Top, PA* (2002), from Grannan's black-and-white *Morning Call Series*, echoes the clashing appearance of the model, an overweight woman in netted stockings and a sleeveless top perched on an oversize sofa. Another image from the same series, *Van, Red Hook, NY* (2003), shows a young man dressed in a silk robe, posed against wildly patterned wallpaper. The seductive quality the sitter aims for is unhinged by the fact that the chair he sits in is too small, undermining the carefully arranged seriousness.

Grannan's photographs are not sensational or willfully antagonistic. Her subjects are commonplace, and their unease is a result not of coercion or manipulation but of the flaws that define them as utterly human. Grannan's most recent series of color photographs, collectively titled *Sugar Camp Road* (2003), presents its subjects in outdoor settings: perching against a roadside rock, stretching under a tree, squatting in a pond of mud. All of the subjects display their physical shortcomings or hint at some potentially violent narrative in the subtext of the image. None of the images, however, capitalize on the superiority of the photographer—and by extension the viewer—but rather aim to create a perfect moment, even if that moment is exquisitely flawed. CR

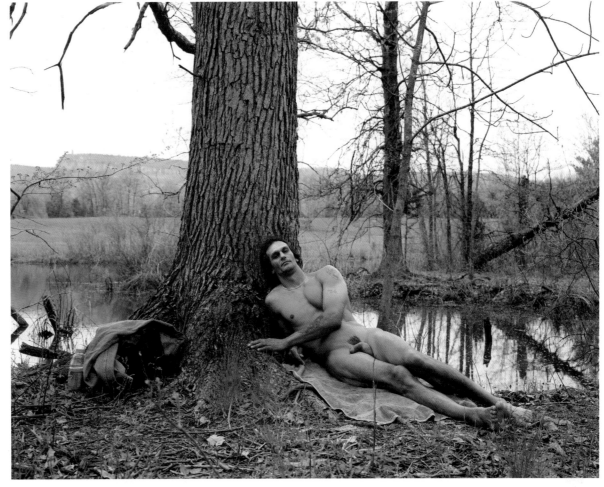

Mike, private property, New Paltz, NY, from the series *Sugar Camp Road,* 2003. Chromogenic color print, 48 x 60 in. (121.9 x 152.4 cm). Collection of the artist; courtesy Artemis Greenberg Van Doren Gallery, New York, and Salon 94, New York

Sam Green
Born 1966, Detroit, MI
Lives in San Francisco, CA

Bill Siegel
Born 1962, Minneapolis, MN
Lives in Chicago, IL

Sam Green and Bill Siegel's feature-length documentary *The Weather Underground* (2003), about the radical left-wing group of the same name, recovers a portion of 1970s history from relative obscurity. Emerging from the antiwar organization Students for a Democratic Society (SDS) during its tormented 1969 national convention, the Weathermen aimed to "bring the war home" and violently overthrow the government of the United States. Through the mid-1970s, the group carried out a string of attention-grabbing bombings of government facilities, without ever seriously hurting anyone or getting caught.

In a series of interviews, former Weathermen Mark Rudd, Bernardine Dohrn, Bill Ayers, and Naomi Jaffe, among others, reflect—regretfully or defiantly—on their violent protest in the service of what they believed was imminent revolution. The documentary assembles archival footage and film stills that illustrate the historical context and the nation's state of unrest at the time, including disturbing images of soldiers killing Vietnamese civilians and slain Black Panther Fred Hampton's blood-soaked mattress. The filmmakers neither condone nor condemn the Weather Underground's actions, and they do not gloss over the group's contradictions. Its members where white and often from affluent backgrounds, for example, and their actions were not necessarily supported by other revolutionary groups such as the Black Panthers. Nonetheless, the film elicits sympathy for the former radicals, and articulates why violent protest seemed to them to be a legitimate option. "We felt that doing nothing in a period of repressive violence was itself violence," explains Jaffe.

Chronicling an episode of past activism and resistance, *The Weather Underground* highlights the extent of turmoil enveloping the country in the late 1960s, a time often perceived as hopeful and idealistic. Documentarians Green and Siegel began working on the project five years ago, but the terrorist attacks of September 11, 2001, and subsequent events have added a new poignancy. Although perhaps not explicitly, the film invites comparison between the early 1970s and the present day, a time when Americans are living through collective trauma and anxiety at home, and the United States is involved in the prolonged aftermath of war abroad. HH

1969 police mug shot of Bernardine Dohrn, former member of the Weather Underground. Still from *The Weather Underground*, 2003. 35mm film, color, sound; 92 min.

Katie Grinnan
Born 1970, Richmond, VA
Lives in Los Angeles, CA

In a project designed to articulate elusive spaces in constant flux, Katie Grinnan creates conditions that allow for spatial ambiguity within the vernacular of the everyday experience. Her sculptural installations are sites where perspective, boundary, and function distort and hybridize, giving way to an internal logic that is both familiar and abstract. Her fractured and colorful constructions made from found objects, paper, photographic elements, and organic materials evoke the notion of utopian independence and other enabling possibilities that arise from fluctuating spatial states and ideas.

The surfaces of her work, often painted and collaged with digitally manipulated photographs, are support structures on which the play of space— doubling, fragmenting, mirroring—occurs. The photographs themselves are of quotidian objects and spaces, such as buildings, fauna, and suburban landscapes, that are digitally abstracted yet still recognizable up close. *Shipwreck* and *Phantom Limb* (both 2003) incorporate these elaborate photo-collages into a larger constellation of tree branches, found objects, and painted foam. Grinnan's use of

both actual and mimicked forms further complicates the definitions of function and representation. *Dreamcatcher* (2002–03) depicts an upside-down forest scene consisting of photographs shaped as vegetation, rope and electrical wire fashioned into vines, and corduroy fabric arranged as mud on the floor. Incorporating photographs of rain forests, deserts, and lawns, the installation is a sculptural abstraction representing Grinnan's memories of traveling in Costa Rica as well as her surroundings in California. *Hubcap Woman* (2003), adorned with a crown and cape made of plastic cast hubcaps, embodies the dualities of presence and ghostliness, idealism and delusion, and the sacred and the ordinary. Weighted by a sewer cover, the hollow white sculpture bears the countenance of the artist merged with that of Bette Davis.

Consisting of photographic elements, found objects, and video projections, the installation combining *Midnight at Noon*, *Level Sky*, and *Heavy Ground* (all 2003) explores mirroring across physical, actual, and filmic space. Images of Halloween lawn ornaments near her studio appear both in

photographic and animated manifestations. Similarly, spatial forms delineated by the painted and photo-collaged segments mimic structural elements of the sculpture. Rain forests, butterflies, and mud puddles in video form double as time-based sculptural elements. By choosing where to stand in the installation, the viewer can engage the various levels of illusional and physical space.

Grinnan's recent work draws on her research of the Great Barrier Reef, tropical rain forests, the Biosphere 2 Center in Arizona, and Arcosanti, a utopian community also in Arizona. This has inspired her use of plants and crop vegetation in her new installations, making reference to experiments in communal farming and living. Within the context of modernity, these sites represent alternate models of independence, from self-sustaining ecosystems to ideal communities. These constructions propose a fluid synthesis of organic and man-made elements, employing technology as a means to investigate the spatial forms and systems that exist in nature and culture. HC

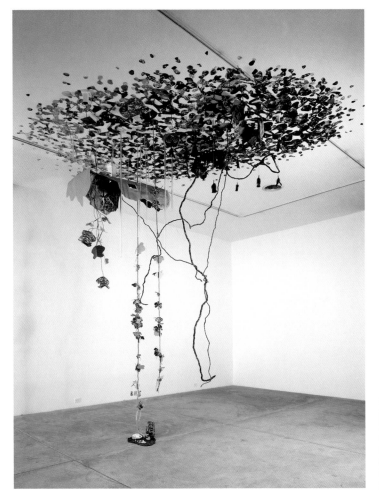

Dreamcatcher, 2003. Chromogenic color prints, ink-jet prints, polycarbonate resin, foam rubber, magnets, steel, cel paint, wood, rope, plaster gauze, tissue paper, feathers, string, acrylic tubes, corduroy, shells, and tile, dimensions variable. Collection of the artist; courtesy ACME., Los Angeles

Wade Guyton
Born 1972, Hammond, IN
Lives in New York, NY

Wade Guyton creates sculptures, installations, photographs, and drawings that engage in a conflicted dialogue with the legacies and vocabularies of Minimalism, simultaneously acknowledging their influence and questioning their operative potential. His work shares with the sculptural practices of the 1960s a sensibility for the properties and functions of a unified visual shape, but derives from them a different set of sculptural functions. Guyton's room-filling installation *The Room Moved the Way Blocked (stage #1)* (1998) consists of a 5-foot-high, 15-square-foot volume built from parquet flooring, placed such that it blocks the gallery's front door. Reminiscent both of the most iconic sculptures of Minimalism and of more utilitarian structures such as concert stages and dance floors, the sculpture is positioned literally and operatively at the threshold between these two spheres of meaning. Because viewers had to mount the sculpture if they wished to use that entrance, its function oscillated between a barrier and a pedestal for public display.

Another series of sculptures, each titled *Fragment of a Sculpture the Size of a House* (2000–03), is derived from a suburban house in Tennessee, which Guyton photographed and completely blackened into a somber silhouette of the building. Each individual sculpture is built as a hollow shape of black wood and aluminum sheets and presents one partial element of a potentially complete sculptural form of the outlined black shape of the house. As individual objects, these sculptures perform contradictory operations within the gallery. Although a fragment of a larger shape, they appear as a gestalt, a sculptural form immediately understood as whole and complete. And although they clearly extend in three dimensions in space, they seem virtually flattened, resulting in the complete cancellation of spatial characteristics in reproductions of the works. Both complete and fragmented, spatial and flat, abstract and highly referential, Guyton's sculptures constantly move in and out of the discourse of Minimalism while retaining most of its formal vocabulary.

Guyton's most recent series, his so-called printer drawings, uses pages from art and architecture books, which he prints over with geometric shapes, using an ink-jet printer. The artist "draws" simple geometric patterns on the computer, often consisting of X-shaped, diagonal, and horizontal bars that cancel out the underlying image. His choice of source material includes black-and-white images of German and Swiss half-timbered houses, Constructivist artworks from the 1920s, and interiors and artworks from the 1960s and 1970s, including iconic public sculptures by Tony Smith and Charles Ginnever. Recently Guyton began to incorporate these designs into his sculptural work by constructing large black wooden X-shapes, which he placed in the windows and leaning against the walls of galleries and exhibition spaces. Translating the drawn visual barrier of the printer drawings into the real space of the gallery, Guyton deliberately blurs the epistemological boundaries between drawing and sculpture, between figure and ground, and between that which constitutes an image and its cancellation. CR

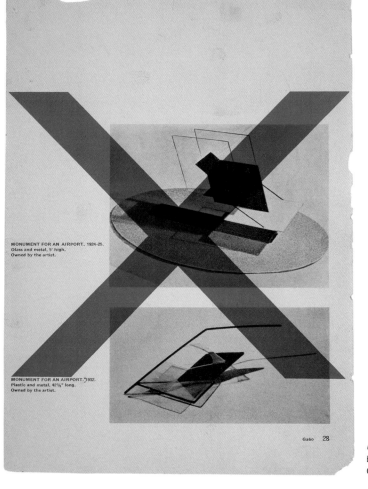

Untitled (Gabo 28), 2002. Ink-jet on book pages, 7 x 10 in. (17.8 x 25.4 cm). Collection of William A. Palmer

Mark Handforth
Born 1969, Hong Kong
Lives in Miami, FL

Mark Handforth's sculptures and installations resonate with both the materials and practices of Minimalism and the sensibilities and objects of the streets and sidewalks. Handforth has used Vespa motor scooters and Honda motorcycles, street lamps and neon tubes in his installations, and has reworked landmarks of modernist furniture in hardwood planks.

For a 2001 exhibition in Turin, Italy, Handforth installed a Vespa in the gallery's backyard and outfitted the scooter with a sprinkler emitting a fine mist of water. As the lit headlights turned the scene into a radiant sequence of rainbows, the work radiated romanticism while simultaneously making reference, as critic Tim Griffin points out, to the final scene of the film *Quadrophenia* (1979) and the working-class neighborhoods adjacent to the gallery. In another work incorporating the classic Italian scooter, titled *Vespa* (2001), Handforth attests to the vehicle's almost mythical stature by decorating a 1960s model with dripping, burning, multicolored devotional candles, turning it into an altar of sorts. For an exhibition in Los Angeles, Handforth

changed the context and reference of his reverence and replaced the Vespa—so emblematic of a certain European sensibility encompassing mod culture and Italian dolce vita—with a Honda motorcycle, more in tune with the biker culture of the American West.

Handforth's engagement with the street and its diverse furnishings also is reflected in several other sculptures, such as *Tyre* (2000) and *Hydrant* (2003), which consist of simple objects placed in the gallery like trophies or debris. For *Untitled* (2003), Handforth fitted a common street lamp into a gallery space by folding it four times along the stem. Turning the lamp into a fragile and eloquently graphic sculpture, the work is both a riff on the Minimalist use of industrial light fixtures as a material and on the post–Abstract Expressionist sculptures in city plazas. For a public art commission, *Lamppost* (2003), Handforth transported the concept back into the urban fabric and placed a street lamp in a civic plaza in New York. The lamp appeared to be half-ripped from its anchoring, bent twice to briefly rise up, and then rested on the ground on one bend with its crown of five lights

shining in a red glow. In other works, Handforth further capitalizes on the reference to Minimalist materials by using standard fluorescent lighting. For *Rising Sun* (2003) he created a halo of radiating light beams, originating from an empty circle partially sunken into the gallery floor. For another series, Handforth re-created scribbled graffiti ("Claudia, I love you kind of; 11:25 pm") and mobiles in fluorescent neon and displayed them under bridges and on ceilings, infusing a clear reference to modernist aesthetics with a tongue-in-cheek romanticism. CR

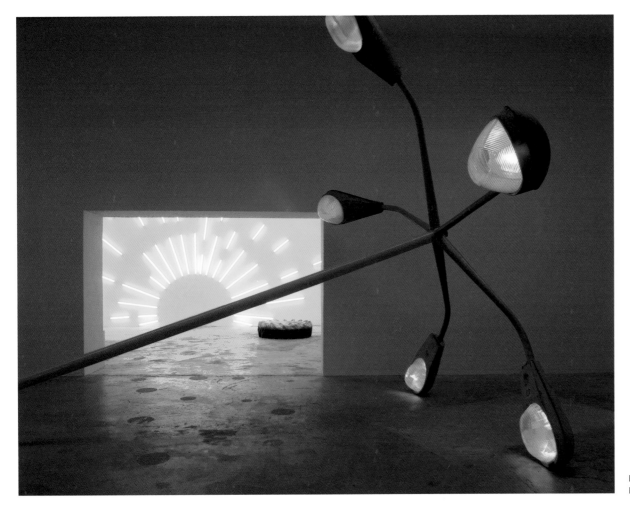

Installation view at Le Consortium,
Dijon, France, 2003

Alex Hay
Born 1930, Brandon, FL
Lives in Bisbee, AZ

In the early 1960s, Alex Hay emerged as a member of the historic performance workshops held at New York City's Judson Memorial Church. In the mid-1960s he collaborated with Robert Rauschenberg in productions for the choreographer Merce Cunningham's world tour and with E.A.T.—the avant-garde group Experiments in Art and Technology founded by Rauschenberg and Billy Klüver—culminating in *9 Evenings of Theater and Engineering* (1966–67), a collaborative event between Bell Laboratory engineers and ten artists, including Hay, Rauschenberg, and John Cage. Hay's studio work of the time delved into a formal investigation of the everyday. It consisted of simple, elegantly deadpan depictions of mundane objects, such as a single sheet of legal paper, a paper airplane, or a sales receipt. In *Cash Register Slip* (1965), Hay reproduced a paint store receipt totaling just over five dollars as an 80-inch-tall painting, and his 8-foot sculpture *Paper Airplane* (1968) consists of a carefully constructed paper plane, folded from a single sheet of paper and then stenciled, painted, and covered in fiberglass and epoxy. Making reference to both Pop art in his choice of subject matter and Minimalism in his restrained approach to composition, Hay's works carefully navigate their position among the dominating currents of the time. Painstaking observations of quotidian objects and refined, smooth surfaces, they are still deeply embedded in the labor-intensive production of painting.

In 1969, Hay moved away from New York, withdrew his works from public view for a period of more than three decades, and dedicated himself to the production of objects necessary for the conduct of everyday life, rather than its depiction. In 2003 he resumed painting, making a series of close-up views of small pieces of scrap wood. Most of Hay's early concerns seem intact, though infused with a more conceptual approach to his subject matter. Functioning purely as abstract surfaces, these works take the painterly potential further without surrendering the investment in the mundane, recognizable, and seemingly banal. They are informed by the knowledge that any painterly representation is a removal, translation, or transformation of sorts, which, if taken purely on the level of the visual, is no longer tied to the form or shape of the object. CR

Gray Wood, 2003. Spray acrylic and stencil on linen, 61 7/16 x 39 5/16 in. (156 x 99.8 cm). Collection of the artist; courtesy Peter Freeman, Inc., New York

David Hockney
Born 1937, Bradford, England
Lives in Los Angeles, CA

Since the early 1960s, David Hockney has defined a unique figurative, painterly vocabulary, and has looked to his own personal experiences and surroundings for the subjects of his works. While he was still in England, Hockney's early explorations into the expressive qualities of figurative painting resulted in works such as *The First Love Painting* (1960) and *Doll Boy* (1960–61). Reacting to American Abstract Expressionism as well as the tormented realism of European Informel, Hockney arrived at works such as *Domestic Scene, Los Angeles* (1963)—a painting of two men in the shower based on photographs from *Physique Pictorial*, a fitness magazine published explicitly for gay men. In 1964, Hockney moved to Los Angeles, drawn by the California light and the openness of the city. In a series of works, most notably the paintings *A Bigger Splash* and *A Lawn Sprinkler* (both 1967), Hockney portrays the endlessly blue and sunny atmosphere of modern California houses, with their swimming pools and neatly trimmed lawns, onto which he sometimes placed reclining young men.

Hockney's personal iconography includes a broad array of portraits of his family and large circle of friends, including Christopher Isherwood and Don Bachardy, Henry Geldzahler, Celia and Ossie Clark (*Mr and Mrs Clark and Percy*, 1970–71), shown in typical 1970s decor and fashion, as well as his parents (*My Parents*, 1977). Throughout the 1970s and 1980s, Hockney painted still lifes, landscapes, and interior scenes that reflect his intense artistic dialogue with such figures as Van Gogh, Matisse, and particularly Picasso, both in his composition and coloring.

In 1982 Hockney began to make photocollages using a Polaroid camera, and produced a series of composite Polaroids. Often constructing landscape scenes from personal journeys or casual gatherings with friends, these photographic works incorporate the immediate space surrounding Hockney and his subjects. Usually including some part of Hockney's body, they map the distance between it and the photograph's subjects, giving literal visual expression to the relationship between artist and model.

Hockney's most recent watercolors continue his pictorial vocabulary in a series of Nordic landscapes (*Tujfjord Nordkapp II*, 2002) and portraits (*Manuela and Norman Rosenthal*, 2002). Large in scale, these watercolors are often composed of four or six individual sheets joined together, and their condensed composition and bold coloration are reminiscent of the artist's works from the 1960s. In recent years, Hockney has become deeply interested in the role played by instruments such as the camera lucida in art historical painting and drawing. His work has influenced a generation of younger artists, his unabashed figurative style and proudly personal subject matter forming an alternative to the dominant tradition of abstraction and serving as a model for painting's renewed focus on the intimate and the figurative. CR

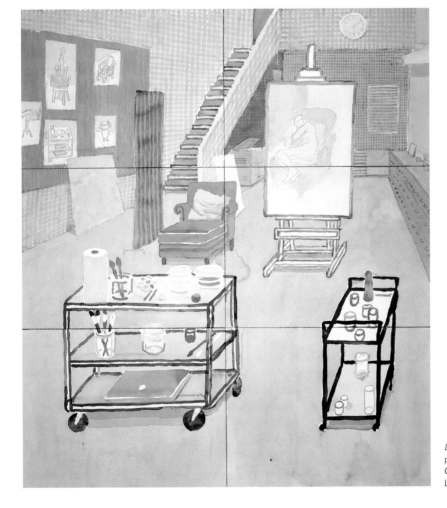

L.A. Studio, 2003. Watercolor on paper, 54 5/16 x 48 1/16 in. (138 x 122.1 cm). Collection of the artist; courtesy L.A. Louver, Los Angeles

Jim Hodges
Born 1957, Spokane, WA
Lives in New York, NY

Jim Hodges's interest in the transformative potential of time-intensive manual labor often results in large-scale installations that incorporate drawing, collage, and humble, everyday materials. His work *A Diary of Flowers* (1994) consists of 565 ink drawings of flowers on paper napkins pinned to the wall, produced in the artist's spare time on excess napkins from the corner deli. Both a record of time passed, much like a diary, and a visually powerful installation, *A Diary of Flowers* combines many of the characteristics of Hodges's works: a focus on the handmade; the grounding of the work in a personal narrative, experience, or feeling; a desire to transform humble materials into an artwork that is both beautiful and meaningful; and the artist's readiness to embrace emotion without falling into the trap of kitsch. In a similar vein, Hodges has also produced spiderwebs made of fine metal chains, which are displayed unassumingly in the corners of exhibition spaces.

In 1995 Hodges began to produce the first of ten silk flower curtains, a series he completed in 1999. Sometimes boldly colorful, sometimes monochromatic, the curtains are imposing cascades sewn together by hand, measuring from ceiling to floor. In addition to embodying his labor-intensive production process, the curtains also imply ephemerality, loss, and mourning; as the last work in the series, *The End from Where You Are* (1999), a curtain made only of black flowers, may be read as a commemorative object. Other works employ similar formal strategies of collage and composition, such as *View* (1998), a two-paneled mosaic of small pieces of mirror first hand-cut by the artist and then painstakingly recomposed, or *As Close as I Can Get* (1998), a large colorful panel constructed of small, randomly composed swatches of Pantone color samples. Hodges's most recent works have expanded his formal vocabulary to include more intricate fabrication techniques, as in the series *like this #1–#13* (2002), which consists of panels of hand-produced and layered translucent multicolored paper, or his work *a view from in here* (2003), a wall-mounted, protruding tree branch that holds a bird's nest, made entirely of glass. Hodges's work continues to be guided by principles of personal investment and empathy, extracting both meaning and compassion from the intensity of the production process and the viewer's ability to identify with the results. CR

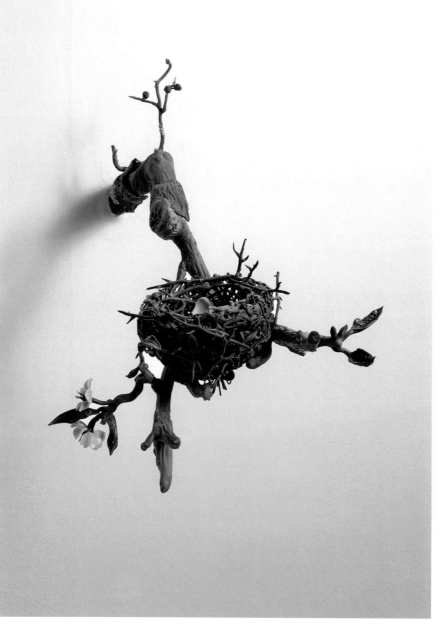

a view from in here, 2003. Glass, 7 x 5 ½ x 25 ½ in. (17.8 x 14 x 64.8 cm). The Rachofsky Collection, Dallas; courtesy Stephen Friedman Gallery, London

Christian Holstad
Born 1972, Anaheim, CA
Lives in Brooklyn, NY

Christian Holstad's art expresses an acute sensitivity to the emotional underpinnings of everyday life. Drawings, sculptures, photographs, performances, collages, and installations distill the results of Holstad's consideration of a wide array of sources into poetic reflections on love and loss. Contemporary news stories and obituaries, Jean Genet's play *The Maids*, library archives, interior design magazines, Hallmark greeting cards, and pornography have all been filtered into his artwork. Holstad often incorporates authentic, period-specific materials, such as 1960s-era vinyl and fabrics or pages cut directly out of magazines, that evoke nostalgia for another age. Craftwork—such as the crocheting used for his soft sculptures of vacuums, log fires, and cakes—is central to Holstad's process. He embraces labor-intensive techniques: each artwork must pass through not only his mind or heart but also his hands, and the resultant objects are imbued with an intimate aura of the personal that comes from spending time with their maker.

An ongoing series of collages juxtaposes pornographic images and magazine-ready domestic interiors, placing gay sex in the traditional domain of the nuclear family. The abundance and comfort of the setting is given over to the loving embrace of each work's two male protagonists. Other works in this series bring brightly colored wallpaper designs that make reference to nightclub interiors into the personal space of a domestic bathroom.

A 2003 solo exhibition titled *Life is a Gift* used the story of David Vetter, better known as the "Bubble Boy"—who was forced to live inside a germ-free plastic bubble due to his weakened immune system—as a springboard for a rumination on the bonds between people in life and death. Among a plethora of other collages, drawings, and sculptures, Holstad re-created the "bubble" as a domestic space within the gallery, inserting into it a knitted sleeping bag and many of his "Eraserhead" drawings. These works begin with photographs cut out of newspapers; Holstad then erases the ink from the newsprint, leaving often deformed, isolated, and slightly pathetic characters staring across blank expanses of paper. The fragility of these drawings and the emotionally resonant sentiments they convey succinctly express Holstad's ability to create poignant artworks from the most mundane sources. BJS

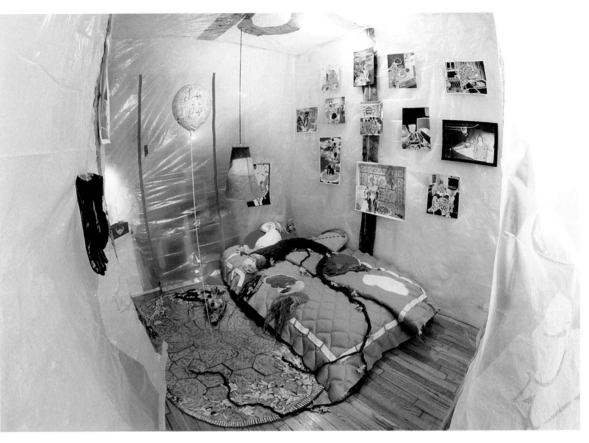

Installation view of *Life is a Gift*, 2003, at a private residence, New York. Mixed media, dimensions variable. Collection of the artist; courtesy Daniel Reich Gallery, New York

Roni Horn
Born 1955, New York, NY
Lives in New York, NY

Roni Horn's work reflects her ongoing exploration of the mutable nature of identity. Her enigmatic images remind us that empirical reality is mediated by human consciousness and that all experience is dependent on variable factors such as space, time, form, place, and memory. Horn poetically employs these elements in sculpture, works on paper, photography, books, and written prose drawing attention to the infinite play of difference as a source for dynamic identities.

Horn draws from the visual strategies of Minimalist sculpture, yet destabilizes the self-referential autonomy of her objects through the metaphorical use of materials and the introduction of language. In early sculptural work, the artist explored the evocative associations one experiences beyond the inherent qualities of a given material. *Gold Mat* (1980–82), a flat rectangular floor piece made of interlocking gold foil, quietly demonstrates how various connotations of gold (i.e., value, status, preciousness) affect our overall perceptual experience of the work. This strategy is also evident in Horn's work that addresses semantic play through sculptural objects. In *Untitled (Buzz and Dust)* (1995), enough aluminum alphabet blocks were scattered on the floor to spell the word "ephemeral" thirty-three times. Within these fixed forms exists the notion of oppositional difference and interdependence.

Through sculptural and photographic installation, Horn investigates the phenomenological basis of the viewer's experience by presenting objects in serialized or doubled forms. Subtle compositional shifts that challenge the spectator's consciousness of difference are characteristic of these works. *Untitled (Flannery)* (1997) presents two seemingly identical blocks of blue glass placed near each other. The viewer must negotiate elements of memory, time, and space to determine the relationship between the two sculptures. Ultimately, these objects define each other through proximity and apparent similarities. Horn's photographic installations also demonstrate that seriality may be constant but mutable; even tightly contained shots of river water become metaphors for change. According to the artist, this changeability is analogous to the state of androgyny, in which the integration of difference is a source of identity. HC

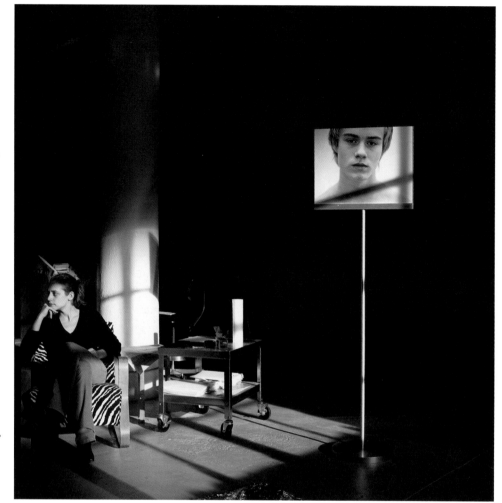

Doubt by Water, 2003–04. Two-sided images with aluminum stanchions and plastic holders, thirty units, image 16 ½ x 22 in. (41.9 x 55.9 cm), stanchion 70 ½ x 14 in. (179.1 x 35.6 cm). Courtesy Matthew Marks Gallery, New York

Craigie Horsfield
Born 1949, Cambridge, England
Lives in New York, NY, and London

Craigie Horsfield's work is grounded in a belief in the central importance of our responsibility to each other. Working collaboratively and over extended periods of time, Horsfield began making film and sound works in the 1960s. In the early 1970s he made the first of the large-scale black-and-white photographs for which he later became known, becoming one of the first of a generation of artists who used the medium of photography in new and unconventional ways.

Over the following two decades, working in Krakow, London, Barcelona, and Rotterdam, Horsfield developed an understanding of society and the individual that was to form the basis of his Barcelona project, begun in 1993 and including *La Ciudad de la Gente (The City of the People)* in 1996, and was to have far-reaching consequences for his work. Until the Barcelona project, Horsfield's social and political thesis had incorporated a highly charged language, expressed in narrative structures using several different media, to develop the notions of "slow time" and an expansive or "profound" present.

While these themes remain important, after the Barcelona project Horsfield bound them more closely to his central concern with human relationships in a series of ambitious and complex projects, often involving several hundred collaborators. These projects, which began as opportunities to form new ways of thinking about social structures and the individual, allowed Horsfield to focus on a transformative social engagement through an attention to conversation, conceived as a means of understanding and acting together, as well as a method of working.

El Hierro Conversation (2002) is the most recent of these long-term projects. El Hierro, the most western of the Canary Islands, lies between Europe, Africa, and the Americas, and has a long history of colonial settlement, subsistence agriculture, and migration. The land is often harsh, and its society fractured. The project, in which many islanders took part, is an account of lives in transition. The installation comprises a projection onto four screens, a sound work with eight voices, and a setting that encourages viewers to enter the social space of El Hierro. Drawing on the island's rich history, Horsfield portrays the residents' customs and rituals as well as the island's wildlife and terrain, allowing his portrait to unfold at a languorous pace over eight hours, suggesting an extended conversation taking place within a common present. Horsfield's meditation on community and social dialogue is an affecting epic of conceptual and formal beauty. CI

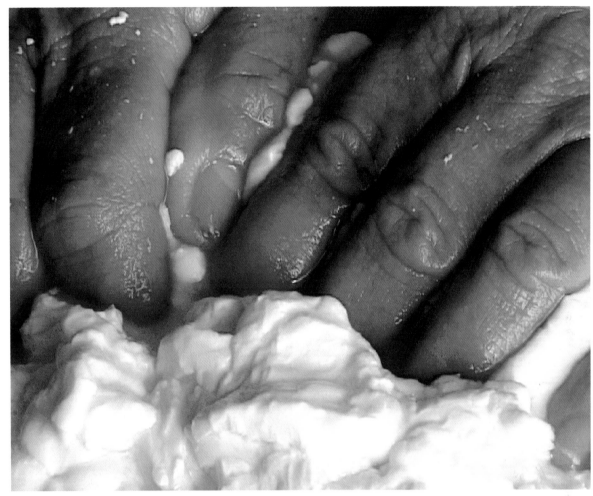

Angela Acosto Padrón making cheese at El Pinar, El Hierro, 2002, from *El Hierro Conversation*, 2002. Video installation, dimensions variable. Collection of the artist

Peter Hutton
Born 1944, Detroit, MI
Lives in Annandale-on-Hudson, NY

Peter Hutton's films defy easy categorization, eschewing narrative as well as the abstract formal vocabulary explored in much experimental film-making. Rather, his work is related to traditions of nineteenth-century landscape painting and still photography. The films are silent and unfold in a series of tableaux separated by black leader, individual shots that are often completely without motion. The meticulously framed compositions of city views or landscapes are depicted in extended takes, inviting the spectator to take time and look closely. While sharing some formal characteristics of structural film, Hutton's approach to the medium is more meditative. "The experience of my films is a little like daydreaming," he says. "It's about taking the time to just sit down and look at things, which I don't think is a very Western preoccupation. A lot of influences on me when I was younger were more Eastern. They suggested a contemplative way of looking...where the more time you spend actually looking at things, the more they reveal themselves in ways you don't expect."

Since 1988, Hutton has been working on a series of films that train his contemplative gaze on the Hudson River in upstate New York, where he lives. *Study of a River* (1997) presents a portrait of the river in winter. Shot in rich black and white, the film observes slowly moving ships, floating slurries of ice, and the snowy shore, reflecting both on the landscape's beauty and its transformation by industry and commerce. Continuing his tribute to the Hudson, *Time and Tide* (2001) was filmed from aboard various boats traveling on the river, and is his first work to use both color and black and white. *Two Rivers* (2002), contrasting the Hudson with China's Yangtze River, was inspired by Henry Hudson's third voyage in search of a trade route to the Great China Sea in 1609.

Hutton's most recent film, *Skagafjördur* (2003–04), draws its title from a particularly striking region of northern Iceland. The film documents the area's ravishing landscape in a series of serene vistas of rolling hills and open sky. After an introductory sequence in black and white, the film switches to luminous color to capture the atmospheric play of light on the coastal valley. Hutton finds the mythic character of Iceland in its ancient physical landmarks, like the imposing Drangey Island, as well as in the brilliant, ephemeral moments slowly transforming the landscape. HH

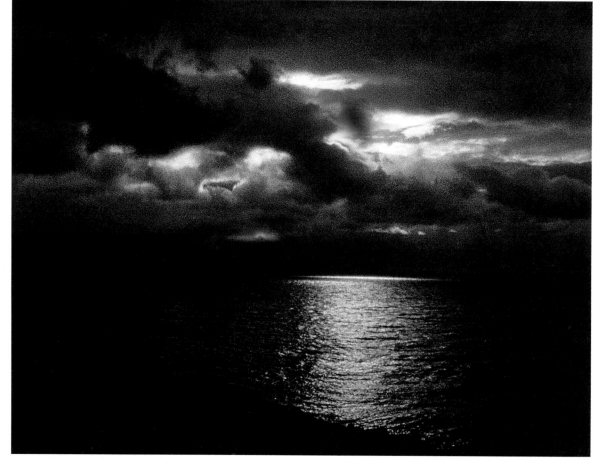

Still from *Skagafjördur*, 2003–04.
16mm film, black-and-white and color, silent; 35 min. Funding provided by Icelandic Film Fund and Whitney Museum of American Art, New York

Emily Jacir
Born 1970, Houston, TX
Lives in New York, NY, and Ramallah, Palestine

Emily Jacir has been crossing borders her entire life. She was raised in Saudi Arabia, attended high school in Italy, college and graduate school in the U.S., and lived in France and Palestine before moving to New York in 1998, all the while traveling to and from Bethlehem, where her parents are from. As a result, Jacir has a special sensitivity to the complexities involved in Palestinian mobility, an issue she has addressed in various projects. In her 130-minute video *Crossing Surda (a record of going to and from work)* (2002–03) she (illegally) hid a camera in her bag after being held at gunpoint for three hours by an Israeli soldier, and then managed to record the rugged, heavily guarded Surda checkpoint between Ramallah and Birzeit University. In *Memorial to 418 Palestinian Villages Which Were Destroyed, Depopulated and Occupied by Israel in 1948* (2001), Jacir invited people living in New York to her studio in the P.S.1 Clocktower in Lower Manhattan to embroider the names of towns destroyed during the erection of the Israeli state in 1948 onto a burlap tent, which acts as a symbol of displacement and the contested notion of home for the Palestinian people.

Jacir bridges the divide between the poetic and the critical in *Where We Come From* (2001–03) through her documentation of restricted movement for Palestinians to and within the historical area of Palestine. The project's thirty photographs and one video, each with corresponding texts (in both Arabic and English), document Jacir's attempt to fulfill the requests of Palestinians to whom she posed the question, "If I could do anything for you, anywhere in Palestine, what would it be?" Though the question is simple, the act of carrying out some of the requests proved exceedingly difficult, even impossible. Jacir utilized her American passport to move throughout Palestinian territories and was unimpeded from January through March 2002, which allowed her to perform almost all of the requests. (At the time of this writing, October 2003, it would be impossible for Jacir to carry out many of the requests due to increased restrictions imposed on those seeking to enter certain checkpoints, borders, and boundaries established by Israel throughout the region.)

Many of the people who responded to Jacir's question either live in exile now or their families were exiled from Palestine in 1948 when approximately 725,000 of their countrymen became refugees. The requests varied: some were imaginative, while others were predicated on need. Iyad, who lives in a refugee camp in Bethlehem and is unable to enter the areas divided in 1948 because of his West Bank ID card, asked Jacir to "water a tree in my village of Dayr Rafat." George, born in Nablus and living in Ramallah, requested that Jacir "walk the streets of Nazareth" because he is prohibited from entering the city. A more practical request came from Amal, who lives in New York and fears that she would not be allowed to leave Gaza if she were to return to her homeland: "Bring clothes and gifts to my family in Khan Yunis whom I have not seen for five years." *Where We Come From* documents a politically fraught situation that most of the world witnesses daily, though from a distance and filtered through the media. Made primarily for a fragmented Palestinian audience, Jacir's account presents the situation with a poetic clarity for those who are not directly familiar with the conflict. **AD**

Abdulhadi, from the series *Where We Come From*, 2001–03. Chromogenic color print and framed text, 27 x 36 in. (68.6 x 91.4 cm) and 8 ½ x 11 in. (21.6 x 27.9 cm). Collection of the artist; courtesy Debs & Co., New York. Originally commissioned for Al-Ma'mal Foundation for Contemporary Art, Jerusalem

Isaac Julien
Born 1960, London
Lives in London

Isaac Julien's documentary *BaadAsssss Cinema* surveys the brief flourishing and sudden demise of American "blaxploitation" cinema in the 1970s. During a time when the major Hollywood studios were facing steep declines in viewership, this brand of gangster or crime movie that featured black actors, fashion, and music became a tremendously successful venture with crossover appeal, helping to save the industry from financial ruin.

Through interviews with actors, directors, and film and cultural critics, as well as numerous movie excerpts, Julien's documentary pays tribute to the genre's cultural significance without diminishing its more dubious underpinnings. Blaxploitation's exuberance, outrageous fashions, and funky music enjoyed huge popularity with audiences, but the films were also controversial for their emphasis on racial and gender stereotypes. Nonetheless, the films provided for the first time in Hollywood abundant roles for black actors—a window of opportunity that closed with the advent of the action blockbuster in the late 1970s and, the documentary suggests, never quite reopened.

An installation artist, filmmaker, and academic, Julien continues to traverse disciplinary boundaries. Throughout his work he has explored the subjects of race and representation, sexual identity, queer desire, and the gaze. A founder of the black film collective Sankofa, Julien garnered acclaim with his experimental documentaries and features, such as *Looking for Langston* (1989), a portrait of the African-American poet Langston Hughes, and *Young Soul Rebels* (1991), a narrative set in London's soul music scene in the 1970s. In recent years, he has turned increasingly toward video installation art. The multiple-screen piece *Paradise Omeros* (2002), which was commissioned by the Bohen Foundation and premiered at Documenta 11 in 2002, traces the experience of a Caribbean immigrant in 1960s London. Partly inspired by Julien's family history, the work activates the "personal as a symbolic 'archive,'" as he states, reflecting on the condition of postcolonial, diasporic subjectivity.

Julien's most recent installation, *Baltimore*, returns to the subject of *BaadAsssss Cinema*. Featuring blaxploitation originator Melvin Van Peebles, it mimics the genre's over-the-top characters and styles, and stages a dialogue by assembling figures from the city's Great Blacks In Wax Museum collection in front of the Baltimore Museum of Art's Renaissance paintings. HH

Poster for *BaadAsssss Cinema*, 2002.
Video, color, sound; 56 min.

Miranda July
Born 1974, Barre, VT
Lives in Los Angeles, CA

Miranda July is a Los Angeles–based artist and writer who creates performances, films, audio works, websites, and works that combine aspects of all of these forms. Her solo projects investigate the effects of social structures on individual consciousness and the infusion of the mundane with spirituality. Her collaborative endeavors similarly engage the fantastic within the social, but with an emphasis on inclusiveness and a do-it-yourself ethic.

July is perhaps best known for her films. An early work, *The Amateurist* (1998), is a surreal short that features July playing a "professional" woman who monitors via video surveillance an "amateur" woman (also played by July). Later videos, such as *Nest of Tens* (2000) and *Getting Stronger Every Day* (2001), are populated with children and adults who attempt to connect with each other and themselves using systems of their own invention. Currently July is making a feature-length film titled *Me and You and Everyone We Know*.

July's solo multimedia performances address some of the same themes. *The Swan Tool* (premiered 2001) is a 45-minute performance that combines live and prerecorded action. Videotaped scenes are projected onto two screens between which July moves, interacting with elements of one or the other while elaborating the story of a woman who cannot decide between life and death. A live score composed by Zac Love accompanies the performance. Through her precisely choreographed interaction with the screens, July's character buries herself, then attempts to go on with daily existence. The *Swan Tool* mixes mundane activity and surreal narrative with an innovative performance style.

Learning To Love You More, included in the 2004 Biennial, is a website July created in 2002 with artist Harrell Fletcher and designer Yuri Ono. The site is dedicated to presenting artwork made by the general public in response to assignments posted by the artists. Diverse results are built into the concept: every submission that follows the instructions of the assignment is accepted, whatever the end result. Each creation is digitally documented and archived online; many of the original works also populate exhibitions in galleries and museums around the world. The project takes the tone of an encouraging friend: the artists believe that the prescriptive nature of the assignments allows people to bypass the task of coming up with an idea, instead allowing them to focus on feelings and experiences. **BJS**

Yester Me, Yester You, 2003. Laser print, 50 x 75 in. (127 x 190.5 cm). Collection of the artist

Glenn Kaino
Born 1972, Los Angeles, CA
Lives in Los Angeles, CA

Glenn Kaino's multivalent conceptual sculptures engage the viewer with immediately recognizable forms that comment on their surroundings and the history from which they stem. Quantum physics, art history, everyday objects, a wry sense of humor, and a keen sense of irony inform Kaino's process, often realized through his poignant juxtapositions and formal simplicity. References to artists before him recur throughout much of Kaino's work; his debt to Marcel Duchamp, for example, is apparent in his predilection for humor, wordplay, and complex conceptual underpinnings. *The Siege Perilous* (2003) consists of a rapidly revolving Aeron chair, an icon of success of the dot-com boom of the 1990s, which takes on the appearance of a chalice as it spins. The work takes its title from the name Merlin gave to the chair in which only the true discoverer of the Holy Grail could sit. Formally, the work also gives a sly nod to Duchamp's *Rotoreliefs* and *Readymades*.

Kaino brings a plug-and-play approach to the material possibilities of an age in which every object, concept, and culture can be used to form an ever-expanding network of cross-references. In his *Desktop Operation: There's No Place Like Home (10th Example of Rapid Dominance: Em City)* (2003), Eastern and Western cultural ideals collide, turning this intersection into a unique work that bears the marks of its hybrid, modern environment. Kaino, a Japanese-American, interposes two seemingly unrelated structures, building a sand fortress that resembles the Emerald City from MGM's 1939 rendition of *The Wizard of Oz* inside a Japanese dry garden, equipped with rake and all. As a metaphor for capitalist wealth or a seat of political power, the Emerald City was a place that lured Dorothy and her friends with the promise of fulfilling their dreams—a promise that was revealed as empty with the discovery that the leader was fraudulent and inept. Because they are made of sand, Kaino's towers, which evoke cylindrical warheads, gradually crumble, a comment on the inevitable collapse of seemingly impermeable empires of might. As a sound structure in a constant state of uncontrollable change and seeming disintegration, the work also refers to Robert Smithson's ideas on entropy.

Kaino also draws on the longstanding tradition of Japanese dry gardens, or *karesansui*, places of serenity and contemplation that are made from fine white gravel (representing water) and large rocks (representing mountains) asymmetrically arranged within the gravel. Observing the balanced spaces between the rocks, as well as the raking of the gravel into linear patterns, is believed to induce a state of meditation for the Zen Buddhist. The artist, however, eliminates the rocks and replaces the linear raking pattern with arrows and intricate "X" and "O" designs that recall both military and football diagrams, substituting symbols of strategic aggression for those of contemplation. The title *Desktop Operation* alludes to the fact that miniature dry gardens are now available to ornament one's workplace—a modern transposition of the sacred to the commercial. Kaino tellingly conflates an ancient Japanese Zen tradition with the increasing commodification of popular culture and some of America's largest exports: Hollywood industry, military might, and the promise of economic advancement. AD

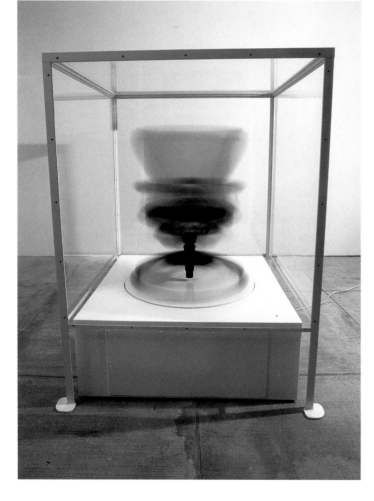

The Siege Perilous, 2003. Aeron chair, electric motor, and vitrine, 65 x 49 x 49 in. (165.1 x 124.5 x 124.5 cm). Collection of the artist; courtesy The Project, New York, and Los Angeles

Mary Kelly
Born 1941, Fort Dodge, IA
Lives in Los Angeles, CA

Often conceived as large-scale installations researched and executed over periods of several years, Mary Kelly's works originate from a rigorously critical dialogue with theories of psychoanalysis, feminism, and art history. From the beginning, her work has drawn from personal observations, anxieties, desires, and actions without uncritically celebrating her position as an artist or essentializing her role as a woman.

One of Kelly's earliest long-term projects, *Post-Partum Document* (1973–79), is an investigation of the intense and charged relationship between the artist and her newborn child. The work is divided into six distinct sections, each of which carefully maps and reconstructs a different element of that relationship by means of salvaged remains, obsessively detailed charts, and diaristic commentary. Moving from the documentation of fecal stains on diaper linings to the analysis of baby utterances and scribbles, from the display of transitional objects to the recounting of the child's first written alphabet, *Post-Partum Document* interrogates the process of separation between mother and child not only in psychoanalytical terms, but also according to an advanced conceptual aesthetic. Two of Kelly's subsequent works continue her investigation of gender roles. In *Interim* (1984–89), the artist concerns herself with the representation of aging, focusing on the themes of body, power, money, and history. In *Gloria Patri* (1992), she turns her attention to the formation of masculinity in both men and women, setting intimate narratives against a backdrop of insignia and rhetoric from the first Gulf War.

Since 1999, Kelly has incorporated into her work compressed lint, which she scavenges from the filter screen of her own dryer. Kelly blocks lines of text on the screen, leaving an intaglio impression on the lint as it accumulates. These units are then combined into sequences to form a narrative in long, continuous relief. For *Mea Culpa* (1999), Kelly wrote brief accounts of politically motivated atrocities witnessed by a female protagonist, and for *The Ballad of Kastriot Rexhepi* (2001), she narrated the story of an infant Albanian boy who was left for dead in the battlefield, only to be found and left behind twice more before being reunited with his family. Both works translate traumatic events filtered from the constant stream of media information and imprint their ghostly presence into the material residue of the lint support. Evoking a sense of historical memory and revealing the forces that shape personal as well as national identity, Kelly's works are complex and carefully crafted, concerned as much with the formal qualities of processes and materials as they are with the narratives they recount. CR

Circa 1968, 2004 (detail).
Compressed lint and projected light,
101 x 105 in. (257.2 x 265.7 cm).
Collection of the artist; courtesy
Postmasters Gallery, New York

Terence Koh
Born 1969
Lives in New York, NY

New York artist Terence Koh creates handmade books and zines, prints, photographs, sculptures, performances, and installations. He first gained notoriety for his website and zine titled *asianpunkboy*, which, in his own words, are "filled with an infusion of gentle surfaces, dissident eruptions, haikus, mapped pictures, dirty illustrations, moist cum, decadent artificial words, love and all manner of faggy filth." Koh's description indicates both the diversity of his art and the queer, punk, and pornographic sensibilities that inform his creations. He reappropriates images from the Internet, magazines, and other artists in the service of a personal exploration that is by turns innocently sweet and rugged.

The Whole Family (2003), Koh's first solo exhibition at peres projects in Los Angeles, divided the gallery's main space and basement into two separate environments. The ground floor, completely empty, featured a 3-inch-wide peephole drilled into the floor with a small ladder dangling below. The basement gallery had been transformed into a total environment composed of objects hung upside-down and shrouded in white, including two live albino budgies, hundreds of pounds of mysterious white powder, a sculpture of a cannon, the word "felt" rendered in white neon, an engraved mirror, a white silk flag, and a rhinestone-encrusted switchblade. Twenty-one identical lavender prints of a boy were taped to the wall and then shot with a small-caliber gun. Each untitled object's form carried its own connotations, making reference to queer, gothic, and other subcultures, but the absence of color variations gave the works a sense of purity, creating a neutral screen upon which viewers could project their own associations.

Untitled (My Coffin) (2002) is a mirrored box, trimmed in white fur, that resembles a casket. It houses a hundred interlocking white Plexiglas boxes, each filled with a white object of personal significance made by, assembled by, or given to the artist, continuing the ancient tradition of carrying gifts into the afterlife. Among the objects are buttons and two deer, two vials, an egg with three strings, a ball of wax, a marble, a sealed letter, and a ring. They are so tightly packed that Koh's body is denied space; instead he is allowed to live secure in the knowledge that all is ready for his passing. Through his delicately sensual objects and environments Koh generates a bricolage of images and influences. The significance of each object he creates or appropriates is tied to both private narratives and a wider set of subcultural associations. BJS

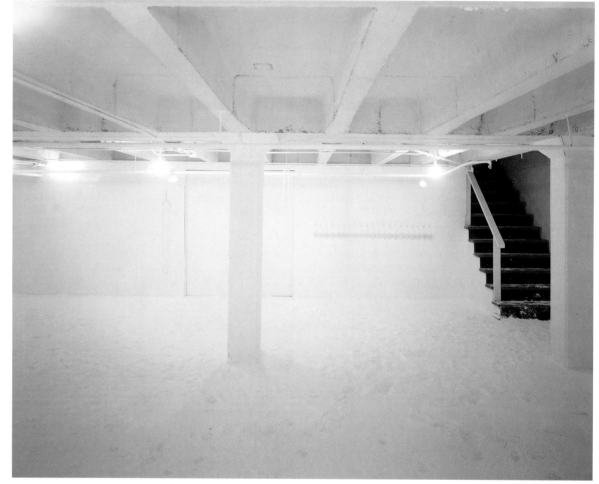

The Whole Family, 2003. Mixed-media installation (detail), dimensions variable
Collection of the artist; courtesy peres projects, Los Angeles

Yayoi Kusama
Born 1929, Matsumoto, Japan
Lives in Tokyo

Since the late 1950s, Yayoi Kusama has used painting, performance, sculpture, and installation to develop a highly personal formal vocabulary that combines repetitive elements such as net and dot patterns with organic and often eroticized sculptural forms. Her early paintings and collages extend the language of Abstract Expressionism and its concern for allover compositions into an intimate form of gridded space. *No. White A.Z.* (1958–59) is a large, monochrome painting consisting of white net patterning across a slightly darker background. In *Airmail Stickers* (1962) adhesive postal stickers, tightly stacked side by side, are collaged across the entire expanse of the canvas.

By the early 1960s Kusama had begun to produce her *Accumulations*—everyday objects such as chairs, tables, and clothes densely covered with hand-sewn, phallic protrusions. In *Accumulation No. 2* (1962), Kusama covered a sofa entirely with white phallic forms, endowing it with an organic appearance and an air of obsessive anxiety. In *Aggregation: One Thousand Boats Show* (1964) a full-size rowboat is adorned with hundreds of such protrusions, all painted a monochrome white. Around the same time, Kusama began to paint net and dot patterns onto household items, and in 1965 she combined all these elements in the installation *Infinity Mirror Room—Phalli's Field* (or *Floor Show*). In *Infinity Mirror Room* a dense field of polka-dotted phallic protrusions extended from the floor of an enclosed space. The walls of the environment were lined with mirrors, leaving only a small passageway into the center of the installation empty. For the installation *Kusama's Peep Show* (1966), the artist constructed a room whose walls and ceiling were covered with mirrors, while the floor was densely filled with glowing electric lightbulbs in different colors. Two small windows allowed the viewer and Kusama to peer inside. Continuing her obsessive, almost psychedelic approach, the installations suggest a kaleidoscopic mode of perception, in which interior rooms contain unbound, seemingly endless spaces. By the late 1960s, Kusama began to stage performances, sometimes covering her naked body, or others' bodies, with patterns.

In the early 1970s, Kusama returned to Tokyo; she voluntarily entered a clinic for the mentally ill, where she has remained ever since. She has continued to produce work at a prolific rate, remarkable in its consistency. Her obsessive arrangements, her often radically eroticized alterations of everyday objects, her fascination with infinity, and the all-encompassing nature of her work have remained at the core of her production.

In her most recent works Kusama continues to create reflective interior environments. *Fireflies on the Water* (2002) consists of a small room lined with mirrors on all sides, a pool in the center of the space, and 150 small lights hanging from the ceiling, creating a dazzling effect of direct and reflected light, emanating from both the mirrors and the water's surface. Like her earliest room-size installations, *Fireflies* embodies an almost hallucinatory approach to reality, while shifting the mood from her earlier, more unsettling installations toward a more ethereal, almost spiritual experience. CR

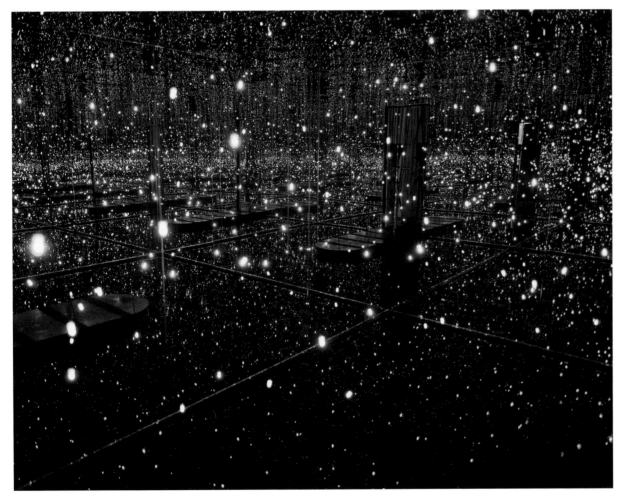

Fireflies on the Water, 2002. Mirror, plexiglass, 150 lights, and water, 115 x 144 x 144 in. (292.1 x 365.8 x 365.8 cm). Whitney Museum of American Art, New York; purchase, with funds from the Postwar Committee and the Contemporary Committee and partial gift of Betsy Wittenborn Miller 2003.322

Noémie Lafrance
Born 1974, Rivière du Loup, Canada
Lives in New York, NY

Noémie Lafrance makes innovative site-specific dance performances that evolve from carefully selected locations, specific subjects, and ideas. The presentations spatially reconfigure audience members in relation to the dancers and the surroundings, whereby the audience becomes involved in the performative process. In *Melt*, presented in 2003 at Brooklyn's Black & White Gallery, three dancers perched on small ledges affixed to a brick wall at varying heights. The dancers were shrouded in costumes that were made by Lafrance out of cheesecloth covered in beeswax and synthetic lanolin and that draped several feet below them. The dancers performed under the direct light of intense heat lamps that gradually melted away the material during the 15-minute performances. Secured to the ledges by a belt carefully hidden from the viewers, the dancers seemed to float above the audience— their gestures suggestive of weightlessness, heat, and summer light.

Another work, *Descent* (2001–03), took place in the thirteen-story spiral staircase of Manhattan's historic Clock Tower Building. Dancers positioned on the many levels of the staircase would appear in unison at visually strategic points along the banisters, dipping, swirling, and incorporating various objects such as feathers, pails, and even a fish throughout the 45-minute performance. Viewers first encountered the performance from above, looking over a balustrade that rises to a height of more than 250 feet. As audience members descended the staircase, witnessing various tableaux on each level, they became increasingly involved in the performance, with dancers appearing above, below, and beside the unwitting gazers. The use of the entire stairwell and the dramatic perspective enhanced the sense of rising and falling within the space. The domestically inspired costumes and props combined with the dancers' movements evocative of female desire drew attention to the functional purpose of the building, which houses the Domestic Violence Court.

For the 2004 Biennial, Lafrance presents *Noir*, an off-site performance set in a commercial parking garage, which takes its inspiration from film noir. An intricate performance involving five female and five male dancers—viewed by the audience through the windshields of parked cars—the dance embodies the tension between passion, fear, love, and suspense in noir cinema. According to the artist, "The juxtaposition of the real space and the stylized action creates the illusion of an event that appears to take place both in reality and fiction." As dancers appear and disappear in the shadows of the garage, the viewers become implicated in the spectacle, which is further underscored by the suspense conveyed in the choreography. **AD**

Descent, 2001–03. Performance at Clock Tower Building, New York, 2002. Courtesy of Sens Production Inc.

Lee Mingwei
Born 1964, Taiwan
Lives in Berkeley, CA, and New York, NY

Lee Mingwei creates participatory installations and performances that explore issues of trust, intimacy, and self-awareness. Often one-on-one events involving strangers, Lee's artworks tend to be open-ended scenarios for everyday interaction that take on different forms depending on the participants. Time is central to this process, and his installations frequently change during the course of an exhibition.

Lee's recent works involve atypical, intimate interactions between the artist and a participant or, at his urging, between multiple participants. *The Tourist Project*, performed thus far in Houston and at The Museum of Modern Art in New York, involves Lee playing the role of a tourist who is to be led through the city by volunteer guides selected by lottery. Each guide determines the itinerary: some may wish to take Lee to famous landmarks, while others prefer a more personal journey. Keepsakes from the trips are brought together where they are to be exhibited, edited, and rearranged to fill up the ever-changing gallery space.

For *The Sleeping Project*, most recently presented at the Taiwanese Pavilion at the 2003 Venice Biennale, Lee invited randomly selected volunteers to spend a night sleeping in the same room with him. While the intimacy was nonsexual, Lee drew attention to the notion that losing consciousness in the presence of a stranger represents perhaps the greatest trust one human can place in another. Lee and each participant brought personal items for their nightstands, which remained on display for the duration of the project.

The Seers Project, first presented in 2003 at Harvard University and included in this exhibition, invites volunteers with a talent for divination—whether through card reading, astrology, I Ching, or other methods—to engage with members of the community who are seeking knowledge or advice. In a wood and canvas enclosure constructed by the artist, informal one-on-one conversations take place between seers and seekers as an outgrowth of the artist's longstanding interest in shamans and the paranormal.

Lee's art is not an end in itself, but rather a means by which he is able to bring together people who would not otherwise interact, and to give everyone involved an experience that is unlikely to be repeated. His projects become part of each participant's personal history, perpetuating themselves in stories told to family and friends and in the altered associations one has with a particular place. BJS

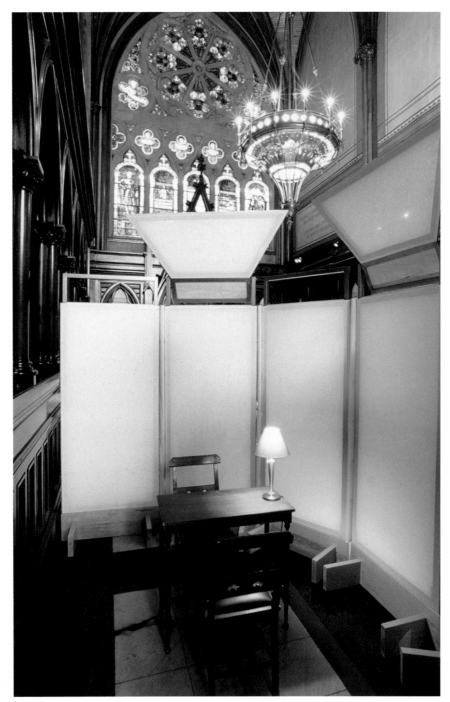

Harvard Seers Project, multimedia interactive installation, May 4, 2003. Courtesy of the artist and Office for the Arts, Harvard University. Commissioned by Office for the Arts, Harvard University

Golan Levin
Born 1972, New York, NY
Lives in Pittsburgh, PA

Golan Levin's work explores the intersection of abstract communication and interactivity. Through performances, digital artifacts, and virtual environments, often created with a variety of collaborators, Levin applies creative twists to digital technologies that highlight our relationship with machines and make visible our ways of interacting with each other.

Dialtones: A Telesymphony (2001) is a musical composition performed through the ringing of the audience's own cell phones. Audiences of up to two hundred people register their cell phone numbers upon entering the theater, receive new ring tones via SMS, and sit in assigned seats. Over the course of thirty minutes and three movements, Levin "plays" their phones by dialing different combinations of phone numbers. He elicits various sounds around the room by clicking a computer screen programmed with the seating chart; up to sixty cell phones may ring at once. The visual aspect of this performance is not overlooked. Levin's interface screen is also projected onto the audience from above, shining light down on each person when their cell phone rings. Levin creates order from what is normally considered disorganized public noise, directing attention to an unexplored dimension of this ubiquitous modern accessory.

Hidden Worlds of Noise and Voice (2002) is an interactive audiovisual installation wherein participants can "see" each other's voices. Sounds are made visible through data goggles that superimpose 3-D graphics onto the real world; speech takes the form of animated graphic figurations that appear to emerge from participants' mouths. A companion piece titled *Re:Mark* (2002) is a two-person installation that emphasizes the domain of the spoken and written word. When an utterance is recognized by the software as a phoneme (ah, ee, oh, etc.), its characters appear on a display; when the noise is not recognized, the screen responds with abstract shapes derived from other properties of the vocalization. Here the interactivity is enhanced, as a computer-vision system allows users to propel these shapes across the screen with their shadows. By rendering these spoken sounds visible and malleable, both artworks encourage a new appreciation of our own voices.

In *The Secret Lives of Numbers* (2002) Levin uses custom software, public search engines, and statistical research techniques to determine the relative popularity of every integer between zero and one million. Popular associations with numbers such as 212, 911, 1040, 1776, and 90210 instruct us that there is a disparity of usage among these figures, and Levin's project aims to create a numeric snapshot of this collective consciousness. Whether working with the common objects of our technological era, pushing the boundaries of interactive machinery, or mining abstract concepts and data sets to discover patterns, Levin's mix of technology and creativity alters the way we experience everyday life. BJS

Golan Levin, with the assistance of
Jonathan Feinberg, Martin Wattenberg,
and Shelly Wynecoop. Screenshot of
The Secret Lives of Numbers, 2002.
Executable program, computer, monitor.
Courtesy of the artist, Turbulence.org,
and bitforms gallery, New York

Sharon Lockhart
Born 1964, Norwood, MA
Lives in Los Angeles, CA

Sharon Lockhart's films and photographs are influenced by Structural and Conceptual film, dance, and performance art of the late 1960s and early 1970s. The visually reductive, precise compositions throughout her work belie her elaborate preparation process and extensive interaction with her subjects. The film *Teatro Amazonas* (1999) portrays an audience seated in the titular theater located in Manaus, Brazil. Mounted on the stage, the fixed camera films the spectators and their behavior during the performance of a Minimalist choral composition. Lockhart spent several weeks interviewing potential audience members in order to select a demographically representative cross section of the town's population. The ethnographic scope is not an end unto itself, however, but a complement to the film's formal investigation of the cinematic gaze.

Lockhart's most recent film, *NŌ*, unfolds like a landscape painting in motion. Filmed in one single take with a fixed camera, the film captures two Japanese farmers' methodical covering of a harvested field with straw. Slowly working their way from background to foreground, a man and woman stack dried stalks into evenly spaced piles. When the surface is filled they begin to rake, now moving backward as they spread straw across the ground, gradually covering the dark soil with a layer of ocher. The image consists of a series of horizontal lines. The farmers enter and exit the frame from the left and right with armfuls of straw, while dark green mountains and orange-tipped trees border the field in the upper middle of the frame and jut into a layer of overcast sky. The horizontality is contrasted with the vertical figures' movement forward, toward the bottom of the frame, accentuating the film's depth of field as well as asserting its relationship to painting traditions depicting a classical relationship of figure to ground.

While the covering of farming soil in preparation for the winter is a mundane task, the farmers' actions appear carefully choreographed, filling the fixed frame precisely for the duration of one continuous shot. Lockhart's film was inspired by *Nō-no ikebana*, a variant of the Japanese flower-arranging practice that uses fruits and vegetables directly from the farm. A related series of photographs depicts the life cycle of an ikebana arrangement of Brussels sprouts. The film documents another, seasonal transformation of a landscape through an established series of human interventions. As in her earlier films, the artist presents the material without context or explanation; neither documentary nor performance, Lockhart's work resides in the unresolved tension between the two, oscillating between stylization and observation. HH

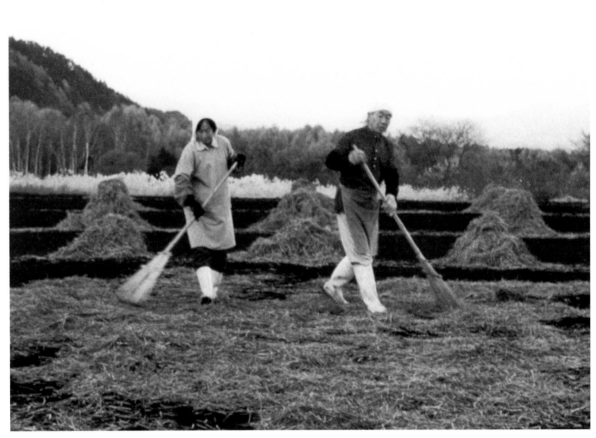

Still from *NŌ*, 2003. 16mm film installation, color, sound; 33 min. Collection of the artist; courtesy Barbara Gladstone Gallery, New York, and Blum & Poe, Los Angeles

Robert Longo
Born 1953, Brooklyn, NY
Lives in New York, NY

Robert Longo's work exists somewhere between cinema, monument, and nightmare. Often using the seduction of cinematic scale as metaphor, Longo explores social, political, and psychosexual representations of power and control. His pictorial language responds to a visual culture dominated by mass media and entertainment. Best known for his large-format black-and-white drawings based on both found and staged photographic sources, Longo has also worked with sculpture, painting, installation, music video, commercial film, and performance. Consistent throughout his work is an attention to formalism, draftsmanship, and spectacle.

Longo's early work employed appropriation strategies that drew on visual techniques from film and television, namely the stop-action imagery and discrete storyboard narratives that were also being employed by contemporaries such as Cindy Sherman. *Men in Cities* (1978–83), a series of forty-four large-scale charcoal and graphite drawings, depicts urban men and women in exaggerated poses and contortions juxtaposed with rigid architectural and sculptural reliefs. Longo exposes the tension

and agitation of urban expectations and institutional oppression, here magnified to monumental proportions. In his epic project *Magellan* (1996), Longo reflects on mass media with 366 television screen–sized drawings—executed one a day for an entire year—of politicians, sports stars, rock musicians, and famous landscapes.

Longo's recent work reflects his meditations on power and control. *The Freud Drawings* (2001) presents a series of charcoal renderings drawn from photographs by Edmund Engleman of Sigmund Freud's Viennese apartment taken prior to his evacuation to London in 1938, necessitated by Nazi occupation. The dark and shadowy interiors evoke a brooding sense of subconscious intensity that alludes to the libidinal dynamics of politics and psychoanalysis. Another recent series, *Monsters* (2001–02), consists of monumental drawings of ocean waves paused at their white teeming crests and dark tubular barrels. Both based on photographs taken by Longo and adapted from surfing magazines, these compelling seascapes are reflections on human emotion and the raw power of

nature. Extreme contrasts of black and white and a sculptural application of charcoal move the drawings beyond photorealist representation into a visceral realm that parallels the sheer scale and energy of nature. With titles such as *Hell's Gate*, *Dragon Head*, and *Godzilla*, taken from popular surf terms and beach locations, each expansive wave formation bears a multitude of visual and metaphorical references to its respective name.

Monsters is part of a trilogy of subtextually related drawings, along with *The Freud Drawings* and *Lust of the Eye* (2003)—based on atomic and nuclear bomb tests—that use the relationship between man and nature to reflect on the combination of fear and attraction elicited by elements of overwhelming power. According to Longo, our very fascination with control propels our destructive desires to want to match or dominate the force of nature. HC

Untitled (Hell's Gate), 2001. Charcoal on mounted paper, 69 x 70 in. (175.3 x 177.8 cm). Collection of Suzanne and Bob Cochran; courtesy Metro Pictures, New York

Los Super Elegantes

Martiniano Lopez Crozet
Born 1966, Buenos Aires
Lives in Los Angeles, CA

Milena Muzquiz
Born 1972, Tijuana
Lives in Los Angeles, CA

Los Super Elegantes is the collaborative team of Martiniano Lopez Crozet, originally from Buenos Aires, and Milena Muzquiz, originally from Tijuana. Together they perform onstage with a backing band (or lip-synch to prerecorded tracks) at concerts, art events, and parties; record albums and make music videos; make photographs and T-shirts, and write, design sets for, and star in their own plays. The two met as art students in San Francisco in 1992, formed Los Super Elegantes in 1995, and by 1997 were living in Mexico City with an album released on a major Latin American label.

Los Super Elegantes' performances are characterized by the pair's raucous energy and a humorously sly critique of the classic male-female entertainer duo. Their between-song banter sends up American cabaret acts while their music tends toward rock and pop styles. In their compositions, a version of

Nirvana's "Rape Me" in French segues seamlessly into glossy Latin pop; Metallica guitar solos, Beach Boys–style harmonies, and house beats can all be found in the same song.

The pair's videos are made with the skills and materials at hand, favoring messy exuberance and the immediacy of the message over any desire for perfection. This attitude playfully makes references to music video clichés, manifesting itself in a plethora of out-of-the-box special effects like dissolves and wipes. In 1997 Los Super Elegantes made *Hollywood*, a video miniseries in the form of the popular *tele-novelas* that permeate Latin American television.

Evolution, a recent work, is about the history of songwriting. The performance begins with the duo sitting on a sofa, talking and laughing to the rhythm of a quiet melodic guitar. The sampled sound of Metallica's guitars come into the mix, followed by

Tartini's *Sonata in A Major*. They stand and sing different parts of the sonata, which then morphs into a psychedelic drums-and-guitar jam. The partners face each other and mirror one another's dance movements. As the performance reaches a fever pitch, a frenetic drum track overtakes the speakers while they stride down a catwalk and vogue along the edges of the performance space.

Lopez Crozet and Muzquiz take on endless roles—rock star, television soap opera characters, writers, onstage provocateurs—without losing themselves in the hypnotic power of those guises. Their pastiche of global pop culture forms speaks to an availability of received styles that is unique to our media-saturated era. Yet the homogenizing power of this universal culture does nothing to devalue the pleasure of what Los Super Elegantes does, for audience or performers. BJS

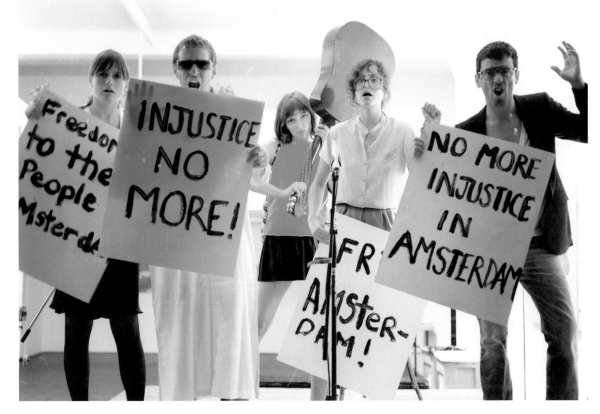

Los Super Elegantes performing in *The Falling Leaves of St. Pierre*, at peres projects, Los Angeles, 2003. Courtesy of the artists

Robert Mangold
Born 1937, North Tonawanda, NY
Lives in Washingtonville, NY

Robert Mangold is an important figure in the generation of artists that developed Minimalist and Conceptual art in the first half of the 1960s, but unlike many of his contemporaries, he did not abandon his belief in painting as a valid artistic practice. Instead, he reworked the parameters of Color Field painting of the 1950s into a Minimalist vocabulary, establishing a personal, almost empirical approach to the relationship between form, color, line, and surface. With every new series, Mangold carefully extrapolates original solutions from the unlimited formal variations these elements provide.

In his earliest series, *Walls* (1964–65) and *Areas* (1965–66), Mangold used plywood and masonite board as support and a spray gun to apply oil paints in muted shades of manila, yellow, brown, and gray reminiscent of envelopes, paper bags, and file folders. The *Walls* series consists of panels with long rectangular incisions into the outer edges, always taking the standardized measurements of two joined boards as a starting point. In works such as *¼ Manila Curved Area* (1966), Mangold first explored the parts of a circle as a compositional device to define the overall shape of a work. This led to his exploration of other basic shapes in his *V*, *W*, and *X Series* (all 1968). In 1970 he began using canvas and acrylic paints, which he applied with a roller, creating individual canvases grouped to construct a frame around an empty center, as in *Frame Paintings* (1970), or visually connecting a hand-drawn circular line with the circular-shaped edge of the support, as seen in *Distorted Circle In and Out of a Polygon 2* (1973). Throughout the 1970s and 1980s, Mangold continued to develop his pictorial language with permutations of these compositional elements. Combining shaped canvases and + and X-shaped forms, and increasingly using bolder colors and hand-drawn circular, elliptical, and cross-shaped figures, he further differentiated the internal compositional logic of his works, with increasingly exuberant and expressive results.

His *Attic* series (1990–91) and *Plane/Figure* series (1992–94) mark a return to more restrained compositions. Consisting of a single geometric line drawn on a monochrome, shaped canvas, these two series revisit the relationship between line and surface, and color and shape, as operative pairs in the creation of a unified form. The subsequent *Plane/Figure (Double Panel)* series (1993–94), *Curved Plane/Figure* series (1994–95), and *Zone Painting* series (1996–97) further explore these concerns, introducing two-colored panels and a monumental size. In his most recent series of works, *Columns* (2002–03), Mangold shifts the orientation of his canvases to the vertical. Columns of closed circles gradually open up into strands of interlocking solid and open lines that touch the sides of the 12-foot-high canvases, transforming from inert geometric shapes into dynamic undulating forms. CR

Column Painting #1, 2002. Acrylic and graphite on canvas, 133 x 31 ⅛ in. (337.8 x 79.1 cm). Collection of the artist; courtesy PaceWildenstein, New York

Virgil Marti
Born 1962, St. Louis, MO
Lives in Philadelphia, PA

Virgil Marti creates installations, hand-patterned wallpaper, and sculptures that pair aesthetic overabundance with mass culture and references to the 1970s suburban subdivision lifestyle of his youth. Many works are site-specific, drawing inspiration from the building in which they are placed and the cultural history of the surrounding area. For an untitled 2001 mural installation at the Pennsylvania Academy of Fine Arts, Marti interpreted the decorative scheme of the academy's late-nineteenth-century Aesthetic Movement building to develop his work's motifs. The mushroom patterning comes from a design that runs around the building's entrance hallway, the stars on the ceiling mimic those above a central staircase, and the flame motifs are derived from a fireplace in a house designed by Frank Furness, the academy's architect.

Other Marti artworks stand out from their environment by disrupting our definition of public space. For *Couch* (2000), the artist intentionally blended public and private space by upholstering with sumptuous fabric a 34-foot wooden bench located in a Philadelphia-area train station. It was a fragment of domestic culture set adrift in a public waiting hall; several commuters enjoyed it so much they asked Marti to upholster furniture for their homes.

Marti stuck close to his own home with *Beer Can Library* (1997), screenprinted wallpaper documenting the collection he amassed with his father during childhood. The archive of eight hundred cans still resides in the family basement, a testament both to family bonding and Marti's pop-archaeological sensibility. His 2002 solo exhibition *Grow Room* and its 2003 reprise as *The Flowers of Romance* may be the clearest synthesis of his investigations to date. Marti transformed a raw exhibition space into a mirrored interior by applying silvery hydroponic mylar panels—typically used for raising plants—to the walls. He imprinted the panels with variously colored floral motifs and macramé patterned in imperfect grids based on spiderwebs. Venetian-style chandeliers, cast from deer antlers in colored resin and tipped with synthetic floral blossoms, added an air of kitsch to the decor. The installation was laced with references to 1960s and 1970s psychedelic drug culture: the off-kilter pattern of the macramé grids is attributed to a scientific study of spiders fed drug-addled flies; mylar is often used in clandestine marijuana farming.

Marti delves into myriad subjects for his art, including interior design, handicraft, school yearbooks, his memories of hometown head shops, advertisements, and architectural friezes. Each installation becomes a synthetic milieu in which the hierarchies between his references are flattened. In Marti's work, high and low are no longer opposed; they are two points along a continuum from which he draws inspiration. The ambivalent presentation of his findings, in which everything can be dematerialized in a matrix of reflections, only partially obscures the pleasure Marti takes in the act of creating. BJS

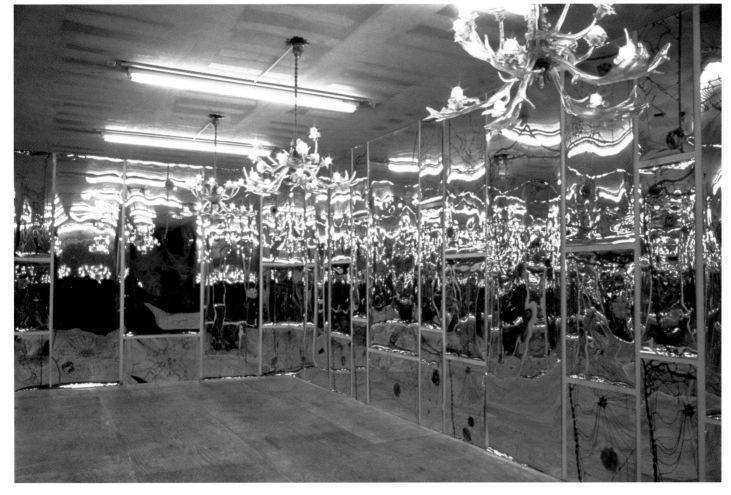

Installation view of *Grow Room*, 2002, at Participant, Inc. Screenprint on mirror mylar, polyester resin, electrical wiring, and macramé, dimensions variable. Collection of the artist; courtesy Participant, Inc., New York

Cameron Martin
Born 1970, Seattle, WA
Lives in Brooklyn, NY

Cameron Martin focuses on representations of nature in nineteenth-century photography, beer and clothing advertisements, movies, and Japanese ukiyo-e prints, among other sources, to make his landscape paintings. He strips much of the pictorial detail from his source imagery and uses the left-over visual information—rolling seas, rocky shorelines, mountaintops, and tree trunks—in spare compositions that signify landscape rather than reproduce it. Nearly monochromatic or starkly black and white, his paintings are rendered in oils, alkyds, acrylics, and the luminescent Interference paint used for auto detailing. The omnivorous eye and recycling of images inherent to Martin's process recalls 1980s appropriation art; his graphic compositions and the hard edges between colors make reference to Pop art and contemporary graphic design.

Untitled CM054 (1999) removes the color and typography from the mountain familiar to us from the Paramount Pictures logo. Martin executes a minimal black-and-white version of the mountain using an iridescent auto finisher's paint that reflects the image of viewers as they pass in front of the work. The image becomes an empty sign: those who might project themselves into the movies that the artist's subject represents can literally see themselves in this painting. Martin's style is even more pared down in *Untitled Study #7* (2001). Two vertical, mottled bands of black paint trisect the horizontal white canvas with the hard edges of woodblock prints; all other information has been stripped away, leaving a picture that suggests a minimal Rorschach test as much as two tree trunks.

The natural world that Martin paints is devoid of human presence. Yet the isolated elements in his paintings could not exist without the intervention of people as diverse as nineteenth-century photographer Carleton Watkins and a Madison Avenue advertising executive, each of whom has created an image the artist saw fit to appropriate. In Martin's Pop-inflected paintings, the critical distance this process offers tames the often awe-inspiring sublimity of waves crashing on the seashore, trees set against a uniformly clear sky, and mountains pushing up from the earth. BJS

Pure Phase Two, 2002. Oil and alkyd on canvas, 72 x 96 in. (182.9 x 243.8 cm). Wellspring Capital Management LLC

Anthony McCall
Born 1946, St. Paul's Cray, England
Lives in New York, NY

Anthony McCall is a key figure in the development of experimental film and installation. His work engages the material properties of film and the cinematic apparatus, and their perceptual relationship to physical space. In the 1970s McCall made a group of films and installations in which the projector beam, articulated through a fine mist or smoke in a darkened space, shifts the reading of film as a model of the unconscious into that of a tangible, sculptural form. In *Line Describing a Cone* (1973), the projector beam becomes not the conduit for a cinematic narrative, but a participatory field within which viewers circulate, moving in and out of the beam as it grows to its full expanse in the space, from a razor-thin line to a large cone of light. Within the darkened space, the film projects an image of a white circle, slowly drawn on a black wall opposite the projector over a period of thirty-one minutes. The shifting of the viewer's attention from the circle forming on the wall to the beam of light itself ruptures any perception of the film screen as the focus of the space, freeing one to experience multiple viewpoints and planes through physical movement around the cone of light.

Other installations by McCall articulate space with light using material strategies, such as varying the orientation of the film print as it is threaded through the projector. In *Four Projected Movements* (1975), a wedge-shaped beam of light appears four times in the corner of a darkened space. The film print is threaded onto the projector differently each time—right way up; upside down; backwards; and upside down and backwards—causing the corner of the beam to move downward from the wall to the floor, upward from the floor to the wall, and back and forth from one side to the other.

In his new installation, *Doubling Back* (2003), McCall opens up a single projector beam into two large bisecting planes that move first toward and then away from each other in a slow exchange of planar forms stretching from the floor almost to the ceiling. Walking through the large planes of light creates the sensation of walking through a wall or a mirror. Standing between the advancing planes, the viewer experiences a kind of warping of space, in which stable enclosure gives way to a gradually shifting relationship between the lines as they ebb and flow. Perhaps his most architectural piece to date, *Doubling Back* reaffirms the fusion in McCall's film works between light, film, geometric form, space, and drawing. CI

Drawing for the film installation
Doubling Back, 2003. Digital print on
paper, 10⅝ x 13⅝ in. (27 x 34.6 cm)

Paul McCarthy
Born 1945, Salt Lake City, UT
Lives in Los Angeles, CA

Since the late 1960s, Paul McCarthy has operated between the boundaries of sculpture, performance, and video, introducing the psychological, the sexual, and the abject into an increasingly complex series of sculptures and tableaux. In his early pieces, he systematically worked through the parameters of Minimalist sculpture and performance. In *Face Painting—Floor, White Line* and *Face, Head, Shoulder Painting—Wall, Black Line* (both 1972), McCarthy painted a line onto the floor and wall of his studio using various parts of his body. In an ensuing series of performances, his body became the primary material of the work, culminating in the performance *Penis Brush Painting, Windshield, Black Paint* (1974), in which McCarthy used his genitals as a tool to apply paint.

Over the next ten years McCarthy produced performances in which he developed his signature materials and narratives. In *Meat Cake #1* (1974), *Hot Dog* (1974), *Sailor's Meat* (1975), *Doctor* (1978), *Pig Man* (1980), and *Mother Pig* (1983) he performed disturbing, sexually charged narratives in carnal scenes incorporating sausages and ground meat,

ketchup, mayonnaise, and mustard, masks and stuffed animals, and television and cartoon characters. Enamored with the acts of defecation and procreation, as well as with the symbolic and narrative registers of popular culture, McCarthy's works are graphic, troubling, and often difficult to endure.

Deeply engaged in the development of performative practices over more than three decades, McCarthy is perhaps best known for his significant body of sculptures, objects, and installations. His installation *Bossy Burger* (1991) is one of the first in which the performative action is fully transferred onto the spatial confines in which it occurs, documented only through the sculptural remains and two videos that comprise the work. Constructed from elements of the television series *Family Affair, Bossy Burger* presents McCarthy engaged in a bizarrely deranged act of preparing a typical American dinner. As the video unfolds, the cooking lesson increasingly gives way to violently and sexually charged acts. His installation *The Garden* (1991–92) consists of a large platform densely filled with an artificial for-

est of trees scavenged from the set of the 1960s television series *Bonanza*. On close inspection, two mechanical, life-size, male rubber figures can be discerned in the wood. While the older of the two is seen copulating with a tree trunk, the younger man desperately attempts to make love to the ground.

In recent years, McCarthy has produced sculptures of increasingly monumental scale, such as his huge, inflatable sculptures *Blockhead* (2003) and *Daddies Bighead* (2003), loosely based on the character Pinocchio and a Daddies brand ketchup bottle, respectively. As invested in the unraveling of psychological and sexual attributes of masculinity as his early performances, McCarthy's installations and sculptures further engage the viewer in the scenario by directly triggering reactions of repulsion, discomfort, or shock. CR

Untitled, 2003. Graphite on vellum,
23½ x 18¾ in. (59.7 x 47.6 cm).
Collection of the artist; courtesy Luhring
Augustine Gallery, New York, and Galerie
Hauser & Wirth, London and Zurich

Bruce McClure
Born 1959, Washington, DC
Lives in Brooklyn, NY

For the past ten years, Bruce McClure has made film projection works and performances that test the static and dynamic possibilities of flashing light. Using altered projectors, he manipulates the image on the screen by intervening in the trajectory of light from the source to the spectator. Rather than investigate the formal properties of light, color, and motion, McClure pursues a kind of phenomenological approach. He is interested in the unique ways in which film apportions time to the senses, forming the material that produces particular cerebral and visceral effects.

In his recent four-projector series titled *Crib and Sift* (2002–04), McClure dispenses with the direct use of color, choosing instead one length of clear leader sprayed with black ink. From the hand-painted original McClure made four prints, two on single-perforated stock and two on double-perforated, allowing him to identify four different orientations for inserting the films in the projector. For some of the works, McClure has retrofitted four projectors with brass plates installed in the gates, masking one half of each individual image. Projected together, they are reassembled on the screen as superimposed quadrants. The works that comprise *Crib and Sift* represent various combinations of the print orientation (which McClure calls "sifting"), and distinct ways of focusing the projector on the gates, the inserts, or the film itself ("cribbing").

In *Presepio*, for instance, McClure focuses on the edges of the brass inserts that bisect each image. These edges are used to define a rectangle on the dark of the screen, which in turn frames an absence that seems to exercise a gravitational pull, sucking frenzied flecks toward the middle of the frame. The orchestrated riot of movement and form triggers spectral afterimage, and creates the impression of three-dimensionality. In *Chiodo*, on the other hand, McClure focuses on the gates. The layered images form irregular clusters of black speckles, foggy, dense clouds alternating with large spots. Occasionally they appear to form patterns and shapes that converge or hang on a central point in the frame, as denoted in the work's title, which is Italian for "nail."

In the *Crib and Sift* series, McClure continuously traverses the border between order and chaos. He establishes a set of clear parameters only to introduce elements of inescapable variation—the framing is always a little different, the films cannot be started at exactly the same time, each projector runs at a slightly variable speed—so that four identical copies are projected in such a way that their outcome is once again unpredictable. Relinquishing the projectionist's control of the screening situation, the artist initiates a noisy onslaught on the viewer's perception. As McClure describes, the works aim to omit "the artistic 'error' of the camera eye favoring the fugitive chiaroscuro in the automatic theater of the human eye that serves as a window to the chicanery of mind." HH

Simulated Crib and Sift Assembly,
2003. Cut Florentine paper. Collection
of the artist

Julie Mehretu
Born 1970, Addis Ababa
Lives in New York, NY

Julie Mehretu's complex paintings and drawings layer and compress data gleaned from our media-saturated lives into coolly rendered, mostly abstract compositions. Architectural plans, newspaper clippings, mall escalators, cartoon fragments, maps, and graffiti morph into points, lines, planes of color, arrows, and small explosions. Despite incorporating as many as six layers of acrylic paint, silica, vellum, rapidograph pen marks, and other materials on each canvas, the works remain diaphanous, reminding us that much of what she renders is intangible. Her busy tableaux evoke the methods through which data, people, and money now travel across continents with unparalleled ease. A multitude of small energy flows and interactions take place, leading the viewer's eye across each composition as we attempt to pick out recognizable fragments.

There is a political aspect to Mehretu's investigation of how local and international structures, economic or otherwise, almost invariably represent specific ideologies. *Retopistics: A Renegade Excavation* (2001) combines renderings of sports stadiums, airport plans, city buildings, and grand staircases, flattening hierarchies among them to present a cacophony of organic lines and shards of color. *Excerpt (Paradigm)* (2003) lays expressive brushstrokes over city maps of the capitals of every country in Africa.

Into her dense whorls of color and line, Mehretu will now often insert organic shapes representing figures. She calls them characters, and they interact in her collaged landscapes, introducing the possibility of narrative amidst her invented worlds. Earlier works set the stage; recent paintings have emphasized personal events, eschewing recognizable blueprints in favor of mental geographies, albeit ones still inflected by the contemporary urban environment.

This synthesis of innumerable visual sources with private accounts can be read as a result of Mehretu's biography: she was born in Ethiopia, raised in Michigan, and schooled in Senegal, Michigan, and Rhode Island. Mehretu has also lived in Houston and in Harlem, New York. Her emphasis on maps and plans as structuring elements for her work, as well as her continued questioning of the nature of representation, speaks to the cosmopolitan, syncretic, and densely visual time in which we live. BJS

Empirical Construction, Istanbul, 2003. Ink and acrylic on canvas, 120 x 180 in. (304.8 x 457.2 cm). Collection of the artist; courtesy The Project, New York and Los Angeles

Jonas Mekas
Born 1922, Semeniškiai, Lithuania
Lives in New York, NY

Since his arrival in New York in 1949, Jonas Mekas has become one of the most important forces in American and international experimental film. A filmmaker and poet, Mekas also established the journal *Film Culture* in 1954, wrote film criticism for the *Village Voice* from 1959 to 1977, and created the distribution agency Filmmakers' Cooperative in 1962. In 1964, Mekas founded the Filmmakers' Cinematheque, which screened avant-garde and experimental films, and in 1970 he established the Anthology Film Archives, one of the largest and most important archives of experimental and avant-garde film.

Mekas's own films often are guided by the principles of the archive and the diary, as he combines and edits material assembled over decades into sequences of discontinuous narratives. Informed by his experience as an exile brought to the United States as a displaced person at the end of World War II, Mekas began filming almost immediately after his arrival. While attempting to turn his scripts of avant-garde narratives and documentaries into films, Mekas continued to collect footage of his immediate surroundings and to keep a filmic diary. After his first diaristic film, *Walden* (1964–69), Mekas continued to work in that format, resulting in films such as *Lost, Lost, Lost* (1949–75) and *Reminiscences of a Journey to Lithuania* (1971–72). Mekas's films present images of intimate moments of friendship and family life, excursions to Montauk and his home country, and sometimes contain rare glimpses of icons of the New York cultural scene, such as Andy Warhol, Lou Reed, John Lennon and Yoko Ono, and Jackie Kennedy with her children. Seemingly random in their internal order, the works are in fact the result of an extremely careful and highly controlled editing process.

In 2000, Mekas released the almost 5-hour-long retrospective film *As I Was Moving Ahead Occasionally I Saw Brief Glimpses of Beauty*. Compiled from personal archival material spanning from 1970 to 1999, the film presents images of friends, Mekas's family, and fleeting moments of happiness and beauty. In title cards stating "this is a political film" that interject images of his family and friends, Mekas not only deliberates on the sometimes very public personae of those close to him, on categories of public and private, and on his role within the larger cultural scene of New York, but also on the fundamentally oppositional role avant-garde film continues to play in regard to the Hollywood industry. Most recently, Mekas has begun to present photograms taken from his films, presenting a sequence of sometimes three, sometimes five frames complete with magnetic soundtrack and sprocket holes. Zooming in on fragments of landscape vistas or portraits of friends, the photograms present "displaced frames" while echoing the basic cinematic characteristic of images sequentially ordered in time. CR

Stills from *Williamsburg, Brooklyn*, 1949–2003. 16mm film, black-and-white, silent; 15 min.

Aleksandra Mir
Born 1967, Lublin, Poland
Lives in New York, NY

Aleksandra Mir's works often take the form of process-oriented performances that mirror corporate and professional structures, historic events, or social services. For one of her first works, *Life is Sweet in Sweden* (1995), Mir established a "tourist office" in the Swedish city of Göteburg during the World Championships in athletics. The office was outfitted with stereotypical furniture for relaxation—sofas, plastic plants, foot massage basins, a fish tank—and was operated by a group of hostesses dressed in uniform. Anyone who was willing to wear the uniform could perform the services of the hostess, and a wide range of people assumed the role; Mir simply provided the structural framework for an otherwise undefined service that was open to personal interpretation. The proximity of the office to the city's red-light district added intentional ambiguity to the function of the office during this large public event.

During the 1996 Roskilde Festival, a four-day music event in Denmark, Mir circulated a petition for more female bands, entitled *New Rock Feminism*, and presented it to the festival organizers. While the result of the work may have been minimal, it reintroduced political procedures into a festival that was founded in 1971 in the spirit of 1960s activism. For an exhibition in Moss, Norway, Mir presented *Cinema for the Unemployed—Hollywood Disaster Movies (1970–1997)* (1998) in an abandoned movie theater. On weekdays, during working hours, she showed classic catastrophe films free of charge and open to the public, while the local unemployment office advertised the project with posters and informational brochures. For her 1999 project *First Woman on the Moon*, Mir staged a moon landing of several female "astronettes" on the Dutch coast near Utrecht. For a single day, heavy machinery turned the sandy beach into a lunar landscape of craters, hills, and holes, and among the regular beach visitors, playing children, and sunbathers Mir and her fellow space travelers planted an American flag in the ground. The next morning, all signs of the event were removed.

Since 2000, Mir has produced *Hello*, which she calls a "found photography work in infinite progress." *Hello* is based on the principle of six degrees of separation and links unrelated people via a succession of found photographs—snapshots, film stills, news images, reproductions of artworks. A sequence might show a photograph of Stalin with Trotsky, one of Trotsky with Frida Kahlo, then a painting of Kahlo with Diego Rivera, and so forth. The project will continue until the possibility of a vast network of interconnected relations, potentially encompassing every person on the planet, is conveyed. Almost all of Mir's events and performances enter into or create a social process that allows for anyone to act as visitor or participant, to observe from a distance or to endow the work with meaning. In the words of Lars Bang Larsen, her works teach an important lesson: "Use your imagination. Celebrate regularly. Make world history." CR

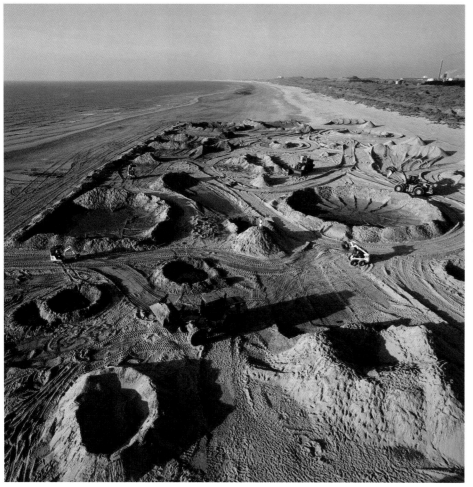

First Woman on the Moon, installation at Wijk aan Zee, The Netherlands, 1999. Produced by Casco Projects, Utrecht

Dave Muller
Born 1964, San Francisco, CA
Lives in Los Angeles, CA

Dave Muller's artistic practice has always been deeply engaged with an open and highly personalized communication with other artists' work. In art school, his studio became a project space for his peers. This later evolved into Three Day Weekend, an ongoing series of convivial gatherings where Muller offered his studio or apartment to friends and other artists he admired and provided an informal framework: spinning records, buying drinks, and encouraging both social exchange and a chance to present work. Muller continues to organize and stage such events both at home and abroad, and they have become a significant element of his artistic production. While the practice of exhibiting other artists' work points to Muller's generosity, it also mirrors his method of sampling, recontextualizing works and exhibitions, along with images and statements by and about the artists he admires.

One facet of Muller's artistic practice consists of watercolor-style drawings that function as possible posters for exhibitions by friends and colleagues,

as well as other cultural phenomena for which he feels an affinity. In one group of drawings Muller refers to the historic 1913 Armory Show poster, but its pictorial language is slightly altered to highlight specific participants. For his *Pollock Sketchbook* series (1999), Muller combined illustrations by Norman Rockwell, comic strips, and factual information about the recent Pollock retrospective at The Museum of Modern Art in New York to create a clever and wildly associative comment on the workings and the heroes of the art world. In *Backstage at the Hamburger Kunstverein, Late June 1996* (2000), Muller created a plausible stack of crates for the works of André Cadere, a 1970s Romanian-French Conceptualist whose work he admires. Cadere resurfaces in the work *Trade?* (2000), which depicts two works by Jorge Pardo, combined with the text "Have two pieces by Jorge Pardo from 1995, will trade for work by André Cadere." At the bottom Muller lists his own phone number.

And in more recent years, Muller has covered the walls of galleries with large expanses of blue-sky drawings, complete with clouds, airplanes, and buildings (*Sprawling*, 2002–03). Another series (*Spatial*, 2000–03) focuses on the night sky, crammed with celestial bodies, nocturnal fauna, and theoretical diagrams.

All of Muller's works are bound together by a belief in the ready availability of his subject matter and his desire to recombine and present it according to his preferences, ideas, and idiosyncracies. For as much as Muller's work is about the systems and networks of the art world, its histories, heroes, and side stories, the filter he imposes is a highly personal one: the puns, allusions, and quotations follow a logic all his own, deeply saturated by his fascinations, friendships, and admirations. CR

Monochrome #35, 2003. Acrylic on paper, 24 x 24 in. (61 x 61 cm). Collection of the artist; courtesy Blum & Poe, Los Angeles, and Murray Guy, New York

Julie Murray
Born 1961, Dublin
Lives in New York, NY

Julie Murray makes evocative and lyrical films, which often combine her own material with preexisting footage such as old industrial and educational films and home movies. Construing sophisticated visual rhymes, juxtapositions, and complex interconnections, her work explores memory and perception using abstract concepts alongside images of phenomena of the physical world. *Untitled (light)* (2002) is a reflection on *Tribute in Light*, an installation composed of two enormous light beacons erected at the site of the World Trade Center in the spring of 2002, illuminating the sky for thirty-two days from dusk to midnight. This solemn meditation on September 11 and its aftermath mirrors the artist's experience of the memorial, as well as the difficulty in sorting through a personal response to the tragedy. To Murray, apprehension of the light towers' sheer visual impressiveness and eloquent poignancy was inseparable from the public debate that followed the attacks, which merged collective mourning with a rush to patriotism that seemed liable to stifle criticism of the United States and imperil civil liberties.

Shot almost entirely at night, the film circumnavigates the base of the static searchlights and the beams that spilled white-blue light into the sky. Rather than showing the memorial in full view from afar, Murray chose to depict the giant beacons up close, in partial views or encroaching into the frame at an angle. Occasional flurries of rain are caught in the lights, floating in the heat generated by the beams and sparkling like snowflakes. Murray also filmed in the area surrounding the site of the memorial, and she includes in the work shots of construction equipment, bulldozers, and security vehicles moving about in the dark. Sharing a similar sense of rhythm, the fragmented images of the beacons and the traffic scenes reflect the artist's experience of the World Trade Center site, with its invitation to gather as well as its uncertain boundaries. "The result was a kind of anxious, cautious sojourn full of damp and twinkling lights, at once beguiling and somber," she notes.

The film's haunting images are accompanied by the continuous sound of a helicopter circling overhead, which at the close gives way to the distant sound of police sirens. The beams of light, which seem to emanate from above, could be confused with helicopter searchlights, a reading whose symbolic significance evokes both security and baleful scrutiny. These sounds, however, are not only immediately associated with the events of September 11; they have also become a ubiquitous presence in the urban sonic landscape. Murray reveals the subtle disconnect of sound and image only gradually, allowing conscious recognition to develop slowly in viewing the film. HH

Stills from *Untitled (light)*, 2002. 16mm film, color, sound; 5 min.

Julie Atlas Muz
Born 1973, Detroit, MI
Lives in New York, NY

Humorous, bawdy, irreverent, and exotic, Julie Atlas Muz is reviving the tradition of the burlesque, performing her dance numbers in venues throughout New York, including the Va Va Voom Room, the Pyramid Club, the Coral Room, the Slipper Room, Joe's Pub, and Galapagos. Transgressive comedy delivered by scantily clad voluptuous women, burlesque dates to the mid-nineteenth century, when prevailing attitudes deemed it scandalous for women to appear in anything but the accepted costume of bourgeois respectability and for them to behave improperly. Since 1995, when Muz moved to New York from Detroit, she has been at the center of the burlesque resurgence in New York.

Whether swimming in an aquarium as a mermaid or donning outlandish costumes that she peels off during her performance, Muz infuses her daringly original works with an air of the unexpected. In her act *I Am the Moon* Muz personifies the surface of the first lunar landing, appearing naked with her entire body covered in silver glitter. A collaborator, playing the role of the universe, his body covered in black paint, lands toy astronauts and spaceships that colonize Muz's body. The five-minute act culminates with one of the astronauts laying claim to the moon by placing the American flag in Muz's rectum.

A contemporary dance choreographer, Muz has also presented her work at performance art venues such as P.S. 122, Chashama, LaMama, and Dixon Place. Whether slapstick, subversive, or caustic, humor remains an essential aspect of her work. For a performance at Chashama, Muz presented *The Thing: A Dance from the Deep*, a water-based performance that took place in a 48-foot-long wading pool and was set to industrial music and distant foghorns. Spectators wore parkas to protect them from the splashing of Muz and her two male dancers. The trio, wearing diaphanous white tunics, took turns sliding and sloshing through the pool, dumping loose change from their pockets, dancing to a go-go number, saluting each other as sailors, and enacting various other melodramatic gestures that kept the act in the realm of the absurd. AD

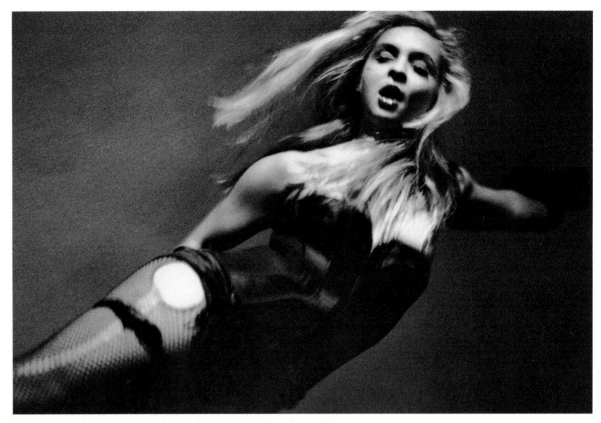

Julie Atlas Muz performing at Red Vixen Cabaret, New York, 2000

Andrew Noren
Born 1943, Santa Fe, NM
Lives in Holmdel, NJ

"Music for light and mind." This is the way in which Andrew Noren has described his cinematic art. For close to forty years, his singularly focused body of work has been devoted to capturing the transformative power of light on celluloid, and more recently digital video. The monumental series *The Adventures Of The Exquisite Corpse*, comprising nine parts made between 1968 and 2003, is a sensual and complex perceptual study in which light emerges as the main subject. Noren records everyday surroundings and people in his life, imaginative inventions based on what is before him: light shining on his wife's hair, water sparkling in a kitchen sink, his own chiaroscuro shadow cast over a sun-flooded garden path. Often the camera will focus on a detail to the point where the image disintegrates into luminous abstract shapes and particles, revealing the chaotic energy that lies beneath the surface of appearances. Noren bypasses narrative expectations to create purely visual experiences, a cinematic poetry dedicated to light and the affirmation of life. His need to respond to light stems from his sense that light is "divine manifestation" and "the living thought of the Sun."

It has been said that all art aspires to the condition of music, and this idea certainly informs Noren's work. His films and videos develop like jazz improvisation, where thematic ideas, impulses, and energies are propelled through countless variations to arrive in the end back where they began, transformed. His digital video *Free To Go (interlude)* (2003), the most recent work in the *Exquisite Corpse* series, combines a dizzying array of techniques in a symphony of form and color. In the opening sequence, Noren manipulates black-and-white footage of vehicular traffic, disrupting linear flow by inserting screens within screens, and thus calling into question basic assumptions of what is foreground and background, or by rotating the image along the central axis to spinning, kaleidoscopic effect. This is then transformed into a passage of New York street scenes depicted in bold, flickering colors. As in the previous movement, the image is treated to increasingly abstract effect, breaking up into pixels of color or morphing into psychedelic patterns and swirls. The third part returns to black and white, combining and reworking images from the previ-

ous sequences and concluding with a series of shots of pedestrians' shadows cast on the city pavement; by alternating positive and negative images many times within a given second of screen time, Noren again creates a mysterious collision of depth and surface, of "here" and "there." His visual music pulsates with a kinetic, fluid energy that confounds "expectations of narrative cohesion," as Noren says in his notes on the work, in favor of rhythmic movement, generating "fictions of space and time, delusions of depth and duration," and invoking the "hallucinatory instability" of the screen's surface. *Free To Go* does indeed free the viewer to revel in and meditate on the riddles of visual perception. HH

Still from *Free To Go (interlude)*, 2003.
Digital video, color and black-and-white,
silent; 61 min.

Robyn O'Neil
Born 1977, Omaha, NE
Lives in Houston, TX

Robyn O'Neil creates imaginary worlds with her meticulously rendered graphite drawings. Landscapes, often covered in snow, are filled with weather implements, defunct telephone poles, pine trees, wild animals and birds, and middle-aged men in sweat suits. O'Neil's invented realities foreground anxieties of contemporary life: in her works both animals and humans seem oblivious to their imminent extinction.

It is this looming sense of danger that lends O'Neil's drawings the quality of science-fiction Surrealism and demonstrates her interest in "the potent, scary things around every corner." Hers is a gentle apocalypse, however, in which innocent desires—calisthenics, walking around, befriending someone different from you—counteract the calamitous forces of earthquakes, hazardous terrain, and bleak weather. The laughable sensation of observing middle-aged men put themselves through the paces of a workout routine on a snowy hill populated with all manner of creatures masks unsettling feelings about just how desolate the scene really is. O'Neil's compositions can be claustrophobically dense with living beings who run, fall, toss balls, or work out, yet often their camaraderie is blocked by poles or trees that inhibit interaction.

It is tempting to invent narratives for each scene. In *Prelude #5* (2003), one man has slung another over his shoulder and carries him away from a downed weather balloon whose metal framework recalls a diagram of electrons moving around a nucleus. Is this a reference to a nuclear explosion that has depopulated the landscape? A third man lies face down in the snow, peering up at his companions as if awaiting his turn to be rescued. O'Neil is intentionally ambiguous when talking about her characters, stating only that they are "walking around encountering others walking around…to put it simply, they are living life." The pratfalls they face show that living life is sometimes not so simple. BJS

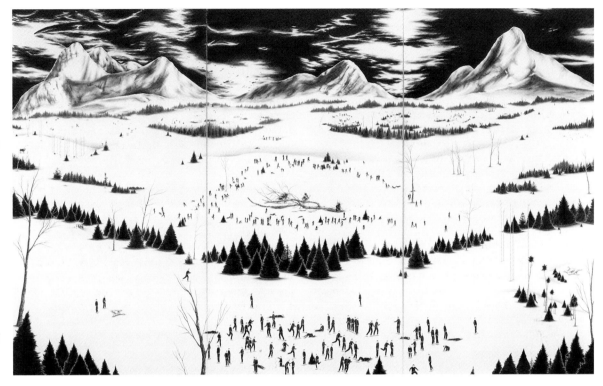

Everything that stands will be at odds with its neighbor, and everything that falls will perish without grace., 2003. Graphite on paper, 91 ¾ x 150 ⅜ in. (233 x 382 cm). Collection of Jeanne and Michael Klein and the Jack S. Blanton Museum of Art, fractional and pledged gift, 2003 Originally commissioned by ArtPace | San Antonio

Catherine Opie
Born 1961, Sandusky, OH
Lives in Los Angeles, CA

Over the past decade, Catherine Opie has taken photographs of subjects as diverse as the gay and lesbian scenes in Los Angeles, the freeways of Southern California, and icehouses in Minnesota. Although very different in style and subject matter, Opie's photographs are connected by what Douglas Fogle has called the "dream of an idea of American community." Her first series of photographs, *Being and Having* (1991), consists of portraits of herself and other women masked as male thugs. Showing only a close-up of the face, cropped by a wooden frame inscribed with a small brass plaque displaying the person's imagined street name, such as "Oso Bad" or "Chief," the images oscillate between the mean and the goofy, as fake mustaches and forced stares are used to keep up appearances and render the images as credible portraits of male subjects.

Opie's series *Portraits* (1993–96) consists of photographs of couples and individuals from the gay and lesbian scene in Los Angeles that endow the subjects with both dignity and familiarity, endearing the members of this community to the mainstream rather than estranging them from it. Opie's stunning platinum-print, black-and-white photographs of Southern California freeways (*Freeways*, 1994–95), her brightly colored images of hideously kitschy entrances and facades of houses in Bel Air and Beverly Hills (*Houses*, 1995), and her deadpan pictures of Los Angeles mini-malls (*Mini-Malls*, 1997–98) expand her formal register and thematic range, although they never stray from the notions of identity and community.

More recently, Opie has presented images of a road trip across the country, documenting the disarmingly ordinary lives of lesbian couples, their friends, and households all over America in *Domestic* (1998), and has portrayed two commonplace structures found in the metropolitan Minneapolis area in *Skyways* and *Icehouses* (both 2001). While skyways shelter the users and inhabitants of buildings from the elements and icehouses rely on the extreme weather conditions of the area, making these structures recognizably regional, both typify distinct social spaces inhabited by a diverse and temporary community of users. Her most recent body of work depicts surfers suspended in the coastal waters of the Pacific, waiting patiently for the perfect wave. Small figures alone or in clusters hover in the vast expanse of water, a horizon line barely visible in the increasingly foggy images, until the photographs dissolve into disorienting, almost imaginary dreamscapes.

Across the diverse range of subject matter, Opie's photographs capture the distinct features that define and delimit the objects of her interest, without ever isolating or marginalizing them. Rather, Opie points to the threshold where the individual and the general intersect and where the concepts and expressions of a specific community begin to merge with the society at large. CR

Untitled (Surfers) #11, 2003. Chromogenic color print, 50 x 40 in. (127 x 101.6 cm). Collection of the artist; courtesy Regen Projects, Los Angeles, and Gorney Bravin + Lee, New York

Jim O'Rourke
Born 1969, Chicago, IL
Lives in Brooklyn, NY

Jim O'Rourke's prolific work in music and his experiments in filmmaking represent a cross-section of his creative practice. Though formally trained as a composer, O'Rourke gradually turned to experimental deconstructions of music using self-reflexive strategies to address issues of medium, sound, gesture, and representation. Unbound by genre, his projects span extensive solo and collaborative work in noise, improvisation, experimental jazz, rock, industrial, and electronic music. His music credits also include roles as producer, composer, arranger, and engineer.

In addition to his post-classical recordings, O'Rourke's early work featured guitar improvisations that disarticulated sonic expectations and social constructions surrounding the instrument. This included unorthodox techniques such as using found objects and homemade devices to provoke resonant and harmonic sounds from the guitar, sometimes removing himself from the performance altogether. Working with tape collage compositions and electro-acoustic music, O'Rourke continued on this trajectory by challenging the impulse to fall into musical gestures, and even the necessity of musical genres themselves. His compositions, which often draw from diverse music traditions such as French *musique concrète*, classical, electronic, and rock, are characterized by sound and stylistic juxtapositions that test formalized listening expectations. O'Rourke's album *I'm Happy, and I'm Singing, and a 1, 2, 3, 4* (2001) features extended electronic compositions that explore subtle changes in harmonic patterning, sonic layering, and experimental instrumentation. His approach to music is also informed by various film techniques, to which he attributes many of his temporal and compositional strategies. Citing iconoclastic directors Nicolas Roeg, Robert Downey Sr., and Russ Meyer as influences, O'Rourke regards filmmaking techniques such as pacing, editing, and reordering as ways of rupturing notions of medium and genre. Much like his tape collage work, his films recontextualize visual elements through manipulation, repetition, and contrast. Often accompanied by his music, O'Rourke's film work offers a synesthetic experience in which both sound and visuals are complementary representations of his creative approach. HC

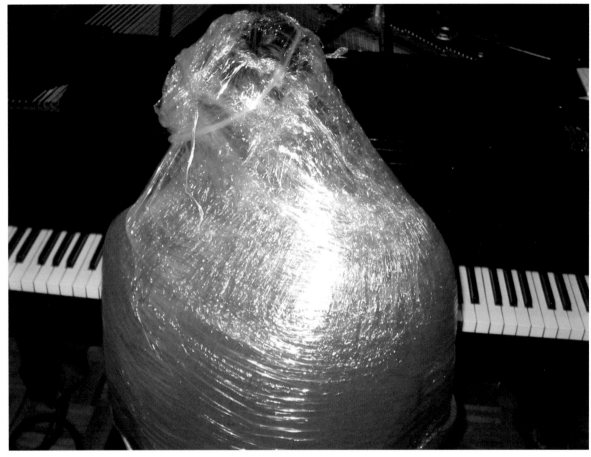

Photograph by Jeff Tweedy

Laura Owens
Born 1970, Euclid, OH
Lives in Los Angeles, CA

Laura Owens's large-scale paintings, each pro-
duced as a singular entity, probe an almost existen-
tial concern for the unique creative act, which
becomes not only the process but also the subject
of her works. "Every painting is about how you
make a painting," Owens says. "I'm always trying
to reinvent the whole idea every time."

Avoiding seriality or groupings, Owens's works
cannot be easily defined by shared thematic con-
cerns or compositional similarities. Seen as a whole,
however, they use some of the most commonplace
genres of painting to create uncanny narratives.
One large painting, *Untitled* (1997), could be read
as a seascape; a large expanse of light blue is bound
at the bottom edge by three horizontal stripes of
successively darker blues. Three heavy marks in
thick black paint suggest birds and are distributed
across the blue expanse to the top, left, and right
edges of the painting. Only the blurry shadows of
the birds' silhouettes on the blue ground provide
an unexpected element of depth, at odds with the
rest of the painting. Another work consists of two
asymmetrical groups of vertical bars that decrease
in width from the left and right edges of the paint-
ing toward the center. The colors range from black,
brown, and gray to a set of pale blues, greens, and
pinks. A more recent work, *Untitled* (2002), exem-
plifies the peculiar conflations that Owens's works
achieve. A large painting, the work is structured
around four tree trunks that sit on a small patch of
land, bound by a greenish blue stream and the
slightly lighter blue of the sky that makes up the
upper half of the work. Populated with animals—
an owl, monkeys, a bear, butterflies, a rabbit, and
a turtle—the work can be read as an image of a
particularly harmonious landscape, rendered by a
tour de force of painterly techniques and allegori-
cal traditions.

The large scale of Owens's paintings, the shifts
of technique, and the artist's frequent response to
the exact dimensions of the gallery walls where
her work will be exhibited all point to a high level
of formal, historical, and site-specific consciousness
in her work. While acknowledging the influence of
Abstract Expressionism and Color Field painting,
Owens tweaks these legacies without ever openly
critiquing them, suggesting a somewhat perverse
pleasure in following the ideologies, rules, and exam-
ples of such distinctly American painterly prac-
tices in her own idiosyncratic manner. CR

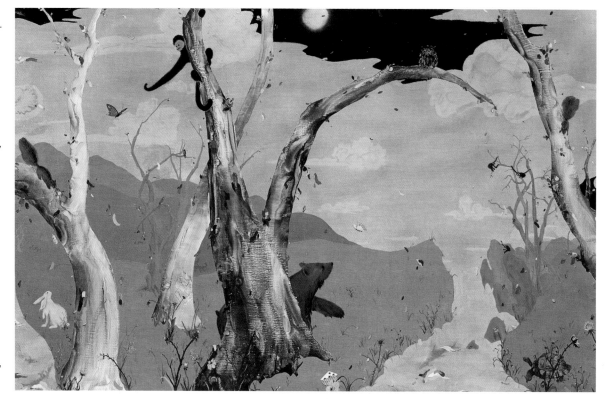

Untitled, 2002. Oil and acrylic on canvas,
84 x 132 in. (213.4 x 335.3 cm). Private
collection; courtesy Gavin Brown's enter-
prise, New York

Raymond Pettibon
Born 1957, Tucson, AZ
Lives in Hermosa Beach, CA

Raymond Pettibon has worked almost exclusively in the medium of drawing since the beginning of his artistic career in 1977. In his works he has created large, room-size installations by clustering existing works on paper with drawings made directly on gallery walls. His work is characterized by a prolific output of monochromatic graphic-style ink-on-paper drawings, sometimes mixed with crayon, pencil, or watercolor.

Pettibon's broad range of references construct a highly personal universe using recurrent themes, characters, and icons. His combinations of visual and literary information bring together image and text in sometimes ironic or sinister ways. Images of trains, baseball players, villains, and nuclear explosions cavort with surfers on the cusp of enormous waves, Elvis, J. Edgar Hoover, or Pettibon's two favorite characters: Vavoom, a minor character from *Felix the Cat*, and Gumby, the 1950s claymation character. His literary references range from William Blake, Henry James, and John Ruskin to the Bible, Mickey Spillane, baseball lore, and underground comics. But Pettibon never simply quotes. Rather, he composes his captions as a reaction to the material he reads and the images they accompany.

Throughout the 1980s, Pettibon produced small, self-published booklets with his drawings, album covers, and concert flyers, invoking the autonomous production methods of fanzines and punk culture, with which he frequently has been associated. He also produced a group of videotapes in which he and friends from Los Angeles played a range of characters, from punk musicians to Charles Manson. Reflecting the 1980s counterculture, Pettibon's work can also be understood as a highly personal, evolving commentary on the American cultural universe: its visual and literary manifestations, its suppressed desires and fears, its political and religious beliefs, and its often violent sexual and criminal transgressions. Pettibon's focus on American 1950s culture refers to a national consciousness that predates the protest movements of the following decade and throws into relief his particular take on recent American history.

Pettibon's artistic production has remained consistent—most of his themes and characters have been fixtures of his works from the beginning— yet his style has become increasingly fluid and all-encompassing. In his most recent room-size wall drawings and installations, Pettibon layers older drawings and pages torn from books and magazines over murals and notes scribbled directly onto the wall. The thematic range of these works is increasingly topical, addressing current political concerns as well as his previous themes. Pettibon's installations shift our attention between individual drawings and the overall graphic environment. CR

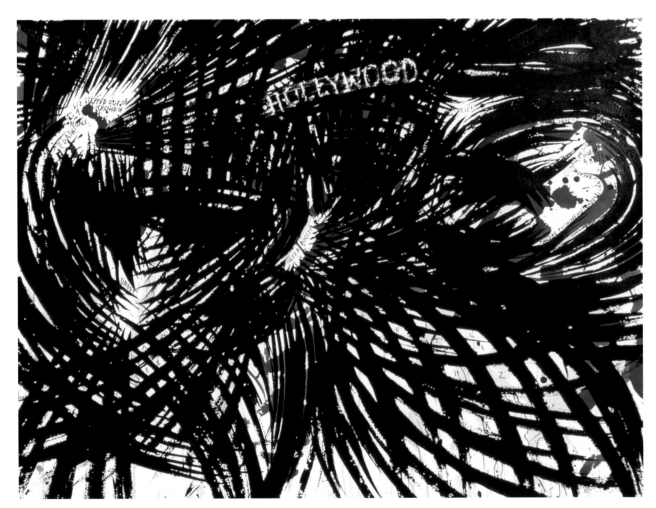

No Title (Liz stepped out), 2002. Ink on paper, 22 ¼ x 30 in. (56.4 x 76.2 cm). Private collection; courtesy Regen Projects, Los Angeles

Elizabeth Peyton
Born 1965, Danbury, CT
Lives in New York, NY

Elizabeth Peyton's paintings and drawings are intimate documents of her personal relationships with friends, lovers, and idols based on photographs found in books and pop magazines and her own snapshots. Peyton's work communicates an undifferentiated treatment of public and private images in her life, with the characters she represents all carrying the same weight of importance.

Rendered in loose gestural strokes, her typically small-scaled paintings depict fleeting and often unexpected moments of endearing introspection. Thick, watery lines and patches of deep, rich color delineate her delicate and waiflike figures. Painted in dark tints and contrasting colors that accentuate the subject's countenance, *Nick (La Luncheonette December 2002)* (2003) shows a young profile portrait of artist Nick Relph lost in momentary contemplation. Peyton chooses to capture her subjects at a tender age or imagined period of youth, further adding to the sense of melancholy and evanescence. Through her paintings, even impersonal photographs of historic figures and pop icons, including Leonardo DiCaprio, Andy Warhol, Kurt Cobain, Napoléon, and Ludwig II, are recovered as personal subjects. The devotional quality of Peyton's portraits counters the subjects' fame and public personas; her quietly familiar depictions erode the anonymity of typical media images.

Peyton overcomes the perceived distances associated with pictorial representation by absorbing the figure in quiet repose and capturing instances unseen by the public eye. Her work is unfettered by irony and is continuous with the tradition of both Romantic and Expressionist painting. The artist's cool and sometimes almost decadent work reflects a belief in the enduring practice of painting and its ability to capture emotional inspiration. According to Peyton, "There is no separation for me between people I know through their music or photos and someone I know personally. The way I perceive them is very similar, in that there's no difference between certain qualities that I find inspiring in them." HC

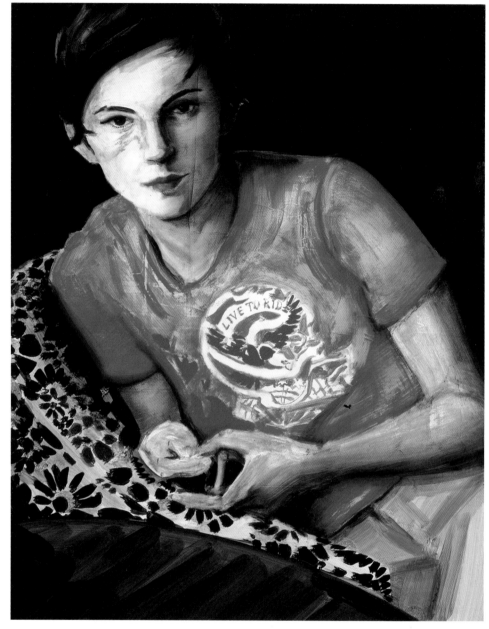

Live to Ride (E.P.), 2003. Oil on board, 15 x 12 in. (38.1 x 30.5 cm). Private collection; courtesy Gavin Brown's enterprise, New York

Chloe Piene
Born 1972, Stamford, CT
Lives in New York, NY

Atavistic and archaic rituals of aggression, violence, and sexuality form the subjects of Chloe Piene's drawings, videos, and book projects. Focusing on the moments and motions of release when tensions, desires, and drives become unbound, Piene presents her protagonists in transitional states of corporeality, where the physical border between the body and its surroundings blurs, or where the visceral collapses into decay.

For her project *Lovelady, Texas* (1999), the artist corresponded with a Texas penitentiary inmate who is sentenced to life without parole for double murder, and collected the letters in a book. The work slowly reveals the troubled and troublesome views of Piene's anonymous correspondent, whose restrained aggression is presented as both symbolic and direct. In a related video, *You're Gonna Be My Woman* (1997–2000), Piene uses a distorting technique to show herself made up with red lipstick and dressed in an undershirt and white panties. Speaking the title line backwards and then reversing it for the projection, Piene suggests the dramatic gender reversals the prisoner experienced during his first week in confinement. By inserting herself into the role he was forced to assume, she again reverses the gendered roles. Her video *The Woods* (2002) presents a scene taken from the mosh pit of a heavy-metal concert. Young men are seen dancing and bouncing to the soundtrack of the concert, but both music and video are starkly slowed down to create a dark, sinister, almost ghostly effect. Both of these videos are charged with the conflicting forces of the subjects' aggression and sexuality and the distancing and dissective method of slow motion. Instead of neutralizing the different drives at play in the scenes, the medium of video creates only a visual barrier, as if the images are kept at arm's length by a glass wall.

Piene's large-scale *Mmasturbator* drawings (all 2003) carefully engage the barriers her previous work erected around the various drives and forces she depicted: between the forces of violence and its moments of sublation, between original aggression and its visual containment. Drawn in delicate lines, the drawings present female bodies in crouching and resting poses, engaged in acts of masturbation. Often cropped or only partly rendered, individual body parts appear as skeletal forms, arms only scarcely covered with tissue and flesh. Here, the turn from sexual to somatic and from physical to pathological is grafted onto one body. For it is not the reality of the drives and their often aggressive manifestations alone that are Piene's subjects, but the attempts at physical containment, and the moments when throbbing desire violently breaks into the spaces of the real. CR

Svelte Mas, 2003. Charcoal on vellum, 42 x 49 in. (106.7 x 124.5 cm). Collection of the artist; courtesy Gasser & Grunert, Inc., New York

Jack Pierson
Born 1960, Plymouth, MA
Lives in New York, NY, and Wonder Valley, CA

Jack Pierson makes photographs, word sculptures, installations, drawings, and artist's books that explore the emotional undercurrent of everyday life, from the intimacy of romantic attachment to the distant idolizing of others. Many works register as melancholic, their beauty speaking to nostalgia for dreams left unfulfilled. Using friends as models, Pierson has consistently engaged star culture through his work, whether the stars are from the screen, stage, or art world. Refusing cynicism or irony, Pierson relates to his viewers by seeming to admit his own attraction to the fantasy life depicted in his artworks.

Pierson's photographs transcend the snapshot aesthetic through the insertion of implied narrative, giving each scene the quality of a film still. The pictures can be read individually or in series, like a storyboard, and their often saturated colors and soft focus impart a dreamy quality that allows the viewer an escape from the everyday. Pierson's photographic world is composed of cigarette butts, empty liquor bottles, and rainy days glimpsed through windows, and is populated by attractive young subjects. His pictures of young men, still lifes, building fragments, flowers, and domestic scenes communicate a delicate mourning for the fleeting nature of each moment captured by the camera lens. The artist constructs a daydream world that plays on Hollywood conventions while remaining opaque enough to allow viewers to project their own narratives into the frame.

The "lettering" pieces, made from found plastic and metal sign letters that are set adrift on gallery walls, similarly compress narrative content. Consisting of a single word or sentence fragment, these sculptures—whose material, color, size, and arrangement often echo the words they depict—embody multiple meanings, and are what Pierson describes as autobiographies of an idea. The artist draws on nostalgia by literally salvaging the past in order to mine it for meaning. Stringing several of these works together creates a poetry of allusion: "gone," "feelings," "lost," "paradise," "hell," "cry," "stay," "maybe."

These two bodies of work by Pierson have been accompanied throughout the past fifteen years by his installations, which draw primarily on the material residue of his own life, including postcards, furniture, photographs, stereo equipment, and clothes; quiltlike collages of cutout photographic fragments that call to mind hard-edged abstract paintings; and an ongoing interest in drawing that has led him from small works composed of abstract blue brushstrokes to overscaled human figures rendered in tempera directly on the wall.

Pierson draws on our collective knowledge of cultural clichés and the desires they elicit, yet it is the unselfconscious nature of his art—his readiness to also fall for his subjects—that allows us to suspend our disbelief. We can be speechless in the face of the exquisite and long for it once it is gone. BJS

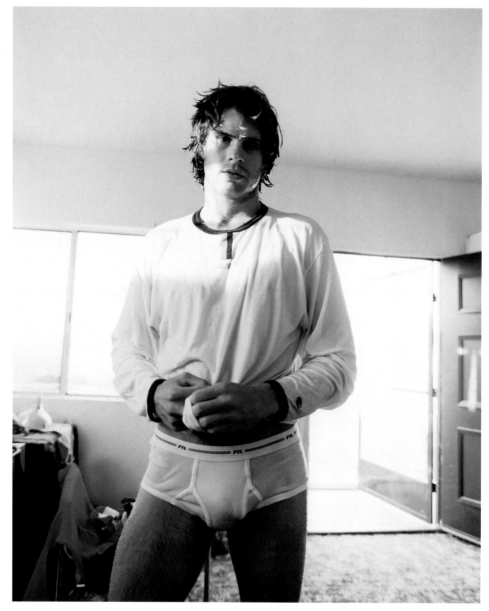

Self Portrait #3, 2003. Ink-jet print, 50 x 60 in. (127 x 152.4 cm). Collection of the artist; courtesy Cheim & Read, New York

Richard Prince
Born 1949, Panama Canal Zone
Lives in Rensselaerville, NY

Richard Prince was a key figure in redefining the direction of art in the late 1970s. Beginning with his earliest work, Prince has appropriated and recontextualized familiar images from American popular culture, including cowboys, bikers, film celebrities, models, and pulp fiction book covers, as well as from underground culture such as Woodstock, punk, and the alternative music scene.

In his iconic series from the 1980s, *Cowboys* (1980–87), Prince appropriated images from Marlboro advertisements, subtly altering the depictions of cowboys set against dramatic mountains and sunsets, on horseback, or sitting around campfires. In 1985 he began an ongoing series of joke paintings, imparting gags about subjects like adultery, alcoholism, and psychoanalysis by stenciling onto the bottom section of a canvas against a colored background. The blankness of the canvas suggests a page with a half-finished drawing for a cartoon, at once elevating a hand-designed image from popular culture onto the stage of painting and questioning painting's relevance as a "pure" medium of high modernism.

Biker culture also plays an important role in Prince's strategies of appropriation. Prince reworks amateur photographs from the racing car and motorcycle world, representing the bare-chested girlfriends of bikers on their heavy machines in works such as *Live Free or Die* (1986). He has also produced several books, including *Jokes Gangs Hoods* (1990), *Adult Comedy Action Drama* (1995), and *The Girl Next Door* (2000), in which he assembles appropriated images around the subject of each book together with personal memorabilia, family photographs, and artwork, in a kind of personal codex that betrays the keen eye of a collector.

In his recent series *Nurse Paintings* (2002–03) Prince reworks 1940s illustrations of female nurses from the covers of erotic pulp novels into large acrylic paintings with drip marks and smears, whose gestural surfaces evoke Abstract Expressionist painting. Prince's newest series, *Hood Paintings* (2003), revisits a subject he addressed in a series from the late 1980s. In both series, Prince cast 1970s muscle car hoods in fiberglass and painted their surfaces, hanging them vertically on the wall as paintings.

While the earlier works evoke the slick surface treatment of custom car design, in the recent works the paint has been applied more loosely, with gestural marks layered onto the pristine surface of the hood. The new paintings were made for the artist's house in the Catskills; he placed the works, along with sculptures and rare ephemera from the Woodstock concert of 1969, in a series of white rooms. In the living room, one hood painting is hung next to Prince's *3rd Place* (1986), a portrait of the punk rock star Sid Vicious. Outside the window, a Dodge Barracuda, custom-painted in gray, can be seen parked in the backyard. The view from the outside becomes part of the installation, locating the hood paintings and their environment somewhere between painting, sculpture, film set, and the domestic space of America. CR

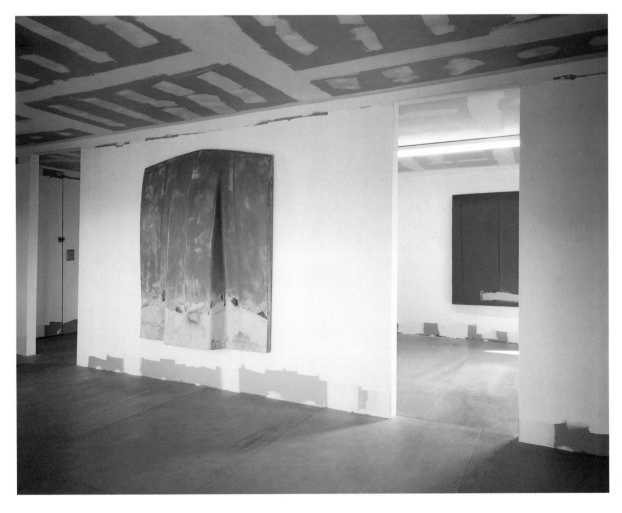

Oak Hill, 2003, installed at Second House, Rensselaerville, New York. Fiberglass, Bondo, acrylic, and wood, 63 x 52 x 6½ in. (160 x 132.1 x 16.5 cm) Collection of the artist; courtesy Barbara Gladstone Gallery, New York

Luis Recoder
Born 1971, San Francisco, CA
Lives in New York, NY

Luis Recoder creates conceptual cinema works that explore the relationships between the film material, film projection, and the space of the cinema He is interested in the qualities of light specific to the cinematic experience, reveling in the physicality lost in digital media. "The flood of conical light of diverse kinds allows us to experience film as if for the first time," he says. "We are not in an epoch of a 'rediscovery' of film but the first witnesses of its coming into being in the nearness of its death."

After working on a series of perceptual studies of light and color titled *Available Light* (1999–), Recoder in his recent works addresses the architectural conditions of the cinema space by integrating the glass of the projection booth. In *Glass: Backlight* (2001–02), thin lines of light seep onto the screen around the borders of a black rectangle that is installed in the booth. Like flickering light leaking through a crack in a wall, the beams emerge and disappear in complete darkness, to a softly crackling audio track evoking breaking waves. Focusing on the projector and beam, Recoder develops a sculptural approach to projected light that evokes the work of Anthony McCall in the early 1970s.

In the double projection *Linea* (2002), Recoder uses two identical films that have been scratched systematically. Projected on top of each other, straight vertical lines emerge out of darkness, oscillating between rhythmic sequencing and arbitrary movement. One projector is set to be slightly out of focus, so that the white lines appear alternately thin and sharp or wide and soft-edged, seeming almost three-dimensional. An inquiry into seriality and repetition, the work touches on post-Minimalist strategies combined with an examination of light, much like Dan Flavin's early light sculptures, but translated into cinematic terms of movement in time. HH

Stills from *Linea*, 2002. 16mm film
double projection, black-and-white,
silent; 18 min.

Liisa Roberts
Born 1969, Paris
Based in Helsinki

Engaged in an investigation of the material and discursive characteristics of image-making, Liisa Roberts's work relocates the medium of film as a conceptual, sculptural, and spatial element. *9 Minutes of Form: A Sculpture by Liisa Roberts: Helsinki, March 1993: for Carlos Basualdo* (1993), a black-and-white film, shows the artist's hand writing on a stack of paper for nine minutes. The counterintuitive titling of the work as a sculpture suggests a phenomenological experience of form, unhinged from the material, three-dimensional object. Time becomes objectified as tangible, while the experienced passing of time is slowed due to the illegibility of the written information. Roberts's installation *betraying a portrait* (1995) continued her investigation into the tangible qualities of space and time. A slide projection of images of the wall on which it would be shown, photographed several hours before the time of its projection, was accompanied by two short films: a panning shot of an interior, and the back of a woman's head and torso. For this meditation on site-specificity, the projection time was chosen to coincide with a par-ticular time of day, position of shadow, and temperature of light.

Roberts's installation *Trap Door* (1996) can be read as an analysis of the spatial possibilities of film. Three screens and three projectors form a triangle of rear projections, standing freely in the space, while a single CinemaScope screen shows a front projection nearby. The wide screen presents a panning shot around a sculpture of the Three Graces, located in Central Park, while the three screens depict the upper body of two women's hands gesticulating in speech, punctuated with images taken from the window of a moving train. *Trap Door* plays with the possibilities of film: presenting a moving image of a static object, or a static shot of a moving body; showing three figures in one frame, or three views of one figure.

Roberts's interest in the slippages between media and appearances, both formal and contextual, material and temporal, informs her most recent work, *Vyborg: a Town Library in Viipuri*, which was initiated in 2000 and includes the subsequent phases *What's the Time in Vyborg?* (2001–) and *ikkuna:okno* (2002–). The work focuses on the restoration of a library built by Finnish architect Alvar Aalto in 1935 in the Russian city of Vyborg, which was part of Finnish territory at the time of construction. Suspended between different national identities, its archival function acting as a monument of "memory" and serving as a beacon for future growth and activity, the library in Roberts's work embodies the disjunctive temporal and spatial identity of the town in which it is located. Central to the undertaking has been a writing workshop, in which the artist invited teenagers to participate in creating a script about their city. Roberts's initiative encompasses a variety of media, approaches, and representations and operates both within and outside the discourse of art. CR

An excursion in Vyborg, Russia, June 18–20, 2003, with Olga Fedotova, Dina Grigorieva, Yana Klichuk, Lyuba Mukhorova, Julia Popova, and Anna Yaskina. Production still from *What's the Time in Vyborg?*, (2001–). 16mm film, sound

Dario Robleto
Born 1972, San Antonio, TX
Lives in San Antonio, TX

Mining sentimental and precious objects such as vinyl record albums, dinosaur fossils, and glass created from nuclear test explosions, Dario Robleto acts as a cultural archaeologist who recontextualizes these objects of recorded history into new systems of meaning and possibility. Based on the power of music and other media with similarly multivalent references, Robleto's sculptures combine evocative materials and historical narratives to create intimate and compelling objects. Weaving layered storylines, Robleto addresses how the notion of faith operates across belief systems such as those embodied by science, religion, and technology. He relates the emotional commitment inherent in the pursuit of these fields to the devotional power of music. Robleto follows the model of the DJ: mixing, sampling, and appropriating fragments from material history and contemporary culture to synthesize a greater sum than the constituent parts.

At War With The Entropy Of Nature/Ghosts Don't Always Want To Come Back (2002) is a weathered mix cassette tape made from every bone in the human body; the audio component contains Electronic Voice Phenomena recordings (voices and sounds of the dead or past detected through magnetic audio tape) of soldiers' voices and battlefield sounds from every American war. The tape is a comment on the absurdity of war, a cacophonous collage of disembodied sounds and distilled violence made from recordings by dedicated paranormal enthusiasts. *Our Sin Was In Our Hips* (2002) investigates music's moral power at the dawn of rock and roll. Robleto attributes his own existence to the physical relationship his parents discovered through rock music, which was demonized as sinful at its outset. Robleto's selective use of vinyl record albums in his work underscores the pervasive resonance of music within history and popular culture: his pelvis sculptures consist of male and female pelvic bone dust and hand-ground vinyl records selected from his parents' album collections. In *My Soul Is Rarely with Me Anymore* (2003), Robleto fashions melted vinyl records of Muddy Waters's "Rollin' Stone" and The Rolling Stones' "Sympathy for the Devil" into leeches, the parasites once used for medicinal treatments. Pointing to the fetishization and eventual wholesale commodification of black American blues, Robleto creates a vessel that refers to cultural appropriation as a process of extracting the soul and the romanticized notion of authenticity in music.

Robleto's titles and elaborate lists of materials serve as liner notes that provide insight into his complex sculptural narratives. Interweaving culture, science, and history, his objects and installations reflect an underlying optimism for regenerating the past as propositions for the future. HC

At War With The Entropy Of Nature/ Ghosts Don't Always Want To Come Back, 2002. Cassette: carved bone and bone dust from every bone in the body, trinitite (glass produced during the first atomic test explosion at Trinity test site, circa 1945, when heat from blast melted surrounding sand), metal screws, rust, and Letraset; audio tape: original composition of military drum marches, weapon fire, and soldiers' voices from battlefields of various wars made from Electronic Voice Phenomena recordings (voices and sounds of the dead or past, detected through magnetic audio tape), 2 1/2 x 3 3/4 x 5/8 in. (6.4 x 9.5 x 1.6 cm). Collection of Julie Kinzelman and Christopher Tribble; courtesy Inman Gallery, Houston

Matthew Ronay
Born 1976, Louisville, KY
Lives in Brooklyn, NY

Playful, inventive, abject, and illogical, Matthew Ronay constructs whimsical arrangements of animals, plants, and inanimate objects that are handmade out of particleboard. Based in fantasy and loose narrative associations, familiar objects become estranged as they are deliberately stripped of their traditional functions and environments. Similarly, seemingly unrelated objects lyrically play off one another, producing a new language by which to understand the mundane. The objects' small scale, simple, bright colors, and imaginative placement recall items from a child's playroom, yet the works simultaneously reveal an expertise in rendering and a striking degree of sophistication: Ronay's titles, for instance, hint that many of his sculptures are based on specific cultural moments, historical figures, or social allegories.

In one of his more complicated sculptural arrangements, *Hidden Wind of Inducement* (2003), a work that is symbolic of flight from Europe to America, a font attached to a wall metaphorically spills forth a stream of holy water, which has traveled through the floor of a colonial church balanced precariously on a single log, which also forms a rabbit trap, with a cornucopia below doubling as the bait. After passing through the church the water travels toward a golden chalice, resting on its side, that lies on a green platform atop the cornucopia. The platform turns into a staircase beneath which lies a bundle of "meat" sticks scattered with canine testicles. Absurd and fantastical, Ronay's scenario invokes the writing style of authors who developed the *nouveau roman*—the French literary style of the mid-1950s and early 1960s characterized by a blurring of illusion and reality, a rejection of finite interpretation, and inconsistency of time and place—especially Alain Robbe-Grillet, whom Ronay cites as one of his favorite writers. Like the writers of the *nouveau roman*, Ronay employs objective clarity and a realistic style that creates an illusion of order. The loose narrative construct, however, points to a more elusive reality. Ronay's sculptures establish nonsensical, elaborate, and open-ended structures through a process of defamiliarization in an attempt to provoke people into questioning the world around them.

70's Funk Concert Model (2003) takes its inspiration from three African-American bands from the 1960s and 1970s: Earth, Wind & Fire; Mandrill; and Curtis Mayfield & The Impressions. The groups are metaphorically represented by sculptures set on three black platforms that represent the stages on which the musicians perform. The various objects arranged around the platforms act as the "cultural atmosphere" surrounding this unlikely musical gathering. One of these constructs, *Infected Carrots* (2003), consists of a fox's severed head, with carrots in its mouth, resting on a boulder. Above the fox is a tree branch that "excretes" a rainbow, supported by a metal detector. Ronay links all these objects with a fantastical narrative that, according to the artist, involves foxes that eat rabbits that have eaten irradiated carrots, causing the foxes to multiply to such a degree that they overtake everything. For Ronay, however, there is no single reading of this fanciful scenario; rather he encourages viewers to invent their own interpretations, seeing greater value in the dialogue that ensues from a questioning viewer. AD

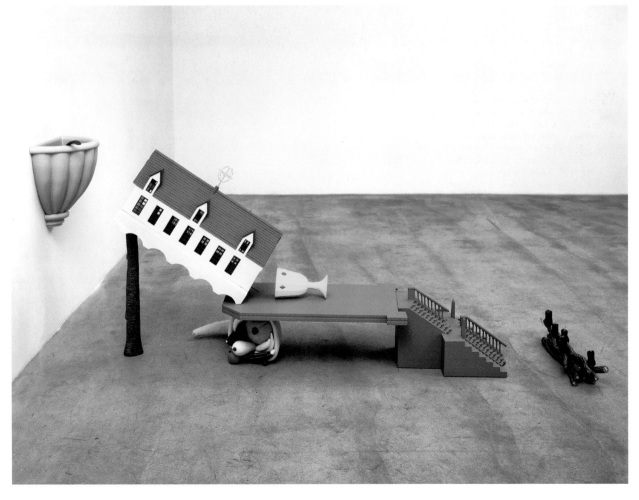

Hidden Wind of Inducement, 2003. Medium-density fiberboard, wood, steel, and paint, 42 3/8 x 45 1/2 x 114 in. (107.6 x 115.6 x 289.6 cm). Collection of Scott and Kelly Miller; courtesy Marc Foxx, Los Angeles

Aïda Ruilova
Born 1974, Wheeling, WV
Lives in New York, NY

New York artist Aïda Ruilova creates short-format videos that combine the collage aesthetic of avant-garde cinema with the tension of horror films. Maximizing the power of both sound and image, Ruilova's meticulously edited works compress cinema's narrative conventions to highlight physical and psychic conflicts. Her actors, often filmed in extreme close-up, seem unable to control their own bodies; some appear to be under attack by the camera while others try to suppress a force yearning to escape from within.

Hey (1999), once exhibited in a decrepit stairwell of P.S.1 Contemporary Art Center in Queens, features a middle-aged woman dangling between a staircase and a floor. The camera views her from behind, and as she looks over her shoulder, her cries—seemingly for help—are interspersed with the amplified scrapes of her fingernails across the banister. *You're Pretty* (1999) features a long-haired shirtless man who alternately caresses a guitar amplifier while crooning "you're pretty" and pushes a vinyl record along the cement floor and rough walls of a dank basement. His aloneness turns the unreality inward, evoking an amplified space of private psychosis.

Tuning (2002) and two untitled works (2002–03) can be seen as bookends to Ruilova's output thus far. *Tuning*, a 40-second homage, features static shots of Ruilova and renowned French horror film director Jean Rollin sitting hand in hand in an ornate drawing room. Set to the sound of repetitive guitar chords, over and over the frame slowly comes into focus, cutting out at the very moment their unsmiling faces are recognizable. The first untitled work is a video featuring a woman draped across the boom arm of a crane that supports a camera. The arm descends into the frame from the right, then rises and falls in concert with the sound of strained breathing. In the second video, set on a rocky cliff at Big Sur, a woman is seen lying on her side with her back to the camera and a reel-to-reel recording device slung over her shoulder. In each video, it is unclear whether the inert woman is dead or alive, and despite the unthreatening settings Ruilova's signature sense of unease creeps into the frame.

Ruilova's works subvert both horror movie and music video clichés, pitting the overplayed drama of the former against the rapid-fire editing of the latter. The result is a staccato take on the grotesque that simultaneously reveals the anxieties of human nature and the optimism of pure beauty. BJS

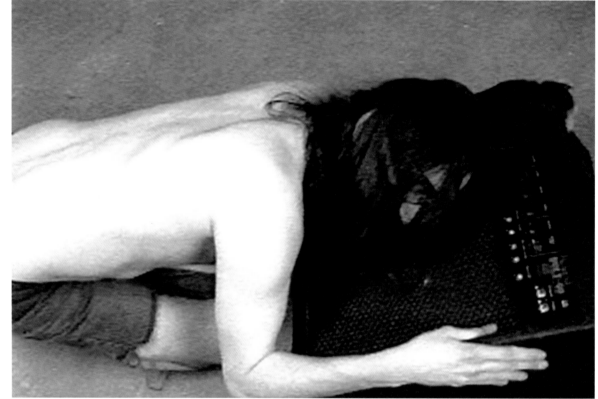

Still from *You're Pretty*, 1999. Video, color, sound; 36 sec.

Anne Marie Schleiner, Brody Condon, and Joan Leandre (the "Velvet-Strike" team)

Anne-Marie Schleiner
Born 1970, Providence, RI; Lives in Boulder, CO

Brody Condon
Born 1974, Tuxpan, Mexico; Lives in Los Angeles, CA

Joan Leandre
Born 1968, Snt. Counpalm, Spain; Lives in Barcelona

Anne-Marie Schleiner is a digital artist, computer game programmer, writer, and Internet curator whose projects explore issues of gender construction in the virtual environment, computer gaming culture, and hacker art. In addition to her interest in game design and programming, Schleiner has developed several "mods," modifications that can be inserted into the code of commercially produced games to alter the scenery, characters, or game play.

Velvet-Strike (2002) can be considered a protest mod. On a website, Schleiner has gathered dozens of "sprays"—virtual spray paint stencils to be used within the environments in the popular multiplayer Internet combat game Counter-Strike—that generate antiwar and antiviolence messages. The sprays range from a declaration asking players to "Give Online Peace a Chance" to a depiction of two male soldiers in a loving embrace. The project also includes what the artist calls "intervention recipes," which instruct players on actions and comments that may interrupt the us-versus-them competitive logic of violent games. Concerned about the increasing parallels found between computer game characters, their environments, the "war on terrorism," and real-life military exercises, Schleiner stakes out territory at a critical remove from these conflations, inveighing the hyperreality of today's militaristic games and encouraging a gaming culture that allows for a wider range of activities and emotions.

A precedent for *Velvet-Strike* can be seen in Schleiner's earlier projects. *Mutation.fem* (2000) is an online collection of female character game hacks originally created for the Museum of Contemporary Art Kiasma in Helsinki, Finland. *Cracking the Maze*, an online curatorial project organized by the artist in 1999, collected subversive game modifications and patches from digital artists and her own original patches that were distributed online. As in *Velvet-Strike*, by emphasizing the use of the game patch as opposed to the creation of an entire game, a user can deploy the patches in wider game culture, "infecting" a public sphere with their provocative messages.

Schleiner actively appropriates the (virtual) space she inhabits and uses it to spread nontraditional messages and attitudes. Delving into the constructs of computer games, the gender and racial configurations of their characters, and the notions of interactivity and addiction the games generate, Schleiner's projects open up an arena for discussion both inside and outside the "host" space of popular computer game culture. BJS

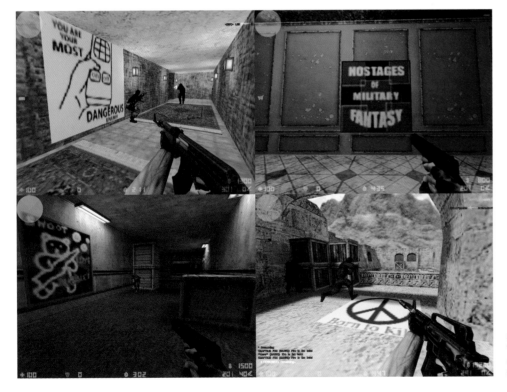

Screenshots from *Velvet-Strike*, 2002. Website, online game intervention, computer, monitor, and DVD documentation. Courtesy of the artists

James Siena
Born 1957, Oceanside, CA
Lives in New York, NY

James Siena's drawings and paintings originate from a set of artistic decisions that determine the conception, production, and context of the works. Siena continues a practice introduced by Conceptual art, and each of his works is constructed using a simple set of instructions. As Siena has stated, "When I make a painting, I respond to a set of parameters, like a visual algorithm. These structuring devices are subject to the fallibility of my hand, and my mind's ability to complete the work as planned." The instructions provide a general description of the shapes and forms to be used, and double as a literary rendering of Siena's operative process. He likens his work to that of a software programmer or, more precisely, a human computer executing a string of programs. Resulting in intensely detailed structures that run up to, but do not exceed, the edges of the support, Siena's practice unfolds in the liminal zone of written instruction and manual execution, rule and interpretation.

For *Untitled Yellow-Black* (1991), the instructions read simply: "Endless line containing black. Line made up of acute angles. No lines may cross each other." The resulting painting is a flaming whirl of jagged black form that moves across the surface like a crystalline growth, creating a stark visual contrast with the bright yellow background against which it is set. Other paintings are constructed from four nesting spirals, each originating in an approximated colored square in the center of the painting and rotating outward to the edges of the support, such as *Four Nesting Spirals* (1999–2000), or present an intricate grid of three differently colored linear lattices, carefully nested without ever touching or crossing each other, as in *Three Combs (Boustrophedonic)* (2001).

Although they are handmade, the works' diverse range of structures also resonates with a theoretical field of references. Produced by algorithms, the complex visual formations reveal the unfolding of a sequence of events and define the relationship between its constituent elements. Siena's use of intricate rules and procedures as both a structuring device for his visual compositions and as a trope for the introduction of a formal, self-referential language is informed by his concern with the history and conventions of abstract painting. Attempting to simultaneously retain the gap between conceptual instruction and manual execution, and to critically respond to abstraction's demand for a self-referential formal procedure, Siena employs diverse strategies to produce complex structures that further his personal exploration of the definitions of visual language. CR

Double Recursive Combs (red and black), 2002. Enamel on aluminum, 29 1/16 x 22 11/16 in. (73.8 x 57.6 cm). Collection of David and Nancy Frej; courtesy Gorney Bravin + Lee, New York

Amy Sillman
Born Detroit, MI
Lives in New York, NY

Working in an expressive, gestural style and deploying a palette of bright pastels, Amy Sillman explores the territory that exists between tragedy and comedy, language and the painterly mark, the conscious and the unconscious. Sillman delights in the process of painting and the aggressive gesture of applying paint to the canvas. Many of her works reveal a strong interest in narrative devices, caricature, and an archaeological layering of space.

Comprising twenty-five canvases arranged in a horizontal line, *Letters from Texas* (2003) refers to the left-to-right movement of the act of writing. Despite their linear progression, however, the canvases are not arranged chronologically. Sillman organized them compositionally, according to similarities in form, color, and line, in a manner that reflects the out-of-sequence cutting and splicing of nonnarrative films during the editing process. The works retain a loose, sketchy, calligraphic quality and function as a procession of ideas recorded through painted gestures. The pale sandy colors and intensity of light seen in the works reflect the Texas desert, where Sillman worked for a period of five months.

Also painted partly in Texas, *Hamlet* (2002) reveals Sillman's interest in novel representations of landscapes. The multiple horizon lines depicted in the work act as a nonlinear narrative device, allowing the painting to be read both from left to right and top to bottom. In the uppermost level, a town or hamlet emerges from the body of a sleeping hermaphroditic figure (with an erect phallus) whose profile is integrated into the land. For the artist, this level represents fertility, life, and hope. Cascading down from here is a colorful waterfall, dominated by bright curving lines tightly packed together, that flows into the middle passage. Sillman's use of dark blues and grays and impastoed rectilinear forms in this section evoke a dense, compacted sense of space and refer to a conflicted psychological state. The head of the figure lying at the base of the layer, his body a thin red line dividing the canvas, consists of a yellow clock face, whose disarrayed numbers allude to time in a state of chaos. In the bottom register, a third figure lies face down. The head explodes in bursts of color, representing death and decay. The three layers in the work bring to mind frames of a filmstrip. Taken together, the framed spaces suggest a physical passage from life to death, and a psychological journey from hope to despair. Oscillating between varying psychological states, the cartoonlike characters in Sillman's *Hamlet* can be seen as both tragic and comic, not unlike those in many of Shakespeare's plays, in particular the one referenced in the painting's title. AD

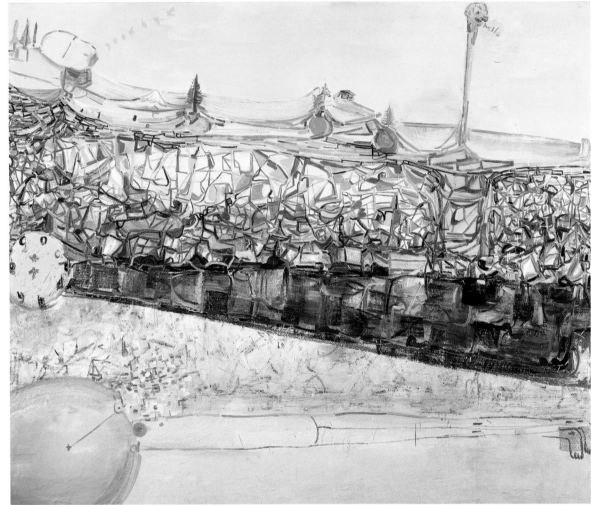

Hamlet, 2002. Oil on canvas, 72 x 84 (182.9 x 213.4). Whitney Museum of American Art, New York; purchase, with funds from the Contemporary Committee 2003.306

SIMPARCH
Founded 1996, Las Cruces, NM
Based in Chicago, IL, and Cincinnati, OH

SIMPARCH, an artists' collaborative formed by Steve Badgett and Matt Lynch, produces works operating on the borders of architecture, design, and popular culture. Creating large-scale works that take into account the specificities and histories of a given site, SIMPARCH highlights how popular iconographies and artistic and architectural languages and concerns intersect. SIMPARCH's earliest projects engaged materials and ideas from American road culture. For *Manufactured Home* (1996), built in southern New Mexico, SIMPARCH created a mobile home structure from tree branches, salvaged packaging, and other debris, merging aspects of a factory-made dwelling with materials and techniques reminiscent of the area's indigenous structures. *Hell's Trailer* (1996), built primarily with billboards recycled from a Route 66 junkyard and detailed with flaming vinyl upholstery on the interior, offers a dysfunctional parallel to the American road vacation.

In more recent projects, SIMPARCH has imported the iconography of different popular cultures into the spaces of the gallery. *Free Basin* (2000) consists of an elevated kidney-shaped skate bowl that is fully accessible to skateboarders during the exhibition. The bottom of the structure, which is built entirely of wood, appears like a carefully crafted autonomous sculpture, its shape inspired by Los Angeles skate culture of the 1970s, when empty swimming pools were used as sites for skateboarding. For *Spec* (2001), SIMPARCH constructed a barrel-vaulted tunnel from prefabricated acoustic ceiling panels and added a bench spanning the entire 72 feet of the tunnel, turning it into a communal gathering space. *Spec* was built as a showcase for Kevin Drumm's electronic music, which was composed specifically for the installation at The Renaissance Society in Chicago.

SIMPARCH's current project, *Clean Livin'* (2003), resonates with the artists' earlier interest in the myths and manifestations of the American West. The project consists of a self-contained and self-powered permanent architectural compound on the grounds of the former Tibbets Airfield in Wendover, Utah, on the state border with Nevada. During World War II, this high-desert airfield was the training ground for the *Enola Gay* and the site of numerous bombing maneuvers; currently it is used as a location for the artist-in-residency program of the Los Angeles–based Center for Land Use Interpretation. In reaction to the site's history of massive resource consumption and hazardous chemical use, *Clean Livin'* provides a facility based on "clean" energy and a moderate lifestyle for creative people in this harsh but compelling environment. Making reference to the mythical American frontier and the area's former use, *Clean Livin'* also reacts to previous examples of experimental communal living and recent scientific environments such as Biosphere 1 and 2.

Uniting all of SIMPARCH's projects is an overarching concern for the works' social potential. Ultimately acting as sites for communal interaction and social exchange, these structures infuse the languages of art and architecture with an acute desire to connect a diverse range of participants. CR

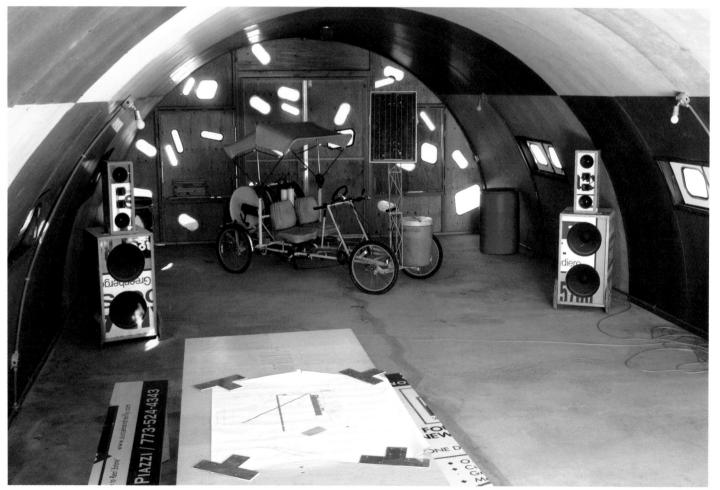

Clean Livin', 2003, facility for the Center for Land Use Interpretation's residency program, Wendover, Utah. Interior view with sound system and CLUI Rover. *Clean Livin'* is a project of Creative Capital and was developed in part at the Illinois Institute of Technology by SIMPARCH and first-year architecture students. CLUI Rover provided by municipalWORKSHOP

Zak Smith
Born 1976, Syracuse, NY
Lives in New York, NY

Zak Smith's stylized portraits and acidic abstractions intimately capture stillness in an ever-encroaching world. His work demonstrates a deconstructed neo-punk aesthetic conversant in comic book–style drawing, vivid psychedelic coloration, experimental photographic processes, and traditional draftsmanship. Using his friends and immediate environment as subjects, Smith renders scenes of youthful ambivalence amid a surplus of surrounding diversions and possessions.

Smith's work includes acrylic portraits based on scenes from his life and images created using experimental photographic techniques. Central to his work is a balance of seemingly disparate aesthetic modes. Using visual elements from painting, drawing, and photography, Smith achieves a hybrid effect that vacillates between sober realism and electrifying abstraction. *Self-Portrait for the Cover of a Magazine* (2001) shows the artist crouching in a room strewn with junk, including cassette tapes and an overturned skateboard. The juxtaposition of his disaffected persona against a painstakingly wrought mosaic background reflects the coexistence of a rebellious punk attitude with a meticulous attention to formalism. This duality continues in the relationships he creates between line and color: in *V in a Corner with a Stuffed Rabbit* (2002), which depicts his recurring muse Varrick in a cluttered bedroom, the liberal splashes of bright colors serve as counterpoint to the hard graphic edges that delineate the forms of the painting. In other works directly inspired by comic book art, such as *Life Will Not Break Your Heart It Will Crush It* (2003), Smith explores photographic portraiture by abstracting an image into geometric seriality, mimicking the panels of comic strips.

Pictures of What Happens on Each Page of Thomas Pynchon's Novel Gravity's Rainbow (2004) consists of more than seven hundred individual drawings, paintings, and photographic works assembled in a grid formation. According to the artist, these images, which range in style and compositional focus, function as visual equivalents to the book's episodic narratives and highly digressive structure. The work can be read as one large abstract composition, or in a more intimate way as elements of an open dynamic narrative. The numerous permutations of visual starting points and paths allow for multiple and simultaneous narrative formations within a discrete body. Many of these individual images have also appeared as decorative backdrops for Smith's portrait works, calling attention to a sense of play between these different modes of representation. HC

Pictures of What Happens on Each Page of Thomas Pynchon's Novel Gravity's Rainbow, 2004 (detail). Ink, acrylic, and mixed media on paper, 755 parts, each 5½ x 4½ in. (14 x 11.4 cm). Collection of the artist; courtesy Fredericks Freiser Gallery, New York

Yutaka Sone
Born 1965, Shizuoka, Japan
Lives in Los Angeles, CA

Yutaka Sone's art describes journeys to unreachable places. Through installation, sculpture, painting, drawing, video, and performance, Sone presents transcendent realms within the context of everyday life. His work offers spectacular extensions to commonplace situations, often evoking notions of the impossible and absurd. This includes video work such as *Birthday Party* (1997), which shows Sone continuously celebrating his birthday at various domestic and public sites, and *Her 19th Foot* (1995), in which nineteen unicycles in a ring are ridden simultaneously by people speaking different languages.

The idea of nomadism is important in Sone's practice. He uses journey as a metaphor to evoke emotions associated with discovering the unknown. Sone's photobook *Sculpture Garden with Gardner* (1999) documents his travels into the dense verdant jungles of Southeast Asia, where the artist hikes through the thicket with a mythical walking stick. The nature of an unrealizable place and the unpredictable role of chance are present in the logic of Sone's work. This is reflected in attempts to make visual records of distant places in *Night Bus* (1995) and the playful use of giant dice dropped from a helicopter in *Double Six* (2000).

Jungle Island (2003) represents what Sone refers to as "unknown landscapes" or environments that are unfamiliar yet connected to elements of everyday reality. The installation transforms the exhibition space into a lush miniature jungle of tropical plants in which the viewer can freely explore winding dirt paths. Hidden among the foliage are white topographical marble sculptures of Los Angeles freeway interchanges. Resembling large flowers in bloom, the immaculately carved forms of the looping interchanges take on an organic presence that transcends their otherwise mundane industrial function and urban surroundings. While physically dividing the landscape, the circuitous network of arteries feeding into the central interchange suggests an interconnectivity specific to the city. At the same time, these junctions appear unpopulated, much like the jungles Sone encounters. "I am seeking a landscape that invokes feelings of unfinished boundaries and the unknown yet includes human activity in the project," the artist has said. Inspired by the presence of such infrastructures in his daily travels in Los Angeles, Sone finds the intersections symbolically compelling in that they present pathways to extraordinary transformations in everyday subjectivities. HC

Installation view of *Highway Junction 110–105*, 2002, at the Museum of Contemporary Art, Los Angeles, 2003. Marble, 10 1/8 x 57 1/8 x 59 1/8 in. (25.7 x 145.1 x 150.2 cm). Tate Britain, London; courtesy David Zwirner, New York

Alec Soth
Born 1969, Minneapolis, MN
Lives in Minneapolis, MN

Evolving from a series of road trips along the Mississippi River that took place over a period of several years, Alec Soth's series *Sleeping by the Mississippi* captures an array of individuals, landscapes, and domestic settings that elicit feelings of isolation, longing, reverie, and a sense of eccentricity specific to the United States. Instead of being the main subject of the compositions, the river provided an organizing structure that Soth could freely explore with his curious and discerning eye. Though the pictures are conceptually related to one another, they are not narratively interdependent. Rather, the link between them is lyrical, reflecting an inspiration rooted in poetry. During the course of the project, Soth revisited the poems of Walt Whitman, James Wright, and John Berryman. The project is also informed by Robert Frank's legendary series *The Americans*. Like Frank's work, *Sleeping by the Mississippi* is a fusion of documentary and poetic styles of photography; it is elastic, unbound by a rigid conceptual framework, and it develops from a sense of wanderlust that is quintessentially American in spirit.

Soth says he is naturally attracted to people and places that embody a quiet sensibility. This is reflected in his choice of an 8 x 10 view camera—each exposure is made on an 8 x 10-inch negative—to capture his subjects and settings. The slow process involved with using this camera lends itself to the stillness and poetic quietude of his pictures, enhancing the reflective quality of his subjects. This particular camera work requires complicit subjects, making evident the sense of trust that Soth establishes with his subjects.

Whether floating on water, surrounded in lights and garlands, or old and discarded, empty beds are a recurring motif throughout the series, invoking an underlying dreaming state. "I want the sequence to feel like lucid dreaming, a kind of rambling dream which you don't quite understand, but also seems to make some sense," the artist has said. One of these beds once belonged to the aviator Charles Lindbergh and is shown tattered and stained on an anonymous blue porch. Soth, in fact, was influenced by a quote from Lindbergh's memoir *The Spirit of St. Louis*: "Over and over again I fall asleep with my eyes open, knowing I'm falling asleep, unable to prevent it. When I fall asleep this way my eyes are cut off from my ordinary mind as though they were shut, but they become directly connected to a new, extraordinary mind which grows increasingly competent to deal with their impressions." Sleep, for Soth, metaphorically alludes to a state in which the mind is free to roam, unencumbered by reason and a received set of rules—a state that encapsulates the poetic, wandering quality of his pictures. AD

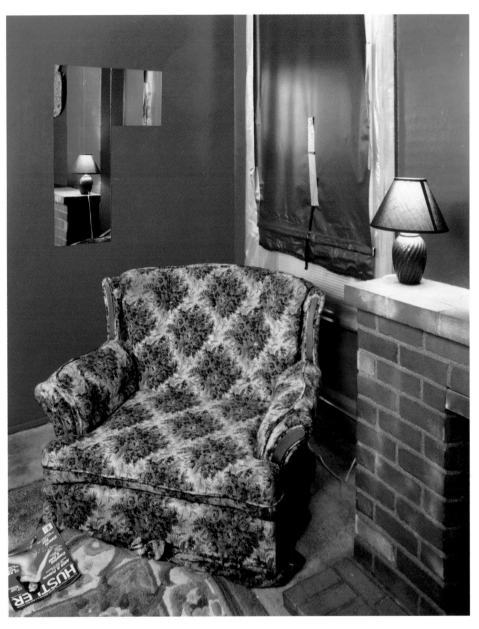

Sugar's, Davenport, IA, from the series *Sleeping by the Mississippi*, 2002. Chromogenic color print, 40 x 32 in. (101.6 x 81.3 cm). Collection of the artist; courtesy Yossi Milo Gallery, New York

Deborah Stratman
Born 1967, Washington, DC
Lives in Chicago, IL

Deborah Stratman's film *In Order Not to Be Here* suggests that suburbia is a nonplace, a sprawling, decentered aggregation of identical buildings bound together by collective aspiration and fear. An examination of suburban lifestyle, violence, and surveillance, the film opens with a night-vision shot of a police arrest, followed by an adapted quote from Thomas Aquinas: "It is not necessary to be someplace else in order not to be here." Stratman goes on to film scenes of absence: shopping centers and single-family homes at night, almost completely devoid of people. A soundtrack of police broadcasts, sirens, and a car alarm eerily punctuates the empty scenes, intensifying the expectation that violence is going to intrude into the nocturnal silence at any moment.

The filmmaker portrays the suburban topology with pensive detachment. Her flashlight encircles the front of a house, illuminating doorway, windows, and roof, and shines on the entries to gated subdivisions. The suburbs stand for a lifestyle associated with comfort, affluence, and, perhaps most important, shelter from the dangers of the city. Stratman draws on the fear that this security is under a constant threat. Her cool surveillance of the nocturnal terrain suggests that underneath their pristine surface the suburbs themselves may be the breeding ground of horrific violence and perversion.

At one point, Stratman inserts into the work a shot of a rotating surveillance camera and bits of black-and-white scenes of empty hallways inside a building. As in her filmed footage, the camera here captures emptiness. It is waiting for something to happen. Whether the danger is real or imagined, Stratman suggests that safety comes at a price, subtly raising questions of privacy breached and civil liberties eroded.

In its spectacular 7-minute closing shot, the film suddenly shifts modes from ominous calm to criminal episode. Stratman stages a manhunt filmed from a helicopter in ghostly night-vision green. The fugitive sprints across a residential lawn, crosses a highway, and continues to run through open fields. While the sequence is accompanied by a radio broadcast reporting a suburban arson incident, the reasons for this hunt remain unclear. Trailed by the helicopter and filmed from above, the running man appears increasingly like a David facing a Goliath. When the camera ultimately loses sight of him as he jumps into a river, the scene registers almost like a victory, vividly illustrating the extent of uneasiness conveyed by the film's ubiquitous surveillance. HH

Still from *In Order Not to Be Here*, 2002. 16mm film transferred to video, color and black-and-white, sound; 33 min.

Catherine Sullivan
Born 1968, Los Angeles, CA
Lives in Los Angeles, CA

Trained in both acting and visual art, Catherine Sullivan works simultaneously in the theater and the gallery space. As an acting student she created original theater pieces that she wrote, designed, and directed, and later as an art student she incorporated video and photography into her practice. Through her long-standing association with fringe theater in Chicago and Los Angeles, she continues to work on theater and performance projects, which often accompany her exhibitions in galleries and museums.

'Tis Pity She's a Fluxus Whore (2003), a two-screen film installation, exemplifies Sullivan's approach. First presented at the Wadsworth Atheneum Museum of Art in Hartford, Connecticut, the dual projection documents a restaging of two events: a performance of John Ford's seventeenth-century Restoration play, presented at the Wadsworth in 1943, and a 1964 Fluxus performance festival held in Aachen, Germany. Sullivan's actors were filmed in the same locations as the originals, but in reverse: her Fluxus artists were filmed in Hartford and the Fordean protagonists in Germany. This gesture

recalls Bertolt Brecht's work and makes literal the artifice of theatrical space.

Five Economies (big hunt/little hunt) (2002) incorporates a kaleidoscopic array of acting styles and scenes from well-known films. big hunt draws on the films Whatever Happened to Baby Jane?, The Miracle Worker, Persona, Tim, and Marat/Sade; the real-life story of Birdie Jo Hoaks, a woman who disguised herself as a young boy in order to collect welfare benefits; and the tradition of Irish wake amusements, in which participants would often play physically rough games with each other. Each was chosen to illustrate Elias Canetti's claim, in Crowds and Power, that power relationships stem from humans' past as both hunter and prey. Actors chosen by Sullivan, filmed in black and white, randomly switch roles as the vignettes slide by, variously communicating hysteria, melancholy, or stoicism solely through silent physical gesture, never producing a final narrative resolution.

In little hunt, the actors and styles are relatively static; an overweight male trained as a ballroom dancer stands across a tennis court from a female

postmodern dancer. However, the setting and the sense of time are askew, as the actors navigate a selection of props from Les Misérables and daylight and nighttime abruptly flip-flop during the film. The vivid interaction between big hunt's actors is counterbalanced by the relative isolation of those in little hunt.

By rendering multiple permutations of each scene, assigning several actors to the same lines, and choosing source materials that are already part of a cultural lexicon, Sullivan atomizes the "total experience" usually offered in a theatrical production. Picking up the pieces and interrogating them, she emphasizes repeated acts of transformation and the uncertainty they generate. BJS

Still from Ice Floes of Franz Joseph Land, 2003. Five-channel video installation, 16mm film transferred to video, black-and-white, sound; screens 1–4: 20 min.; screen 5: 40 min. Collection of the artist; courtesy Metro Pictures, New York

Eve Sussman
Born 1961, London
Lives in Brooklyn, NY

Eve Sussman's work originates from her fascination with simple gestures and casual expressions, which she observes, captures, and stages in videos, films, installations, and photographs. Often Sussman uses Super-8 cameras and simple, low-tech surveillance equipment to gain access to the situations to which she is drawn. She makes reference to both scientific methods of long-term observation common in zoological and anthropological studies and the cinema vérité tradition in filmmaking.

For her installation *Ornithology* (1997), Sussman presented live-feed footage of pigeons in an airshaft behind the gallery where the work was shown. Wall-sized projections of pigeons observed from an extremely near vantage point both monumentalized the much-maligned bird and revealed a previously unknown economy of gestures. Additionally, a birdwatching tower in the airshaft was accessible to

visitors via a ramp through the window. Once outside, the viewers equally became subjects under surveillance, to be studied along with the birds in the video projections. For *How to Tell the Future from the Past* (1997), presented at the 1997 Istanbul Biennial, Sussman wired the entire Serkeçi train station with surveillance cameras and combined the live-feed video with narratives in Turkish and English. The synthesis of the live imagery with the stories created hybrid moments in which the action happening in the present became illustrations for the recounting of the past.

Making forays into narrative, Sussman became interested in how the seemingly untouched reality of cinema vérité and the controlled operations of scripting and choreography overlap and collide. In her short film *Mop Day After (Solace)* (2001) she combined domestic documentary footage, shot during

the days immediately following September 11, 2001, with a staged video of the soprano Kati Agocs singing Henri Purcell's *Music for Awhile* to a group at a breakfast table who are oblivious to the singer.

Sussman's most recent work, *89 Seconds at Alcazar* (2003), takes Diego Velázquez's famous painting *Las Meninas* (1658) as a point of departure. Restaging the situation leading up to the moment depicted in the painting, *89 Seconds at Alcazar* presents an imagined unfolding of minute movements. By linking the singular moment of the painting with a continuity of events, Sussman constructs a chain of images that unhinge the scene from its iconographic imprisonment in art historical discourse. Considered a seminal work of art history for its complex and sophisticated layering of framing operations, *Las Meninas* becomes visually and temporally framed in Sussman's work. CR

Eve Sussman (in back) with members of the cast and crew of *89 Seconds at Alcazar*, 2003: (left to right) Richard Tabnik, Walter Sipser, Jeff Wood, Karen Young, Zachary Mills, Andrea Huelse, Erin Kaleel, Jen Heck, (in front) Sofie Zamchick, and Helen Pickett

Julianne Swartz
Born 1967, Phoenix, AZ
Lives in New York, NY

Julianne Swartz creates site-specific sculptural interventions in typically underutilized architectural spaces. Her installations integrate elements such as sound, light, fans, optical devices, and linear strands that unify the disparate components of a particular site. Swartz adeptly transforms everyday space into something extraordinary and unexpected, turning stable structures into ethereal, ambiguous environments. Infusing vitality into mundane objects, Swartz thrives on the fulcrum between the fragile and the structurally sound, between the poetic and the prosaic. She achieves this balance through an economy of select materials and processes.

In *Line Drawing* (2003), a site-specific installation at Artists Space in New York, Swartz bored small, circular holes in the wall of the gallery—an act that calls to mind the work of Gordon Matta-Clark, one of the first artists to deconstruct an architectural structure. By inserting lenses, mirrors, and PVC pipes into these holes, Swartz produced provocative portals that distorted the spaces visible on the other side of the wall. A continuous blue line threaded through the gallery and unseen spaces behind the walls focused the viewer's sight on distant, out-of-reach places while linking the isolated areas of the gallery. As the blue line continued through hallways, bathrooms, offices, and exhibition galleries, it merged public and private spaces, rendering transient, illusory visions within commonplace reality.

For the 2004 Biennial, Swartz takes as her site the Whitney's winding, six-story stairwell. Swartz anchors her project in a remote crawl space (previously known only to the museum's engineers) located on the landing between the third and fourth floors of the museum. The hidden space is visually excavated with brilliant light, while speakers inside emit a cacophony of voices humming "Somewhere over the Rainbow," that familiar utopian song of longing and transcendence. The discordant sounds emanating from the piping heighten the evanescent quality Swartz manages to elicit from a site that is inextricably grounded in the real. As visitors descend and ascend five flights of stairs, they encounter different voices at varying volumes, carried through strategically placed tubes that cascade down through the stairwell from the crawl space. Swartz visually and sonically transforms the Whitney's stairwell through her imaginative exploration and beckons the viewer to an isolated, forgotten area of the building's structure. AD

Corridor Transfer #3, 2002. Site-specific installation at the Center for Curatorial Studies, Bard College, Annandale-on-Hudson, New York. PVC pipe, mylar, mirror, lenses, pinwheel, fan, and light, dimensions variable. Courtesy Christinerose/Josee Bienvenu Gallery, New York

Erick Swenson
Born 1972, Phoenixville, PA
Lives in Dallas, TX

Erick Swenson creates meticulously detailed sculptures of animals that do not exist. His apes, sheep, and deer—rendered at the wrong scale, given human qualities, or otherwise off-kilter—and fantasy hybrid creatures populate a world created by impossible or undiscovered branches of the evolutionary tree. Swenson makes molds from handmade clay models that are then cast in polyurethane resin and hand-painted. He tweaks the verisimilitude of sculptors like Duane Hanson and Ron Mueck, both of whom render human figures with utmost precision: Swenson's hyperrealism, based on his studies of anatomical books and skeletal models, shies away from these artists' depictions of an "everyman" in favor of more dramatic qualities.

Earlier installations placed several of Swenson's creations in constructed environments, conjuring the sense of a natural history museum diorama gone awry. For the 1998 exhibition *Obviously a Movie*, he set a group of animals—two apes outfitted in hiking gear, a foxlike creature, and a poodle-horse hybrid—on rocky outcroppings, gazing across the room at each other as artificial snow gently blanketed the scene. A movie set is suggested by the fact that the viewer is able to take everything in, including the rotating PVC pipe punctured with holes that generated the "snow." The exhibition title and the imaginary narratives set in motion by the works' juxtaposition further the references to cinema: the protagonists could have been created by a special effects studio.

Recent sculptures compress the story-line potential into a single pregnant moment: in one, a young buck, legs awkwardly spread and rear end up in the air, rubs its antlers against a fabricated oriental rug in an attempt to remove their velvet. Nature and culture meet in this factitious creation: the intricate patterning of the rug is eroded where the antlers touch it. This frozen motion is distinctly animalistic—bucks shed the velvet from their antlers every autumn in anticipation of sparring—yet delicate and touching in a way that evokes empathy normally reserved for humans.

In another series, small, white, hairless fawns are swept off their feet by oversize opera capes that wrap around their legs and tails. They evoke a range of cultural associations: whimsical Bambi cartoons and capricious fairy tales come to mind. They are delicately balanced on one leg and set by themselves in the gallery, fighting tiny battles all alone in the unending tug-of-war between nature and culture. Swenson's unique blend of quirky science, labor-intensive verisimilitude, and artistic freedom makes a compelling case for both sides of the equation. BJS

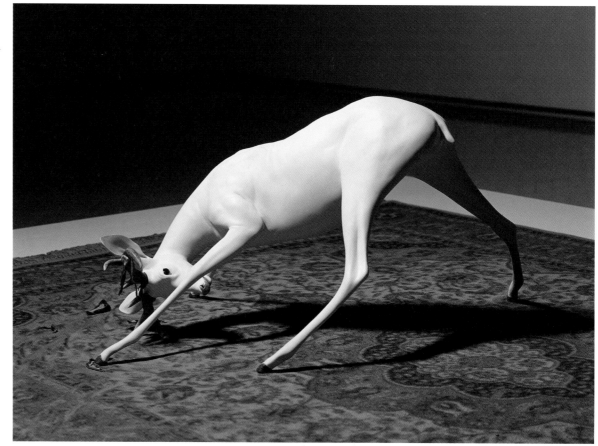

Installation view of *Untitled*, 2001 (detail), at the Museum of Contemporary Art, Sydney. Polyurethane resin and acrylic, 26 x 132 x 84 in. (66 x 335.3 x 213.4 cm). Cooper Family Foundation; courtesy James Cohan Gallery, New York, and Angstrom Gallery, Dallas

Fred Tomaselli
Born 1956, Santa Monica, CA
Lives in Brooklyn, NY

A central figure in the Californian 1970s counter-culture scene of punk rock and hallucinogenic drugs, Fred Tomaselli began producing his signature two-dimensional works—drawings, collages, photomontages, and paintings—in the late 1980s. The large-scale drawing *Every Rock Band I Can Remember Seeing, Every Vertebrate That Has Become Extinct Since 1492* (1990) is split in half and presents what the title describes. On the left, the names of animals are registered in white below different-sized haloes, and on the right, the names of rock bands are inscribed along a network of lines akin to the diagrams of celestial constellations. Reminiscent of both schematic representations of starry skies and personal charts, the drawing brings together two important elements of Tomaselli's work: his personal experience, history, and influences, and an investigation into perceptions and representations of nature.

Tomaselli arranges pills, leaves, insects, and cutouts of animals and body parts into deliriously multifaceted patterns and ornate floral designs. He often incorporates drugs—over-the-counter medicine and prescription pharmaceuticals, as well as street drugs and marijuana leaves—into his compositions, with the patterns and designs of their arrangement suggesting the expanded fields of perception and the heightened visual experiences induced by their consumption. The work *Ripple Trees* (1994) features a seemingly infinite pattern of intersecting circles of white pills, arranged around different designs of multicolored pills and marijuana leaves, set against a painted background of trees at dawn. For *Gravity's Rainbow* (1999), Tomaselli created hundreds of chains of pills, leaves, flowers, real insects, and collaged photo cutouts of little hands, feet, mouths, and eyes that cascade from the top of the painting to form a dense mesh of multicolored, intersecting "necklaces."

In his most recent works, Tomaselli has expanded his compositional technique, moving away from pattern-based works to more figurative compositions, using tiny photocollage elements. *Field Guides* (2002) shows a nighttime scene of a human figure plowing a field, seemingly attacked by (or merging with) a swarm of butterflies. Both field and background landscape are painted, but the figure is composed of a multitude of individual elements from anatomical reference books: mouths, muscles, and internal organs. *Us and Them* (2003) uses a similar technique, presenting an Adam and Eve scene next to a tree against a night sky.

These works highlight the underlying concern of Tomaselli's artistic practice, which has often been obscured by the reception of his drug-related works: a continuing inquiry into the different philosophies and representational strategies by which nature has become part of culture. Tomaselli has said: "The history of the American landscape was the imposition of utopian belief on nature and the perception of nature is always deformed by ideology." His hybrid compositions expose their artificiality while simultaneously hinting at a different, and possibly more visionary, universe. CR

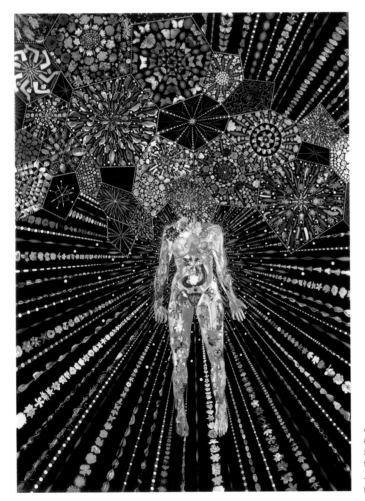

Airborne Event, 2003. Mixed media, acrylic, and resin on wood, 84 x 60 (213.4 x 152.4). Lent by the American Fund for the Tate Gallery and the collection of John and Amy Phelan, fractional and promised gift

Tracy and the Plastics

Wynne Greenwood
Born 1977, Seattle, WA
Lives in Brooklyn, NY

Tracy and the Plastics is a low-fi art punk band from Washington State consisting of members Tracy, Nikki, and Cola. All three are alter egos of Wynne Greenwood: when the band performs live, Greenwood assumes the role of bandleader Tracy, while Nikki and Cola are present only as video projections. The audience is treated not only to music, which Tracy produces on drum machines and an array of keyboards, but the interaction between Tracy and her videotaped counterparts.

A Tracy and the Plastics performance is full of disjunctions: between video and live actor, the var-ied personalities of the band members, and the expected smoothness of the show and its unavoid-able technical difficulties. The result is a sometimes entrancing, sometimes confusing, weirdly enter-taining experience. Greenwood rarely steps out of the character of Tracy onstage, and her interaction with her video companions is disarmingly sincere.

The Plastics originated as characters in a choose-your-own-adventure mystery that Greenwood was writing. The characters' ability in that setting to rearrange and rebuild their world according to their own desires led the artist to flesh them out to varying degrees in real life. The band updates the early-twentieth-century tradition of accompany-ing films with live music. Originally, the music attempted to respond to and emphasize the action on screen; Greenwood, on the other hand, fuses sound and image in an attempt to make video an interactive medium. She has created a cyborg band, part video and part person, that challenges the domination of conventional modes of performance in American culture, especially mass media. BJS

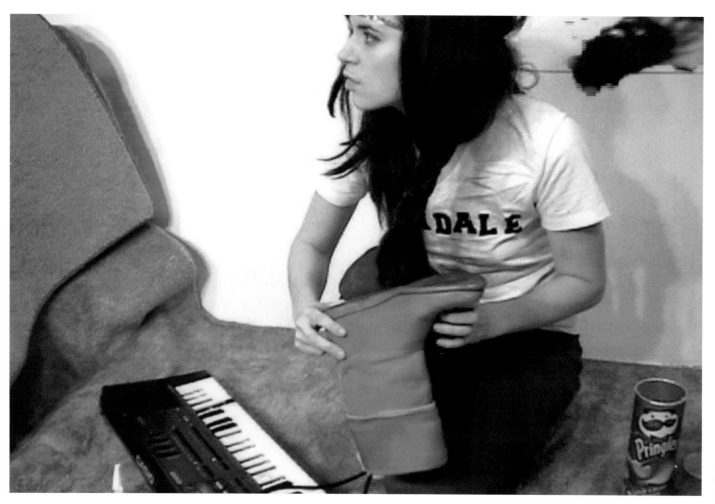

"Nikki swats a fly, makes up a guitar part."
Still from *We Hear Swooping Guitars*,
2003. Video, color, sound. 14 min.

Jim Trainor
Born 1961, Philadelphia, PA
Lives in Chicago, IL

Jim Trainor's animations blend whimsical humor with the bizarre or macabre. Often scatological and explicit, with a deadpan wit, his films typically depict animals or plants (Trainor is a birdwatcher and an avid reader of nature and science books). He works with felt-tip pens and typing paper, choosing not to "register" his drawings, the method by which animators fix each image in front of the camera in an identical position. As he traces each individual drawing off the preceding one with thick markers, little inaccuracies manifest themselves, resulting in subtle movements on the screen. The shapes, lines, and dots in Trainor's animations quaver and bounce, usually against backgrounds of uniform color. While the films have an apparent technical simplicity, his working methods are exacting and painstakingly slow; he completes only about six minutes of finished film per year.

The Bats (1998) and The Moschops (2000), two short films narrated from the perspective of the respective animals, are drawn in his characteristic style of minimal lines on black or white. The protagonist of The Bats tells the story of a life governed by instinct: "Each spring, I looked forward to having sexual intercourse. I loved to comb myself and defecate and drink water." Depicting a species from the Permian period, the eponymous creatures in The Moschops also defecate, copulate, and are driven to actions they don't understand. Unlike most animation using animals, Trainor does not anthropomorphize his subjects. Rather, he emphasizes the creatures' strange otherness, while shrewdly hinting at the ways in which humans are perhaps not so very far removed from them.

In The Magic Kingdom (2003), Trainor departs from his earlier work by mixing live-action with animated sequences. The camera records captive primates, as well as a hippo, a tapir, and an anteater in the zoo as the animals climb on trees, groom themselves, or doze in their artificial environments behind walls or glass. The film mimics conventions of the traditional nature documentary, slyly portraying imported exotic plants, re-created habitats, and naturalistic painted backdrops as though they were a slice of nature. Interspersed are brief animated sequences resembling schematic diagrams, abstract compositions of wobbly dots and lines that seek to evoke the animals' own unarticulated perception of the physical limits of their world. The stylized animations draw further attention to the artificiality of the zoo environment while the documentary nature of the live-action footage is transformed into a melancholy reflection on captivity. HH

Stills from The Magic Kingdom, 2003.
16mm film, color, sound; 7 min.

Tam Van Tran
Born 1966, Kontum, Vietnam
Lives in Redondo Beach, CA

Tam Van Tran's artworks extend the boundaries of both painting and drawing, using a range of materials and techniques to create abstract compositions whose references sweep from the microscopic to the boundless. His earlier paintings were acrylics on canvas; more recently, he has placed a greater emphasis on materials, using crimped paper, staples, hole punches, and pigments infused with organic matter such as chlorophyll and spirulina to create works that often feature wavy protrusions, lending them a sculptural presence.

The combination of natural and industrial materials parallels the associations most visible in Tran's works. Earlier works emphasized fragmented grids of acrylic connected by thin lines, set against uniformly colored backgrounds, which were inspired by traditional Chinese landscape painting yet evoked computer networks, city plans, and futuristic architectural structures. More recent works, including an ongoing series of large-scale drawings collectively titled *Beetle Manifesto*, eschew the space-age references for an intimate focus on organic matter, conjuring forests, leaves, and microscopic views of cells. For these latter works Tran draws on large swaths of paper that he cuts into thin strips and then sutures back together with thousands of staples; irregularities in the labor-intensive process often warp the artwork and push his drawings into the third dimension. The arcing tracks of holes punched into the paper appear as if they were made by the mouths of the insects implied in the title.

The use of natural materials offers Tran a back-door entry to natural references, while his art remains engaged with issues of abstract painting. He sees that the filigreed lines of connectors on a computer chip are visually similar to human veins or those of leaves. He shifts back and forth between the industrial and the organic, the abstract and the representational, and the delicate and the roughly handmade, holding them all in a productive tension. BJS

Beetle Manifesto IV, 2002. Chlorophyll, spirulina, pigment, staples, binder, aluminum foil, and paper, 92 x 91 x 12 in. (233.7 x 231.1 x 30.5 cm). Collection of the artist; courtesy Cohan and Leslie, New York

Banks Violette
Born 1973, Ithaca, NY
Lives in New York, NY

Banks Violette investigates the seductive artifice of evil and its physical manifestations beyond the recesses of the American psyche. Employing the dark, stylized iconography of subcultures such as heavy metal music, he draws on the aestheticized imagery of death, fascism, and the satanic occult that often fuel gothic teen fantasies. At the same time, he reveals a culture of adolescent alienation and nihilism directly embodied in these fantasy narratives.

Violette's work documents cultural moments in which actual events are animated by an intense belief in fictional imagery and the perceived lifestyles it represents. This includes fulfilling archetypal narratives associated with rock martyrdom or performing prescribed cult rituals. His work *Arroyo Grande 7-22-95* (2002) is a memorial to the ritual murder committed by three California teenagers in the eucalyptus groves of Arroyo Grande, California, in 1995. All aspiring members of a heavy metal band, the boys abducted a female classmate and stabbed her to death as an offering to Satan in hopes of fame for their group. Later the killers admitted that they were fixated on the well-known

band Slayer and were acting out in a way they felt was justified by the group's songs. *Arroyo Grande* presents two obsessively crafted installations: one inspired by Slayer iconography that represents the teenage criminals, and the other an homage to the slain girl that includes a white unicorn sculpture, *Ghost* (2002).

Violette's most recent installation evolves around the culturally resonant narrative of Nirvana band leader Kurt Cobain's suicide. Each element of the monochrome installation refers to the archetype of self-destruction in rock music as the ultimate sign of devotion. Five black-and-white X-ray-like drawings, which depict horses running, theatrical spotlights, and Cobain passed out on stage, partially obscure a large wall drawing of metal band Judas Priest's linear graphic logo. An epoxy scaffold stage occupies the center of the installation on which the abstract remnants of a destroyed drum set are scattered among sprouting black cone-shaped stalagmites. Violette considers Cobain's suicide part of a devotional mandate set forth by rock music, which also propelled the early death of legendary drum-

mer Keith Moon and teen suicides by Judas Priest fans. Beyond appropriation, the artist explores how these symbols become ritualistic emblems for groups of disenchanted youth. His work materializes these ruptures in mainstream society where fiction manifests itself as reality. HC

Untitled (model for a future disaster), 2003. Steel, drum hardware, polystyrene, polyurethane, and tinted epoxy, 33 x 48 x 48 in. (83.8 x 121.9 x 121.9 cm). Over Holland Collection; courtesy Team Gallery, New York

Eric Wesley
Born 1973, Los Angeles, CA
Lives in Los Angeles, CA

Eric Wesley's installations, drawings, and sculptures draw upon the rich and complex cultural realities of contemporary America, while retaining a confident, at times mockingly aggressive relation to the conventions of the art world. Often, Wesley's works appear as clandestine or malevolent, disguised attacks on the expectations of the viewer. His installation *Kicking Ass* (2000) illustrates the artist's playful refusal to accept the conditions of the white cube as the canonical space in which to present art. The installation consists of a full-scale mechanical donkey that has kicked through the white wall behind it, leaving a gaping hole. For exhibitions in Turin and New York, Wesley installed a mock bomb manufacture disguised as a paint shop and a black market tobacco production facility, respectively. In *OUCHI* (2002), Wesley installed cleanly stacked metal cans of house paint in the front gallery, along with signage common for industrial showrooms; in the back room, tools and machines used to place explosive material within metal containers were prominently displayed. And for *New Amsterdam* (2002–03), he fabricated a compact manufacturing unit for tobacco products, complete with germination unit, growing beds, and drying boxes, while other parts of the gallery space were devoted to the rolling, packaging, and promotion of his brand of cigarettes. For a 2002 exhibition in Karlsruhe, Germany, Wesley constructed a high-tech cooking facility designed to produce an endless burrito. Disguised by a vaguely Spanish-colonial facade of three arched doorways and placed behind a false wall on an elevated platform, the kitchen consists of a multilevel apparatus with gas burners, a funnel system, and rolling work space.

Another series of works presents watercolors of seemingly idyllic underwater scenes, featuring SCUBA divers exploring coral reefs, vegetation, and schools of fish. Titled *Settle out of Court* (2003), with each individual sheet bearing the name of a state, such as *TX*, *NJ*, and *NM*, the series is far from innocent. Originating from a joke that asks: "What do you call fifty lawyers on the bottom of the sea?" (answer: "A good start"), the images are based on photographs that portray attorneys during a SCUBA vacation. In funny, crude, and sometimes mockingly naïve depictions, the watercolors seem to pit man against nature, while the title suggests an ironic reading. Although Wesley's works initially seem tied to international and conceptual aesthetics prevalent in the last decade, they are in fact connected to location-specific, politically ambivalent situations. Whether he infuses a firmly conceptual installation with the context of Latino culture in Los Angeles, makes reference to the anarchistic tradition of postwar Italy, or proposes a riff on the tightened tobacco legislation in New York City, Wesley's works register unease with their site of exhibition without ever being openly disruptive. CR

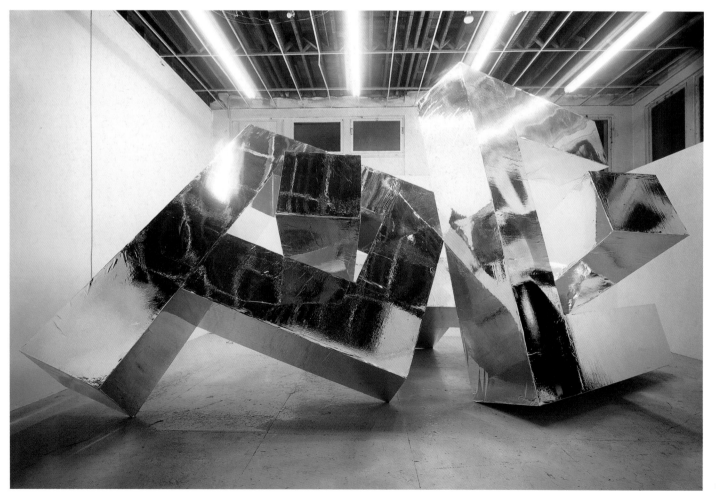

PYC Corporate Icon, 2003. Wood, cardboard, and mylar, 144 x 228 x 348 in. (365.8 x 579.1 x 883.9cm). Collection of the artist; courtesy PYC/CAOG

Olav Westphalen
Born 1963, Hamburg, Germany
Lives in Brooklyn, NY

A comic skewering of the cultural absurdities of everyday life, current events, and the intellectual pretensions of the worlds of critical theory, science, and art unifies Olav Westphalen's practice. In drawings, sculptures, videos, and performances, Westphalen displays a canny understanding of how cultural texts and objects are received. His art freeze-frames the moment of perception in order to give the viewer an opportunity to see it from multiple perspectives. Westphalen does not emphasize verisimilitude with his sculptures and props: he will use a humble material if it manages to convey his intended meaning. The artist's low-tech approach clues the viewer in to the fact that he is not afraid to laugh at his own inadequacies.

Westphalen has recently sculpted the imagined arrest scenes of corporate executives. One, when viewed from the front, appears to be simply a painted wood carving of a man in a well-fitting suit, his hands clasped behind his back. It is only when you walk to the rear of the sculpture that you notice a pair of handcuffs binding his wrists. Here Westphalen has rendered a news photograph of an Enron executive in three dimensions, documenting a new type of criminal whose notoriety is unique to our moment. In *Erfahrungswerte* (1994), Westphalen used a video camera to record scientifically useless "reflexology studies" in a museum room decorated to resemble a doctor's office. Each visitor was interviewed while a grid was drawn on his or her right foot and a "scientist" pressed each of the grid's fields in succession. Westphalen later presented the study's findings in a deadpan academic-style public lecture. His drawing series *Roadside Signs* (1998–99) comments on the popularization of French critical discourse in America by repositioning key authors as nothing more than a name adorning suburban neon business signs.

Westphalen's past as a television comedy writer and political cartoonist in his native Germany shines through in the works' visual economy: no detail wavers from its support of the concept. The aim of a joke is to provide closure in the form of laughter. Westphalen chooses instead to sustain the ambiguity, causing baffled amusement as often as an audible giggle.

Westphalen's *Extremely Site-Unspecific Sculpture* (2000) has three independently telescoping legs, a lightweight polyurethane body designed for flotation, and a solar panel, all of which give it complete independence from context. Its nonjudgmental critique of ubiquitous site-specific installations is compressed into the four words of its title. With little description offered by the work's title, viewers come up with a range of interpretations—from reified art object to CIA spy satellite—for the vaguely robotic object. Westphalen describes the E.S.U.S. as "friendly but indifferent," words that also sum up his role as an irreverent but gentle art world provocateur. BJS

Statue (seated), 2003. Polystyrene, resin, and tempera paint, 55 x 36 x 30 in. (139.7 x 91.4 x 76.2 cm). Private collection; courtesy maccarone inc., New York

Statue (seated), 2003 (detail)

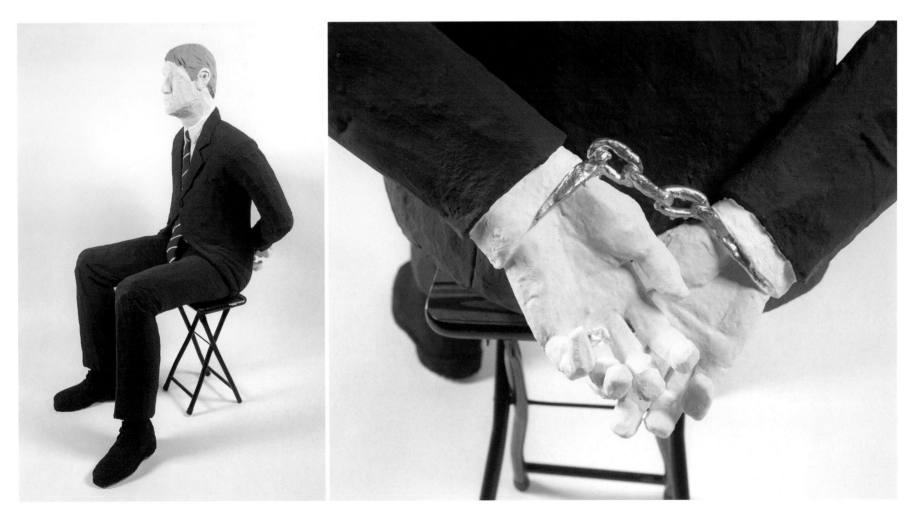

T. J. Wilcox
Born 1965, Seattle, WA
Lives in New York, NY

The common thread running through T. J. Wilcox's films is perhaps cinephilia itself. In addition to composing his short works of live-action footage, traditional stop-frame and digital animation, and material rephotographed from a television monitor, Wilcox culls from archival, newsreel, and found footage. Shot on Super-8 stock, the films are then transferred to video for editing, and finally printed onto 16mm film for projection. As a result of the transfers the films' colors shift, causing them to attain a grainy, worn texture that appears simultaneously antiquated and timeless. "At the labs they think I'm losing image," Wilcox says, "but I always feel like I'm gaining something new with each step in the process." His films are typically silent and subtitled, projected in the white cube of the gallery, where they are accompanied by the whirring sound of the 16mm film projector. According to the artist, the short distance between the projected image and its source "activates" the space between, creating an almost sculptural, three-dimensional experience.

His most recent series, *garlands*, consists of twelve short episodes in three films that create a fleeting collage of memoir and anecdotal incident. *Ann* commemorates the artist's stepmother, "the first innately cool person [he] had ever met." Dying at age 42, she asked that her ashes be spread in several different places. These are documented in Wilcox's film, alongside photographs of the vibrant Ann herself. Ara Tripp's successful protest against "decency" laws is chronicled in another episode. A transsexual and gender activist, she climbed on top of a power line with bared breasts, and did not leave until she voluntarily gave herself up to the police. *Fraise des bois*, a stop-frame animation of a group of German wood figurines against a background of wild strawberry plants, and the humorous *How to Explain the Ephemeral and Tenuous Character of Life to a Child*, depicting Humpty Dumpty rag dolls perched on a stone wall, refer to the imagery of childhood.

Like many of his short films, these works are suffused with a faint sense of nostalgia, which resonates not only with the way Wilcox treats his films to make them appear timeworn, but also with the intimacy of the viewing situation. Combining the genres of home movie, documentary, and animation, the short works that make up Wilcox's *garlands* map historical footnotes and personal histories to larger effect. HH

Composite image of title frames from *garland 1* (2003, 16mm film, color, silent; 8:06 min.), *garland 2* (2003, 16mm film, color, silent; 5:47 min.), and *garland 3* (2003, 16mm film, color, silent; 9:05 min.)

Andrea Zittel
Born 1965, Escondido, CA
Lives in Brooklyn, NY, and Joshua Tree, CA

Since the early 1990s, Andrea Zittel has researched, designed, and remodeled her own domestic environments, which serve as the model and test case for all of her experimental living structures. Under the heading of A–Z Administrative Services, Zittel began designing her series of *A–Z Living Units* (1991), domestic prototypes that could be customized for different owners and situations. These mobile and operable modular structures combine the elementary functions of domestic living—sleeping, cooking, personal hygiene, paperwork—into one compact design. Each year a new model of the *Living Units* was produced and the eventual owners were encouraged to further adapt or modify each unit to suit their own needs and tastes. In 1995, Zittel started traveling back to her home state of California and began to design more mobile and suburban-inspired units, such as *A–Z Travel Trailer Units* (1996) and *A–Z Escape Vehicles* (1997). The *A–Z Escape Vehicle*, a small portable capsule that could be parked in the living room or the backyard, proposed a new model of recreational vehicle that facilitated the owner's ultimate escape fantasy.

For the exhibition *Sculpture Projects Münster* in Germany, Zittel created *A–Z Desert Islands* (1997), a series of artificial islands that floated in a lake, and in 1999, the artist fabricated a hollow concrete island with the interior of a house built inside it off the coast of Denmark, which she inhabited for a month.

A–Z Cellular Compartment Units (2001), built for the Ikon Gallery in Birmingham, England, explored the increasing compartmentalization of urban architecture by creating a cluster of interlocking chambers that turn a one-room apartment into a "luxury apartment" with ten rooms, each with its own specific function, such as library, gym, dining room, and den. Zittel's most recent project originated from the purchase of a small 1930s homestead and 20 acres of land in Joshua Tree, in California's high desert. Zittel uses the house and the isolated property, which she named A–Z West, to further expand her research into the possibilities and material conditions of her designs. For wall and ceiling panels, Zittel pulped and reprocessed paper trash and cast it to make forms that can dry

in the desert heat, while for her clothes she devised a simple rectangular sheet of cloth, kept together with safety pins, and hand-processed felt dresses. Alluding to such utopian experiments as the German Bauhaus or the Russian Constructivists and their desire to merge all facets of art and life, as well as the quintessentially American traditions of automobility and mobile-home living, Zittel's work inhabits both the history of art and the lessons of home economics. **CR**

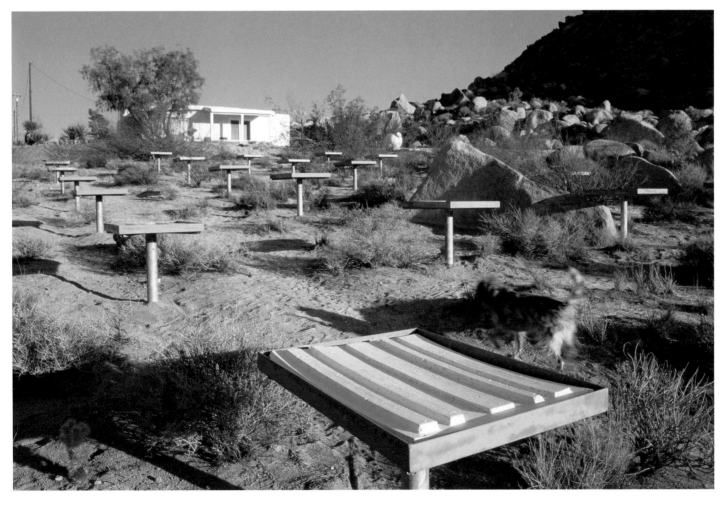

The A–Z Regenerating Field, 2002. Twenty-four galvanized-steel drying racks with vacuum-formed styrene inserts, and paper pulp made from household paper waste, dimensions variable. Courtesy Andrea Rosen Gallery, New York, and Regen Projects, Los Angeles

works in the exhibition*

*as of January 15, 2004

Dimensions are in inches followed by centimeters; height precedes width precedes depth.

Marina Abramović

Count on Us, 2003
Video installation, dimensions variable
Collection of the artist; courtesy Sean Kelly Gallery, New York
Funded by the Contemporary Art Museum, Kumamoto, Japan

Laylah Ali

Untitled, 2004
Gouache on paper, 27 x 35 (68.6 x 88.9)
Courtesy 303 Gallery, New York

Untitled, 2004
Gouache on paper, 27 x 35 (68.6 x 88.9)
Courtesy 303 Gallery, New York

Untitled, 2004
Gouache on paper, 27 x 35 (68.6 x 88.9)
Courtesy 303 Gallery, New York

Untitled, 2004
Gouache on paper, 27 x 35 (68.6 x 88.9)
Courtesy 303 Gallery, New York

David Altmejd

Delicate Men in Positions of Power, 2003
Mixed-media installation, 120 x 240 x 96 (304.8 x 609.6 x 243.8)
Collection of the artist

Untitled (Blue Jay), 2004
Fiberglass, resin, hair, and crystals, dimensions variable

Untitled (Swallow), 2004
Fiberglass, resin, hair, and crystals, dimensions variable
Both sited at the Andrew Haswell Green Memorial Site in Central Park
A project of the Public Art Fund program "In the Public Realm," which is supported by the National Endowment for the Arts, the New York State Council on the Arts, a State Agency, the City of New York Department of Cultural Affairs, the Office of the Brooklyn Borough President, The Greenwall Foundation, The Silverweed Foundation, The JPMorgan Chase Foundation, and friends of the Public Art Fund
A Public Art Fund project in the Whitney Biennial; sponsored by Bloomberg and generously supported by Adam Lindemann

Antony and the Johnsons

Turning, 2004
Performance

Cory Arcangel/BEIGE

Naptime, 2003
Hacked Super Mario game cartridge and monitor, dimensions variable
Courtesy of the artists, Foxy Production, and Team Gallery, New York
Music by Paul B. Davis [BEIGE]

Super Mario Clouds v2k3, 2003
Hacked Super Mario game cartridge, dimensions variable
Private collection; courtesy of the artists and Team Gallery, New York

The 8bit Construction Set (Cory Arcangel/BEIGE)
Rudy's Cake Walk, 2002
Sound work
Courtesy BEIGE Records

assume vivid astro focus

assume vivid astro focus 8, 2004
Mixed-media installation, dimensions variable
Collection of the artist; courtesy John Connelly Presents, New York, and peres projects, Los Angeles

assume vivid astro focus, in collaboration with Rama Chorpasm (DJ booth design)
Garden 10, 2004
Printed vinyl output, 1,476 x 576 (3,749 x 1,463)
Sited at Skaters' Road in Central Park
A project of the Public Art Fund program "In the Public Realm," which is supported by the National Endowment for the Arts, the New York State Council on the Arts, a State Agency, the City of New York Department of Cultural Affairs, the Office of the Brooklyn Borough President, The Greenwall Foundation, The Silverweed Foundation, The JPMorgan Chase Foundation, and friends of the Public Art Fund
A Public Art Fund project in the Whitney Biennial; sponsored by Bloomberg and generously supported by Adam Lindemann

Hernan Bas

Floating on the Dead Sea, with Ghost Ship Pirated by Hedi Slimane, 2003
Mixed media on paper, 30 x 22 (76.2 x 55.9)
Rubell Family Collection LTD; courtesy Fredric Snitzer Gallery, Miami

Hooked on a Feeling, 2003
Mixed media on paper, 12 x 10 (30.5 x 25.4)
Collection of Heather Urban; courtesy Fredric Snitzer Gallery, Miami

In Too Deep, 2003
Mixed media on paper, 9 x 7 (22.5 x 17.5)
Collection of Amy Cappellazzo and Joanne Rosen; courtesy Fredric Snitzer Gallery, Miami

Laocoön's sons, 2003
Mixed media on paper, 30 x 22 (76.2 x 55.9)
Collection of Stanley and Nancy Singer

Laying Back, 2003
Mixed media on paper, 11 x 10 (27.9 x 25.4)
Private collection

The Loveliest Song, 2003
Mixed media on paper, 30 x 22 (76.2 x 55.9)
Rubell Family Collection LTD; courtesy Fredric Snitzer Gallery, Miami

Shipmate (Hook Heart), 2003
Mixed media on paper, 30 x 22 (76.2 x 55.9)
Lindemann Collection; courtesy Fredric Snitzer Gallery, Miami

Underwater World, 2003
Mixed media on paper, 30 x 22 (76.2 x 55.9)
Collection of Stanley and Nancy Singer

Dike Blair

Untitled, 2002
Gouache and graphite on paper, 12 x 16 (30.5 x 40.6)
Collection of the artist; courtesy Feature Inc., New York

Untitled, 2002
Gouache and graphite on paper, 18 x 24 (45.7 x 61)
Collection of the artist; courtesy Feature Inc., New York

then, into, 2003
Fluorescent lights, carpet, color transparency (Duratrans), glass, wood, and paint, 32 x 144 x 45 (81.3 x 365.8 x 114.3)
Collection of the artist; courtesy Feature Inc., New York

Untitled, 2003
Gouache and graphite on paper, 16 x 12 (40.6 x 30.5)
Collection of the artist; courtesy Feature Inc., New York

Untitled, 2003
Gouache and graphite on paper, 10 x 14 (25.4 x 35.6)
Collection of the artist; courtesy Feature Inc., New York

Untitled, 2003
Gouache and graphite on paper, 12 x 16 (30.5 x 40.6)
Collection of the artist; courtesy Feature Inc., New York

Untitled, 2003
Gouache and graphite on paper, 24 x 18 (61 x 45.7)
Collection of the artist; courtesy Feature Inc., New York

Untitled, 2003
Gouache and graphite on paper, 24 x 18 (61 x 45.7)
Collection of the artist; courtesy Feature Inc., New York

Jeremy Blake

Reading Ossie Clark, 2003
Digital animation on DVD, color, sound; 9 min. continuous loop
Collection of Ellen and Steve Susman; courtesy Feigen Contemporary, New York

Mel Bochner

Indifference, 2003
Oil and acrylic on canvas, 45 x 60 (114.3 x 152.4)
Collection of the artist; courtesy Sonnabend
Gallery, New York

Meaningless, 2003
Oil and acrylic on canvas, 45 x 60 (114.3 x 152.4)
Collection of the artist; courtesy Sonnabend
Gallery, New York

Mistake, 2003
Oil and acrylic on canvas, 45 x 60 (114.3 x 152.4)
Collection of the artist; courtesy Sonnabend
Gallery, New York

Nothing, 2003
Oil on canvas, 45 x 60 (114.3 x 152.4)
Collection of Jill and Peter Kraus

Stupid, 2003
Oil and acrylic on canvas, 45 x 60 (114.3 x 152.4)
Collection of the artist; courtesy Sonnabend
Gallery, New York

Andrea Bowers

*Diabloblockade, Diablo Nuclear Power Plant,
Abalone Alliance, 1981*, 2003
Graphite on paper, 8 x 10 (20.3 x 25.4)
Gaby and Wilhelm Schürmann Collection; courtesy
Sara Meltzer Gallery, New York, and Chouakri
Brahms, Berlin

*Magical Politics: Women's Pentagon Action, 1981,
Detail of Woven Web Around Pentagon*, 2003
Graphite on paper, 8 x 10 (20.3 x 25.4)
Gaby and Wilhelm Schürmann Collection; courtesy
Sara Meltzer Gallery, New York, and Chouakri
Brahms, Berlin

*Seneca Falls, New York, 1983, Women Climbing
Over the Fence to Protest the Nuclear Test Site*,
2003
Graphite on paper, 30 x 22¾ (76.2 x 57.8)
Collection of the artist; courtesy Sara Meltzer
Gallery, New York, and Chouakri Brahms, Berlin

Vieja Gloria, 2003
Video, color, sound; 45 min.
Collection of the artist; courtesy Sara Meltzer
Gallery, New York

Slater Bradley

Theory and Observation, 2002
Single-channel video installation, sound; 4 min.
Marieluise Hessel Collection on permanent loan to
the Center for Curatorial Studies, Bard College,
Annandale-on-Hudson, New York

Stan Brakhage

Persian Series 13–18, 2001
16mm film, color, silent; 11 min.

Max, 2002
16mm film, color, silent; 4 min.

Chinese Series, 2003
35mm film, color, silent; 2 min.

Cecily Brown

Black Painting 2, 2002
Oil on linen, 90 x 78 (228.6 x 198.1)
Whitney Museum of American Art, New York;
purchase, with funds from Melva Bucksbaum and
the Contemporary Committee 2003.304

Black Painting 4, 2003
Oil on linen, 78 x 90 (198.1 x 228.6)
Collection of the artist; courtesy Gagosian Gallery,
New York

Tom Burr

Blackout Bar, 2004
Vinyl, wood, plexiglass, steel, vinyl stools, glass,
and miscellaneous bar debris, dimensions variable
Collection of the artist; courtesy American Fine Art
Co., New York

Ernesto Caivano

Alignments in Bloom, 2003
Ink on paper, 9 x 6 (22.9 x 15.2)
Collection of Stanley and Nancy Singer

The Birds and Water Fall (I–IV), 2003
Ink on paper, 11 x 14 (27.9 x 35.6)
Collection of the artist; courtesy Guild & Greyshkul,
New York

Capture and Release, 2003
Ink on paper, 9 x 6 (22.9 x 15.2)
Collection of AG Rosen

Devastated by the Code, 2003
Ink on paper, 12 x 24 (30.5 x 61)
Collection of AG Rosen

Fraying the Ropes, 2003
Ink on paper, 9 x 6 (22.9 x 15.2)
Collection of AG Rosen

The Land Inhabited, 2003
Ink on paper, 30 x 80 (76.2 x 203.2)
Collection of Kenneth L. Freed

A Philapore, an Opening, a Web of Code, 2003
Ink on paper, 30 x 40 (76.2 x 101.6)
Collection of Kenneth L. Freed

Philapores Navigate the Log and Code, 2003
Ink on paper, 14 x 22 (35.6 x 55.9)
Collection of Victor Masnyj

Storming the Code I, 2003
Ink on paper, 22 x 14 (55.9 x 35.6)
Collection of Robert Crabb

Storming the Code II, 2003
Ink on paper, 22 x 14 (55.9 x 35.6)
Collection of the artist; courtesy Guild & Greyshkul,
New York

Traps, Screens, and Offerings, 2004
Ink on paper, 16½ x 91½ (41.9 x 232.4)
Collection of the artist; courtesy Guild & Greyshkul,
New York

Maurizio Cattelan

Kitakyushu 2000—New York 2004, 2004
Fiberglass sculpture buried under Museum floor-
boards, life-size
Collection of the artist; courtesy Marian Goodman
Gallery, New York

Pip Chodorov

Charlemagne 2: Piltzer, 2002
16mm film, color, sound; 22 min.

Liz Craft

Death Rider (Libra), 2002
Bronze, 55 x 107 x 31 (139.7 x 271.8 x 81)
Collection of Richard B. Sachs; courtesy Marianne
Boesky Gallery, New York

Old Maid, 2003
Bronze, 48 x 30 x 18 (121.9 x 76.2 x 45.7)
Collection of the artist; courtesy Marianne Boesky
Gallery, New York

The Shopping Cart, 2003
Bronze, 75½ x 67 x 56 (191.8 x 170.2 x 142.2)
Collection of the artist; courtesy Marianne Boesky
Gallery, New York

The Spare (II, III, IV), 2004
Bronze, three pieces, each approximately 33 x 46
x 39 (83.8 x 116.8 x 99)
A Public Art Fund project in the Whitney Biennial;
sponsored by Bloomberg and generously supported
by Adam Lindemann

Santiago Cucullu

Untitled, 2004
Contact paper, dimensions variable
Collection of the artist

Amy Cutler

Campsite, 2002
Gouache on paper, 46½ x 47⅝ (118.1 x 121)
Private collection

Saddlebacked, 2002
Gouache on paper, 24¾ x 30 (57.8 x 76.2)
Weatherspoon Art Museum, The University of North
Carolina at Greensboro, Museum purchase with
funds from the Dillard Fund, 2002

Bionic Contortion, 2003
Gouache on paper, 45⅛ x 40⅝ (114.7 x 103.2)
Collection of Vicky Hughes and John A. Smith;
courtesy Leslie Tonkonow Artworks + Projects,
New York

Castoroide Colony, 2003
Gouache on paper, 54½ x 40 (138.4 x 101.6)
Collection of the artist; courtesy Leslie Tonkonow
Artworks + Projects, New York

Tiger Mending, 2003
Gouache on paper, 17¾ x 14¾ (45.1 x 37.5 cm)
Collection of Stanley and Nancy Singer

Taylor Davis

Pallet, 2002
Pine and mirror, 5 x 52 x 45 (12.7 x 132.1 x 114.3)
Collection of the artist

24 Boards, 2002
Pine, 45 x 98 x 37 (114.3 x 248.9 x 94)
Collection of the artist

February 13th, 2003
Black walnut and black mirror, 64 x 21 x 18 (162.6
x 53.3 x 45.7)
Collection of the artist

Sue de Beer

Hans und Grete, 2002
Two-channel video installation, dimensions variable
Collection of the artist; courtesy Postmasters
Gallery, New York, and Sandroni Rey Gallery,
Los Angeles

Lecia Dole-Recio

Untitled, 2002
Paper, vellum, tape, and gouache, 67 x 67
(170.2 x 170.2)
Collection of Kenneth L. Freed

Untitled, 2003
Paper, vellum, tape, and gouache, 70 x 66 ½
(177.8 x 168.9)
Collection of the artist; courtesy Richard Telles
Fine Art, Los Angeles

Untitled, 2003
Paper, vellum, tape, and gouache, 84 x 94 ½
(213.4 x 240)
Collection of the artist; courtesy Richard Telles
Fine Art, Los Angeles

Sam Durant

Legality is not Morality, 2003
Vinyl text on electric sign, 74 x 56 x 11 (188 x
142.2 x 27.9)
Collection of the artist; courtesy Blum & Poe,
Los Angeles, and Galleria Emi Fontana, Milan

Legality is not Morality (index), 2004
Graphite on paper, 30 x 22 (76.2 x 55.9)
Collection of the artist; courtesy Blum & Poe,
Los Angeles, and Galleria Emi Fontana, Milan

Lie Can Live Forever (index), 2004
Graphite on paper, 22 x 30 (55.9 x 76.2)
Collection of the artist; courtesy Blum & Poe,
Los Angeles, and Galleria Emi Fontana, Milan

Strike (index), 2004
Graphite on paper, 22 x 30 (55.9 x 76.2)
Collection of the artist; courtesy Blum & Poe,
Los Angeles, and Galleria Emi Fontana, Milan

We Are the People (index), 2004
Graphite on paper, 30 x 22 (76.2 x 55.9)
Collection of the artist; courtesy Blum & Poe,
Los Angeles, and Galleria Emi Fontana, Milan

Bradley Eros

Aurora Borealis, 2003
16mm film, anamorphic lens, color, sound; 11 min.

Deliquescence, 2003
8mm and 16mm film performance, variable speed,
colored gels, external glass lens, hand masking,
black-and-white and color, sound; 7 min.

spidery, 2003
Super-8 film and slide projector performance, vari-
able speed, colored gels, external glass and water
lens, hand flicker, black-and-white, sound; approxi-
mately 7 min.

Spencer Finch

Darkness (artist's studio, January 2004), 2004
Grid of drawings, pastel and colored pencil on
paper, each drawing 10 x 11 (25.4 x 27.9)
Collection of the artist; courtesy Postmasters
Gallery, New York

*Night Sky (over the Painted Desert, Arizona,
January 11, 2004)*, 2004
Eighty hanging lamps and four hundred bulbs,
180 x 360 (457.2 x 914.4)
Collection of the artist; courtesy Postmasters
Gallery, New York

Rob Fischer

Thirty Yards, 2003–04
Mixed-media installation, 108 x 90 x 252 (274.3 x
228.6 x 640.1)
Collection of the artist

Kim Fisher

Beryl, 15, 2003
Oil on linen, 29 x 29 (73.7 x 73.7)
Collection of Alan Powers; courtesy of the artist
and China Art Objects Galleries, Los Angeles

Golden Beryl, 2003–04
Oil on linen, 29 x 29 (73.7 x 73.7)
Collection of the artist; courtesy China Art Objects
Galleries, Los Angeles

Labradorite, 31, 2003–04
Oil on linen, 80 x 71 (203.2 x 180.3)
Collection of the artist; courtesy China Art Objects
Galleries, Los Angeles

Tourmaline, 33, 2003–04
Oil on linen, 72 x 68 (182.9 x 172.7)
Collection of the artist; courtesy China Art Objects
Galleries, Los Angeles

Morgan Fisher

(), 2003
16mm film, black-and-white and color, silent;
21 min.
Courtesy Galerie Daniel Buchholz, Cologne, and
China Art Objects Galleries, Los Angeles

Harrell Fletcher and Miranda July with participants

www.learningtoloveyoumore.com, 2002–
Website, computer, monitor

*Learning To Love You More Assignment #29:
Record a Choir (real or constructed)*, 2004
Digital audio installation and custom electronics;
varying lengths
Collection of the artists

James Fotopoulos

Families, 2002
16mm film, black-and-white, sound, 97 min.

The Glass House, 2003
Digital video, color, sound; 60 min.

Leviathan, 2003
Digital video, color, sound; 60 min.

Barnaby Furnas

Hamburger Hill, 2002
Urethane on linen, 72 x 120 (182.9 x 304.8)
Collection of Dean Valentine and Amy Adelson;
courtesy Marianne Boesky Gallery, New York

Suicide I, 2002
Urethane on linen, 60 x 39 (152.4 x 99.1)
Collection of the artist; courtesy Marianne Boesky
Gallery, New York

Martyr, 2003
Urethane on linen, 72 x 60 (182.9 x 152.4)
Lindemann Collection

Sandra Gibson

Bellagio Roll, 2003
Super-8 film, color, silent; 5 min.

NYC Flower Film, 2003
Super-8 film, color, silent; 5 min.

Outline, 2003
35mm film, CinemaScope, color, silent; 5 min.

Palm, 2003
Super-8 film, color, silent; 5 min.

Jack Goldstein

Under Water Sea Fantasy, 1983/2003
16mm film, color, sound; 6:30 min.
Courtesy Galerie Daniel Buchholz, Cologne

Katy Grannan

From the series *Sugar Camp Road*

*Carla and pit bull, Gate House Road, New Paltz,
NY*, 2003
Chromogenic color print, 48 x 60 (121.9 x 152.4)
Collection of the artist; courtesy Artemis Greenberg
Van Doren Gallery, New York, and Salon 94,
New York

Kamika, near Route 9, Poughkeepsie, NY, 2003
Chromogenic color print, 48 x 60 (121.9 x 152.4)
Collection of the artist; courtesy Artemis Greenberg
Van Doren Gallery, New York, and Salon 94,
New York

Mike, private property, New Paltz, NY, 2003
Chromogenic color print, 48 x 60 (121.9 x 152.4)
Collection of the artist; courtesy Artemis Greenberg
Van Doren Gallery, New York, and Salon 94,
New York

Sam Green and Bill Siegel

The Weather Underground, 2003
35mm film, color, sound; 92 min.

Katie Grinnan

Dreamcatcher, 2003
Chromogenic color prints, ink-jet prints, polycar-
bonate resin, foam rubber, magnets, steel, cel
paint, wood, rope, plaster gauze, tissue paper,
feathers, string, acrylic tubes, corduroy, shells, and
tile, dimensions variable
Collection of the artist; courtesy ACME., Los Angeles

Hubcap Woman, 2003
Plastic, concrete, sewer cover, 53 x 65 x 123
(134.6 x 165.1 x 312.4)
Collection of the artist; courtesy ACME., Los Angeles

Level Sky and *Heavy Ground*, 2003
Two DVD projections, dimensions variable
Collection of the artist; courtesy ACME., Los Angeles

Midnight at Noon, 2003
Ink-jet print, metal pipe, foam rubber, metal,
paper, chromogenic color print, spray paint, con-
crete, wood, tube, asphalt, and hubcap, 66 x 87 x
84 (167.6 x 221 x 213.4)
Collection of the artist; courtesy ACME., Los Angeles

Wade Guyton

Untitled (Gabo 28), 2002
Ink-jet on book pages, 7 x 10 (17.8 x 25.4)
Collection of William A. Palmer

Untitled, 2003
Ink-jet on book pages, 7 x 10 (17.8 x 25.4)
Collection of the artist

Untitled Action Sculpture (Breuer), 2003
Altered steel chairs, dimensions variable
Collection of the artist

Untitled Printer Drawings, Group 1, 2003
Ink-jet on book pages, 48 x 60 (121.9 x 152.4)
Collection of the artist

Untitled Printer Drawings, Group 2, 2003
Ink-jet on book pages, 48 x 60 (121.9 x 152.4)
Collection of the artist

Untitled Printer Drawings, Group 3, 2003
Ink-jet on book pages, 48 x 60 (121.9 x 152.4)
Collection of the artist

X Sculpture, 2004
Wood, dimensions variable
Collection of the artist

Mark Handforth

Highway Star, 2003
Steel and mirrored plexiglass, 96 x 58 x 20 (243.8
x 147.3 x 50.8)
Collection of Susan and Michael Hort

DiamondBrite, 2004
Aluminum and lights, 180 x 192 x 120 (457.2 x
487.7 x 304.8)
Collection of the artist; courtesy Gavin Brown's
enterprise, New York

OLIVE-CHROME-OLIVE, 2004
Olive wood, chromed steel, and stainless steel,
33 x 25 x 60 (83.8 x 63.5 x 152.4)
Collection of the artist; courtesy Gavin Brown's
enterprise, New York

Western Sun, 2004
Fluorescent lights with amber gels, dimensions
variable
Collection of the artist; courtesy Gavin Brown's
enterprise, New York

Alex Hay

Gray Wood, 2003
Spray acrylic and stencil on linen, 61 7/16 x 39 5/16
(156 x 99.8)
Collection of the artist; courtesy Peter Freeman,
Inc., New York

Raw Wood, 2004
Spray acrylic and stencil on linen, 57 1/4 x 42 1/2
(145.4 x 108)
Collection of the artist; courtesy Peter Freeman,
Inc., New York

David Hockney

Ann Graves, 2003
Watercolor on paper, 41 3/4 x 29 1/2 (106 x 74.9)
Collection of the artist

Cactus Garden IV, 2003
Watercolor on paper, 36 1/4 x 48 (92.1 x 121.9)
Collection of the artist; courtesy L.A. Louver,
Los Angeles

Charlie Scheips, 2003
Watercolor on paper, 36 1/4 x 24 (92.1 x 61)
Collection of the artist

David Graves, 2003
Watercolor on paper, 41 1/2 x 29 5/8 (105.4 x 75.2)
Collection of the artist

Gregory Evans, 2003
Watercolor on paper, 41 5/8 x 29 5/8 (105.7 x 75.2)
Collection of the artist

Interior with Lamp, 2003
Watercolor on paper, 36 x 72 (91.4 x 182.9)
Collection of the artist; courtesy L.A. Louver,
Los Angeles

L.A. Studio, 2003
Watercolor on paper, 54 5/16 x 48 1/16 (138 x 122.1)
Collection of the artist; courtesy L.A. Louver,
Los Angeles

Richard Schmidt, 2003
Watercolor on paper, 41 1/2 x 29 5/8 (105.4 x 75.2)
Collection of the artist

Saturday Rain II, 2003
Watercolor on paper, 48 1/4 x 18 (122.6 x 45.7)
Collection of the artist

View from Terrace III, 2003
Watercolor on paper, 36 1/4 x 96 (92.1 x 243.8)
Collection of the artist; courtesy Richard Gray
Gallery, New York

Jim Hodges

a view from in here, 2003
Glass, 7 x 5 1/2 x 25 1/2 (17.8 x 14 x 64.8)
The Rachofsky Collection, Dallas

Untitled, 2004
Chromogenic color print, 60 x 94 (152.4 x 238.8)
Collection of the artist; courtesy CRG Gallery,
New York

Untitled, 2004
Chromogenic color print, 60 x 94 (152.4 x 238.8)
Collection of the artist; courtesy CRG Gallery,
New York

Christian Holstad

From the series *Another Dark Room in Which to
Stagger Sorrow*

Fear Gives Courage Wings, 2003
Lighted mirror, towel, iron rods, silkscreened
image, leather, plastic beads, sequins, roller
skates, CD player, speakers, felt, cotton, foam,
plastic flies with glitter, ribbon, wood, white leather
handmade underwear, altered plastic afro pick with
glitter, and competition pom-poms with mylar
strips, dimensions variable
Collection of Dean Valentine and Amy Adelson

Come Out! Come Out, Wherever You Are!, 2004
Cotton, polyester batting, wool, foam, vinyl, tin
can, and wire, dimensions variable
Collection of the artist; courtesy Daniel Reich
Gallery, New York

Dignity, 2004
Wallpaper and lauan, dimensions variable
Collection of the artist; courtesy Daniel Reich
Gallery, New York

Roni Horn

Doubt by Water, 2003–04
Two-sided images with aluminum stanchions and
plastic holders, thirty units, image 16 1/2 x 22
(41.9 x 55.9), stanchion 70 1/2 x 14 (179.1 x 35.6)
Courtesy Matthew Marks Gallery, New York

Wonderwater (Alice Offshore), 2004
Four paperback books in slipcase, annotated by
Louise Bourgeois, Anne Carson, Hélène Cixous,
and John Waters. Published by Steidl Verlag,
Göttingen, Germany

Craigie Horsfield

El Hierro Conversation, 2002
Video installation, dimensions variable
Collection of the artist

Peter Hutton

Skagafjördur, 2003–04
16mm film, black-and-white and color, silent;
35 min.
Funding provided by Icelandic Film Fund and
Whitney Museum of American Art, New York

Emily Jacir

From the series *Where We Come From*

Hana, 2001–03
Chromogenic color print and framed text, 15 x 20
(38.1 x 50.8) and 8 ½ x 11 (21.6 x 27.9)
Collection of the artist; courtesy Debs & Co.,
New York. Originally commissioned for Al-Ma'mal
Foundation for Contemporary Art, Jerusalem

Ibrahim, 2001–03
Framed text, 8 ½ x 11 (21.6 x 27.9)
Collection of the artist; courtesy Debs & Co.,
New York. Originally commissioned for Al-Ma'mal
Foundation for Contemporary Art, Jerusalem

Mahmoud, 2001–03
Chromogenic color print and framed text, 27 x 36
(68.6 x 91.4) and 8 ½ x 11 (21.6 x 27.9)
Collection of the artist; courtesy Debs & Co.,
New York. Originally commissioned for Al-Ma'mal
Foundation for Contemporary Art, Jerusalem

Marie-Therese, 2001–03
Chromogenic color print and framed text, 27 x 36
(68.6 x 91.4) and 8 ½ x 11 (21.6 x 27.9)
Collection of the artist; courtesy Debs & Co.,
New York. Originally commissioned for Al-Ma'mal
Foundation for Contemporary Art, Jerusalem

Munir, 2001–03
Chromogenic color print and framed text, 36 x 27
(91.4 x 68.6) and 8 ½ x 11 (21.6 x 27.9)
Collection of the artist; courtesy Debs & Co.,
New York. Originally commissioned for Al-Ma'mal
Foundation for Contemporary Art, Jerusalem

Mustafa, 2001–03
Chromogenic color print and framed text, 10 x 10
(25.4 x 25.4) and 8 ½ x 11 (21.6 x 27.9)
Collection of the artist; courtesy Debs & Co.,
New York. Originally commissioned for Al-Ma'mal
Foundation for Contemporary Art, Jerusalem

Rami, 2001–03
Chromogenic color print and framed text, 20 x 16
(50.8 x 40.6) and 8 ½ x11 (21.6 x 27.9)
Collection of the artist; courtesy Debs & Co.,
New York. Originally commissioned for Al-Ma'mal
Foundation for Contemporary Art, Jerusalem

Reem, 2001–03
Chromogenic color print and framed text, 9 x 12
(22.9 x 30.5) and 8 ½ x11 (21.6 x 27.9)
Collection of the artist; courtesy Debs & Co.,
New York. Originally commissioned for Al-Ma'mal
Foundation for Contemporary Art, Jerusalem

Rizek, 2001–03
Four chromogenic color prints and framed text,
each print 5 x 7 (12.7 x 17.8) and 8 ½ x 11
(21.6 x 27.9)
Collection of the artist; courtesy Debs & Co.,
New York. Originally commissioned for Al-Ma'mal
Foundation for Contemporary Art, Jerusalem

Sonia, 2001–03
Chromogenic color print and framed text, 15 x 15
(38.1 x 50.8) and 8 ½ x 11 (21.6 x 27.9)
Collection of the artist; courtesy Debs & Co.,
New York. Originally commissioned for Al-Ma'mal
Foundation for Contemporary Art, Jerusalem

Isaac Julien

BaadAsssss Cinema, 2002
Video, color, sound; 56 min.
Courtesy the Independent Film Channel

Glenn Kaino

*Desktop Operation: There's No Place Like Home
(10th Example of Rapid Dominance: Em City)*, 2003
Wood, paint, plastic tarp, sand, water and flood-
light, 96 x 144 x 120 (243.8 x 365.8 x 304.8)
Collection of the artist; courtesy The Project,
New York and Los Angeles

Mary Kelly

Circa 1968, 2004
Compressed lint and projected light, 101 x 105
(257.2 x 265.7)
Collection of the artist; courtesy Postmasters
Gallery, New York

Terence Koh

The Whole Family (Bigger), 2004
Mixed-media installation, 96 x 96 x 96 (243.8 x
243.8 x 243.8)
Collection of the artist; courtesy peres projects,
Los Angeles

Yayoi Kusama

Fireflies on the Water, 2002
Mirror, plexiglass, 150 lights, and water, 115 x
144 x 144 (292.1 x 365.8 x 365.8)
Whitney Museum of American Art, New York;
purchase, with funds from the Postwar Committee
and the Contemporary Committee and partial gift
of Betsy Wittenborn Miller 2003.322

Untitled, 2004
Stainless steel, dimensions variable
Sited in the Conservatory Water Pond in
Central Park
A Public Art Fund project in the Whitney Biennial;
sponsored by Bloomberg and generously supported
by Adam Lindemann

Noémie Lafrance

Noir, 2004
Performance

Lee Mingwei

Whitney Seers Project, 2004
Multimedia interactive installation,
dimensions variable
Courtesy of the artist, Lombard-Freid Fine Arts,
New York, and Eslite Gallery, Taipei

Golan Levin et al.

The Secret Lives of Numbers, 2002
Executable program, computer, monitor
Courtesy of the artist, Turbulence.org,
and bitforms gallery, New York
www.turbulence.org/Works/nums/

Sharon Lockhart

NŌ, 2003
16mm film installation, color, sound; 33 min.
Collection of the artist; courtesy Barbara Gladstone
Gallery, New York, and Blum & Poe, Los Angeles

Robert Longo

Untitled (Hell's Gate), 2001
Charcoal on mounted paper, 69 x 70 (175.3 x
177.8)
Collection of Suzanne and Bob Cochran; courtesy
Metro Pictures, New York

Untitled (The Ledge), 2002
Charcoal on mounted paper, 96 x 72 (243.8 x
182.9)
Collection of Marvin Numeroff; courtesy Metro
Pictures, New York

Untitled (Angel's Wing), 2003
Charcoal on mounted paper, 37 ¾ x 64 ¾ (95.9 x
164.5)
Collection of Isabel Wilcox; courtesy Metro
Pictures, New York

Los Super Elegantes

Untitled, 2004
Performance

Robert Mangold

Column Painting #2, 2002
Acrylic and graphite on canvas, 133 x 31 ⅝ (337.8
x 80.3)
Collection of the artist; courtesy PaceWildenstein,
New York

Column Painting #3, 2002
Acrylic and graphite on canvas, 123 x 33 (312.4
x 83.8)
Collection of Mr. and Mrs. Christopher Harland

Column Painting #6, 2003
Acrylic and graphite on canvas, 133 x 31 ½ (337.8
x 80)
Collection of the artist; courtesy PaceWildenstein,
New York

Virgil Marti

Grow Room 3, 2004
Screenprint on mirror mylar, polyester resin, elec-
trical wiring, and macramé, dimensions variable
Collection of the artist

Cameron Martin

Untitled (100), 2001
Oil on canvas, 87¼ x 108 (221.6 x 274.3)
Collection of Adam Levinson

Pure Phase Two, 2002
Oil and alkyd on canvas, 72 x 96 (182.9 x 243.8)
Wellspring Capital Management LLC

Above the Salt, 2004
Acrylic on canvas, 78 x 96 (198.1 x 243.8)
Collection of the artist; courtesy Artemis Greenberg
Van Doren Gallery, New York

Anthony McCall

Doubling Back, 2003
Installation with film projector and hazer, 16mm
film, black-and-white, silent; 30 min.
Collection of the artist

Paul McCarthy

Michael Jackson, Big Head (Bronze), 2002
Bronze, 120 x 96 x 48 (304.8 x 243.8 x 121.9)
Sited at Doris C. Freedman Plaza
Private collection
A Public Art Fund project in the Whitney Biennial;
sponsored by Bloomberg and generously supported
by Adam Lindemann

Daddies Big Head, 2003
Steel and balloon fabric, 360 x 120 x 120 (914.4 x
304.8 x 304.8)
Sited at Lasker Rink in Central Park
Courtesy of the artist, Luhring Augustine Gallery, New
York, and Galerie Hauser & Wirth, London and Zurich
A Public Art Fund project in the Whitney Biennial;
sponsored by Bloomberg and generously supported
by Adam Lindemann

Bruce McClure

Circle Jerks, 2002, from the series *Crib and Sift*,
2002–04
Four 16mm film prints in four projectors, variable
transformers, and colored gels, sound; 14 min.

Chiodo, 2003, from the series *Crib and Sift*,
2002–04
Four 16mm film prints in four projectors fitted
with horizontal and vertical brass plates, black-
and-white, silent; 14 min.

Cut, 2003
One 16mm black-and-white film print, one length
of 16mm clear leader, red gel, optical sound
modified with equalizer and digital delay; 12 min.

Presepio, 2003, from the series *Crib and Sift*,
2002–04
Four 16mm film prints in four projectors fitted
with horizontal and vertical brass plates, black-
and-white, silent; 14 min.

You Know My Methods, 2003
Two 16mm negative prints for two projectors fitted
with vertical brass plates, black-and-white, sound;
13 min.

Julie Mehretu

Empirical Construction, Istanbul, 2003
Ink and acrylic on canvas, 120 x 180 (304.8
x 457.2)
Collection of the artist; courtesy The Project,
New York and Los Angeles

Rise of the New Suprematists, 2001
Ink and acrylic on canvas, 96 x 120 (243.8 x
304.8)
Collection of Marvin and Alice Kosmin; courtesy
The Project, New York and Los Angeles

Jonas Mekas

Mysteries, 1966/2002
16mm film, black-and-white, sound; 38 min.
Music by Philip Glass

Williamsburg, Brooklyn, 1949–2003
16mm film, black-and-white, silent, 15 min.

Travel Songs, 2003
16mm film, color, silent; 28 min.

Aleksandra Mir

No Smoking, 2004
Plastic signs, each 1 ⁷⁄₈ x 7 ⁷⁄₈ (4.8 x 20)
Collection of the artist

Dave Muller

*Tentatively Titled: Greatest Hits from the Late 90s
to the Present*, 2003–04
Acrylic on paper, dimensions variable
Collection of the artist; courtesy Murray Guy,
New York, and Blum & Poe, Los Angeles

Three-Day Weekend Event (Two Parts), 2004
Temporary installation
Arsenal Gallery in Central Park
A Public Art Fund project in the Whitney Biennial;
sponsored by Bloomberg and generously supported
by Adam Lindemann

Julie Murray

Untitled (light), 2002
16mm film, color, sound; 5 min.

Julie Atlas Muz

The Rite of Spring, 2004
Performance

Treasure Box, 2004
Performance

Andrew Noren

Free To Go (interlude), 2003
Digital video, color and black-and-white, silent;
61 min.

Robyn O'Neil

*Everything that stands will be at odds with its
neighbor, and everything that falls will perish
without grace.*, 2003
Graphite on paper, 91 ³⁄₄ x 150 ³⁄₈ (233 x 382)
Collection of Jeanne and Michael Klein and the
Jack S. Blanton Museum of Art, fractional and
pledged gift, 2003
Originally commissioned by ArtPace | San Antonio

Catherine Opie

Untitled (Surfers) #8, 2003
Chromogenic color print, 50 x 40 (127 x 101.6)
Collection of the artist; courtesy Regen Projects,
Los Angeles, and Gorney Bravin + Lee, New York

Untitled (Surfers) #9, 2003
Chromogenic color print, 50 x 40 (127 x 101.6)
Collection of the artist; courtesy Regen Projects,
Los Angeles, and Gorney Bravin + Lee, New York

Untitled (Surfers) #10, 2003
Chromogenic color print, 50 x 40 (127 x 101.6)
Collection of the artist; courtesy Regen Projects,
Los Angeles, and Gorney Bravin + Lee, New York

Untitled (Surfers) #11, 2003
Chromogenic color print, 50 x 40 (127 x 101.6)
Collection of the artist; courtesy Regen Projects,
Los Angeles, and Gorney Bravin + Lee, New York

Untitled (Surfers) #12, 2003
Chromogenic color print, 50 x 40 (127 x 101.6)
Collection of the artist; courtesy Regen Projects,
Los Angeles, and Gorney Bravin + Lee, New York

Untitled (Surfers) #13, 2003
Chromogenic color print, 50 x 40 (127 x 101.6)
Collection of the artist; courtesy Regen Projects,
Los Angeles, and Gorney Bravin + Lee, New York

Jim O'Rourke

We're All in This Together, 2003–04
Continuous digital audio installation
Collection of the artist

Not Yet, 2004
Film and sound performance

Laura Owens

Untitled, 2004
Oil and acrylic on canvas, 132 x 111½ (335.3 x
283.2)
Collection of the artist; courtesy Gavin Brown's
enterprise, New York

Raymond Pettibon

Title on the Line, 2004
Ink on paper, dimensions variable
Collection of the artist; courtesy Regen Projects,
Los Angeles

Elizabeth Peyton

September (Ben), 2001
Oil on board, 12⅛ x 9⅛ (30.8 x 23.2)
Private collection; courtesy Gavin Brown's enter-
prise, New York

Julian, 2003
Pastel on paper, 16 ½ x 11 ¾ (41.9 x 29.8)
Private collection; courtesy neugerriemschneider,
Berlin

Live to Ride (E.P.), 2003
Oil on board, 15 x 12 (38.1 x 30.5)
Private collection; courtesy Gavin Brown's enter-
prise, New York

Maritime (E.P.), 2003
Colored pencil on paper, 9 x 11⅝ (22.9 x 29.5)
Private collection; courtesy neugerriemschneider,
Berlin

Nick (La Luncheonette December 2002), 2003
Oil on board, 7¼ x 9 (18.4 x 22.9)
Collection of Karen and Andy Stillpass; courtesy
Gavin Brown's enterprise, New York

Walt, 2003
Colored pencil on paper, 6 x 8⅝ (15.2 x 21.9)
Collection of the artist

Chloe Piene

Blackmouth, 2003
Video installation, dimensions variable; 4 min.
Collection of the artist; courtesy Gasser & Grunert,
Inc., New York

Mmasturbator, 2003
Charcoal on vellum, 44 x 36 (111.8 x 91.4)
Private collection; courtesy Gasser & Grunert, Inc.,
New York

No Face, 2003
Charcoal on vellum, 32½ x 41½ (82.6 x 105.4)
Collection of Catherine Orentreich; courtesy Gasser
& Grunert, Inc., New York

Untitled (CP#2), 2003
Charcoal on vellum, 56½ x 36½ (143.5 x 92.7)
Hoffmann Collection, Berlin; courtesy Gasser &
Grunert, Inc., New York

Jack Pierson

Self-Portrait #1, 2003
Ink-jet print, 50 x 60 (127 x 152.4)
Collection of the artist; courtesy Cheim & Read,
New York

Self-Portrait #3, 2003
Ink-jet print, 50 x 60 (127 x 152.4)
Collection of the artist; courtesy Cheim & Read,
New York

Self-Portrait #6, 2003
Ink-jet print, 50 x 60 (127 x 152.4)
Collection of the artist; courtesy Cheim & Read,
New York

Self-Portrait #15, 2003
Ink-jet print, 50 x 60 (127 x 152.4)
Collection of the artist; courtesy Cheim & Read,
New York

Self-Portrait #20, 2003
Ink-jet print, 50 x 60 (127 x 152.4)
Collection of the artist; courtesy Cheim & Read,
New York

Richard Prince

Canal Zone, 2003
Fiberglass, Bondo, acrylic, and wood, 49⅝ x 62⅜
x 12¼ (126 x 158.4 x 31.1)
Collection of the artist; courtesy Barbara Gladstone
Gallery, New York

Haight-Ashbury, 2003
Fiberglass, Bondo, acrylic, and wood, 50 x 50½ x
58½ (127 x 128.3 x 148.6)
Collection of the artist; courtesy Barbara Gladstone
Gallery, New York

Oak Hill, 2003
Fiberglass, Bondo, acrylic, and wood, 63 x 52 x
6½ (160 x 132.1 x 16.5)
Collection of the artist; courtesy Barbara Gladstone
Gallery, New York

Preston Hollow, 2003
Fiberglass, Bondo, acrylic, and wood, 70 x 59½ x
9¾ (177.8 x 151.1 x 24.8)
Collection of the artist; courtesy Barbara Gladstone
Gallery, New York

Luis Recoder

Glass: Backlight, 2001–02
16mm film with paper masking, color, sound;
12 min.

Linea, 2002
16mm film double projection, black-and-white,
silent; 18 min.

Liisa Roberts

What's the Time in Vyborg? (working title), work in
progress at time of printing
16mm film, sound
Courtesy of the artist and Silva Mysterium Oy,
Helsinki
Acknowledgments: Centre National de la Cinema-
tographie, Paris; Göran Christenson, Malmö
Konstmuseum, Malmö; Mika Hannula, Academy of
Fine Arts Helsinki; Timo Humaloja and Veli Granö,
AVEK, Helsinki; Yvon Lambert, Galerie Yvon
Lambert, Paris; Friedrich Meschede, DAAD, Berlin;
NIFCA–Punkt residency program; Willem Peppler;
Marketta Seppälä, FRAME–Finnish Fund for Art
Exchange, Helsinki; Tatyana V. Svetelnikova, Alvar
Aalto Library, Vyborg; Illya Szilak and Chris Vroom,
New York; Sari Volanen, YLE–TV1, Helsinki

Dario Robleto

*At War With The Entropy Of Nature/Ghosts Don't
Always Want To Come Back*, 2002
Cassette: carved bone and bone dust from every
bone in the body, trinitite (glass produced during
the first atomic test explosion at Trinity test site,
circa 1945, when heat from blast melted surround-
ing sand), metal screws, rust, and Letraset; audio
tape: original composition of military drum march-
es, weapon fire, and soldiers' voices from battle-
fields of various wars made from Electronic Voice
Phenomena recordings (voices and sounds of the
dead or past, detected through magnetic audio
tape), 2½ x 3¾ x ⅝ (6.4 x 9.5 x 1.6)
Collection of Julie Kinzelman and Christopher
Tribble; courtesy Inman Gallery, Houston

Our Sin Was In Our Hips, 2002
Hand-ground vinyl records, melted vinyl records,
male and female pelvic bone dust, polyester resin,
spray paint, pigments, dirt, concert spotlight,
female pelvis made from artist's mother's 45 rpm
rock 'n' roll records, and male pelvis made from
artist's father's 33 rpm rock 'n' roll records, 12 x 9
x 9 (30.5 x 22.9 x 22.9)
Collection of Peter and Linda Zweig; courtesy
Inman Gallery, Houston

*Hippies And A Ouija Board (Everyone Needs To
Cling To Something)*, 2003
Cast and carved dehydrated bone calcium and
bone dust from every bone in the body, home-
brewed moonshine and wine health tonics (potato-
derived alcohol; water, sugar, fermented black
cherries, yeast, gelatin, tartaric acid, pectinase,
sulfur dioxide, and oak flavoring) fortified with one-
hundred-year-old hemlock oil, Devil's Claw, witch
hazel bark, swamp root, powdered rhubarb,
pleurisy root, belladonna root, white pine tar, coal
tar, dandelion, sarsaparilla, mandrake, mullein,
scullcap, cramp bark, elder, ginseng, horny goat
weed, tansy, sugar of lead, mercury with chalk and
tin-oxide; calcium, potassium, creatine, zinc, iron,
nickel, copper, boron, vitamin K, crushed amino
acids, home-cultured antibiotics, chromium, mag-
nesium, colostrum, ironized yeast, ground pituitary
gland, ground wisdom teeth, ground sea horse,
shark cartilage, coral calcium, iodine, and castor
oil; various 1960s 45 rpm records cast in prehis-
toric whale-bone dust, microcrystalline cellulose,
rust, cold-cast iron and brass, antique syringe,
crushed velvet, leather, water-extendable resin, and
Letraset, 23 x 19 x 42 (58.4 x 48.3 x 106.7)
Collection of the artist; courtesy ACME.,
Los Angeles

Our 60s Radicals Forgot To Stay Suspicious, 2003
Cast of homemade paper (pulp made from cotton,
military sheet music from American wars, and bone
dust from every bone in the body), dehydrated
bone calcium, bone charcoal, ground trinitite
(glass produced during the first atomic test explo-
sion at Trinity test site, circa 1945, when heat from
blast melted surrounding sand), wheat starch,
cold-cast steel, nickel, and zinc, melted bullet
lead, rust, shatterproof Lexan, and Letraset, 25 x
21 x 2 (63.5 x 53.3x 5.1)
Collection of the artist; courtesy ACME.,
Los Angeles

Vatican Radio, 2003
Antique radio: cast and carved bone charcoal and
melted vinyl records of U.S. presidents addressing
or declaring war, sulfur, dehydrated bone calcium,
cold cast zinc, silver and nickel, melted bullet
lead, pigments, dirt, rust, water extendable resin,
Letraset, speaker; soundtrack: loop of the radio
broadcast of the first number being called in the
draft lottery of World War II (October 29, 1940),
Marvin Gaye's "Sexual Healing," and church bells
and choirs, 15½ x 10 x 20 (39.4 x 25.4 x 50.8)
Soundtrack production assistance by Justin Boyd
Collection of the artist; courtesy ACME.,
Los Angeles

Matthew Ronay

From the series *70's Funk Concert Model*

Decoration Declaration, 2003
Medium-density fiberboard, steel, epoxy, and paint, dimensions variable
Collection of the artist; courtesy Andrea Rosen Gallery, New York

The Impressions/Curtis Mayfield, 2003
Medium-density fiberboard, wood, copper, and paint, 72 x 45 ¾ x 35 ¼ (182.9 x 116.2 x 89.5)
Collection of the artist; courtesy Andrea Rosen Gallery, New York

Infected Carrots, 2003
Medium-density fiberboard, wood, copper, and paint, 69 x 21 x 60 ½ (175.3 x 53.3 x 153.7)
Collection of Stanley and Nancy Singer

Irreversible Algorithm, 2003
Medium-density fiberboard, wood, copper, string, and paint, dimensions variable
Collection of the artist; courtesy Andrea Rosen Gallery, New York

Mandrill, 2003
Medium-density fiberboard, wood, copper, masonite, and paint, 72 x 45 ¾ x 47 ¾ (182.9 x 116.2 x 121.3)
Collection of the artist; courtesy Andrea Rosen Gallery, New York

Aïda Ruilova

Almost, 2002
Video, color, sound; 19 sec.
Collection of the artist; courtesy Salon 94, New York, and Artemis Greenberg Van Doren Gallery, New York

Come Here, 2002
Video, color, sound; 29 sec.
Collection of the artist; courtesy Salon 94, New York, and Artemis Greenberg Van Doren Gallery, New York

I Have to Stop, 2002
Video, color, sound; 33 sec.
Collection of the artist; courtesy Salon 94, New York, and Artemis Greenberg Van Doren Gallery, New York

3, 2, 1 (I love you), 2002
Video, color, sound; 14 sec.
Collection of the artist; courtesy Salon 94, New York, and Artemis Greenberg Van Doren Gallery, New York

No-no, 2003
Video, color, sound; 22 sec.
Collection of the artist; courtesy Salon 94, New York, and Artemis Greenberg Van Doren Gallery, New York

Anne-Marie Schleiner, Brody Condon, and Joan Leandre (the "Velvet-Strike" team)

Velvet-Strike, 2002
Website, online game intervention, computer, monitor, and DVD documentation
Collection of the artists
www.opensorcery.net/velvet-strike

James Siena

Battery, 2002
Reduction linoleum cut, 21 ¼ x 18⅝ (54 x 47.3)
Printed at Pace Ink; published by Pace Editions Inc., New York

Double Recursive Combs (red and black), 2002
Enamel on aluminum, 29¹/₁₆ x 22¹¹/₁₆ (73.8 x 57.6)
Collection of David and Nancy Frej

Interlocked Lattice (Large), 2003
Graphite on paper, 16 ½ x 12 ¾ (41.9 x 32.4)
The Judith Rothschild Foundation, New York

Lighthouse Variation with Crosses, 2003
Graphite on paper, 16 ½ x 12 ¾ (41.9 x 32.4)
The Judith Rothschild Foundation, New York

Small Blue Lighthouse Variation, 2003
Colored pencil on paper, 5 ¾ x 3 ¾ (14.6 x 9.5)
Collection of Patricia A. Bell

Small Distorted Lattice, 2003
Graphite on paper, 5 ¾ x 3 ¾ (14.6 x 9.5)
Collection of Patricia A. Bell

Lighthouse Variation, 2003–04
Enamel on aluminum, 19¼ x 15⅛ (48.9 x 38.4)
Collection of the artist; courtesy Gorney Bravin + Lee, New York

Upside Down Devil Variation, 2004
Engraving; sheet, 26⅝ x 22 ¼ (67.6 x 56.5); plate, 19½ x 15 (49.5 x 38.1)
Published by Harlan & Weaver, Inc., New York

Amy Sillman

Hamlet, 2002
Oil on canvas, 72 x 84 (182.9 x 213.4)
Whitney Museum of American Art, New York; purchase, with funds from the Contemporary Committee 2003.306

Cost of Living, 2003
Oil on canvas, 66 x 78 (167.6 x 198.1)
Collection of the artist; courtesy Brent Sikkema Gallery, New York

The Egyptians, 2003
Oil on canvas, 72 x 84 (182.9 x 213.4)
Collection of the artist; courtesy Brent Sikkema Gallery, New York

SIMPARCH

Untitled, 2004
Mixed-media installation, dimensions variable
Collection of the artist

Zak Smith

Pictures of What Happens on Each Page of Thomas Pynchon's Novel Gravity's Rainbow, 2004
Ink, acrylic, and mixed media on paper, 755 parts, each 5 ½ x 4 ½ (14 x 11.4)
Collection of the artist; courtesy Fredericks Freiser Gallery, New York

Yutaka Sone

Highway Junction 110–10, 2002
Marble, 9 ½ x 52 ½ x 51 ¼ (24.1 x 133.4 x 130.2)
The Museum of Contemporary Art, Los Angeles; courtesy David Zwirner, New York

Highway Junction 405–10, 2003
Marble, 8⅞ x 46 ½ x 63 ½ (22.5 x 118.1 x 161.3)
Collection of Edward Israel; courtesy David Zwirner, New York

Alec Soth

From the series *Sleeping by the Mississippi*

Charles, Vasa, MN, 2002
Chromogenic color print, 40 x 32 (101.6 x 81.3)
Collection of the artist; courtesy Yossi Milo Gallery, New York

Green Island, IA, 2002
Chromogenic color print, 40 x 32 (101.6 x 81.3)
Collection of the artist; courtesy Yossi Milo Gallery, New York

Herman's Bed, Kenner, LA, 2002
Chromogenic color print, 32 x 40 (81.3 x 101.6)
Collection of the artist; courtesy Yossi Milo Gallery, New York

Mother and Daughter, Davenport, IA, 2002
Chromogenic color print, 40 x 32 (101.6 x 81.3)
Collection of the artist; courtesy Yossi Milo Gallery, New York

New Orleans, LA, 2002
Chromogenic color print, 32 x 40 (81.3 x 101.6)
Collection of the artist; courtesy Yossi Milo Gallery, New York

Patrick, Palm Sunday, Baton Rouge, LA, 2002
Chromogenic color print, 40 x 32 (101.6 x 81.3)
Collection of the artist; courtesy Yossi Milo Gallery, New York

Saint Genevieve, MO, 2002
Chromogenic color print, 32 x 40 (81.3 x 101.6)
Collection of the artist; courtesy Yossi Milo Gallery, New York

Sugar's, Davenport, IA, 2002
Chromogenic color print, 40 x 32 (101.6 x 81.3)
Collection of the artist; courtesy Yossi Milo Gallery, New York

Venice, LA, 2002
Chromogenic color print, 32 x 40 (81.3 x 101.6)
Collection of the artist; courtesy Yossi Milo Gallery, New York

Deborah Stratman

In Order Not to Be Here, 2002
16mm film transferred to video, color and black-and-white, sound; 33 min.

Catherine Sullivan

Ice Floes of Franz Joseph Land, 2003
Five-channel video installation, 16mm film transferred to video, black-and-white, sound; screens 1–4: 20 min.; screen 5: 40 min.
Collection of the artist; courtesy Metro Pictures, New York

Eve Sussman

89 Seconds at Alcazar, 2003
Video projection, high-definition video, color, sound; 12 min.
This piece has been made possible by the following institutional and corporate sponsors: New York State Council on the Arts; HD Cinema; Panasonic; Black Magic Design; Atto Technologies; Smack Mellon Studios; Materials for the Arts–NYC DCA; Daniel Wurtzel Studios; Seelevelstudios Inc.; University of Hertfordshire, U.K.; NY Props

Julianne Swartz

Somewhere Harmony, 2003–04
Site-specific installation with plexiglass, plastic tubing, wire, speakers, soundtrack, fiberoptic wire, lenses, mirror, and halogen light, dimensions variable
Collection of the artist

Erick Swenson

Untitled, 2001
Polyurethane resin and acrylic, 26 x 132 x 84 (66 x 335.3 x 213.4)
Cooper Family Foundation; courtesy James Cohan Gallery, New York, and Angstrom Gallery, Dallas

Fred Tomaselli

Breathing Head, 2002
Photocollage, leaves, gouache, acrylic, and resin on wood panel, 60 x 60 (152.4 x 152.4)
Collection of Douglas S. Cramer

Airborne Event, 2003
Mixed media, acrylic, and resin on wood, 84 x 60 (213.4 x 152.4)
Lent by the American Fund for the Tate Gallery and the collection of John and Amy Phelan, fractional and promised gift

Doppelgänger Effect, 2004
Photocollage, leaves, pills, acrylic, and resin on wood panel, 96 x 96 (243.8 x 243.8)
Collection of the artist; courtesy James Cohan Gallery, New York, and White Cube, London

**Tracy and the Plastics
(Wynne Greenwood)**

Untitled, 2004
Performance

Jim Trainor

The Magic Kingdom, 2003
16mm film, color, sound; 7 min.

Tam Van Tran

Beetle Manifesto IV, 2002
Chlorophyll, spirulina, pigment, staples, binder, aluminum foil, and paper, 92 x 91 x 12 (233.7 x 231.1 x 30.5)
Collection of the artist; courtesy Cohan and Leslie, New York

Beetle Manifesto XI, 2004
Chlorophyll, spirulina, pigment, staples, binder, and paper, 89 x 86 x 21 (226.1 x 218.4 x 53.3)
Collection of the artist; courtesy Cohan and Leslie, New York

Banks Violette

burnout (fadeaway) / vol. 1, 2003
Graphite on paper, 40 x 60 (101.6 x 152.4)
Collection of Susan and Harry Meltzer; courtesy Team Gallery, New York

burnout (fadeaway) / vol. 2, 2003
Graphite on paper, 40 x 60 (101.6 x 152.4)
Collection of Susan and Tony Koestler; courtesy Team Gallery, New York

DeadStar Memorial Structure (on their hands at last a) 4.1.94, 2003
Steel, plywood, tinted epoxy, drum hardware, polystyrene, polyurethane, and speed-rail pipe fittings, dimensions variable
Collection of the artist; courtesy Team Gallery, New York

Powderfinger Christ (Kurt Cobain) 4.1.94, 2003
Graphite on paper, 40 x 60 (101.6 x 152.4)
Collection of Matt Aberle; courtesy Team Gallery, New York

spotlight (blackhole) / vol. 1, 2003
Graphite on paper, 40 x 60 (101.6 x 152.4)
Collection of the artist; courtesy Team Gallery, New York

spotlight (blackhole) / vol. 2, 2003
Graphite on paper, 40 x 60 (101.6 x 152.4)
Private collection; courtesy Team Gallery, New York

Judas Priest (Suicide Anthem), 2004
Wall drawing, dimensions variable
Collection of the artist; courtesy Team Gallery, New York

Eric Wesley

Scale Sets for the Upcoming Television Production of "…So, This Is Reality," 2004
Mixed media, 120 x 120 x 120 (304.8 x 304.8 x 304.8)
Collection of the artist; courtesy China Art Objects Galleries, Los Angeles

Olav Westphalen

Map, 2003
Acrylic and ink on paper, 49 x 67 (124.5 x 170.2)
Collection of the artist; courtesy maccarone inc., New York

Ming, 2003
Acrylic and ink on paper, 75 x 60 (190.5 x 152.4)
Collection of the artist; courtesy maccarone inc., New York

Statue (seated), 2003
Polystyrene, resin, and tempera paint, 55 x 36 x 30 (139.7 x 91.4 x 76.2)
Private collection; courtesy maccarone inc., New York

Statue (standing), 2003
Polystyrene, resin, and tempera paint, 72 x 30 x 24 (182.9 x 76.2 x 61)
Collection of the artist; courtesy maccarone inc., New York

Untitled, 2003
Acrylic and ink on paper, 46 ½ x 70 (118.1 x 177.8)
Collection of the artist; courtesy maccarone inc., New York

Tiger, 2004
Fiberglass and paint, life-size
Sited on Wien Walk near Central Park Zoo
A Public Art Fund project in the Whitney Biennial; sponsored by Bloomberg and generously supported by Adam Lindemann

T. J. Wilcox

garland 1, 2003
16mm film, color, silent; 8:06 min.
Collection of the artist; courtesy Metro Pictures, New York

garland 2, 2003
16mm film, color, silent; 5:47 min.
Collection of the artist; courtesy Metro Pictures, New York

garland 3, 2003
16mm film, color, silent; 9:05 min.
Collection of the artist; courtesy Metro Pictures, New York

Andrea Zittel

Prototype for Raw Desk #2, 2001
Medium-density fiberboard, paint, polyurethane, fabric and foam cushion, and miscellaneous accessories, 28 x 126 x 126 (71.1 x 320 x 320)
Collection of the artist; courtesy Andrea Rosen Gallery, New York, and Regen Projects, Los Angeles

Sufficient Self, 2004
Audiovisual presentation
Collection of the artist; courtesy Andrea Rosen Gallery, New York, and Regen Projects, Los Angeles

screening and performance schedule

*as of January 15, 2004

All film and video screenings are held in the Kaufman Astoria Studios Film & Video Gallery, unless otherwise noted. All performances take place in the Lower Lobby area, unless the offsite venue is listed.

Friday, March 12
SoundCheck MUSIC PERFORMANCE:
Dave Muller and Los Super Elegantes

Saturday, March 13
SCREENING:
Deborah Stratman, *In Order Not to Be Here*, 2002

Andrea Bowers, *Vieja Gloria*, 2003

Wednesday, March 17
DIGITAL ART PRESENTATION:
The Kitchen, 512 West 19th Street
Anne-Marie Schleiner, Brody Condon, and Joan Leandre, *Velvet-Strike*; and Harrell Fletcher and Miranda July, *Learning To Love You More*

Thursday, March 18
SCREENING:
Jonas Mekas, *Travel Songs*, 2003; *Williamsburg, Brooklyn*, 1949–2003; and *Mysteries*, 1966/2002

Every Thursday, March 18–April 29
PERFORMANCE:
Whitney Museum at Altria, 120 Park Avenue
Lee Mingwei, *Whitney Seers Project*

Friday, March 19
SoundCheck MUSIC PERFORMANCE:
BEIGE Presents:
jamie arcangel and the arcangels
the 8bit construction set
paul b. davis
cory arcangel

Saturday, March 20
SCREENING:
Stan Brakhage, *Max*, 2002; *Chinese Series*, 2003; and *Persian Series 13–18*, 2001

Sandra Gibson, *Outline*, 2003; *Palm*, 2003; *Bellagio Roll*, 2003; and *NYC Flower Film*, 2003

Jim Trainor, *The Magic Kingdom*, 2003

Morgan Fisher, *()*, 2003

Peter Hutton, *Skagafjördur*, 2003–04

Wednesday, March 24, and Thursday, March 25
DANCE PERFORMANCE:
Dance Theater Workshop,
219 West 19th Street
Julie Atlas Muz, *The Rite of Spring*

Friday, March 26
SoundCheck MUSIC PERFORMANCE:
Tracy and the Plastics

Thursday, April 1
SCREENING:
Sam Green and Bill Siegel, *The Weather Underground*, 2003

Friday, April 2
SCREENING:
James Fotopoulos, *Leviathan*, 2003; and *Families*, 2002

DANCE PERFORMANCE:
Dance Theater Workshop,
219 West 19th Street
Julie Atlas Muz, *The Rite of Spring*

Saturday, April 3
DANCE PERFORMANCE:
Dance Theater Workshop,
219 West 19th Street
Julie Atlas Muz, *The Rite of Spring*

SCREENING:
Luis Recoder, *Glass: Backlight*, 2001–02; and *Linea*, 2002

Bradley Eros, *Deliquescence*, 2003; *Aurora Borealis*, 2003; and *spidery*, 2003

Bruce McClure, *Cut*, 2003; *Chiodo*, 2003; *Presepio*, 2003; and *Circle Jerks*, 2002

Pip Chodorov, *Charlemagne 2: Piltzer*, 2002

Andrew Noren, *Free To Go (interlude)*, 2003

Thursday, April 8
SCREENING:
Isaac Julien, *BaadAsssss Cinema*, 2002

Saturday, April 10
SCREENING:
Jonas Mekas, *Travel Songs*, 2003; *Williamsburg, Brooklyn*, 1949–2003; and *Mysteries*, 1966/2002

PERFORMANCE:
Angel Orensanz Foundation Center for the Arts, 172 Norfolk Street
Catherine Sullivan, *Ice Floes of Franz Joseph Land (Orensanz Manifestation)*

Sunday, April 11
PERFORMANCE:
Angel Orensanz Foundation Center for the Arts, 172 Norfolk Street
Catherine Sullivan, *Ice Floes of Franz Joseph Land (Orensanz Manifestation)*

Thursday, April 15
SCREENING:
Stan Brakhage, *Max*, 2002; *Chinese Series*, 2003; and *Persian Series 13–18*, 2001

Sandra Gibson, *Outline*, 2003; *Palm*, 2003; *Bellagio Roll*, 2003; and *NYC Flower Film*, 2003

Jim Trainor, *The Magic Kingdom*, 2003

Morgan Fisher, *()*, 2003

Peter Hutton, *Skagafjördur*, 2003–04

Friday, April 16

MUSIC PERFORMANCE:
St. Ann's Warehouse,
38 Water Street, Brooklyn
Antony and the Johnsons with Charles
Atlas, *Turning*

Saturday, April 17

MUSIC PERFORMANCE:
St. Ann's Warehouse,
38 Water Street, Brooklyn
Antony and the Johnsons with Charles
Atlas, *Turning*

SCREENING:
Sam Green and Bill Siegel, *The Weather
Underground*, 2003

**Tuesday, April 20,
and Wednesday, April 21**

PERFORMANCE:
Whitney Museum at Altria, 120 Park Avenue
Los Super Elegantes, *Untitled*

Thursday, April 22

SCREENING:
Jonas Mekas, *Travel Songs*, 2003;
Williamsburg, Brooklyn, 1949–2003; and
Mysteries, 1966/2002

Friday, April 23

SoundCheck MUSIC PERFORMANCE:
Jim O'Rourke

Thursday, April 29

SCREENING:
Sound and Image
Jim O'Rourke, *Not Yet*, 2004

Pip Chodorov, *Charlemagne 2: Piltzer*, 2002

Bruce McClure, *You Know My Methods*, 2003

Friday, April 30

PERFORMANCE:
The Kitchen, 512 West 19th Street
"Performing Technology from the 2004
Whitney Biennial"
Golan Levin, Tracy and the Plastics, and
Cory Arcangel/BEIGE

Saturday, May 1

PERFORMANCE:
The Kitchen, 512 West 19th Street
"Performing Technology from the 2004
Whitney Biennial"
Golan Levin, Tracy and the Plastics, and
Cory Arcangel/BEIGE

SCREENING:
Pip Chodorov, *Charlemagne 2: Piltzer*, 2002

Andrew Noren, *Free To Go (interlude)*, 2003

Wednesdays–Sundays, May 5–23

DANCE PERFORMANCE:
Location TBA
Noémie Lafrance, *Noir*

Thursday, May 6

MUSIC PERFORMANCE:
Knitting Factory, 74 Leonard Street
Tracy and the Plastics

Friday, May 7

SoundCheck MUSIC PERFORMANCE:
Antony of Antony and the Johnsons

Saturday, May 8

SCREENING:
A Tribute to Stan Brakhage

Thursday, May 13

SCREENING:
Sam Green and Bill Siegel, *The Weather
Underground*, 2003

Saturday, May 15

SCREENING:
Luis Recoder, *Glass: Backlight*, 2001–02;
and *Linea*, 2002

Bradley Eros, *Deliquescence*, 2003; *Aurora
Borealis*, 2003; and *spidery*, 2003

Bruce McClure, *Cut*, 2003; *Chiodo*, 2003;
Presepio, 2003; and *Circle Jerks*, 2002

Pip Chodorov, *Charlemagne 2: Piltzer*, 2002

Andrew Noren, *Free To Go (interlude)*, 2003

Thursday, May 20

SCREENING:
Stan Brakhage, *Max*, 2002; *Chinese Series*,
2003; and *Persian Series 13–18*, 2001

Sandra Gibson, *Outline*, 2003;
Palm, 2003; *Bellagio Roll*, 2003; and *NYC
Flower Film*, 2003

Jim Trainor, *The Magic Kingdom*, 2003

Morgan Fisher, *()*, 2003

Peter Hutton, *Skagafjördur*, 2003–04

Friday, May 21

SCREENING:
Kaufmann Conference Room, 809 United
Nations Plaza, 12th floor
Liisa Roberts, *What's the Time in Vyborg?*,
2003–04

DANCE PERFORMANCE:
The Coral Room, 512 West 29th Street
Julie Atlas Muz, *Treasure Box*

Saturday, May 22

SCREENING:
Kaufmann Conference Room, 809 United
Nations Plaza, 12th floor
Liisa Roberts, *What's the Time in Vyborg?*,
2003–04

WHITNEY STAFF

*as of January 15, 2004

Jay Abu-Hamda
Adrienne Alston
Ronnie Altilo
Martha Alvarez-LaRose
Basem D. Aly
Callie Angell
Xavier Anglada
Marilou Aquino
Bernadette Baker
Harry Benjamin
Hillary Blass
Richard Bloes
Amanda Brown
Steven Buettner
Meghan Bullock
Douglas Burnham
Ron Burrell
Garfield Burton
Pablo Caines
Meg Calvert-Cason
Andrew Cappetta
Gary Carrion-Murayari
Howie Chen
Ivy Chokwe
Kurt Christian
Ramon Cintron
Lee Clark
Ron Clark
Melissa Cohen
Deborah Collins
Arthur Conway
Heather Cox
Stevie Craig
Sakura Cusie
Holly Davey

Heather Davis
Nathan Davis
Evelyn De La Cruz
Anthony DeMercurio
Eduardo Diaz
Eva Diaz
Apsara DiQuinzio
Gerald Dodson
Elizabeth Dowd
Anita Duquette
Tara Eckert
Alvin Eubanks
Altamont Fairclough
April Farrell
Kellie Feltman
Kenneth Fernandez
Jeanette Fischer
Mayrav Fisher
Rich Flood
Rowan Foley
Samuel Franks
Murlin Frederick
Annie French
Belinda Frost
Donald Garlington
Cassandra Garner
Larissa Gentile
Filippo Gentile
Larry Giacoletti
Kimberly Goldsteen
Jennie Goldstein
Mark Gordon
Pia Gottschaller
Paola Hago Castro
Evelyn Hankins
Joann Harrah
Collin Harris
Barbara Haskell

K. Michael Hays
Barbara Hehman
Dina Helal
Carlos Hernandez
Karen Hernandez
Amy Herzog
Thea Hetzner
Nicholas S. Holmes
Henriette Huldisch
Wycliffe Husbands
Chrissie Iles
Stephany Irizzary
Carlos Jacobo
Floyd Johnson
Ralph Johnson
Lauren Kash
Chris Ketchie
Wynne Kettell
David Kiehl
Tom Kraft
Margaret Krug
Tina Kukielski
Diana Lada
Joelle LaFerrara
Michael Lagios
Anne Lampe
Raina Lampkins-Fielder
Sang Soo Lee
Kristen Leipert
Monica Leon
Vickie Leung
Lisa Libicki
Kelley Loftus
Jennifer MacNair
Carol Mancusi-Ungaro
Jennifer Manno
Joel Martinez

Sandra Meadows
Graham Miles
Dana Miller
Shamim M. Momin
Victor Moscoso
Carol Nesby
Colin Newton
Kirsten Nobman
Carlos Noboa
Camille Obering
Darlene Oden
Richard O'Hara
Caroline Older
Meagan O'Neil
Nelson Ortiz
Carolyn Padwa
Anthony Pasciucco
Christiane Paul
Angelo Pikoulas
Kathryn Potts
Marla Prather
Linda Priest
Vincent Punch
Elise Pustilnik
Christy Putnam
Suzanne Quigley
Michael Raskob
Bette Rice
Emanuel Riley
Lawrence Rinder
Felix Rivera
Jeffrey Robinson
Georgianna Rodriguez
Joshua Rosenblatt
Matt Ross
Amy Roth
Debbie Rowe
Jane Royal

Carol Rusk
Doris Sabater
Angie Salerno
Warfield Samuels
Stephanie Schumann
David Selimoski
Anna Sheehan
Debra Singer
Frank Smigiel
G.R. Smith
Stephen Soba
Karen Sorensen
Barbi Spieler
Carrie Springer
Mark Steigelman
Marvin Suchoff
Mary Anne Talotta
Kean Tan
Caroline Thomas
Tami Thompson-Wood
Phyllis Thorpe
Joni Todd
Robert Tofolo
James Tomasello
Lindsay Turley
Makiko Ushiba
Ray Vega
Eric Vermilion
Helena Vidal
Naseem Wahlah
Cecil Weekes
Adam D. Weinberg
Monika Weiss
John Williams
Rachel de W. Wixom
Jennifer Wolf
Sylvia Wolf
Andrea Wood

photo credits

lead sponsor statement

At Altria Group, Inc. we believe that the arts challenge us to explore new and diverse perspectives by inspiring dialogue and debate. We also believe that artists are among the most significant innovators of our time, and we look to them for inspiration and for commentary on an ever-changing world. This is why we have supported arts organizations around the world for more than forty-five years, including the Whitney Museum of American Art—a valued partner since 1967.

We are pleased to once again support the Whitney Biennial, which celebrates the mosaic of vision and voices of contemporary American artists. We salute the curatorial team who has brought together these works, as well as the artists who are part of this exhibition. We hope this exhibition will provoke and challenge, and we also hope it will bring enjoyment to all.

Jennifer P. Goodale
Vice President, Contributions

 Altria

colophon

The 2004 Biennial Exhibition was organized by Chrissie Iles, curator of film and video; Shamim M. Momin, branch director and curator of the Whitney Museum of American Art at Altria; and Debra Singer, associate curator of contemporary art, with the assistance of Meg Calvert-Cason, biennial coordinator; Gary Carrion-Murayari, curatorial assistant; Howie Chen, gallery/curatorial coordinator; Lee Clark, gallery/curatorial assistant; Apsara DiQuinzio, curatorial assistant, contemporary art; Henriette Huldisch, coordinator of film and video; and Jennifer Manno, biennial assistant.

This publication was produced by the Publications and New Media Department at the Whitney Museum of American Art, New York: Rachel de W. Wixom, head of publications and new media; Thea Hetzner, associate editor; Makiko Ushiba, manager, graphic design; Vickie Leung, production manager; Anita Duquette, manager, rights and reproductions; Basem D. Aly, web coordinator.

Texts on the individual artists were written by Howie Chen (HC), Apsara DiQuinzio (AD), Henriette Huldisch (HH), Chrissie Iles (CI), Christian Rattemeyer (CR), and Brian J. Sholis (BJS).

Project Manager: Kate Norment
Editor: Libby Hruska
Catalogue Design: Omnivore, Inc. (Alice Chung, Karen Hsu)
In-house Design Consultant: Makiko Ushiba
Proofreaders: Susan Richmond, Beth A. Huseman

Printing: Steidl, Göttingen, Germany
Color Separations: Steidl, Göttingen, Germany

Printed and bound in Germany